MINING PHOTOGRAPHS AND OTHER PICTURES 1948-1968

The Nova Scotia Series
Source Materials of the Contemporary Arts

Editor: Benjamin H. D. Buchloh

Volumes 1-8 were edited by Kasper Koenig

MINING PHOTOGRAPHS AND OTHER PICTURES 1948-1968

A Selection from the Negative Archives of Shedden Studio, Glace Bay, Cape Breton

PHOTOGRAPHS BY LESLIE SHEDDEN

Essays by Don Macgillivray and Allan Sekula
Introduction by Robert Wilkie

Edited by Benjamin H.D. Buchloh and Robert Wilkie

The Press of the Nova Scotia College of Art and Design
and The University College of Cape Breton Press

Published by
The Press of the Nova Scotia College of Art and Design
5163 Duke Street, Halifax, Nova Scotia,
Canada B3J 3J6 Tel. (902) 422-7381

Co-published by
The University College of Cape Breton Press
P.O. Box 5300, Sydney, Cape Breton, Nova Scotia,
Canada B1P 6L2 Tel. (902) 539-5300

Canadian Cataloguing in Publication Data
Shedden, Leslie
Mining Photographs and Other Pictures, 1948-1968

(The Nova Scotia series; v. 13)
ISBN 0-919616-25-9

1. Coal mines and mining — Nova Scotia — Glace Bay —
History — 20th century. 2. Miners — Nova Scotia — Glace
Bay. 3. Photography of coal mines. 4. Shedden, Leslie. I.
Buchloh, Benjamin H. D. II. Wilkie, Robert. III. Title. IV.
Series: The Nova Scotia series: source materials of the
contemporary arts; V. 13.
HD9554.C23G55 338.2'724'0971695C83-094174-6

Published 1983

Printed and bound in Halifax, Nova Scotia, Canada

Design and production by Benjamin H. D. Buchloh, Allan Scarth
and Bob Wilkie

Pressman: Guy Harrison

CONTENTS

Editorial Note

In the summer of 1980 the photographic archive of Leslie Shedden was brought to our attention by Cyril Mac-Donald who had acquired Shedden Studio in Glace Bay, Cape Breton, Nova Scotia. This happened at a moment when the traditional criteria for the editorial policy at the Press of the Nova Scotia College of Art and Design and its commitment to a program of publishing 'source materials of the contemporary arts' underwent critical revision.

It no longer seemed reasonable or productive to continue a policy that exclusively published artists' writings and documents regardless of their relevance for the situation of the institution and its primary audience and support groups — the students, the local community and the audience for cultural criticism in general. This seemed all the more evident when those artists in the field of contemporary visual art that previously had seemed internationalist and progressive in their concerns, were replaced by a new generation of art producers whose primary interest was the successful entry into the market and the international art world institutions with all of their provincial limitations.

At the same time it was understood that neither a false regionalism nor a nationalism within a traditional high-art framework could resolve the historical contradiction which had become increasingly evident in what was once high cultural practice and what has now become part of the cultural industry. It became clear that contemporary cultural practice that defined itself as critical practice had to address issues that were at the same time more general (the conditions of mass culture) and more specific (the particular formations of ideology in the place where critical practice wants to be operative).

This documentation of the photographic activities of a local commercial photographer from Cape Breton — beyond the inherent interest of the body of photographs itself — intends therefore to function as an attempt at or an example of a critical investigation of the conditions of cultural production at a very specific moment: the historical intersection between colonization and marginalization, its social and political implications, and its cultural consequences.

The Press of the Nova Scotia College of Art and Design would like to thank first of all Leslie Shedden for his permission to publish this archive. Furthermore, we would like to thank Leslie Shedden and his wife Mary, who have been supportive of this project over an extended period of time. They have collaborated in the most generous manner with Robert Wilkie, the co-editor of this book, in retrieving and providing necessary information.

Clearly our thanks should go also to Cyril MacDonald, owner of Shedden Studio, Glace Bay, Cape Breton, who brought the archive to our attention originally and provided access to the negatives for the reproduction of the photographs in this volume.

The Press was fortunate to receive the contributions of two scholars for this publication that provide the necessary historical background and theoretical context for the reading of the photographic archive. Don Macgillivray, labour historian at the University College of Cape Breton, Sydney, Cape Breton, has written an essay that clarifies the history of the region and the character and motivations of its population: the political and cultural consciousness of the population of Cape Breton which sustains its struggle against absentee corporate power whether it be British, American or Canadian and which belies the cliches of natural amenities and impoverished but hearty country living within which the tourism industry nowadays tries to contain the island.

Allan Sekula, historian and critic of photography at Ohio State University, has contributed an essay on the history of the representation of labour and photography's role in the instrumentalization of the human individual. The essay's scope and substance is not only an adequate recognition of the subject of the book, the photographs of Leslie Shedden, but also an essay that will have to be considered as an exemplary step in the development of a more adequate reading and writing of photographic history.

Finally I would like to thank my co-editor Robert Wilkie for his commitment to the project in general, from its initial stages to the final design and production. Without his involvement this book would not have been published in its present form. His research of the historical and geographical details of the photographic archive in particular provides the reader with captions that are specific and prevent the photographs from being mere "pictures" and make them readable as an historical documentary. Robert Wilkie's introduction is based on a personal knowledge of the people and the region of Cape Breton, Nova Scotia. We hope very much that the book will find its readers first of all among these people.

Benjamin H.D. Buchloh
April, 1983.

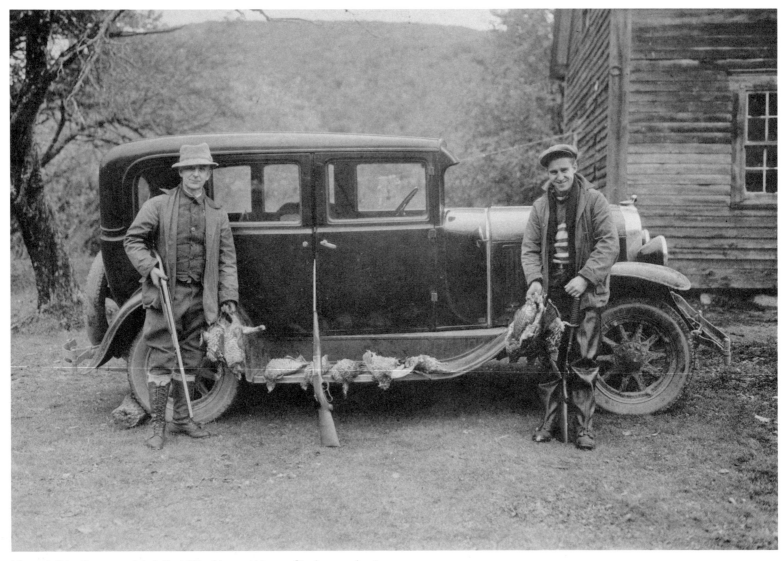

Figure 1. Cape Breton, undated. David Shedden and his son, Stanley, on a hunting trip in rural Cape Breton. (Collection: Leslie Shedden)

'MINING' PHOTOGRAPHS AND OTHER PICTURES*
By Robert Wilkie

I

Introduction: Shedden Studio 1916-1977

More than half the photographs that are reproduced in this book are the result of a professional relationship between Shedden Studio, under the proprietorship of Leslie Shedden, and the Dominion Steel and Coal Corporation (Dosco). This relationship began in the late 1940's. The other half are the result of commercial contacts between Shedden Studio and the general community of Glace Bay, Cape Breton. But the story of these relationsips begins much earlier with the arrival of two men to Cape Breton, Nova Scotia around the turn of the century.

In 1893, a Boston financier, H. M. Whitney, consolidated a number of existing coal companies in south Cape Breton into the Dominion Coal Company. Six years later he formed the Dominion Iron and Steel Company, introducing industrial capitalism to the region. Whitney like so many other financial adventurers was soon on his way — he had lasted less than a decade — leaving behind his name and a legacy of difficulties.[1] Much of Cape Breton's steel and coal industries fell into the control of Central Canadian interests shortly after

1900. But there was little harmony among these absentee capitalists, and the continued long-distance juggling of Cape Breton's industrial ownership resulted in the foundation, in 1910, of the Dominion Steel Corporation, a holding company with strong ties to the Bank of Montreal and the Bank of Commerce.[2] This centralized ownership of Cape Breton's wealth has been the key to the area's continued underdevelopment and roller coaster economy.

With a few more changes in the financial hierarchy the British Empire Steel Corporation (Besco), "the largest industrial consortium in Canada at that time," emerged.[3] Over the next nine years Besco was to wage some of the most brutal anti-labour campaigns in Canada's history against the local workers and their families. On three occasions the military were called upon by the civil powers to aid Besco in solving industrial disputes. The industrial area of Cape Breton was literally occupied by an army paid for in part by the people it was there to suppress. These labour disputes, a collapsing market for steel, and poor management resulted in Besco's demise, and in 1928

*Many thanks to Leslie Shedden and Mary Shedden for inviting me into their home and for sharing their memories of their family and of Shedden Studio with me; to Vivian Cameron for working with me on all stages of this manuscript and in some cases making substantial contributions to it; to Gary Kibbins, Don Macgillivray and Allan Sekula for their criticisms and suggestions; to Don MacLeod for allowing me unlimited access to his otherwise unavailable doctoral thesis on mining in Nova Scotia between 1858 and 1910; and to Benjamin Buchloh for his reading and patience as co-editor.

Besco was transformed into the Dominion Steel and Coal Corporation (Dosco). With Dosco came promises of peace with labour and a bright future of economic prosperity. Dosco's promises fell on the mistrusting ears of an embittered working class.[4]

David Thomson Shedden came to Glace Bay, Cape Breton around 1910.[5] David Shedden, like many other immigrants to Cape Breton who came riding in on this tide of industrial expansion, was a native of Scotland. He was the son of a successful Glasgow butcher and had trained as a meatcutter in his father's employ. With this trade David Shedden would support himself and his family for the first few years after his arrival in Canada. But his days as a tradesman were numbered. From a very early age David Shedden was fascinated with photography, an activity that was made available to amateurs in North America by George Eastman in 1884.[6] This avocation eventually led to Shedden's career as a commercial photographer. While continuing to labour as a meatcutter, David Shedden also worked part-time as a photographer and after several years his photographic work was recognized as professional by the local population. This transformation from amateur to professional, and thereby, from meatcutter to photographer, eventually led to the foundation of Shedden Studio in 1916. In 1929 the building that housed Shedden Studio was destroyed by fire and the entire negative archives accumulated to that date were engulfed in those flames.

It is quite likely that many of the pre-1929 Shedden photographs can still be found in the attics and parlours of Glace Bay. The Shedden photographs from that period probably conformed to the formal traditions that commercial photography invariably produced, those of portraitive, wedding pictures, documents of events and other community activities. We know that during this period there was some relationship, possibly indirect, between Shedden and Besco, but that connection survives only through memories of photographs. David Shedden's youngest son, Leslie, recalls a photograph of an officer who commanded Federal calvary troops in one of the many battles between Besco and local workers. This officer, a Captain Wood, commissioned David Shedden to document the military occupation of Glace Bay in 1923. Leslie Shedden's memory is of Wood's posing beside his horse, an imposing and authoritative figure. David Shedden's photograph may resemble others taken at the same time recently used to illustrate an historical account of the events in a military journal.[7] Although several commercial photographers and numerous amateurs were active throughout this period, very few known photographs have survived — some of them, like the Shedden account, exist only as memories — while historical accounts of these events rely primarily on writings: official documents, newspaper reports, personal memoirs and the like.

Most of the work done by Shedden and his commercial colleagues commemorated more personal and mundane events: birthdays, anniversaries, religious ceremonies, marriages, graduations: photographs originally taken to celebrate, later used to remember. One typical example of this work is the portrait taken by David Shedden in 1935 of James Bryson McLachlan, a pioneer and a leader in the Cape Breton labour movement; a portrait used by McLachlan in his political campaign for the federal elections of 1935. The photograph, which found its way into the Beaton Institute Archives of the University College of Cape Breton, was later used to illustrate at least one book that discusses McLachlan's life as an activist.[8] We can imagine this picture serving a more private commemorative function for McLachlan and his relatives in addition to these more public political and historical meanings.

Unlike photographers in large commercial studios, small town commercial photographers often personally handle all the stages of production. But despite this element of coherent craft, much of the work of a small town photographer is inclined to be formulaic and repetitive. David Shedden found escape from tedium and from the business demands by mak-

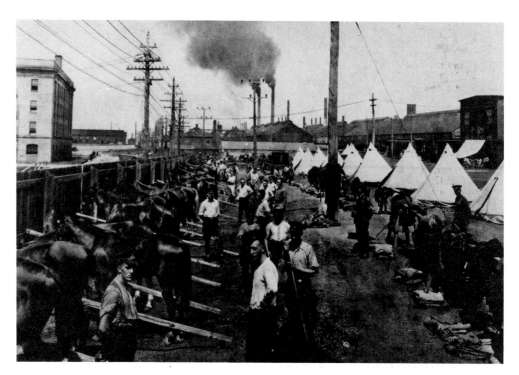

Figure 2. Sydney, 1923. "B" Squadron of the Royal Canadian Dragoons, part of the Federal military contingent brought in to suppress labour activities during the 1923 strikes against Besco. (*Canadian Defense Quarterly*, Summer 1978)

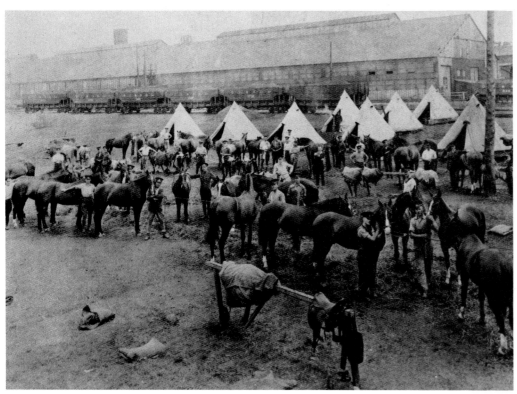

Figure 3. Sydney, 1923. Royal Canadian Dragoons at Besco plant before moving to Glace Bay to police the coal miners strike there. (*Canadian Defense Quarterly*, Summer, 1978)

Figure 4. James Bryson McLachlan, 1935. Photograph taken by David Shedden and used by McLachlan in his campaign for the federal elections of 1935. (Beaton Institute Archives)

ing and exhibiting photographs that he regarded as independent works of art. He submitted these pictures to national and international photographic Salons, which were modeled on a mode of jury selection and exhibition in nineteenth century academic painting, and where pictorialism was the dominant, guiding esthetic principle. While producing his commercial photographs as usual, he was also vigilant for that certain qualification in his subject that would transform clientele into objects of esthetic contemplation, and with contractual responsibilities aside, he would photograph consenting individuals with these Salons in mind.

Two of these photographs from the mid-thirties survive in the private collection of Leslie Shedden. One portrait, simply entitled ''Vagrant,'' is of a black man, arrested by the local constabulary and brought to Shedden Studio to be photographed for police records. The man was a transient, unemployed worker, one of the millions affected by the depression of the thirties. ''Four Score and Ten'' is the title of the second portrait. Like the portrait of the vagrant, this photograph focuses on the head and shoulders of a figure, but this time the subject is an elderly woman, most likely a citizen of the local community, who had probably commissioned Shedden to photograph her. Both have the look of well-crafted, crafted, carefully made portraits which assume a very traditional pose. Both have been photographed with a soft-focus lens which gave an expressive dimension reminiscent of Corregio and his descendents among the painters of the nineteenth century. What is more interesting, though, is the sub-stratum of society from which these people came and that Shedden chose to estheticize and to exhibit — the poor and the old.

In modern industrial societies, both age and poverty are seen as threatening to the middle class. But the aged in Cape Breton fared much better, where the tradition of kinship and the extended family resisted the generational fragmentation of family life which, elsewhere, in more advanced industrialized centres, seemed to imitate industry itself. In more urban

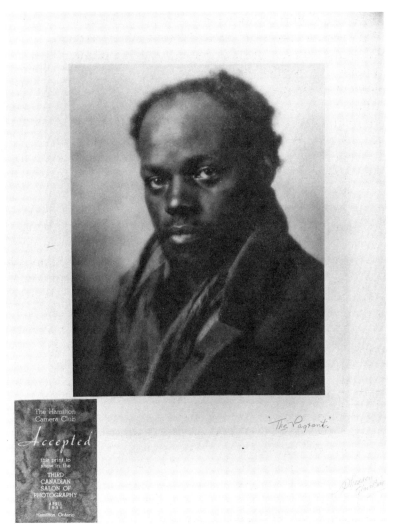

Figure 5. "Vagrant," a photograph by David Shedden accepted into the Third Canadian Salon of Photography in 1936. (Collection: Leslie Shedden)

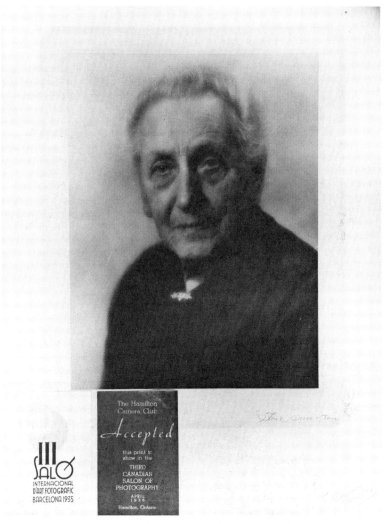

Figure 6. "Four Score and Ten," a photograph by David Shedden accepted into the Third International Salon of Photography, Barcelona, Spain, 1935 and into the Third Canadian Salon of Photography in 1936. (Collection: Leslie Shedden)

environments, the poor and the unemployed were also treated with less respect. The destitute, at this time suffering from the effects of the Great Depression, were even more brutally marginalized and were given little relief through welfare, charity, and social reform movements.[9] David Shedden's intentions in these portraits seem more transcendent than mundane, although we might think that his choices had some ground in the characteristic attitude of Cape Bretoners. But, when exhibited in remote Salons, these pictures served to erase the phobia of the *other*, that is, of anything that exists as different from or a threat to the security of bourgeois culture. This "otherness" of death (represented by the elderly woman) and of class and race (represented by the itinerant black man) is romanticized and thereby neutralized by the photographer's camera. These images have been torn from reality, estheticized, and thereby rendered unthreatening. Hung in Salons, these photographs (and frequently those represented in them) are now "controlled" by the middle class consumer. Neither "Vagrant" nor "Four Score and Ten," is extremely original or explicit in its representation — by this I mean distanced from their actual situation. Both were accepted into the Third Canadian Salon of Photography held in Hamilton, Ontario in 1936 and "Four Score and Ten" was accepted by the Third International Salon of Photography in Barcelona, Spain in 1935.

By 1930, Shedden Studio had become a family enterprise with Stanley Shedden, oldest of the five Shedden children, becoming an active photographer as well. If few of David Shedden's photographs survive, there are even fewer of Stanley's. But there is one rather striking and somewhat candid photograph that he took for ciculation as a news photo. It is a picture of a rather remarkable airplane crash. Beryl Markham was the first woman to fly the Atlantic from east to west, and after just completing her trans-Atlantic crossing in September, 1936, she crashed in a marshy area near Baleine Cove, Cape Breton.[10] The aircraft sits in the mud, nose neatly buried as if it had been deliberately covered, but at the same time it has the look of a real tragedy. Fortunately Markham walked away unscathed and Stanley's photograph was picked up by several newspapers covering the victory of the crossing and the mishap at its end. This was a rare foray into photojournalism for the Shedden family. Perhaps Stanley Shedden would have continued to be the Studio's official photojournalist if he had not died prematurely after several years of illness in 1937, at the age of 27. After Stanley's death the charge of maintaining the Studio eventually passed on to Leslie, youngest of the Shedden brothers.

As a youth, Leslie had accompanied his father on some of his field commissions and through these experiences became more active in the everyday functioning of the Studio. Through this informal, part-time apprenticeship, he was to acquire an understanding of the techniques and responsibilities of commercial photography. In the summer of 1939, like his father before him in the 1920's, Leslie enrolled in the Winona Lake School of Photography in Winona Lake, Indiana, where he developed beyond those rudiments and learned the latest skills in lighting techniques, composition, landscape and portrait photography, and colour hand-tinting, taught by successful commercial photographers who visited the school for two week teaching sessions. The training was intensive and costly, but the school was the "best in North America" according to Leslie Shedden. After fulfilling the requirements, Leslie Shedden returned to Glace Bay, to his father's studio, now well known and respected by the local public. He expected to work alongside his father, only to be faced with a world mobilizing for World War II.

In 1939 Leslie Shedden enlisted in the Royal Canadian Air Force and after his basic training was attached to the R.C.A.F. Photography section. He reached the rank of Sergeant, spending the major portion of his military service posted in Sydney, several miles from Glace Bay. He took aerial photographs of harbours, war manoeuvres, mock sea battles, and convoys off the coast of the Maritime Provinces. He also documented

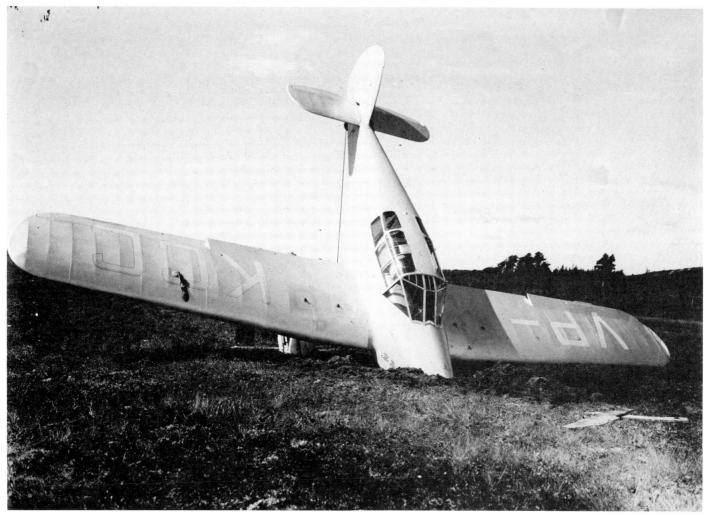

Figure 7. Baliene, Cape Breton, September, 1936. Photograph taken by Stanley Shedden of Beryl Markham's airplane, "The Messenger," just after crashing in a marshy area near Baleine, Cape Breton. Markham was the first woman to complete a solo, east to west, trans-Atlantic flight. The crash was due to fuel shortage at the end of that flight. (Collection: Leslie Shedden)

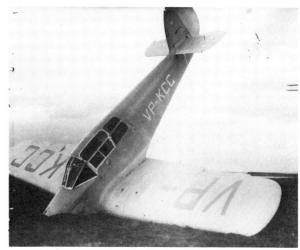

Figure 8. Baleine, Cape Breton, 1936. Photograph of Markham's airplane as it appeared in the *New York Times* on September, 1936. (*New York Times*/Associated Press, 1936)

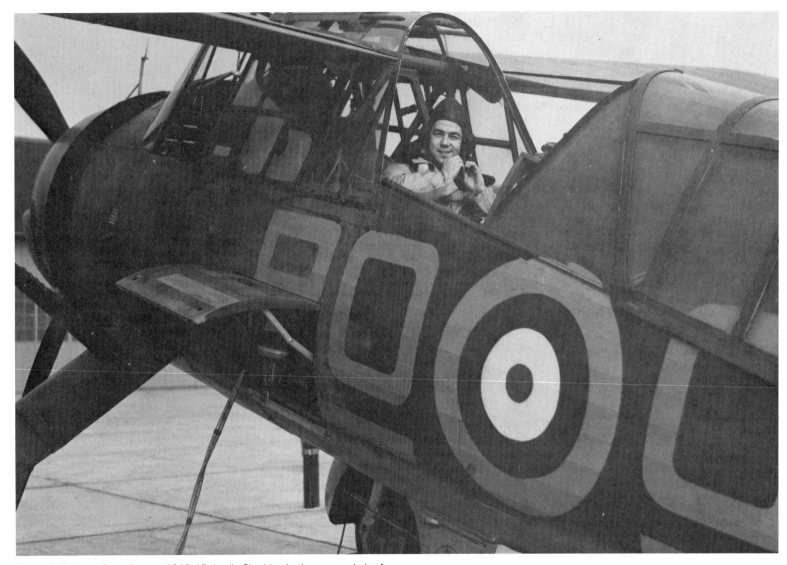

Figure 9. Sydney, Cape Breton, 1940-45. Leslie Shedden in the rear cockpit of
a Lysander military reconnaisance aircraft, preparing for an aerial photo mission.
(Collection: Leslie Shedden)

airplane crashes and accidents at the Sydney airfield. When not otherwise busy he and Photo Section colleagues would occasionally photograph each other in sometimes candid, sometimes heroic poses. The picture of Shedden, seated in the rear cockpit of a Lysander reconnaissance aircraft, preparing for a mission, appears to be positioned between the two, although, in fact, it is a mock heroic photograph. (In this connection the photograph of the Markham plane has perhaps the same contradictions, seen as both comic and tragic). What Shedden played on here also was the traditional image of the airborne adventurer. Beryl Markham, for instance, was probably similarly pictured in the cockpit of her plane, just before taking off on her trans-Atlantic adventure. In any case, in September of 1945, Shedden made a trans-Atlantic crossing of his own and for the remainder of his military career was stationed in Lunenburg, Germany, documenting the post-war military operations in Europe.[11]

After being honourably discharged from the Airforce, Leslie Shedden returned home to assume the role of primary photographer for Shedden Studio. His first task was to clear up the backlog of printing and finishing work overwhelming the now aging David Shedden. By the time of his father's death in 1948 Leslie had assumed all major responsibility for the photography, production and administration of the Studio. For the next thirty years, Leslie, along with his wife Mary and for a short time, his mother Myrtle Shedden, maintained a reliable commercial photography studio for the people of Glace Bay, Mary and Myrtle Shedden assisted in print processing, booked appointments and handled the Studio's accounts. Leslie Shedden photographed weddings, made formal portraits and passport photos, and pictured storefronts, interiors of groceterias, schools, churches, and banks. He was commissioned annually to photograph the students and faculty of at least three high schools and six nursing schools in the area for their yearbooks. He was called upon by various small businesses, municipal governments and community groups to record highlights in local community and institutional life for news releases and for posterity. The Studio serviced four local outlets (three drugstores and one bookstore) processing roll film for amateur and family photographers in the Glace Bay area.

As a commercial photographer Shedden found himself photographing everything from mining machines far beneath the ocean floor to the turning of sod for a local park. But Shedden maintains that his most technically proficient work was as a portraitist. Not only did Shedden take the photographs, but after processing and printing them he would routinely and meticulously hand-colour thousands of portraits for his clients. This was his practice for thirty years. Colour photography was not popular in Cape Breton until the mid-sixties and even then Shedden would resist the ever-growing demands to produce professional colour work, adhering to the craft he had mastered at Winona Lake in 1939. The key word here is craft, for what Shedden was really resisting was the mechanization of photographic production, since the colour process involved sending the negatives off to a distant laboratory beyond the control of the craftsman. Not until the 1970's would Shedden adapt his studio to colour work.

Shedden took pride in the high quality of his hand-tinted portraits and it was this activity that led him to apply these talents to another type of photograph. Every so often Shedden travelled to the Cape Breton countryside in search of eye catching landscape views. By printing selected images on a flat or textured paper and applying colour by hand, he created something that stood between colour photography and traditional landscape painting. *(see Appendix III).* These hand-coloured photographs, similar to present-day postcards of the same areas, were then framed and offered at a minimal price to the local public. As in the two Salon portraits by David Shedden, Leslie Shedden here produced esthetcized works meant to replace the traditional landscape paintings people might hang in their homes. These less expensive substitutes were available

to customers of a lower income bracket as well.[12] At the same time these colour landscapes celebrated the local beauty of the region to which hordes of tourists flocked in order to "consume" its natural picturesque areas. That consumption was both visual and actual, as any indigenous, historical and manufactured artifacts became fair game for weekend visitors. Lumps of coal, lighthouses made from sea shells, carvings, pottery, lobster traps, hand-tinted photographs and even picture books served and serve today for these curio hunters as symbolic reminders of the place, the authentification of their past presence there, and in a sense, their conquest of Cape Breton.

Leslie Shedden worked very hard during his years as a commercial photographer, usually starting very early in the morning and working all day to keep up with his various responsibilities. As a modest and generous person he had a reputation for fair dealing with all of his clients. He was well aware of the differing incomes and abilities to pay. His biggest client, with whom he would be involved for over twenty years, was Dosco. The result of this extended relationship was the production of a photographic archive (approximately 2000, 4" x 5" negatives) which depicts many aspects of the company: its assets and properties, and its employees, both managerial and labouring. Even though Shedden considers these, like his coloured landscapes, as secondary to his portrait work what we as viewers see are intelligently composed, informative, useful, often witty, and even brilliant photographs from an archive that was produced under what were sometimes very intimidating circumstances.

About 1948 Leslie Shedden was first contacted by the public relations department of Dosco. From that time on, he worked largely with two men, Ernest Beaton and Lawrence Doucette, both attached to the Public Relations Department. Occasionally Shedden worked for Frank Doxy, an assistant to the chief Dosco executive in the area, Harold Gordon. The relationship between the Dosco middle men and Leslie Shedden was fairly informal and he became very close friends with Ernie Beaton, whose reputation for humour and congeneality was widespread among the employees of Dosco. (Beaton, once a miner, had worked his way up through the ranks into the Dosco hierarchy). As a raconteur, Beaton frequently distracted Shedden from the tedium and dangers of the trips to the mines. Typically, for a Dosco commission, Shedden was contacted a day or two in advance, and occasionally when emergencies arose, on the day itself. He and his contact, usually Ernie Beaton, prearranged their agenda, frequently meeting at the Studio and from there travelling to the various collieries in Cape Breton and mainland Nova Scotia. These outings took him not only to the depths of industrial Cape Breton's coalfields stretching several miles beneath the ocean floor, and to the pit-bottoms of the Pictou coal-fields, but on at least one occasion to Wabana, Newfoundland, to photograph the iron ore mining operation, which formed an integral part of the corporation's holdings. Shedden became familiar with the entire range of Dosco's mining operations. He took pictures of newly acquired machinery, recently improved machinery, broken-down machinery, machinery in action and machinery with proud executives, engineers and workers standing by. The construction of tunnels, completed tunnels, new conveyor systems, haulage engines, the winding towers and power plants of Dosco were the subject of the Shedden camera. Workers were photographed shoveling coal, operating mining machines and tending machines in the shops; warehouse workers, laboratory technicians, clerical workers, and salesmen were all recorded in their working environments. Pictures of office parties, of executive meetings, of baby and wedding showers and of retirement presentations for departing employees, of company baseball and bowling teams, of presentations for achievements in safety and production, all became a part of the Dosco archive. Officially, he made portraits of the executives and the upper managerial strata of Dosco, and unofficially, while on his various other missions, he would ask the workers who happened to be on the job to pose for informal portraits. With

the introduction of television into the local area, Shedden was commissioned by Dosco to make a series of stills for the local T.V. station for the promotion of the use of coal in the home.

Overall, the photographic documentation was systematic, meticulous, and thorough; not one event escaped the sophisticated eye of Dosco's corporate public relations. But after twenty years of service and after the production of at least two thousand photographs for Dosco's public relations machine, Shedden terminated the Dosco/Shedden Studio relationship. With the retirement of his friend Ernie Beaton and with the burden of his increasing age, the long and dangerous trips to the coal face were no longer of interest to Leslie Shedden, and in 1968 he made his last trip into the coal mines of Cape Breton.

For the next ten years Leslie Shedden maintained his commercial photo practice and continued to do work for the people of Glace Bay and surrounding areas. But gradually the work began to catch up with him and in 1977 he decided to retire from the photography business altogether. He sold his Studio to a local, young photographer, leaving his name with its established reputation, and with this reputation an assurance of the continuing prosperity Shedden Studio had seen in the past.

But the story of these photographs does not end with the demise of the Dosco relationship, nor with Shedden's retirement. Many questions can be asked. What became of these pictures once Leslie Shedden handed them over to Dosco? What happens to the image(s) of a photographer once entered into this exchange of images referred to by Allan Sekula as "the traffic in photographs?"[13]

Only the young ladies participate in the Christmas Party festivities at the Glace Bay Offices of the Dominion Coal Company and they do make a pretty picture around the tree. Lucky Santa is Jimmy MacDougall.
— Photo by Shedden

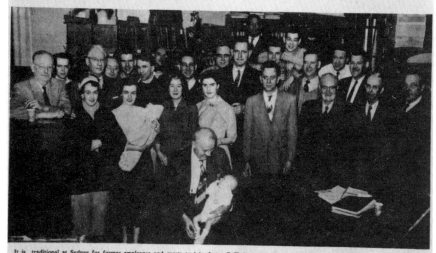

It is traditional at Sydney for former employees and guests to join the staff Christmas Parties at Christmas and the Engineering Party had a very special guest, Baby Barry Heffernan. Barry seems to be enjoying the attention paid him by the Dean of Dosco Engineering, A. P. Theuerkauf.
— Photo by Abbass

—||—
"It is management's job to think in terms of people and to act in a way that will build rather than destroy the individual dignity of every citizen. It is a challenging job for anyone, particularly because this is one field in which complete success can never be attained."

— Frederick J. Bell.

—||—
A citizen was walking up Fifth Avenue when he was button-holed by a character who said: "Shay, can you tell me where to find "Alcoholisch Anonymush?"

"Why? Do you want to join?"

"No, wanna resign!"

'4 | Teamwork

Figure 10. A page from the Dosco employee relations journal *Teamwork*, picturing Dosco office workers at the Christmas parties in Glace Bay and Sydney. (*Teamwork*, January, 1956)

II

The 'Teamwork' of Business and the Business of *Team-work* in the World of Dosco

With the end of the Second World War millions of servicemen returned home. Some, like Shedden, returned to jobs that awaited them while others had expectations of guaranteed employment as just reward for their patriotic service. Their return was accompanied by an intensive shift in the strategies of those who managed the economy. They were faced with the economic need to return millions of women to unpaid domestic work.[14] They had to satisfy a huge, demanding, post-depression, post-war workforce and industries had to be geared to civilian consumption. War-time technological improvements had involved a greater reliance on refined energy resources, especially gasoline and diesel fuel. Consequently new refineries were built; however in the post-war economy, when these refineries found no market in the armed forces, substitute markets had to be created: thus automobile production was expanded, commercial aviation encouraged, railways converted to diesel fuel, electric generating plants and domestic heating converted from coal to oil. During this time many transformations took place in social relationships. The workers found themselves being treated primarily as consumers, and hence, as an audience for advertising and other improved forms of mind management.[15]

Once coerced physically, the people of Cape Breton now experienced a form of mental persuasion. Dosco was certainly not Besco and labour relations of the 1940's and 1950's did not compare with the brutality seen in the 1920's. Yet Dosco was still controlled by outside interests; its holdings ranged from Central Canada to the Maritime Provinces and to Newfoundland. The coal and steel produced in Cape Breton found markets throughout the world. Dosco's international profile naturally determined the manner in which the company related to its shareholders, its management and employees, and its customers.

Dosco published two magazines mixing public and employee relations. *Teamwork,* which spoke to the workforce, was published from the mid 1940's to the mid 1950's. *Dosco World,* which assumed a more public profile, appeared from the mid 1950's until Dosco's demise in 1967. Of the two journals *Teamwork* seemed to have more respect for the intellectual capacity of its readers.[16] Throughout its history it carried two continuing features: an editorial and something called "Quotes to Note." The latter, a single page feature in every issue, simply reproduced passages from the writings and speeches of famous statesmen, businessmen, military officers, philosophers and institutions. These homilies constantly repeated the call for free enterprise. The praises of individualism, co-operation, advertising, automation, communication and anti-communism were sung repeatedly. This eclectic page of truisms and reflections on the human condition was intended to build a stronger team within this industrial "family", with the aim of increasing productivity and corporate profit. One such mini-sermon indicated how personal dignity

could contribute to the cause of productivity:

Employers need to remember that an elementary demand among mankind is for maintenace of dignity. The dignity of man is just as important within the factory cafeteria as it is in an exclusive city club.

Dignity of workers may be maintained when employers praise generously, give credit publicly when credit is due, unbend in the presence of employees so as to raise the employees' self-esteem, judge justly and not hastily, and accept criticism with appreciation.

Employees owe it to themselves to choose among the occupations open to them the one in which they can best serve, and they owe it to their employers to do their best in it, to develop and preserve a working discipline, to guard against letting their emotions run away with their working sense, and to avoid, as they expect their superiors to avoid, shop politics.[17]

Not only does this flagrantly insult the dignity and intelligence of the worker but such patronizing attitudes coming from the clean air of the business office did little to ease the oppression of a workplace such as a coal mine stretching several miles beneath the ocean floor.

Throughout this montage of quotations not once do we hear the voice of the worker. The "teamwork" so consistently alluded to is a teamwork of business and political elite that desires only the continued suppression of the workers' voice and consequently of the workers' needs.

In similar fashion the "editorial" feature echoes the constant urging for teamwork between management and employees, as we see in this example from the April, 1952 issue in which discusses the hazards of day-dreaming.

Day-dreaming can be amusing, even fun, if you do it at the right time in the right place. In fact, almost anything is fun in its proper time and place! But if you do it at your work, it's more likely to spell trouble.

Out on the job a day-dreamer is a liability to his fellow worker and to himself. He is a safety hazard that can't be removed by anyone but himself.

He is dangerous because he is hard to find. There is no warning and yet he is a potential accident and his absence of thinking jeopardizes all people around him as well as himself. Teamwork at work gives you the very best in human satisfaction. A day-dream out of place can rob you of your best friend, bring permanent injury to your buddies or untold suffering to yourself.[18]

Admonishments such as this tended to obfuscate the actual working conditions — unhealthy and dangerous — of the miner, his job insecurity, his low wages. They tended to efface his real needs (which management might have seen as dreams) for a safer working environment, more job security, better wages, an increased standard of living, and more educational opportunities. Throughout its pages *Teamwork* praises the beauty of industry, the advantages of advertising, the need for for increased "communications" and the fruits of mechanization, and, at the same time, pictures many of its employees enjoying office parties or receiving formal praise from Dosco for their service to the company. Understandably, we never hear of the inadequacy of workers' facilities or the inefficiency of the technology that the company boasted of so proudly. Nor is their any mention of the continuing economic underdevelopment or the constant depletion of the natural resources of the region.[19]

Dosco World transformed the earlier call for teamwork into the image of an all-encompassing corporate family. The main feature of that magazine was a short (usually two page) photo essay accompanied by a simplistic text. An article in the Autumn, 1959 issue entitled "Dosco is a Big Family" informs the reader that "family is a good word, too, to describe Dosco since it is a family of companies — some 33 in all, employing more than 21,000 people."[20] A world was constructed where executive and employee could be seen as father and son (or daughter) or where miner and diesel engine become siblings

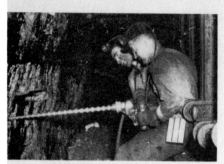

TWO CAPE BRETON MINERS are shown drilling at the coal face deep in one of Dosco's mines, which often run for miles under the sea.

DOSCO QUARRIES ITS LIMESTONE for iron making at Aguathuna, Nfld.

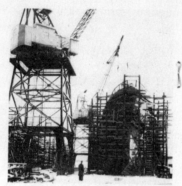

DOSCO'S NAME IS WELL KNOWN in ship-building circles. Here, a destroyer escort is shown under construction at our famous Halifax Shipyards.

DOSCO has three railway companies of its own, used largely for inter-company purposes. One is the Essex Terminal Railway at Windsor, Ontario.

DOSCO IS A BIG FAMILY

Here are amazing facts about our company that should make you proud to be associated with some 21,000 other Dosco employees.

"BIG" is just about the best word you can find to describe Dosco because everything about the company seems to be big. It is one of the biggest employers in the nation . . . Dosco people produce some of the biggest things made in Canada —ships, railway cars, bridges, steel and a host of other products—and it operates the country's biggest drydock, the biggest forging press and the world's largest galvanizing kettle.

And "family" is a good word, too, to describe Dosco since it is a family of companies—some 33 in all, employing more than 21,000 people.

There are Dosco people in Newfoundland mining high grade iron ore, and quarrying limestone . . . others are carrying it in our own ships to Sydney where coal from our Nova Scotia mines is used to make it into iron and steel. There are hundreds of Dosco people at Trenton, N.S. who turn this steel into valuable products, others in Saint John, N.B. who use it for nails and fencing, and shipyard workers at Halifax and Dartmouth who make ships from this same steel.

Dosco steel is also made in Montreal and it is used for window sash, for in-dustrial pipe and wire. There's a steel fabricating plant in Toronto, a bridge company in Windsor, an electric power generating company in Sydney and railways in the Maritimes and in Ontario. In all, Dosco operates in 18 communities in Eastern Canada stretching across five provinces and more than 2,000 miles.

But above all, Dosco is people—some 21,000 employees with families that bring the total to roughly 100,000 people. There are enough of us, in fact to fill a city the size of Saint John or Halifax.

There's not much doubt that Dosco is a "Big Family."

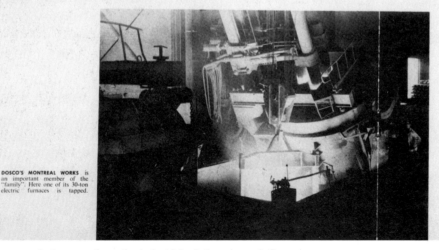

DOSCO'S MONTREAL WORKS is an important member of the "family". Here one of its 30-ton electric furnaces is tapped.

LOADED WITH IRON ORE for the export market, a ship is shown at Dosco's Wabana Mines pier in Newfoundland.

8

Figure 11. Two page photo essay from the industrial relations journal, *Dosco World*, picturing different aspects from the Dosco ''family.'' (*Dosco World,* Autumn, 1959)

through photographic juxtaposition. In *Dosco World,* children of Dosco employees are now "Dosco boys and girls" or "Dosco youngsters" seen preparing for school or college, both of course paid for by Dosco through the sweat of 'Dosco Daddies'.[21]

In one very profound effort to localize the familial universality of Dosco, the cover story of Volume 3, Number 2, entitled "The 624 MacDonalds of Dosco" exploits the predominant Celtic heritage of the Cape Breton region. This three page photo-essay pictures employees in every level of employment, from the deeps of the coal mines to the superintendent's desk, all with the surname MacDonald. There are even two Mac-Donalds at Dosco's Montreal works, it is pointed out, "one of which can only speak French!" Thus Dosco lay claim to the unification of two minority cultures in the Dominion under the name of MacDonald, but more importantly, within the 'Family of Dosco'. And there is more. For the article begins with saying, "MacDonalds are God's chosen people" and since these MacDonalds are Dosco employees, there seems to be some implication that Dosco itself is God's chosen industry. So the keywords now become Family, God and Dosco.[22]

While the largest portion of each number of *Dosco World* features various aspects of Dosco work, Dosco recreation, Dosco achievements and occasionally a successful ex-Dosco employee, the final two pages are consistent from issue to issue. "People in Focus" presents several captioned photographs of Dosco employees who, having contributed to the well-being of the Dosco family, are honoured by their inclusion in this corporate family album. But opposite this page where the distinguished children of Dosco are honoured we find an image of a corporate patriarch, in the form of the President's report and his photo-portrait. Every issue of *Dosco World* ends with a sometimes somber, sometimes cheerful message from the President, A. L. Fairley, Jr. Here again the call for teamwork is raised. In the Summer of 1962 issue for example, Fairley wrote "Teamwork is a word that gets much mention

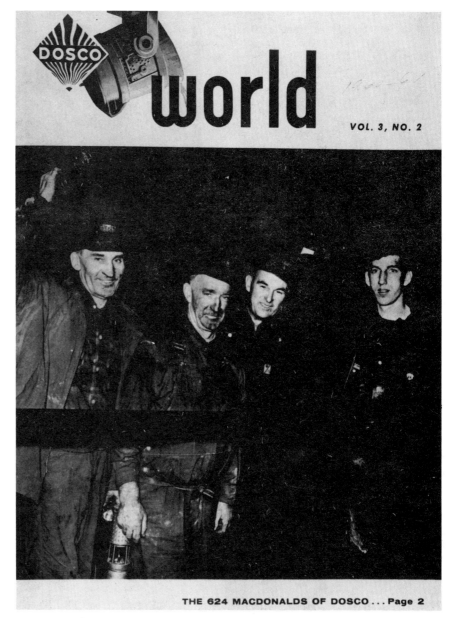

Figure 12. Cover of *Dosco World* picturing four of "The 624 MacDonalds of Dosco," after finishing a day's work at No. 26 Colliery in Glace Bay, Cape Breton. (*Dosco World,* Vol. 3, No. 2)

IRON WORKER Edwin Stewart, 49, is alive, well and happy today, thanks to his safety hat. He is pictured above holding his hard hat and a 15-lb. piece of angle iron which fell 15 feet, striking the back of his head while he was working on a repair program at Dosco's #1 Blast Furnace. A fatal injury and perhaps sudden death was prevented by the wearing of the hard hat. Stewart suffered only two stitches to his head.

SYDNEY MEN ON CBC SAFETY PROGRAM: C. N. Murray, general manager of the Sydney steel plant; Martin Merner, president of the Steelworkers Union; and Safety leader Joe Legge are seen in a CBC studio being interviewed on the occasion of the Sydney plant's winning an industrial safety award. The Industrial Accident Prevention Association advised the plant that it led all industries in Class 7, which includes the major Canadian steel producers. It marked the 14th time in 15 years that the local safety record was taken by the Sydney plant which, in 1961, bettered its own all-time record by 10 percent.

PEOPLE IN FOCUS

world

APRIL **1962**

Published quarterly by the Public Relations Department, Dominion Steel and Coal Corporation, Limited, Montreal, for employees of all Dosco companies. Material may be reprinted, but a credit line would be appreciated.

Address all communications to the Public Relations Department, Dominion Steel and Coal Corporation, Limited, P.O. Box 249, Montreal, Que.

ROYAL CANADIAN NAVY PADRE B. A. Peglar reads the prayer of dedication at the launching of fisheries patrol vessel "Cape Freels" at Halifax Shipyards at Mrs. W. J. Browne, St. John's, Newfoundland, wife of Canada's Solicitor-General, and Dan Scouler, Jr., the yard's General Manager look on. Mrs. Browne was the sponsor of the vessel that will serve in waters off Newfoundland.

FREDERICK W. STRUM, (above) joined the Halifax Shipyards employ as a boy of sixteen. Last month after 30 years service he was named Superintendent of the Shipyards' Marine Slips in Dartmouth, N.S. A native of Mader's Cove, N.S. he has a thorough knowledge of all of the yard's operations and has worked in stores, drafting and other posts.

The President reports:

My Dear Fellow Employees:

The writing of this letter coincides with our Corporation's Annual Meeting. At this meeting I reported, on behalf of all of us in Dosco, to our shareholders on the activities of the Company for the year 1961.

The financial results for the year were not good. Our profit was $1,112,707. and for a company of our size, with its many plants and operations, this is not a good showing.

While some individual employees may shrug this off with a simple "well, that's the shareholder's worry," I would hasten to point out that it is a worry for all of us—employees and shareholders alike.

Profits in our free economy are to some degree a mark of a company's efficiency. As well, profits strongly indicate whether a company has the ability to grow.

To grow, we must have capital—money—for new buildings, new equipment and for research. We can only obtain that money by winning the faith of the investing public. And that can only be done by assuring an adequate return on investment.

So it is important to every one of us that Dosco be more profitable.

Our company will certainly grow and will prosper if we all recognize that we live in a competitive society. Dosco products and services are not the only such products and services available to the public. We will only sell that public—both here and abroad—if our products are right in both price and quality. This is something that we, as individual employees, can control. If we do our own individual jobs to the best of our ability, then we should not have too much to worry about.

As I mentioned earlier, we all need help. We have to have good equipment and facilities with which to work. These have been and will continue to be acquired. And the best way to ensure continued improvement in this direction is for us to woo the investing public—whether it be an individual with $100 to invest or a trust company with millions—by improving our profit position.

The responsibility of being profitable rests with each one of us. Give this some thought. It is a challenge for all of us in the year ahead.

Yours truly,

A. L. Fairley Jr.

Figure 13. The last two pages of every issue of *Dosco World* carried "People in Focus" and "The President's Report." (*Dosco World,* August 1960

in this world today. It is on the lips of Army Generals, football coaches and the Chairman of your local Red Feather Drive."[23] Elsewhere he calls for the necessity of profit and the need for individuals to take their jobs seriously in order to allow growth in the world of Dosco. Invariably the letter begins with "My Dear Fellow Employees," an endearment strengthened by an image of the President himself in the upper right hand corner of the page (generally pictured as corporate director, occasionally as worker). In another issue, Fairley reinforced his paternal position with the words ". . . . while it is impossible for me to sit down and 'chat' with all of you individually and personally, I am anxious to bring this Dosco family of ours closer together." That the journal itself is to function as a "family album", the President himself confirms in his next sentence "I see the *Dosco World* as a means to this end."[24] What further enforces this image of the corporate family is a list of all the subsidiary and associated companies printed just below the President's Report. Not only does the journal incorporate the individual worker, from executive to miner into a supposed concrete family, but it also extends this family abstractly with this list of sibling companies.

What is important to recognize here is that not only does the corporation try to represent or imagine corporate familial relations in *Teamwork* and *Dosco World* but the representations themselves are taken from actual situations where the worker(s) are led to believe, if only once in a lifetime, that they belong to an all encompassing and caring community. Ironically, this caring patriarchal company would desert its dependents several years later because of the threat of declining profits.

During the period in which Dosco published these two journals the company was also faced with overwhelming competition from other non-renewable fuel resources, especially oil and gas. Consequently, throughout its public relation bids, Dosco was very aggressive, and at the same time apologetic, in its selling of modernization programs. Altruistically, *Dosco World* told its readers that "keeping modern requires foresight and alertness but it pays off in the mutual welfare of all in community happiness."[25]

It would be nothing less than crude to presume that Dosco public relations, with its media interventions could be given credit for mollifying a whole population, especially one with a tradition of militancy and a memory of past abuses. On Friday, November 13, 1967 (more commonly known as "Black Friday" to Cape Bretoners) Dosco announced the imminent closure of Sydney Steel and one week later on November 19, 1967, 20,000 members of the community marched through the streets of Sydney in protest. The result was the nationalization of both the coal and the steel industry. The Sydney Steel Plant, if only tenuously, is still operating today and the coal industry, through its recent renaissance, is providing some hope, however little that may be.[26]

III

Conclusion

> *Although the camera itself is a mechanically neutral and accurate instrument, the photographer is not. Just as with more conventional forms of documentation, the camera can shape and distort our image of the past. Only when we understand how and why the camera was used can we come to terms with the range and focus, the limits and perspectives, the problems and potential of this book.*
>
> (All That Our Hands Have Done)27
>
> *The reasons for a photograph of the King taking precedence, even today, over importance and interest invested in a family collection, and over a photograph of children playing in the street, spring directly from the notion that history and documentation should be concerned with the outstanding and extraordinary.*
>
> (Camerawork 16)[28]

In this book, photographs that once appeared in a specific promotional network surface again amid a world that is awash with a relentless tide of images — both photographic and electronic. They have been resurrected, along with pictures produced under more general professional circumstances (wedding, graduations, portraits) from the dusty archives of a studio which, for all intents and purposes, may be described as ordinary and situated within a traditional frame of reference that determines the activities and products of most commercial photographers. They have been lifted from one context or another, brought together, systematically edited, organized and finally published in a book, which, by virtue of its companion volumes, may be referred to as 'source materials for the contemporary arts'. But Leslie Shedden makes no claims for his identity as an artist, let alone a "contemporary" one. He saw himself as a photographer who "did his job and did it well." His photographic skills were accessible to and required by a wide range of individuals and institutions. Occasionally we may even see the final product of these business transactions as the result of a sort of pseudo-collective project — between craftsperson and client; between photographer and subject — where the commissioned photograph is akin to the tailor made suit; fulfilling both the consumer needs of its wearer and the creative needs of the maker. But where is the commercial photograph situated in the broad expanse of the photographic discourse? Do we call them industrial photographs, family photographs, advertising photographs, historical photographs? And do we extend their reading into the ethereal but inade-

quate realm of high art? How has this recovery operation affected these photographs?

It is at this point, where the activities of producing and editing photographs seem to resist each other and at the same time complement one another, that some serious considerations must be made. By resistance I mean something that may be better stated as the transposition of active and passive roles, where the photographer, once actively producing photographs, now assumes a passive position, while the editors intervene from their passive (non-producing) role and activate work made by someone else. So, in fact, it is in the archive itself that this resistence takes place — between production and curation; between photographer and editor — where the photographer resists inclusion and the editor resists exclusion. On the one hand, we have the photographer, who, in fulfilling his business obligations, produced images intended for specific readings — those of advertising, public relations, celebration and personal memory — with little claim over their distant future determination. On the other hand there are the editors.[29] In a sense we have been 'mining' photographs from an inert archives, and in doing so have fulfilled our obligations by contributing to the continuing work of social historians, socially engaged artists, and individuals and groups, who wish to assist in the reclamation of an otherwise suppressed history.

The intervention into photographic archives such as this, with its somewhat formal but diverse representations of community life — both public and private — allows for a critical reading of the photographs' primary commercial functions, and subsequently, re-contextualized, they offer a more useful interpretation of the past. Photographs once stripped of their previous designation of commercial exchange (advertising, public relations, etc.), may be reconsidered along with other photographs (historical, family, documentary, etc.) and re-presented as evidence of the past, as tools for engaging memory. As well they may offer esthetic pleasure.

In the case of a photographic archive such as this, the acti-

vation of the archive contributes to the re-making of a visual history, a visual history that goes beyond the adulation of the countryside, the city, anachronistic royalty, and burdensome celebrities and attempts to dispel this dominant representation of history.

We ought to admit that it is in part by virtue of their visual ''qualities'' that these photographs are being introduced into a contemporary, high art milieu. Here then, the danger of complete estheticization as well as the opposite danger of de-estheticizing photographs to a status of scientific objects, empirical fragments, must be recognized. This project endeavours to prevent these misreadings.

This book, therefore, has two ambitions. The first is to take a position against the systematic appropriation of traditional documentary photography by dominant cultural institutions, and to demonstrate that a body of work such as Shedden's is not at all condemned to merely serve the interests of its corporate sponsors. Secondly, we hope to make an intervention in the arena of dominant esthetic practice, which has come to define itself, at least in part, through the exclusion of archives such as Shedden's. We hope to establish an interaction within the hierarchical ordering of cultural practices. It should be pointed out that this book does not claim to close the gap between popular culture and the culture of the fine arts, and in a deeply important sense, it can make no claims to represent the peoples and history of Cape Breton. What it does represent, in full view of its contradictions, is an attempt to provide a critical link between a social history, a group of cultural forms, and the people who live that history and that culture.

Notes

1. Don Macgillivrary, ''Henry Melville Whitney Comes to Cape Breton: The Saga of a Gilded Age Entrepreneur,'' *Acadiensis* (Autumn, 1979) pp. 44-70.

2. David Frank, ''The Cape Breton Coal Industry and the Rise and Fall of the British Empire Steel Corporation,'' in D. Macgillivray and B. Tennyson, eds., *Cape Breton Historical Essays* (Sydney: U.C.C.B. Press, 1980) p. 115.

3. Don Macgillivrary, ''Military Aid to the Civil Power: The Cape Breton Experience in the 1920's,'' in *Cape Breton Historical Essays*, p. 98.

4. For a more extensive history of military intervention in industrial Cape Breton during the 1920's see Macgillivray's "Military Aid" and for more complete analysis of Besco see Frank's "Rise and Fall of Besco" both in *Cape Breton Historical Essays.*

5. Leslie Shedden, interview. All the data that follows pertaining to Shedden Studio, its relationship with Dosco, its activities in the community and about Leslie Shedden and other members of his family, are derived from a series of informal interviews between Leslie Shedden and the author, conducted over the period of time between May 1980 and January 1983.

6. Josef Maria Eder, *History of Photography* (New York: Dover, 1978 (1905)). Edward Epstean, translation, pp. 486-92.

7. Captain L. W. Bentley, "Aid to the Civil Power: Social and Political Aspects 1904-1924," in *Canadian Defence Quarterly, Vol. 8, No. 1,* (Toronto: Summer, 1978), pp. 44-51.

8. Paul McEwen, *Miners and Steelworkers,* (Toronto, 1976), pp. 167-69.

9. Martha Rosler, "In, Around, and Afterthoughts (On Documentary Photography)" in *3 Works,* (Halifax: N.S.C.A.D., 1981) pp. 71-2.

10. *New York Times,* 6 September 1936, p.1.

11. Not only the military but the certified independent war photographers and wartime photojournalists contributed to the gigantic pool of war imagery. Since the end of World War II we have witnessed a spate of illustrated accounts, historical and otherwise, depicting general warfare, more specific military campaigns, civilian hardships and more recently, revolutions in many parts of the world, illustrated with photographs (whose makers are now anonymous — and this would include Shedden) culled from the numerous archives and collections. Not only do these publications tend to esthetisize war and allow us the vicarious experience of the battlefields in the comfort of our homes, but they invariably present war as events that are disconnected from the rest of history, and they usually disregard the social, cultural and more importantly, the economic conditions leading to that war. And not only this, they disassociate those events from the actual experience of a living human being, namely the photographer. I am grateful to Martha Rosler for allowing me access to her unpublished manuscript on war photography.

12. Walter Benjamin, "The Work of Art in the Age of Mechanical Reproduction" in Hannah Arendt, ed., *Illuminations* (New York: Schocken 1969), pp. 217-51 and John Berger, *Ways of Seeing,* (London: Penguin, 1972), pp. 7-34.

13. Allan Sekula, "The Traffic in Photographs," in *Art Journal* (Spring, 1981), pp. 15-25.

14. For an excellent analysis of the mobilization of women for production work in war-time factories and their subsequent post-war re-domestication see the film *Rosie the Riviter,* produced and directed by Connie Field, (1980). See also Adolf Strumthal, "Measures to Deal with Labour in Disarmament" in E. Benoit and K. E. Boulding, eds., *Disarmament, and the Economy,* (New York: Harper & Row, 1963), pp. 182-202.

15. During this post-war period American economic imperialism, with its giant oil companies, is central to this economic transformation. See Harry Magdoff, *The Age of Imperialism; the Economics of U.S. Foreign Policy,* (New York: Monthly Review, 1969), Emile Benoit "Alternatives to Defence Production" in E. Benoit and K. E. Boulding, eds., *Disarmament and the Economy,* (New York: Harper & Row, 1963) pp. 203-22, Michael Tanzer, *The Race For Resources: Continuing Struggles over Minerals and Fuels,* (New York: Monthly Review, 1980), pp. 15-40. For more on forms of mental persuasion inherent in advertising, public

relations and mass communications, see Herbert Schiller, *The Mind Managers,* (Boston. Beacon, 1973), Stuart Ewen and Elizabeth Ewen, *Channels of Desire,* (New York: McGraw-Hill, 1982), and for early forms of this see Stuart Ewen, *Captains of Consciousness,* (New York: McGraw Hill, 1976).

16. This may be due to the fact that *Teamwork* was produced locally in Cape Breton and that *Dosco World* was produced by a public relations office in Montreal.

17. *Teamwork,* (Sydney: February, 1951) Dosco Industrial Relations Department, p.3.

18. *Teamwork,* (Sydney: April, 1952) p.6.

19. Although these problems were, understandably, never dealt with in *Teamwork* or *Dosco World,* they were dealt with in the locally published union papers, the *Labour Leader,* the *Maritime Labour Herald* and the *Glace Bay Gazette,* all now defunct.

20. *Dosco World,* (Montreal: Autumn, 1959), Dosco Public Relations Department.

21. *Dosco World,* (Autumn, 1959).

22. *Dosco World,* (Vol. 3, No. 2).

23. *Dosco World,* (Summer, 1962).

24. *Dosco World,* (Autumn, 1959).

25. *Dosco World,* (August, 1960).

26. The Sydney Steel Corporation (Sysco) now controlled by the Provincial Government of Nova Scotia, with financial assistance from Ottawa, is once again experiencing difficult times. This past winter (1982-83) contracts for steel rails were at an all time low and almost the entire workforce was laid off temporarily. The coal industry, now controlled by the Cape Breton Development Corporation (Devco) has recently been given a boost with the development of the Lingan mine in the south side of the coal fields and the Prince mine in the north. Construction on a third new mine at Donkin is now proceeding slowly.

27. Craig Heron, Shea Hoffmitz, Wayne Roberts and Robert Stacey, eds., *All That Our Hands Have Done: A Pictorial History of the Hamilton Workers,* from the McMaster Labour Studies Programme, McMaster University, (Hamilton: Mosaic, 1981), p.vi

28. David Russell and the Manchester Studies team "Any Old Albums? — Building a People's History," in *Camerawork.* No. 16, (London: Half Moon Photography Workshop, 1979), p.2.

29. I refer her to the editors of the photographic archives, not the official editors of the book. The editors of this archive include Benjamin Buchloh, Connie Hatch, Gary Kibbins, Don Macgillivray, Susan McEachern, Allan Sekula and Bob Wilkie.

30. In Canada, the work of the McMaster Studies Programme and their publications, *All That Our Hands Have Done: A Pictorial History of the Hamilton Workers* and *Baptism of a Union,* may be seen in this light. The work of Carol Conde and Karl Beveridge, two artists doing work with various unions in Ontario is important. In England, the continuing work of the Half Moon Photography Workshop and their publication *Camerawork* (No. 1-25) and Photography Workshop and their recent volume entitled *Photography/Politics: One* have made significant contributions to the understanding of the theory and practice of photography and the closure of the gap between them. In the United States see the work of Connie Hatch, Fred Lonidier, Martha Rosler, and Allan Sekula, all artists working in various cities throughout the U.S.

The Plates

1. Photographs commissioned by Dosco*

* The Dominion of Canada Steel and Coal Corporation

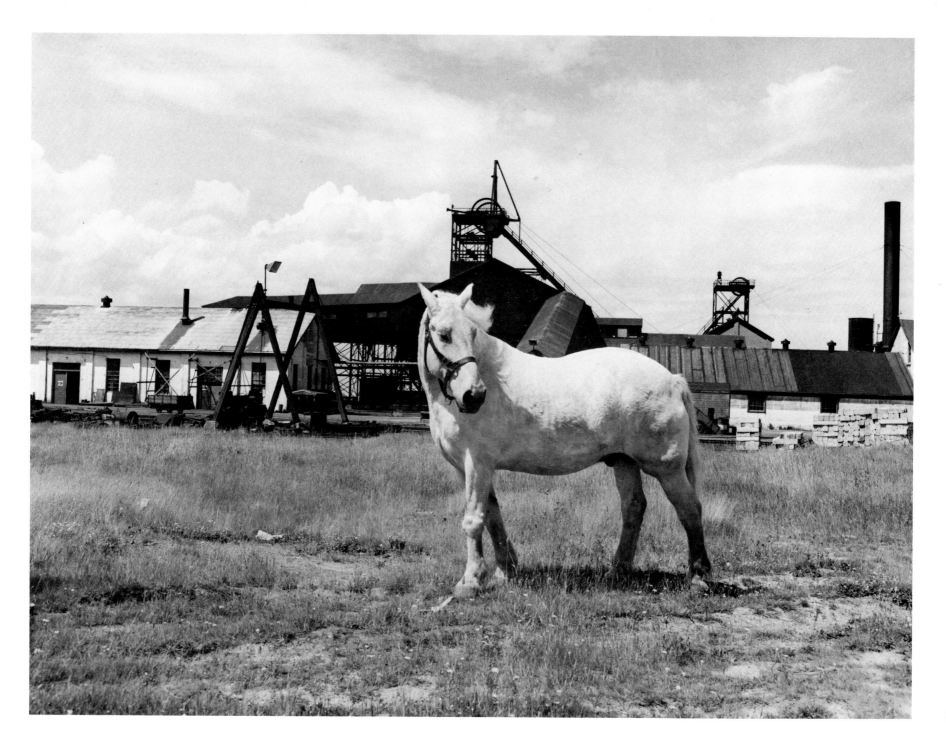

3

1. No. 1-B Colliery, 1955. ''Fraser''. The last of the No. 1-B pit ponies. Fraser spent more of his life-time at the service of the coal company than any other horse in the company's history. He is shown here on the occasion of his retirement.

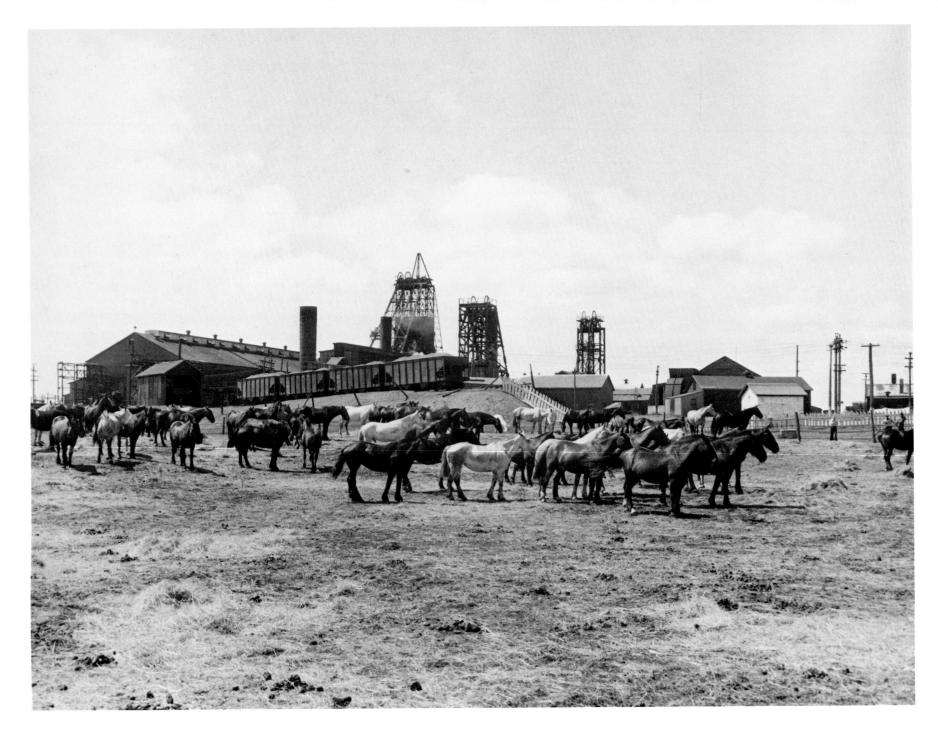

4

2. No. 20 Colliery, 1952. "Horses on Vacation". The only time the pit ponies were brought to the surface was during the miners' three week vacation period. The vacation period was also used to maintain the mines.

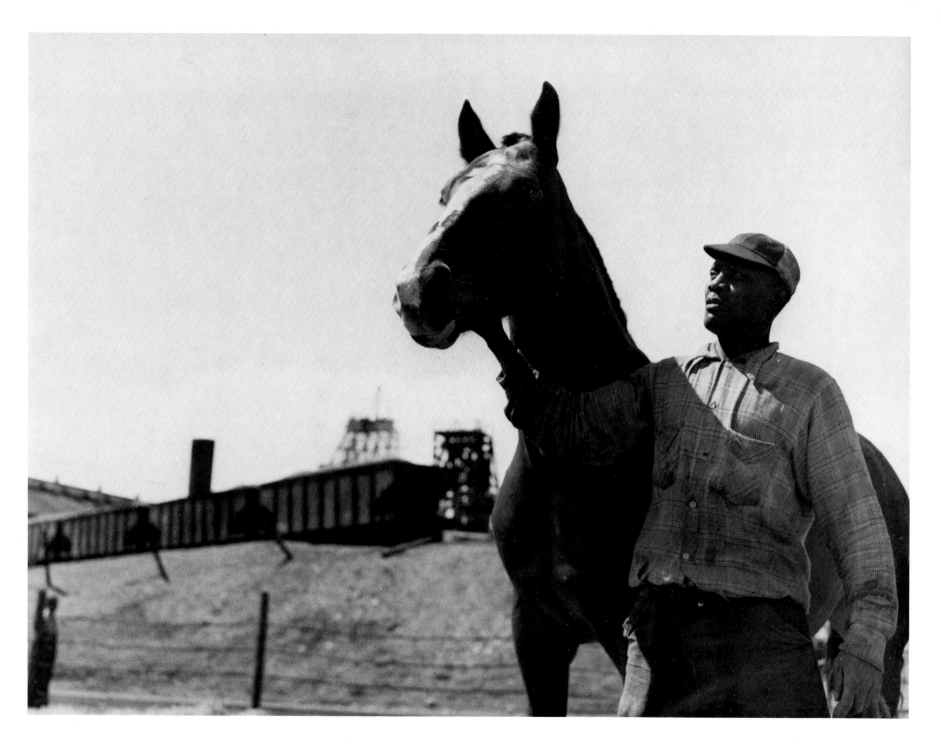

5

3. No. 20 Colliery, 1952. The stable manager, Les Howell, with "Shirley", one of the pit ponies.

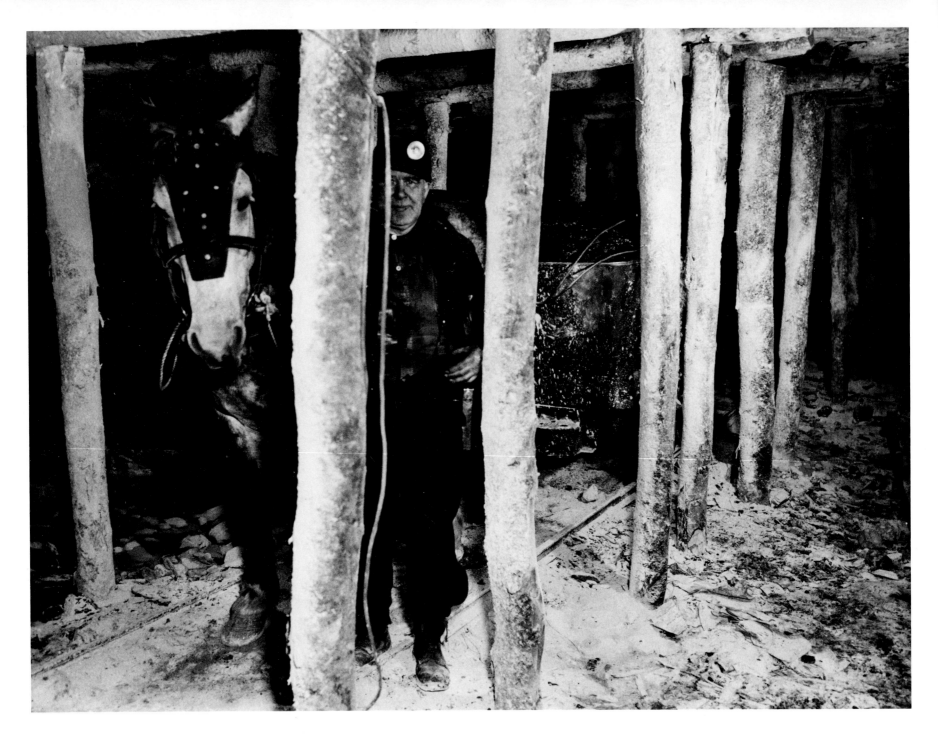

6

4. No. 20 Colliery, 1952. The pit ponies were eventually replaced by underground electrical diesel and conveyor belts.

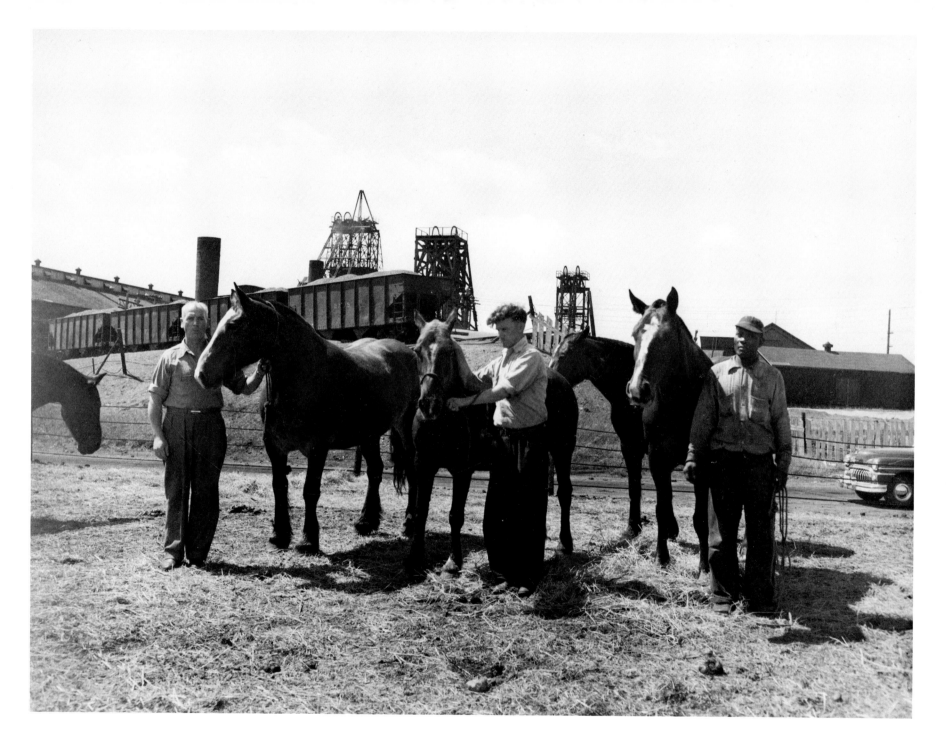

7

5. No. 1-B Colliery. Four pit ponies with their handlers pose for the photographer with the Colliery surface area in the background.

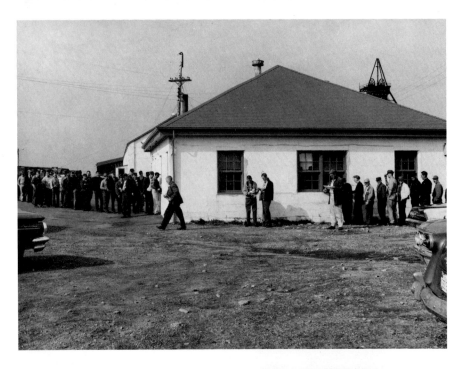

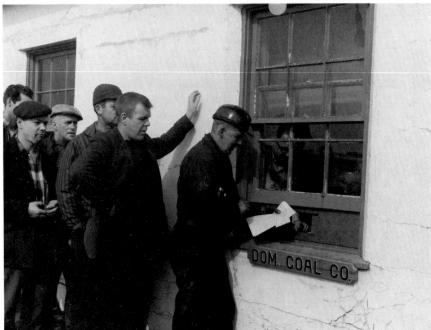

8

6. *(top)* No. 26 Colliery, 1963. Miners on payroll, receiving for the first time a cheque instead of cash.

7. *(bottom)* No. 26 Colliery, 1963. Miners on payroll, receiving for the first time a cheque instead of cash.

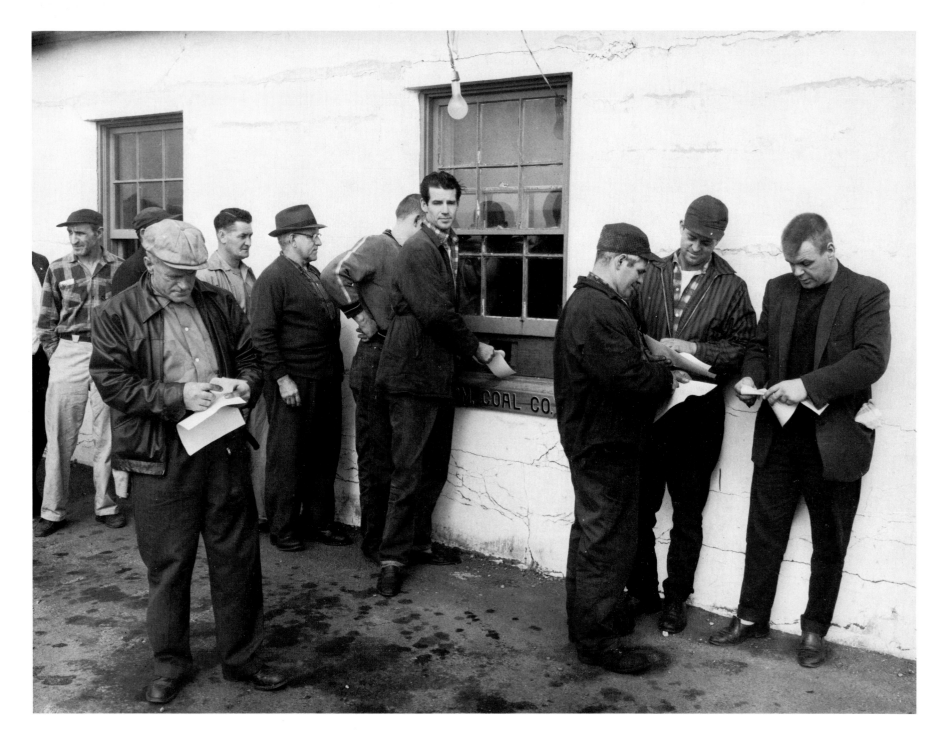

8. No. 26 Colliery, 1963. Miners on payroll, receiving for the first time a cheque instead of cash.

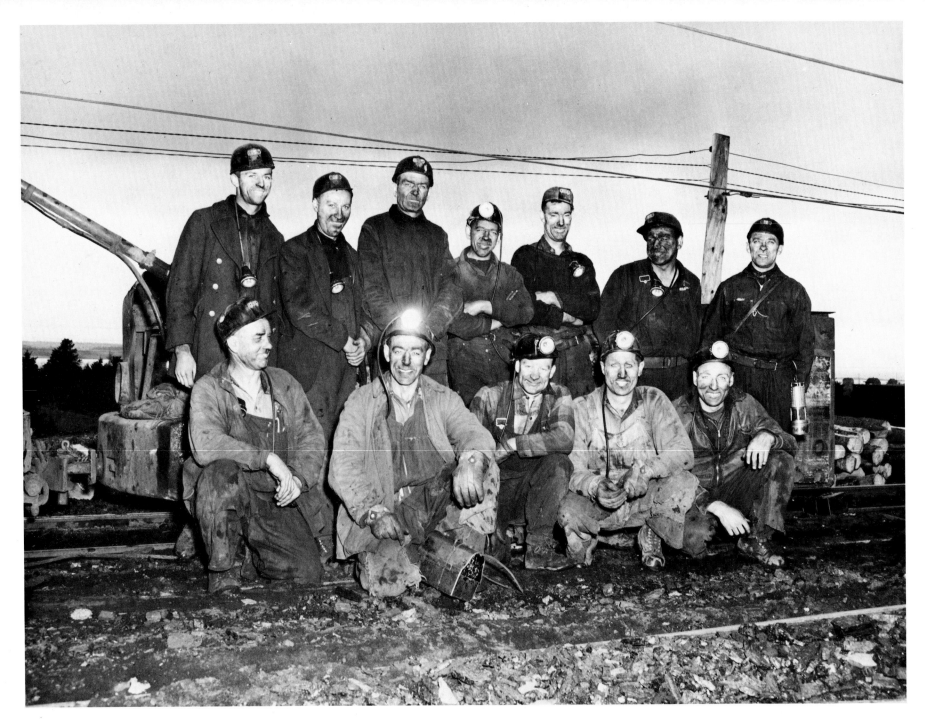

10

9. No. 25 Colliery, 1954. Joy Loader group. These miners, operators of the Joy Loader, pose
for the photographer, at dusk after finishing an eight hour shift in the mine.

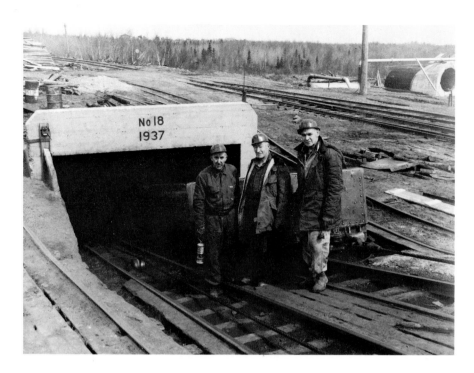

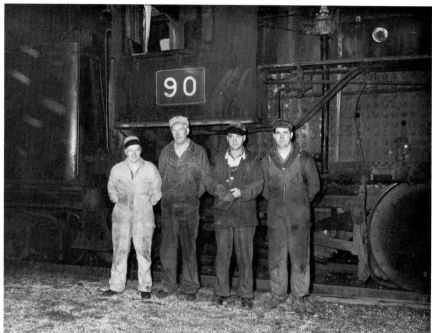

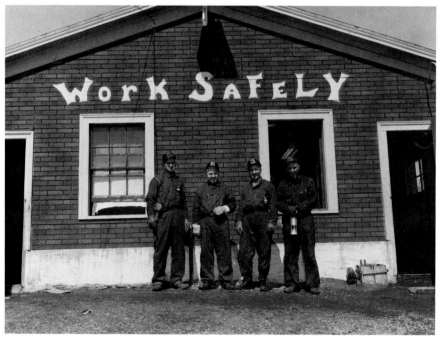

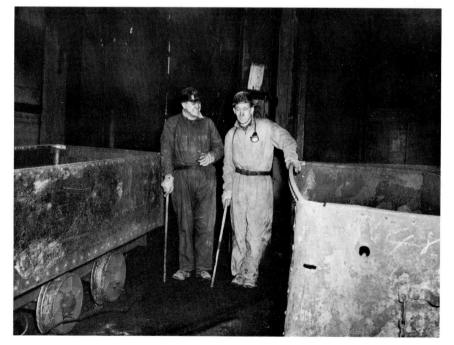

11

10. *(upper left)* No. 18 Colliery, 1963. Three managers at the entrance to No. 18 Colliery.

11. *(lower left)* No. 18 Colliery, 1959. Mine manager on far right with three men outside the lamp house. The lamp house distributed the rechargable lamps that were attached to the miners' helmets.

12. *(upper right)* Sydney and Louisbourg Railway Steam Locomotive, 1961. Four locomotive crew members next to the No. 90 locomotive just before its final run.

13. *(lower right)* McBean Colliery, undated. Two men next to empty coal cars. The sticks identify the men as mine inspectors.

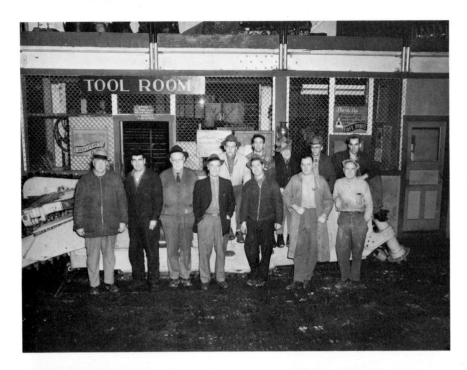

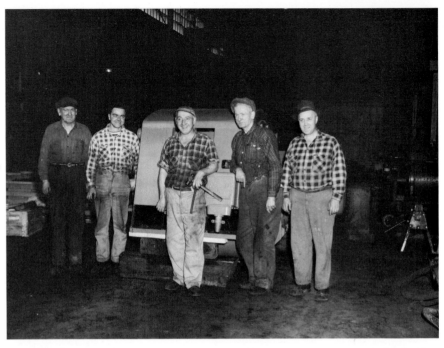

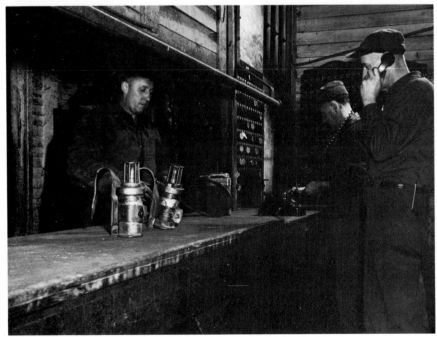

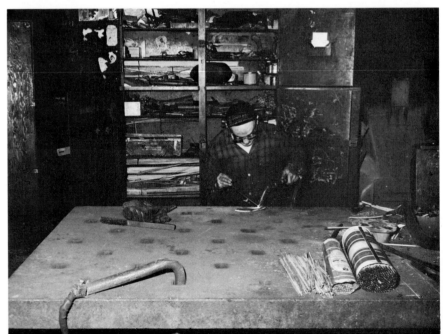

14. *(upper left)* Machine Shop, Glace Bay, 1959. Shop personnel in front and on top of the Dosco Continuous Miner.

15. *(lower left)* No. 26 Colliery, 1963. Lamp cabin. The lamp that was attached to every miner's helmet was distributed from here and returned for re-charging at the end of each shift.

16. *(upper right)* Sydney Mines Shop (machine shop), 1958. Four shop workers standing next to the drive motor which they have been repairing.

17. *(lower right)* Dosco Machine Shop, 1960. Welder at work at his bench.

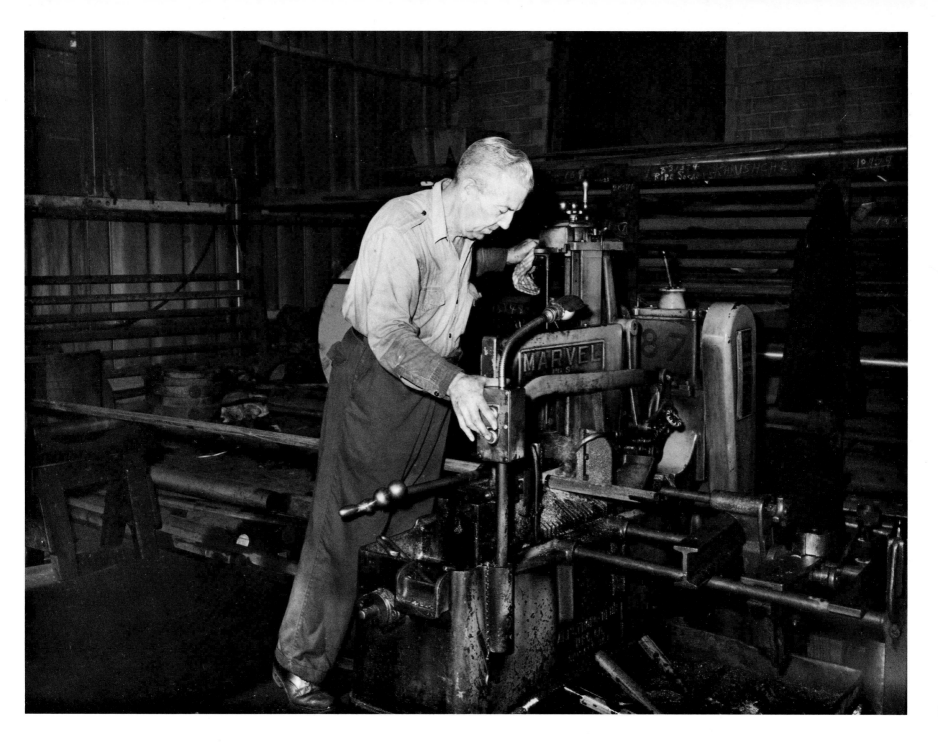

13

18. Dosco Machine Shop, 1960. Machinist at work.

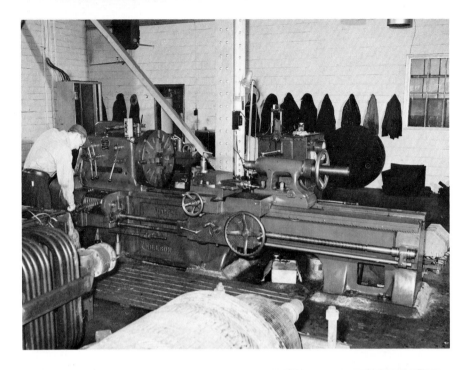

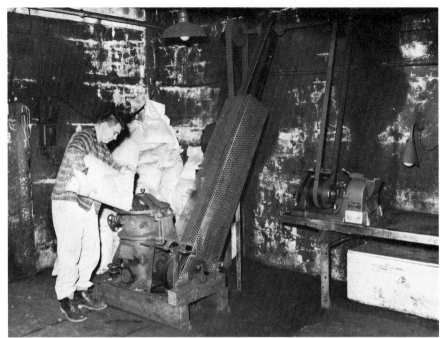

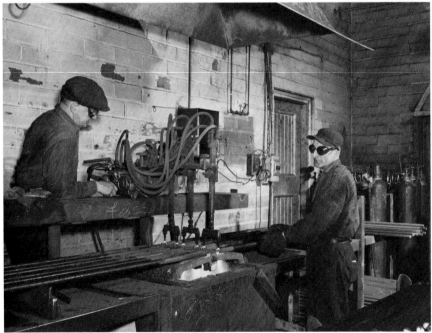

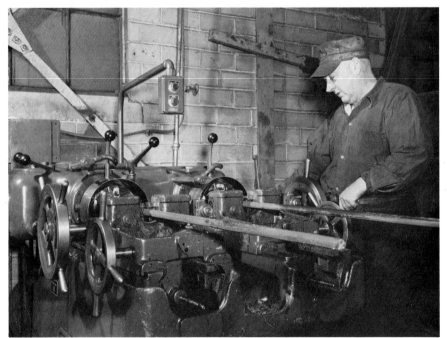

14

19. *(upper left)* Glace Bay, Machine Shop. Undated. Shop worker near lathe.

20. *(lower left)* Glace Bay, Machine Shop, 1956. Two shop workers tending roof bolting machine.

21. *(upper right)* Glace Bay, Laboratory, 1962. Technician feeding coal into crusher. Coal was crushed for analysis in the company laboratory.

22. *(lower right)* Glace Bay, Machine Shop, 1956. Shop worker operating a roof bolting machine.

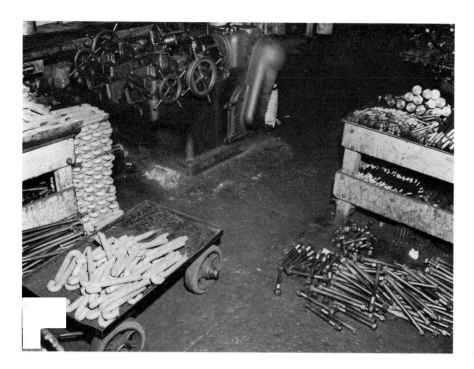

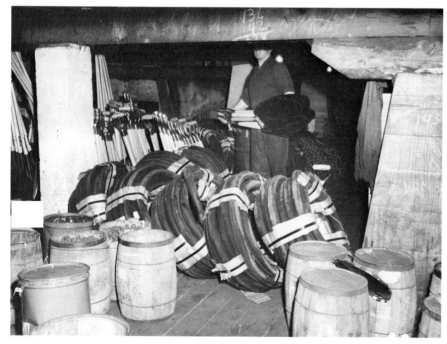

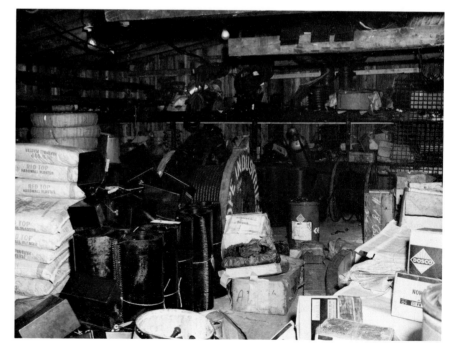

23. *(upper left)* Glace Bay, Machine Shop, 1957. Interior of the machine shop showing roof-bolts and the roof bolting machine.

24. *(lower left)* Glace Bay, Warehouse, 1965. Interior of warehouse holding materials, tools, and equipment for the mines.

25. *(upper right)* Glace Bay, Warehouse, 1965. Interior of warehouse holding materials, tools, and equipment for the mines.

26. *(lower right)* Glace Bay, Warehouse, 1965. Interior of warehouse holding materials, tools, and equipment for the mines.

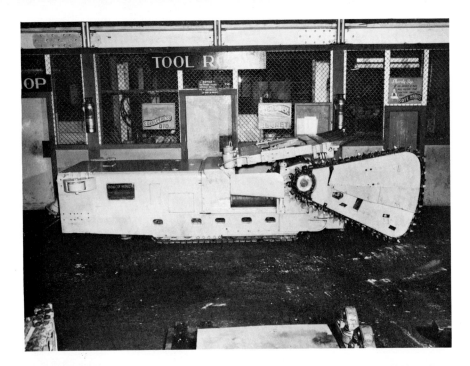

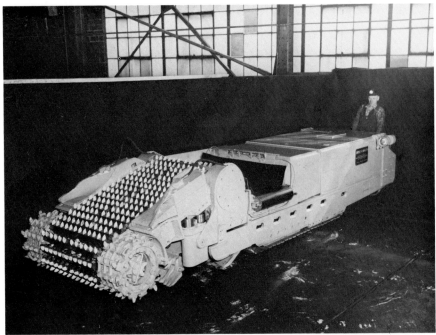

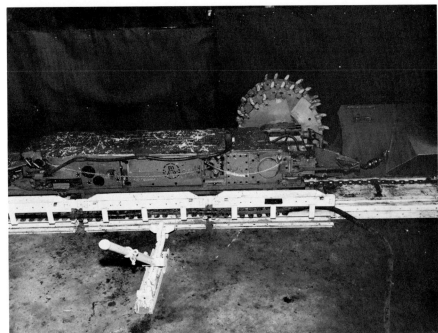

27. *(upper left)* Dosco Miner, 1959. Dosco Miner photographed in the machine shop showing outboard jib.

28. *(lower left)* Dosco Miner, 1953. Close up view of the controls at the back end of the Dosco Miner.

29. *(upper right)* Dosco Miner, 1957. Side view of Dosco Miner with an operator at the controls. A canvas backdrop was used to obscure the normal shop environment.

30. *(lower right)* Anderton Shearer, 1965. The Anderton Shearer, a more advanced long wall mining machine which replaced the Dosco Miner.

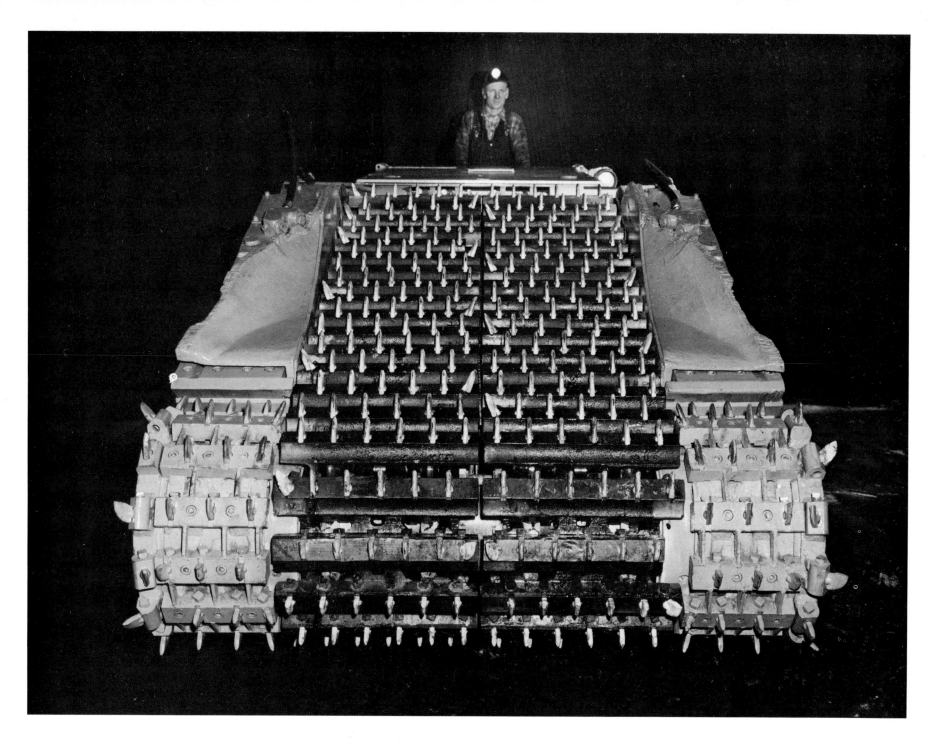

31. Dosco Miner, 1965. Frontal view of Dosco Miner showing the cutting jib.

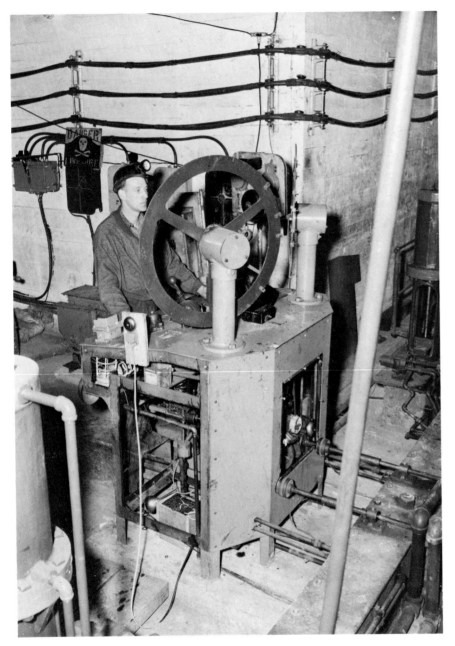

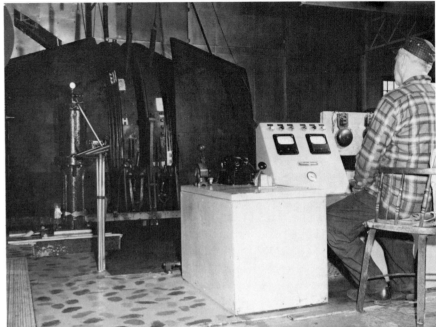

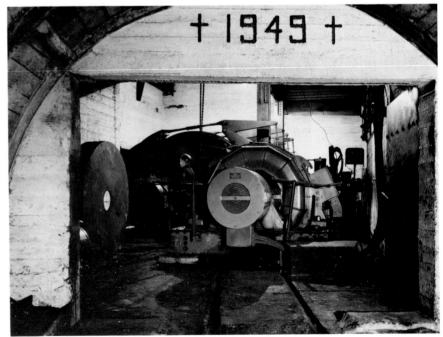

32. *(above)* No. 1-B Colliery, undated. Worker at controls of haulage engine.

33. *(upper right)* No. 20. Colliery, 1957. Hoist Engine Room. Worker monitors gauges while hoist is in operation.

34. *(lower right)* No. 1-B Colliery, 1952. Hoist room with haulage engines.

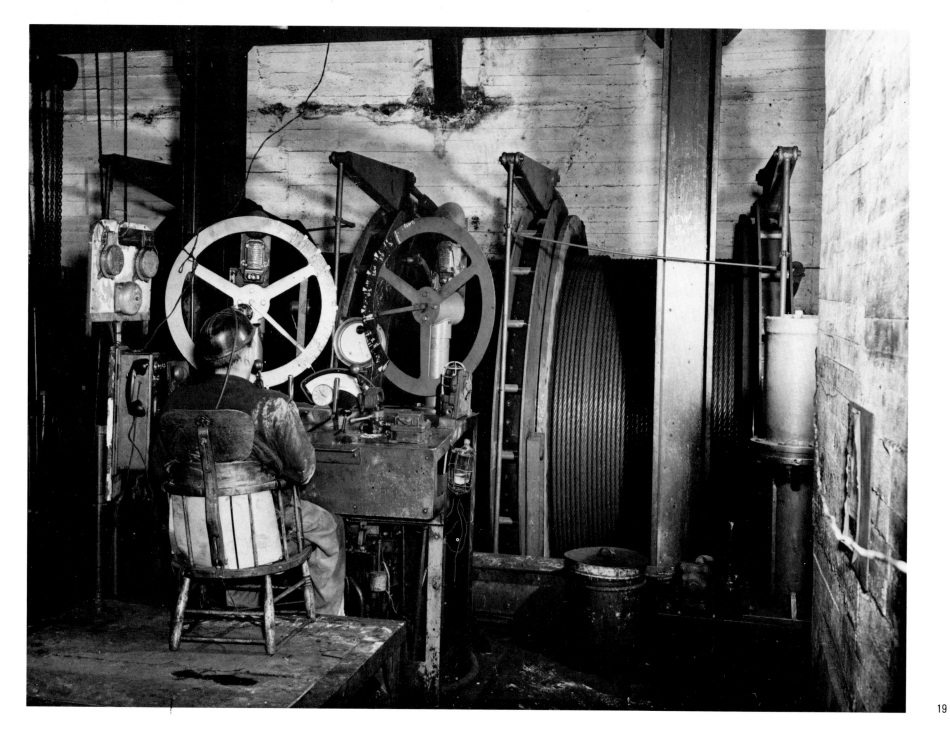

35. No. 1-B Colliery, 1953. Hoist Engine Room for haulage.

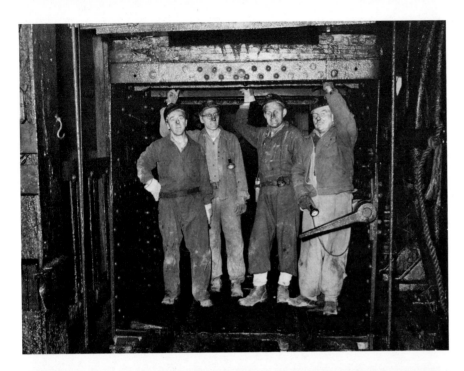

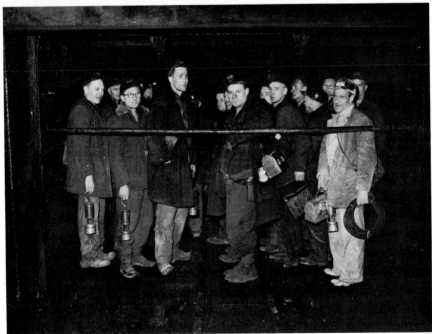

36. *(top)* No. 20 Colliery, 1959. Four company officials on lift just after arriving at the surface.

37. *(bottom)* No. 26 Colliery, 1963. Group of miners standing on the lift or cage which will carry them down the shaft to the access tunnel which eventually leads to the coal face.

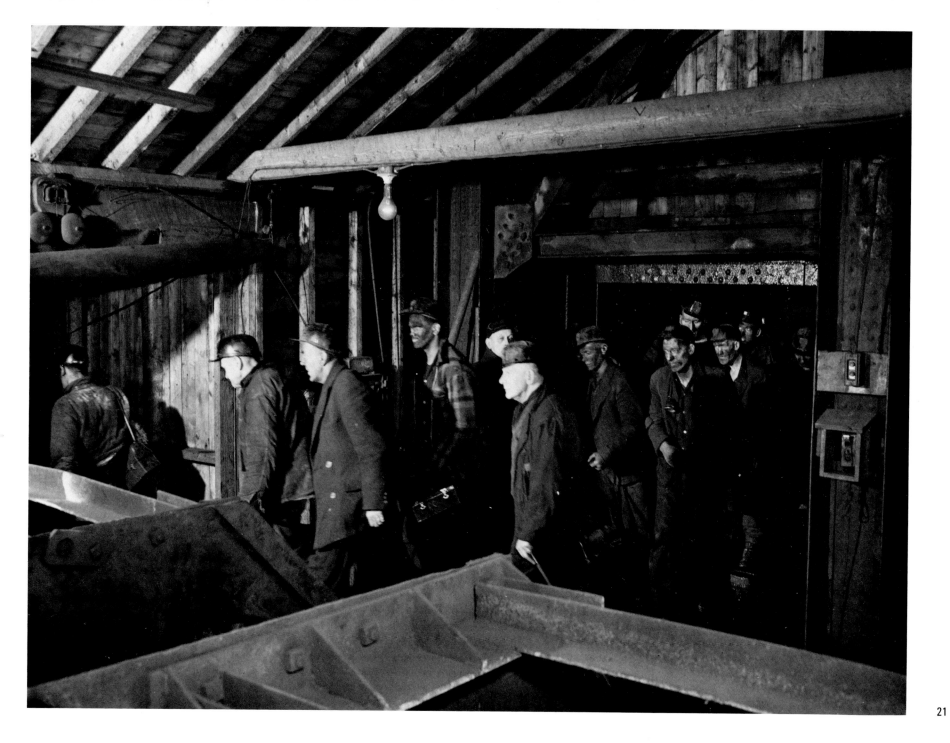

38. No. 20 Colliery, 1955. Miners leaving elevator cage at the shift's end.

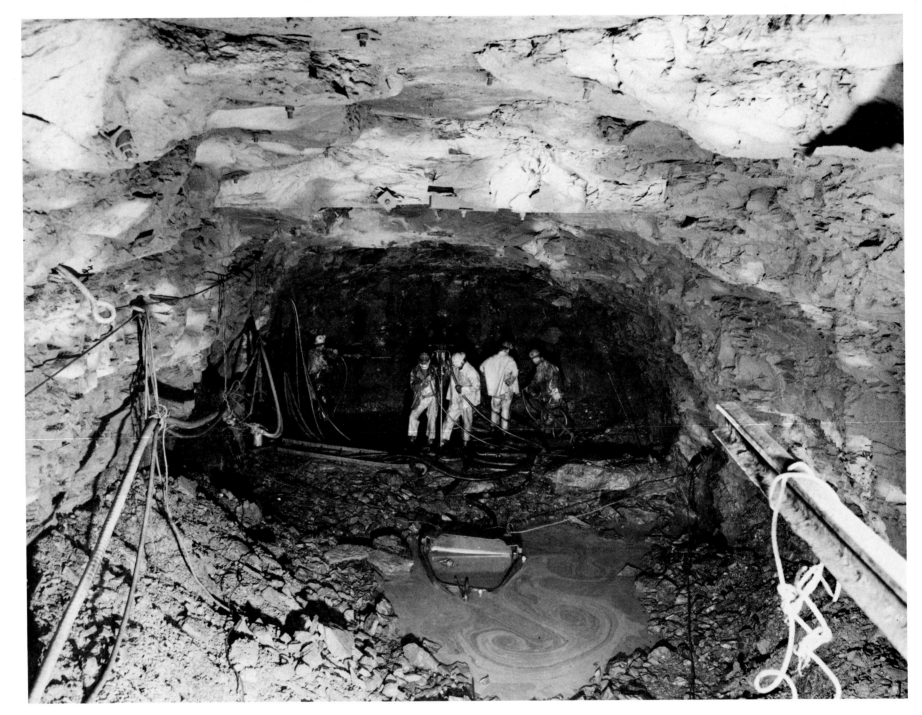

22

39. No. 20 Colliery, 1952-53. Tunnel drivage. Hard-rock miners tunnelling through to the coal seam.

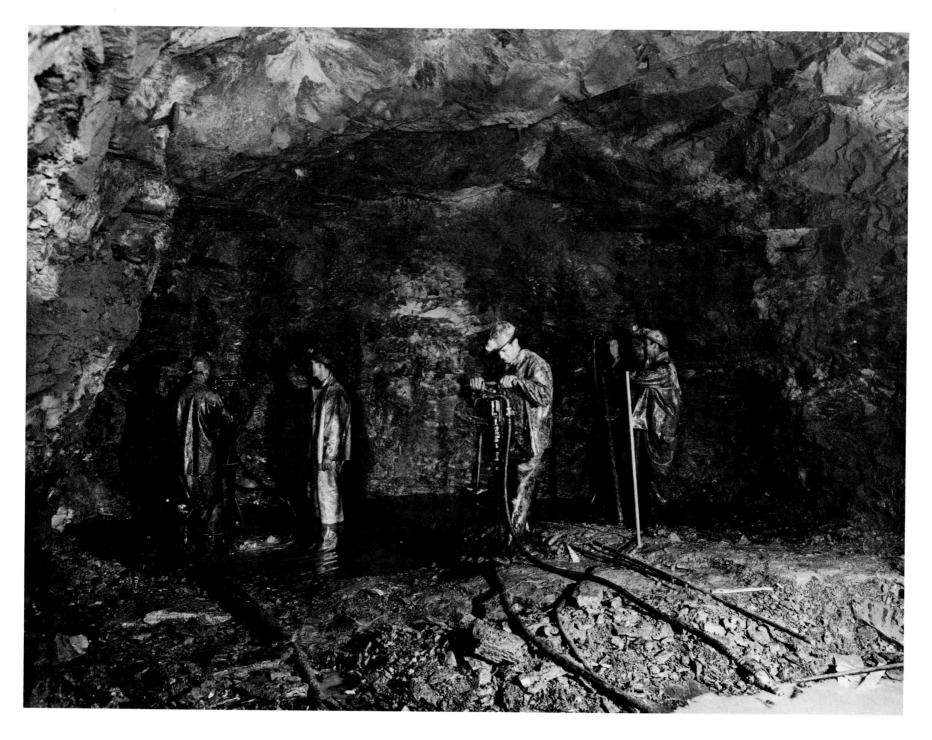

40. No. 20 Colliery, 1952-53. Tunnel drivage. Another view of men operating the air driven
jack-leg drill.

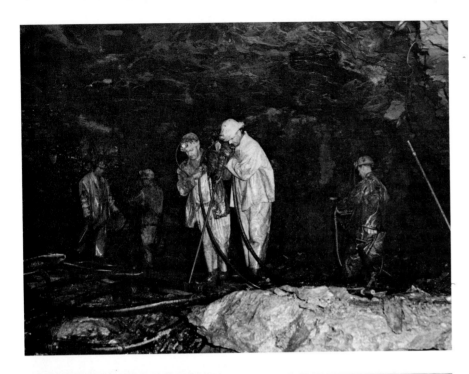

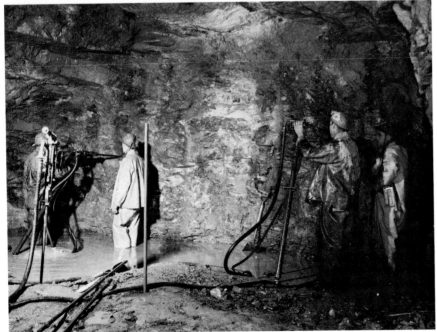

41. *(top)* No. 20 Colliery, 1952-53. Tunnel drivage. Four hard-rock miners operating the air driven jack-leg.

42. *(bottom)* No. 20 Colliery, 1952-53. Tunnel drivage.

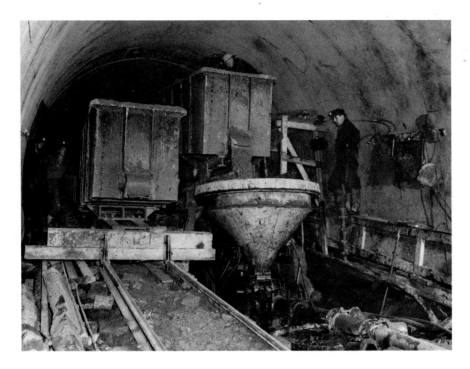

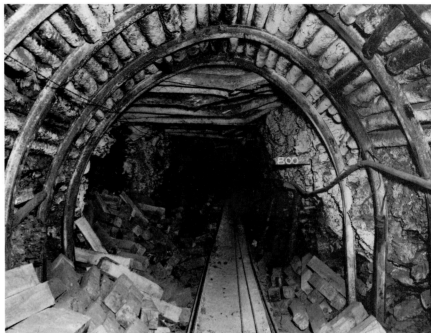

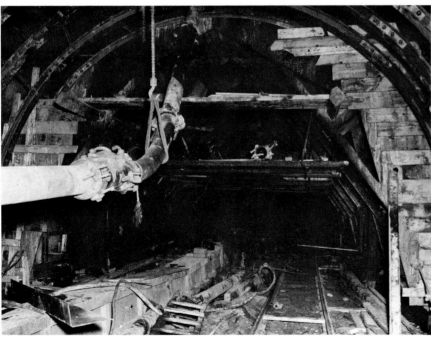

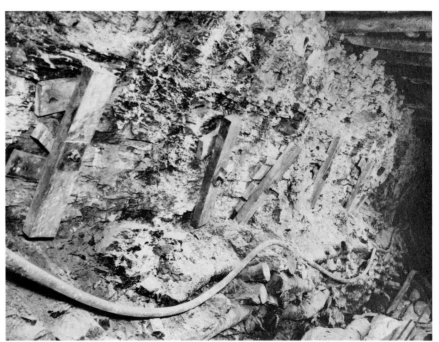

43. *(upper left)* Princess Colliery, 1955. Construction of access tunnel. The cement is being dumped into a hopper which then forces it into a tube to carry it to the arch forms where it eventually sets to form the arch tunnelling seen here.

44. *(lower left)* Princess Colliery, 1955. Construction of access tunnel.

45. *(upper right)* No. 12 Colliery, 1952. Arch booming. Arch booming with wooden logs is still used in some modern coal mining operations.

46. *(lower right)* No. 12 Colliery, 1952. Bolting along the ribs or side of the shaft.

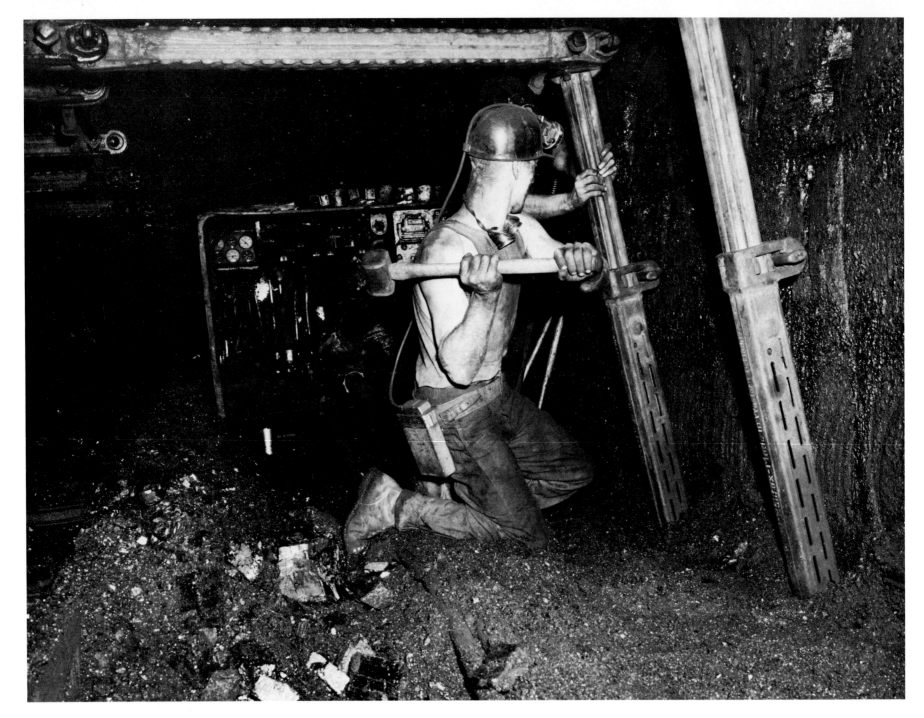

26

47. Princess Colliery, 1955. Miners installing friction steel support jacks for the Dosco Miner.

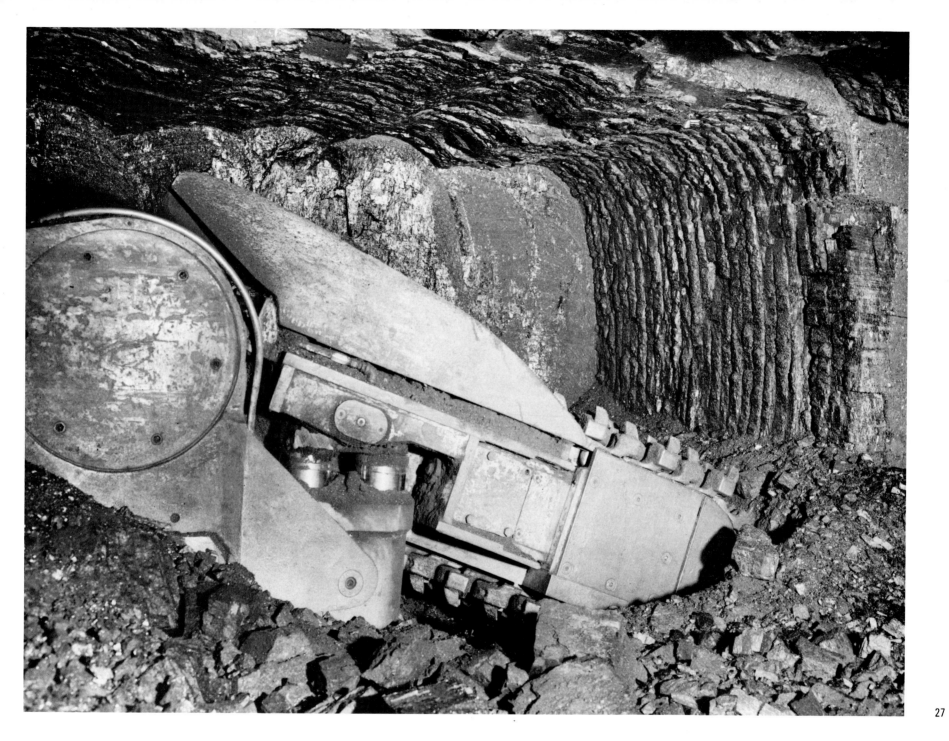

48. No. 18 Colliery, 1953. View of Dosco Miner in action, with the cutting jib gouging into the coal face on the downward cycle.

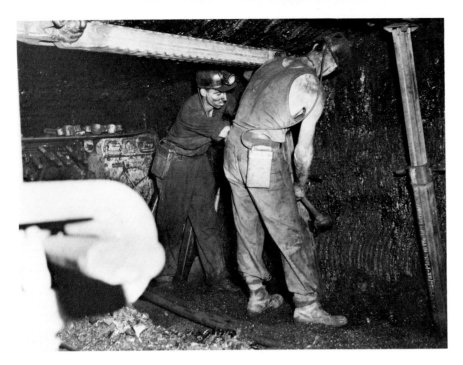

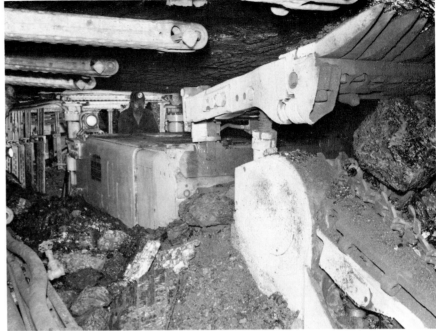

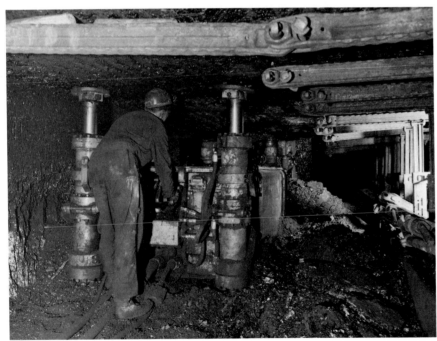

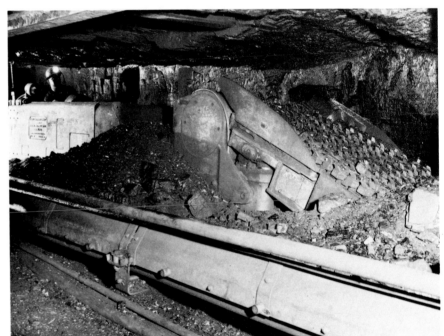

28

49. *(upper left)* Princess Colliery, 1955. Miners installing friction steel support jacks for Dosco Miner.

50. *(lower left)* No. 20 Colliery, 1959. Miner operating the Dosco Continuous Miner at the coal face. The Continuous Miner is operated by controls at the back of the machine. The two hydraulic shafts prevent the roof from falling in on operator and machine.

51. *(upper right)* No. 20 Colliery, 1959. Dosco Continuous Miner with the cutting jib on the downward cycle and the wedges scraping coal from the top of the face.

52. *(lower right)* No. 18 Colliery, 1959. An early version of the continuous miner.

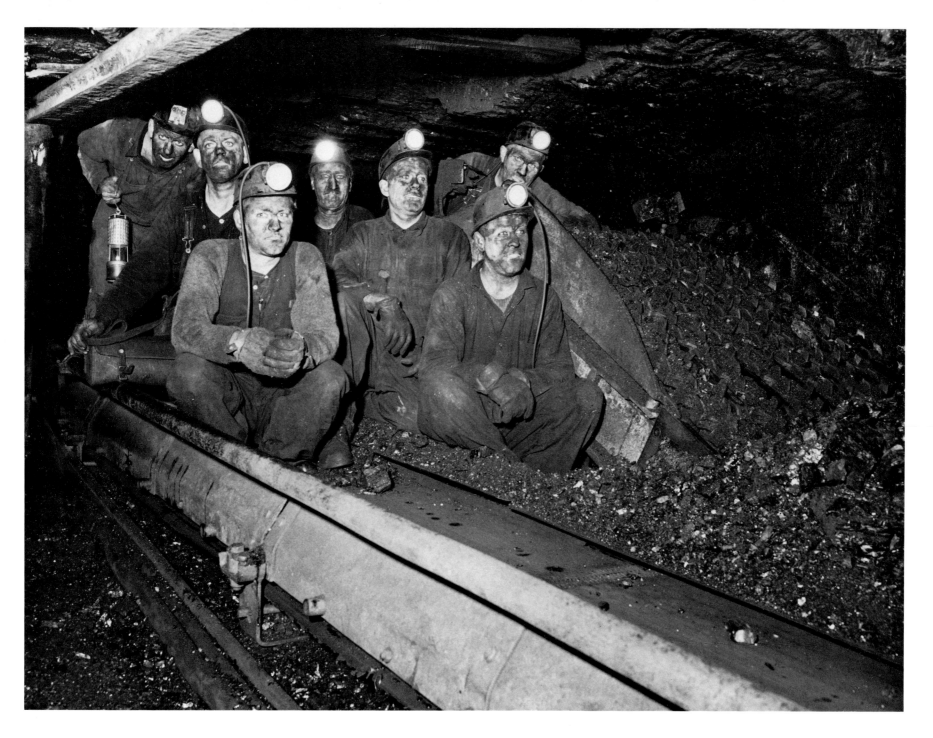

53. Undated. Dosco Miner crew next to their machine.

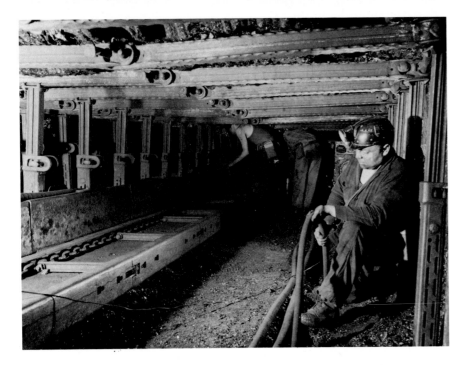

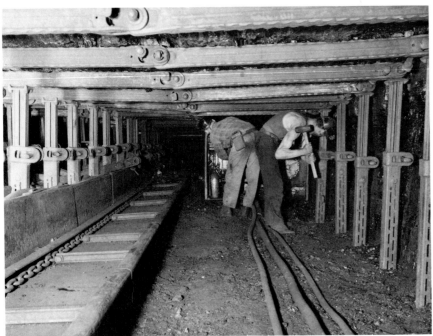

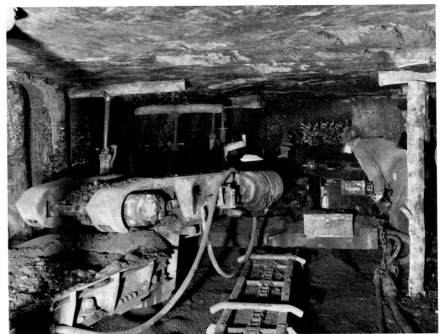

54. *(upper left)* Princess Colliery, 1959. Miners positioning steel supports at long wall face.

55. *(lower left)* Princess Colliery, 1959. Installation of friction steel roof supports for Dosco Miner.

56. *(upper right)* No. 20 Colliery, 1959. Joy Continuous Miner assemblage with cutting head in the background, pivotal conveyor and chain conveyor to the underground cars, in the foreground.

57. *(lower right)* No. 20 Colliery, 1959. Back end of Joy Continuous Miner where the coal drops off the pivotal conveyor onto the chain conveyor.

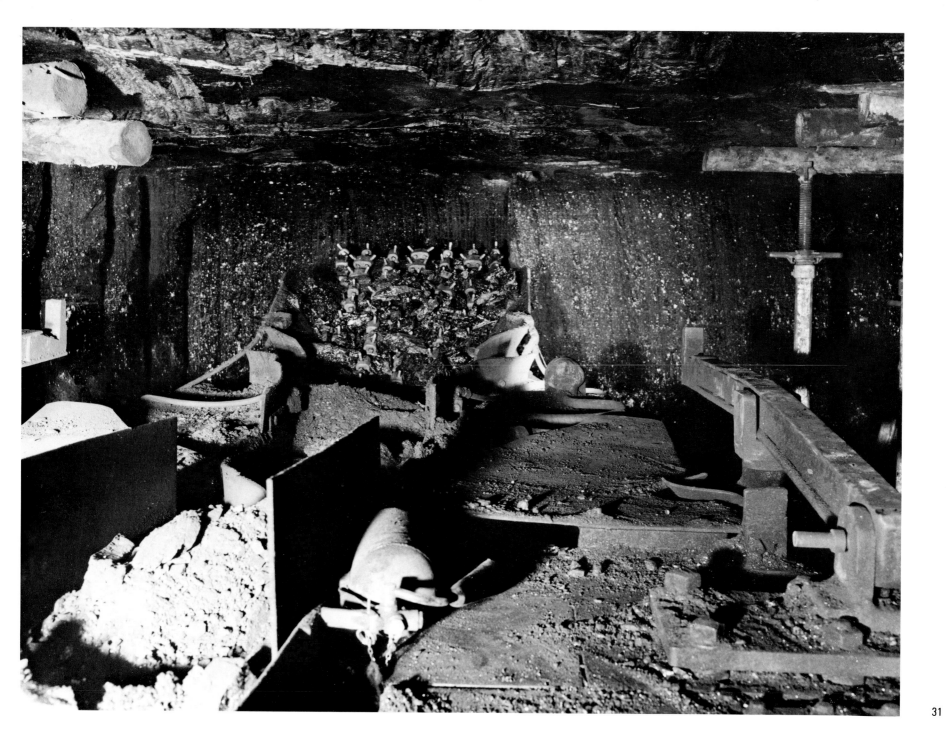

58. No. 20 Colliery, 1959. Joy Continuous Miner in operation at the coal face.

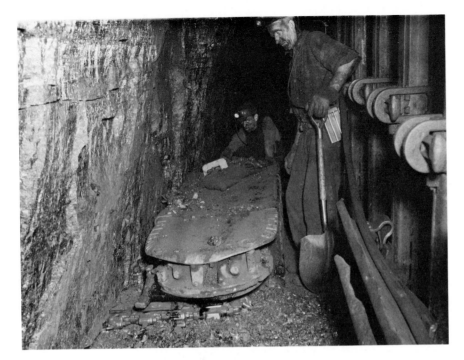

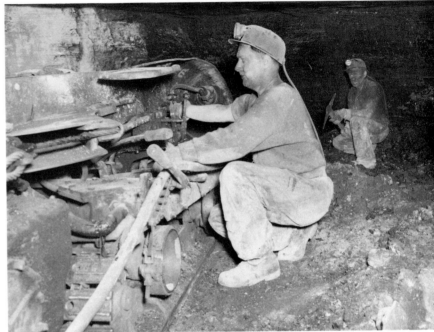

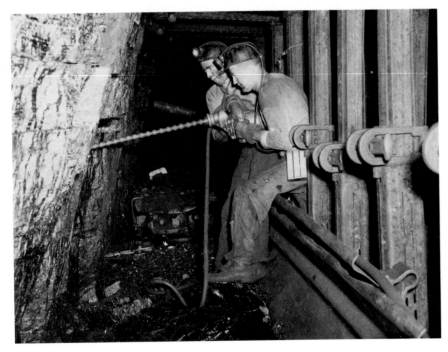

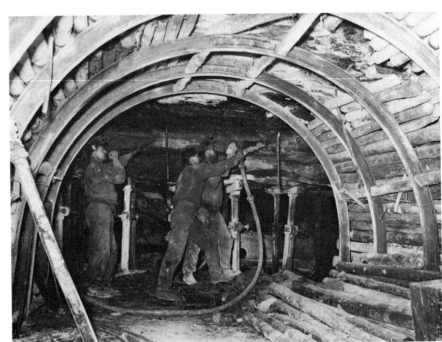

59. *(upper left)* McBean Colliery, 1958. An undercutter machine at McBean Colliery with miners standing by.

60. *(lower left)* McBean Colliery, 1959. Boring into long wall face. An undercutter is in the background.

61. *(upper right)* No. 20 Colliery, 1952. Miner at controls of Joy Loader.

62. *(lower right)* No. 20 Colliery, 1958. Top brushing at material level. Brushing knocked down any loose coal after the area had been initially mined. The Dosco Miner can be seen in the background.

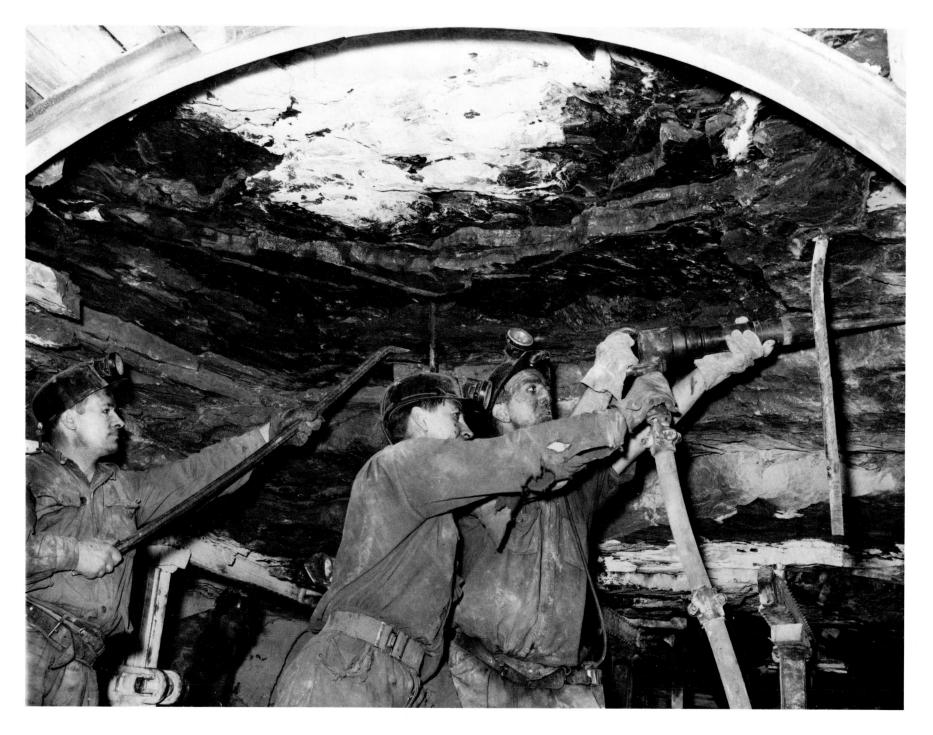

63. No. 20 Colliery, 1958. Top brushing at material level.

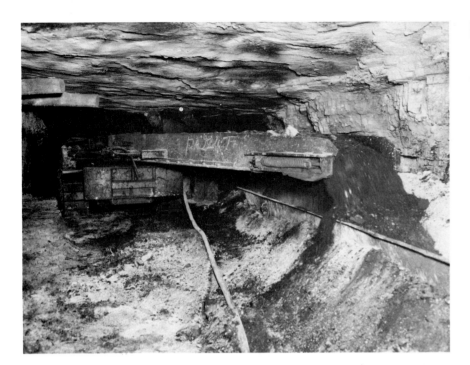

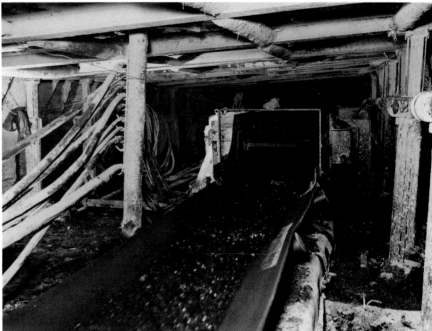

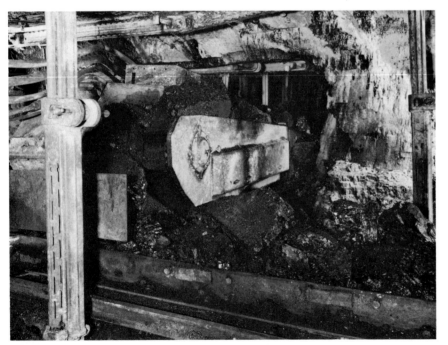

64. *(upper left)* Princess Colliery, 1953. Back end of Joy Loader where the pivotal conveyor spills coal onto the face conveyor. Two miners can be seen in the background at the controls of the machine.

65. *(lower left)* No. 20 Colliery, 1959. Face conveyor discharging coal onto stage loader which carries coal to underground railroad cars.

66. *(upper right)* No. 20 Colliery, 1959. Conveyor which transports coal directly from the Dosco Miner at the coal face to the underground cars.

67. *(lower right)* No. 20 Colliery, 1959. Loading head where the coal from the face is loaded into waiting cars which transport the coal to the tipple area.

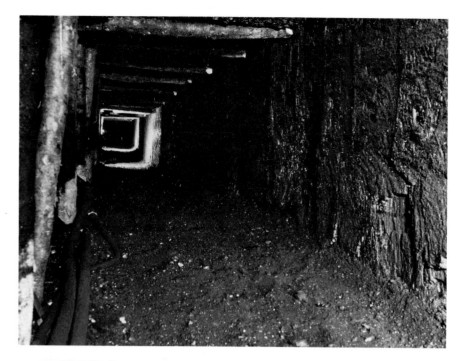

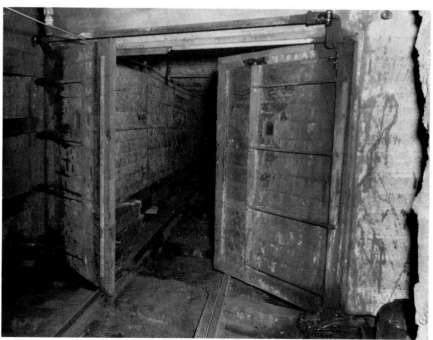

68. *(top)* No. 18 Colliery, 1953. Long wall face after it has been cut by a continuous miner.

69. *(bottom)* No. 20 Colliery, 1953. Automatic air course doors. These automatic doors are located in the tunnels; they replace the 'trapper boy' of earlier days when child labour was common in the coal mines.

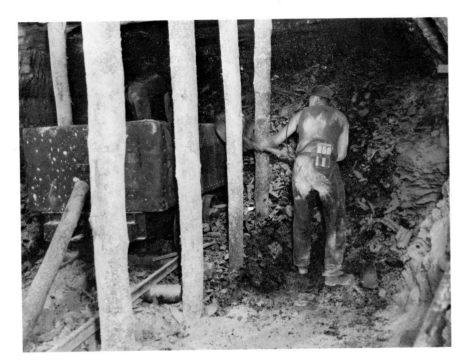

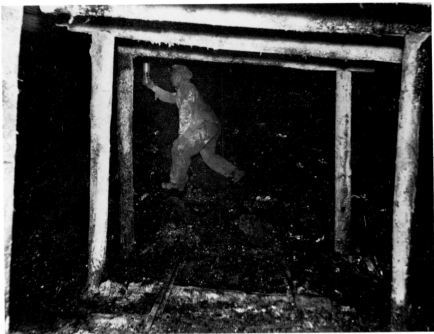

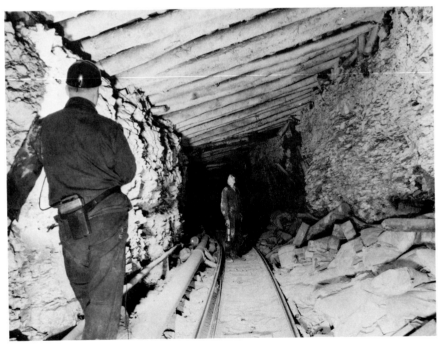

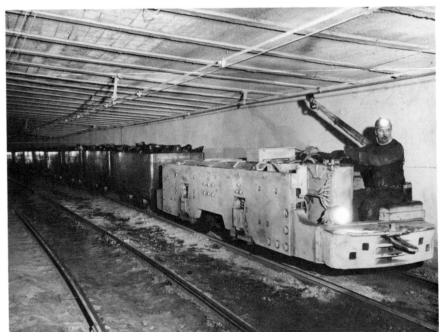

36

70. *(upper left)* No. 20 Colliery, 1949. Miners hand-loading coal at the pit bottom in the old room and pillar mining method that was replaced by mechanical long wall mining.

71. *(lower left)* No. 12 Colliery, 1950. Inspection of wall supports. One miner stands in the foreground, his back to the camera, holding the light for the photographer while the other man inspects the wall support at the long wall level.

72. *(upper right)* Undated. Pit bottom. Testing for poisonous and flammable gases.

73. *(lower right)* No. 26 Colliery, 1959. Electric trolley hauling string of loaded cars.

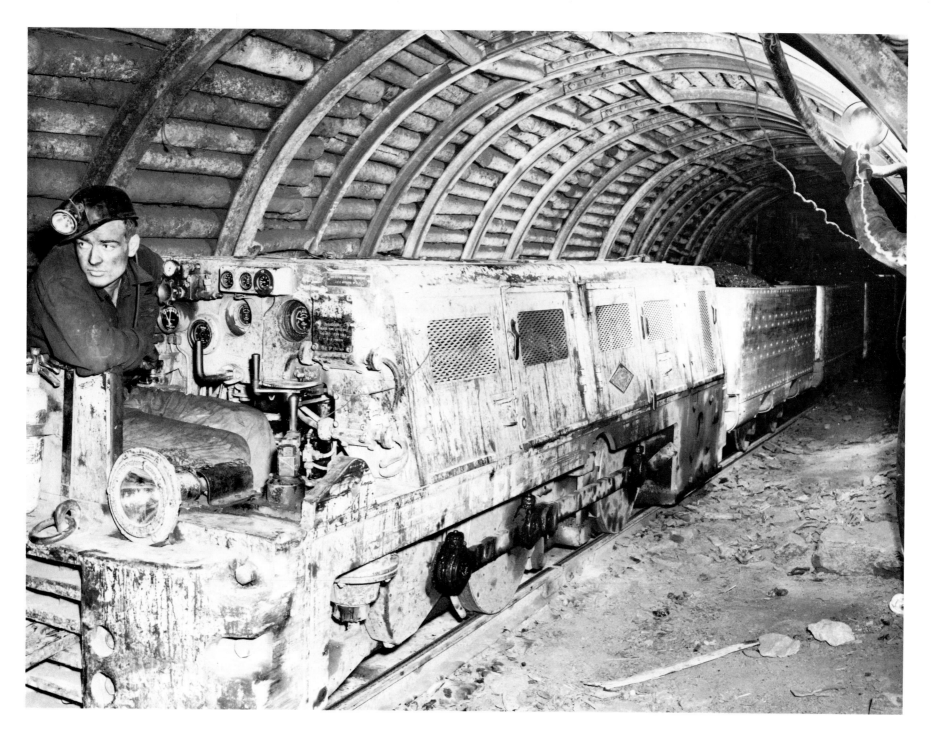

74. No. 20 Colliery, 1951-53. Diesel engine hauling string of cars loaded with coal. The man
at the right, half out of the photo frame, is holding a light for the photographer. The photograph
was intended to be cropped.

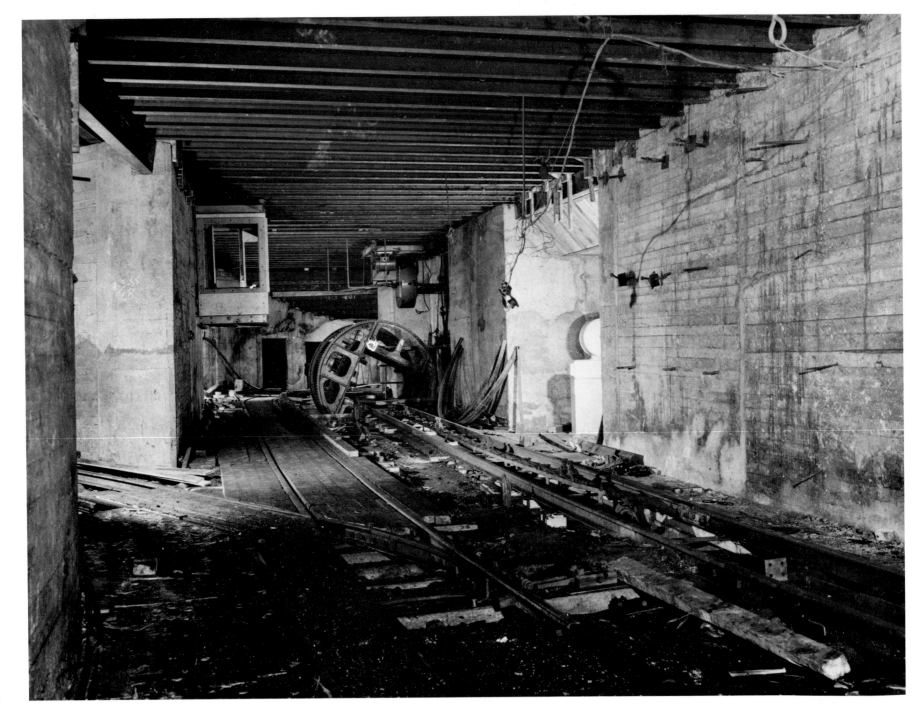

38

75. Princess Colliery, 1955. Tipple area under construction at pit bottom. Recess at right contains scales where coal is weighed before entering the tipple to be dumped.

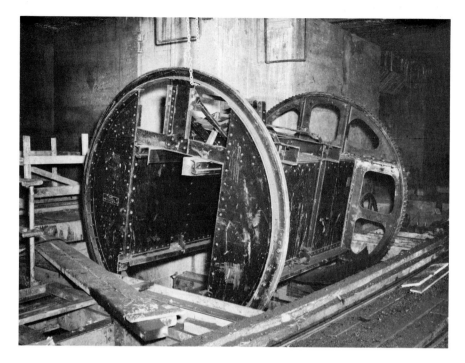

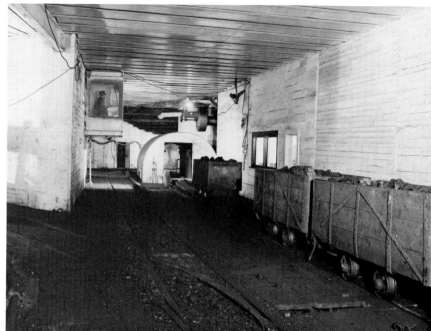

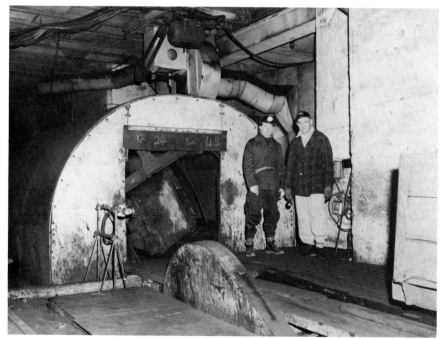

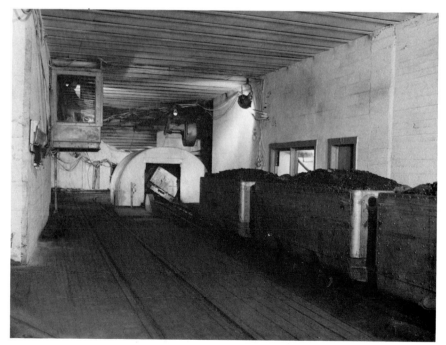

76. *(upper left)* Princess Colliery, 1959. Steel frame of the tipple mechanism.

77. *(lower left)* Princess Colliery, 1958. Two company officials next to the tipple.

78. *(upper right)* Princess Colliery, 1959. Tipple area with operator in glassed-in control booth at the upper right. The operator 'creeper feeds' the loaded cars individually into the tipple where they are rotated or 'tipped' and emptied onto a conveyor which carries the coal to the surface and wash plant.

79. *(lower right)* Princess Colliery, 1959. Another shot of the tipple area. This was taken after the preceding and was reshot after the area was cleaned up and more presentable cars were available.

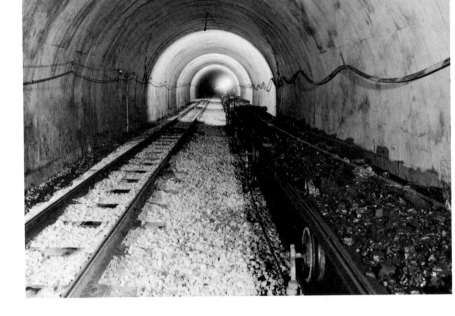

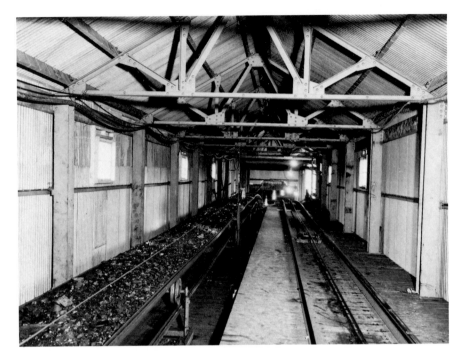

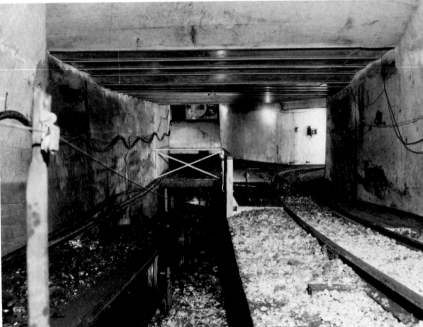

80. *(upper left)* Princess Colliery, 1955. Another area of the access tunnel showing a loaded conveyor alongside the underground tracks.

81. *(lower left)* Princess Colliery, 1955. Pit bottom showing the conveyor which carries coal to the surface from the tipple area. The tracks to the right lead back into the tipple area and off to the mining operations.

82. *(upper right)* Princess Colliery, 1955. Bankhead showing a loaded conveyor and tracks connecting to underground rail system.

83. *(lower right)* No. 4 Colliery, 1953. Haulage engine and hoist apparatus. The haulage engine hoisted the cage up and down the shaft.

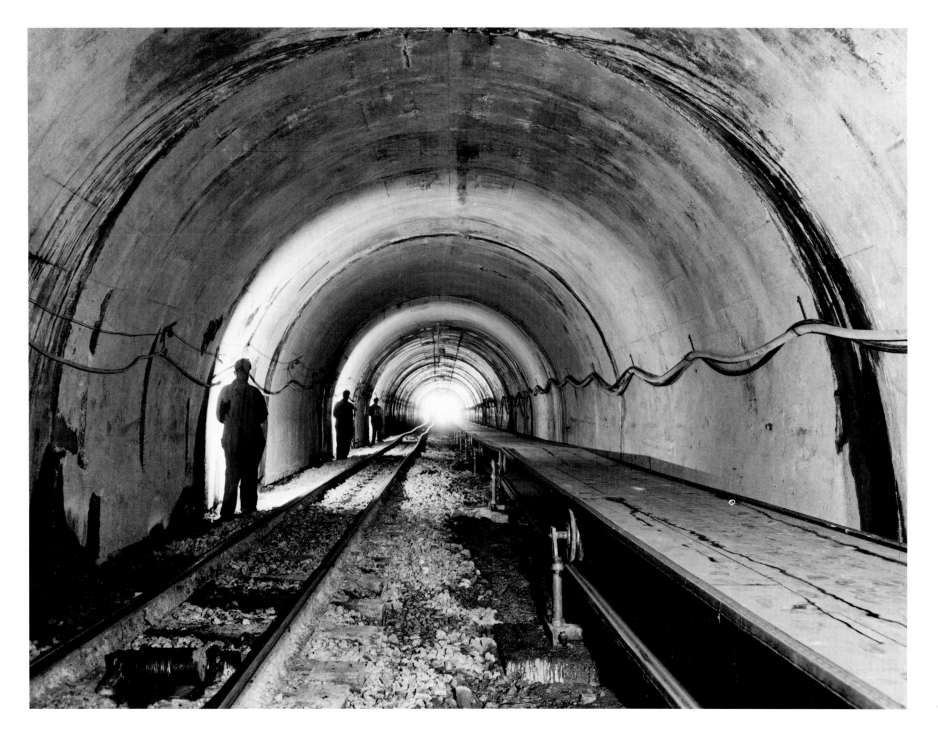

84. *Princess Colliery, 1955.* Access tunnel at Princess Colliery with conveyor belt and tracks. The photographer positioned a man with a light at various intervals to provide lighting for several multiple exposures thus the ghost image of the man appears here at three different points.

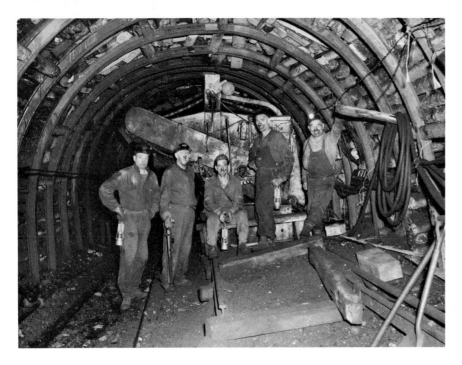

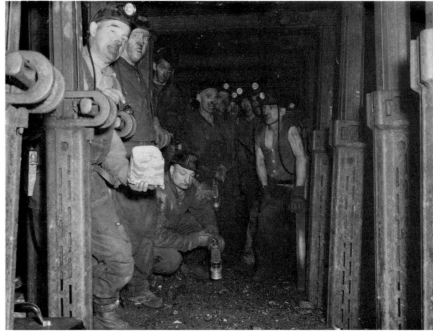

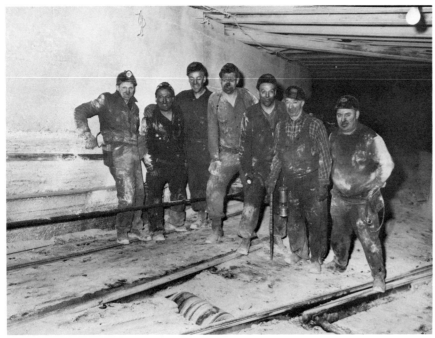

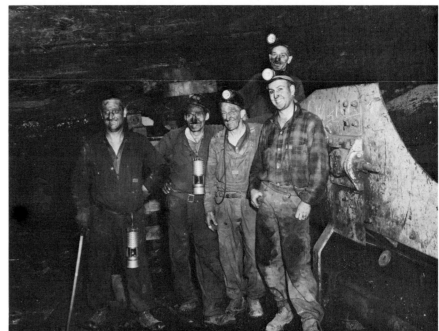

85. *(upper left)* McBean Colliery, 1959. Group of company officials and mine manager in front of Sydney Mines loader.

86. *(lower left)* No. 26 Colliery, 1963. Group of miners pose for photographer in an access shaft of No. 26 Colliery, known as the Arch Deep.

87. *(upper right)* McBean Colliery, 1959. Miners at the long wall site. The man in extreme foreground is holding the photographer's flashbulbs.

88. *(lower right)* Princess Colliery, 1957. Group of miners and inspectors standing by the receiving end of Sydney Mines loader.

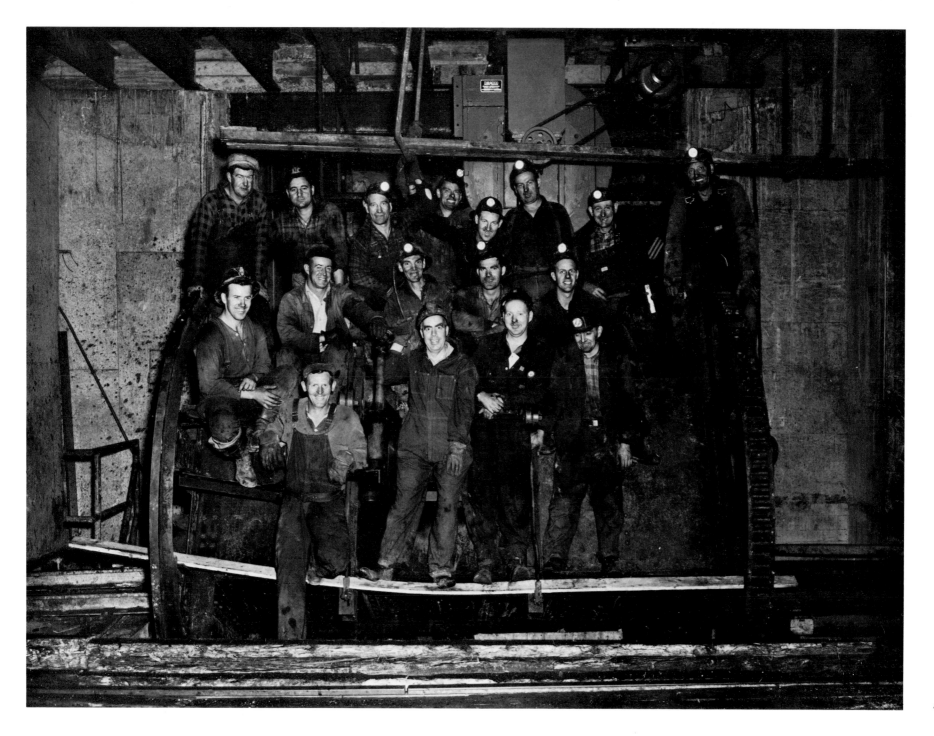

89. Princess Colliery, 1955. Engineers and hard-rock miners on the incomplete tipple mechanism at Princess Colliery. Hard-rock miners tunnelled through the bedrock and other layers of hard-rock to gain access to the softer coal seam.

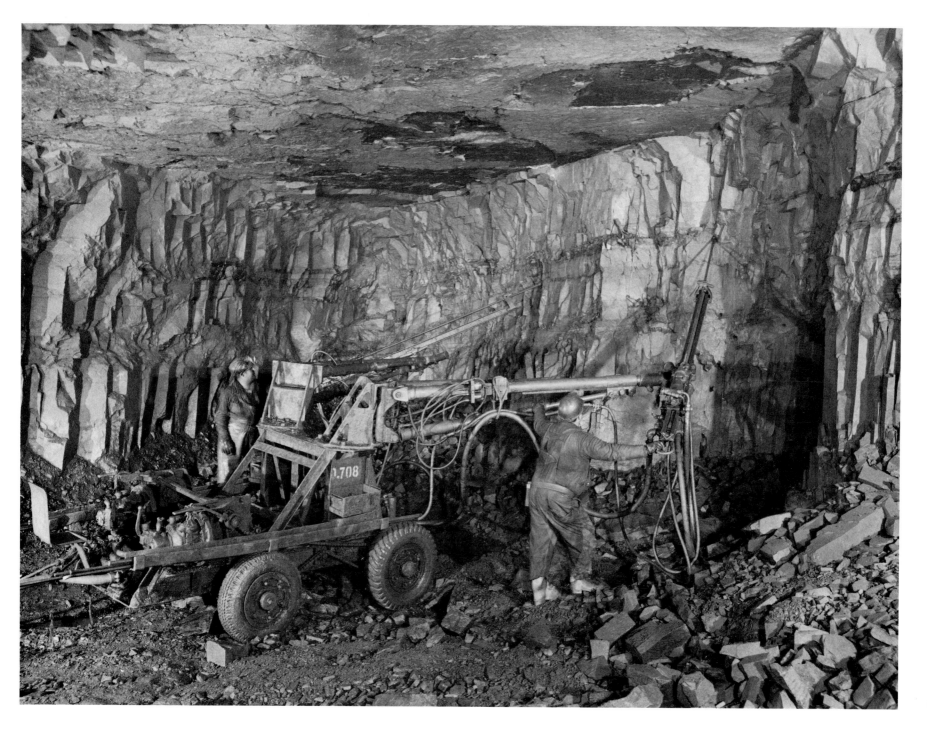

90. Wabana, Newfoundland, 1959. Drill design. The miners or drill operators follow a pattern while drilling holes for the charges. Setting the patterns is a matter of great skill and experience.

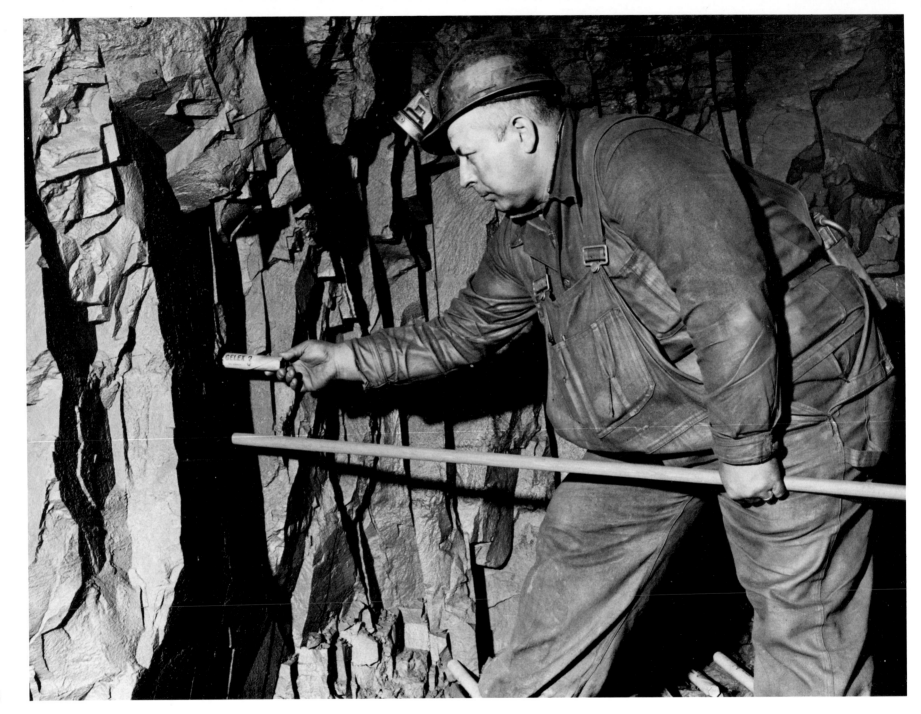

91. Wabana, Newfoundland, 1959. Miner poses during the setting of a dynamite charge.
The pole pushes the charge deep into the unmined ore.

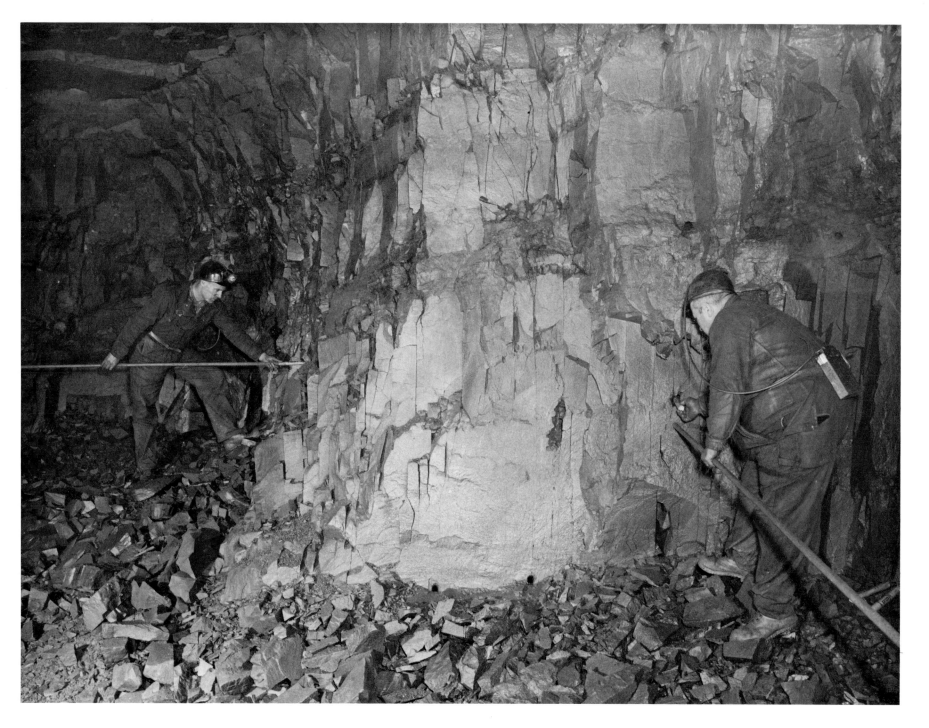

92. Wabana, Newfoundland, 1959. Setting charges at the top of a stope. The blast brings down the ore which is then gathered and transported by the Joy Loader.

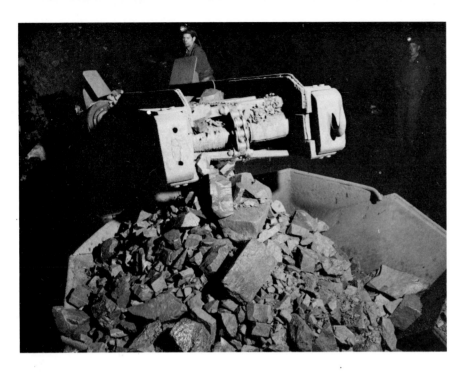

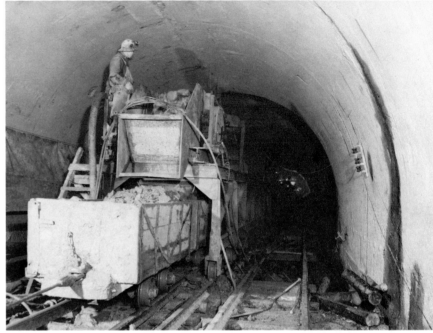

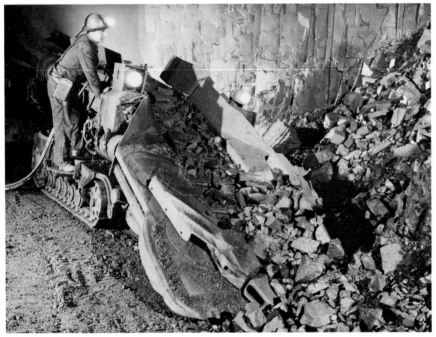

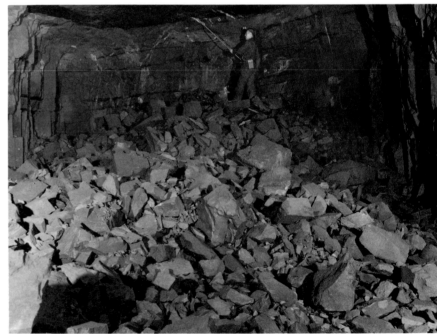

93. *(upper left)* Wabana, Newfoundland, 1959. Joy Loader loading ore onto the conveyor which carries it to waiting underground railcars.

94. *(lower left)* Wabana, Newfoundland, 1959. Joy Loader scooping up the iron ore.

95. *(upper right)* Princess Colliery, 1955. Construction of access tunnel.

96. *(lower right)* Wabana, Newfoundland, 1959. Knocking down the loose ore after a blast.

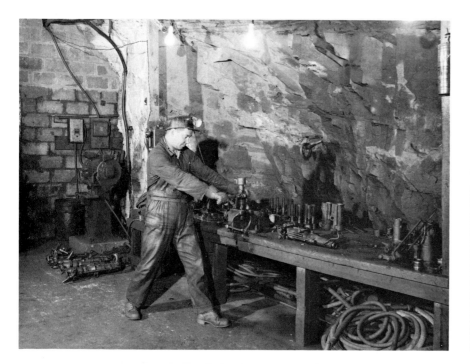

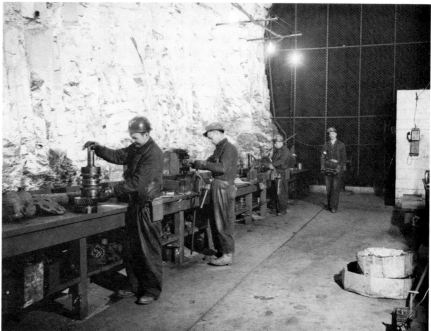

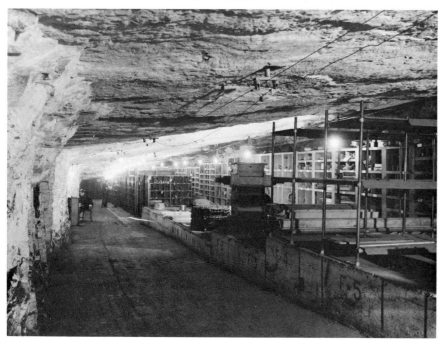

97. *(upper left)* Wabana, Newfoundland, 1959. Worker in underground machine shop.

98. *(lower left)* Wabana, Newfoundland, 1959. Underground shop at Wabana iron ore mines.

99. *(upper right)* Wabana, Newfoundland, 1959. Workers at the work bench in an underground machine shop at Wabana.

100. *(lower right)* Wabana, Newfoundland, 1959. Above ground conveyor carrying ore to preparation area.

101. Undated. Group of managers crossing the surface yard.

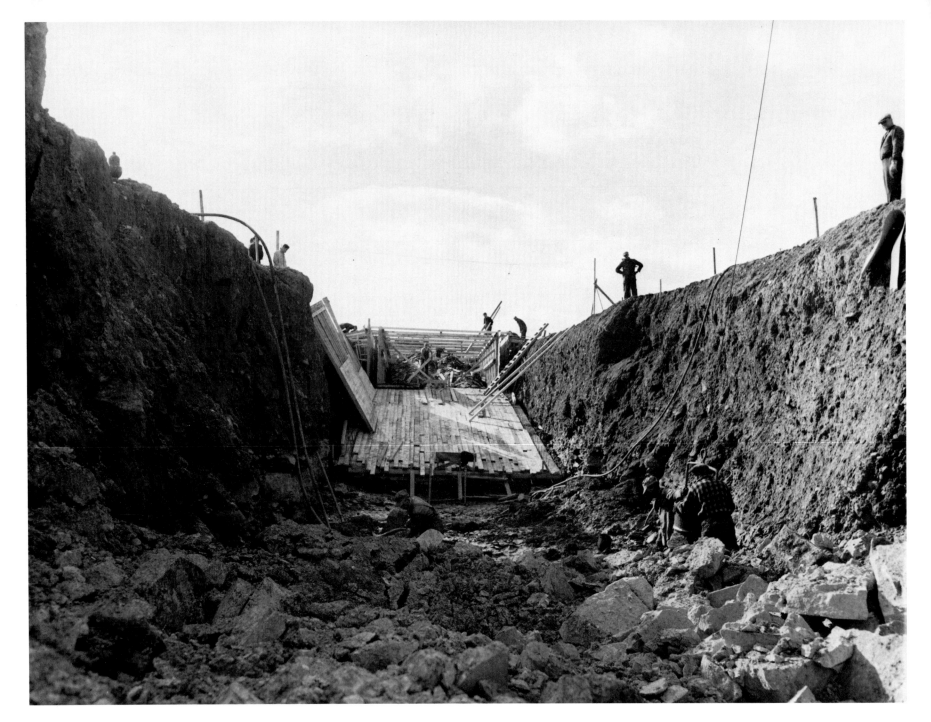

52

102. No. 20 Colliery, 1952. Starting excavation or slope for the access tunnel.

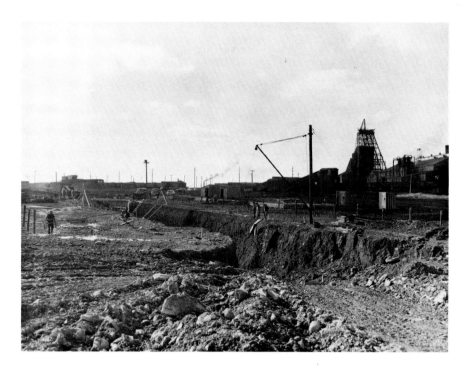

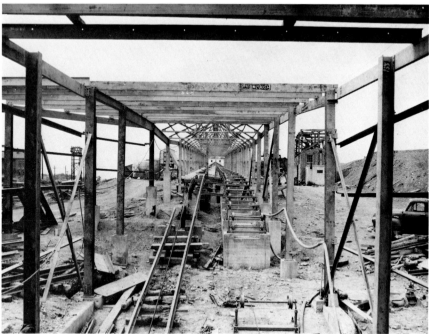

103. *(top)* No. 20 Colliery, 1952. Another view of slope excavation for access tunnel.

104. *(bottom)* Princess Colliery, 1955. Surface construction of access tunnel.

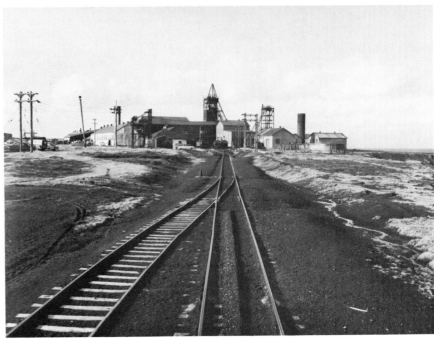

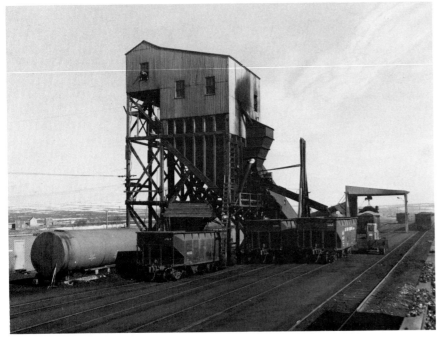

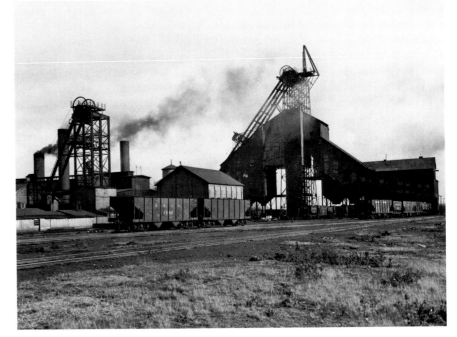

54

105. *(upper left)* Glace Bay, undated. Exterior of Power Plant.

106. *(lower left)* Coal Screening Plant, 1962.

107. *(upper right)* No. 26 Colliery, 1956. Surface view of the pit head and power plant.

108. *(lower right)* No. 20 Colliery, undated. Surface view. Pit head and railcar loading depot.

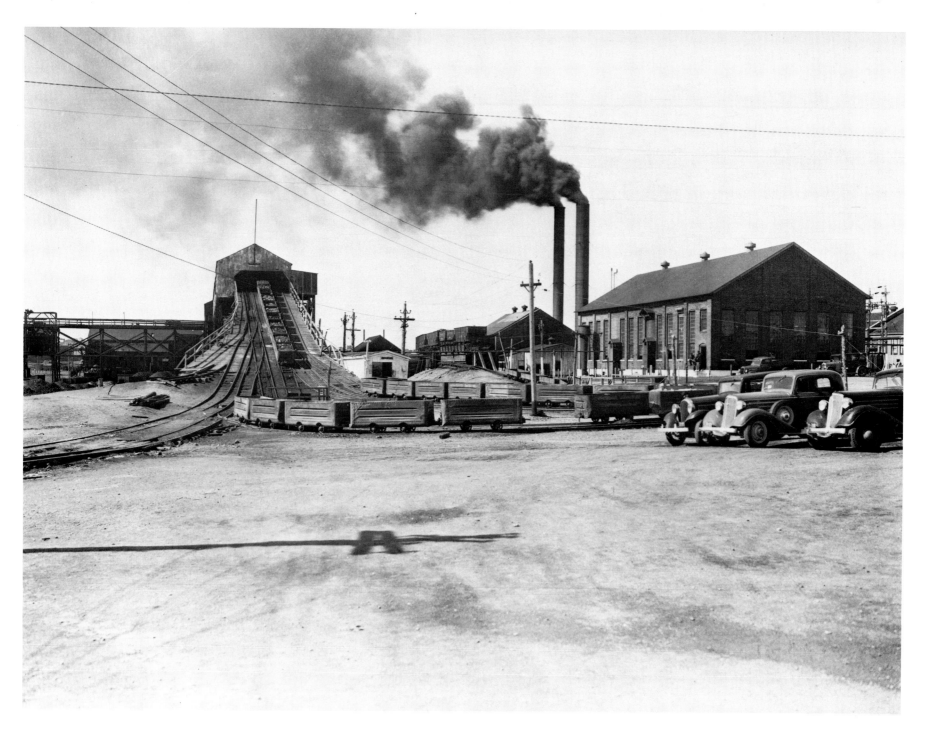

109. No. 12 Colliery, undated. Surface view. Loaded underground cars can be seen emerging from the surface housing of the approach tunnel.

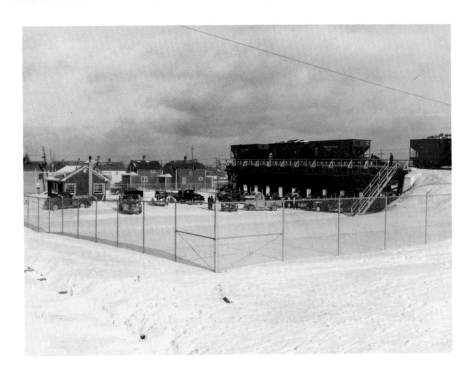

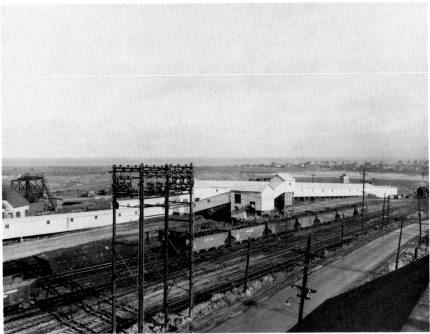

56

110. *(top)* New Waterford, 1956. Domestic coal pocket, a terminal where coal was loaded on trucks to be distributed to private homes and local businesses.

111. *(bottom)* Princess Colliery, 1955. View of surface works.

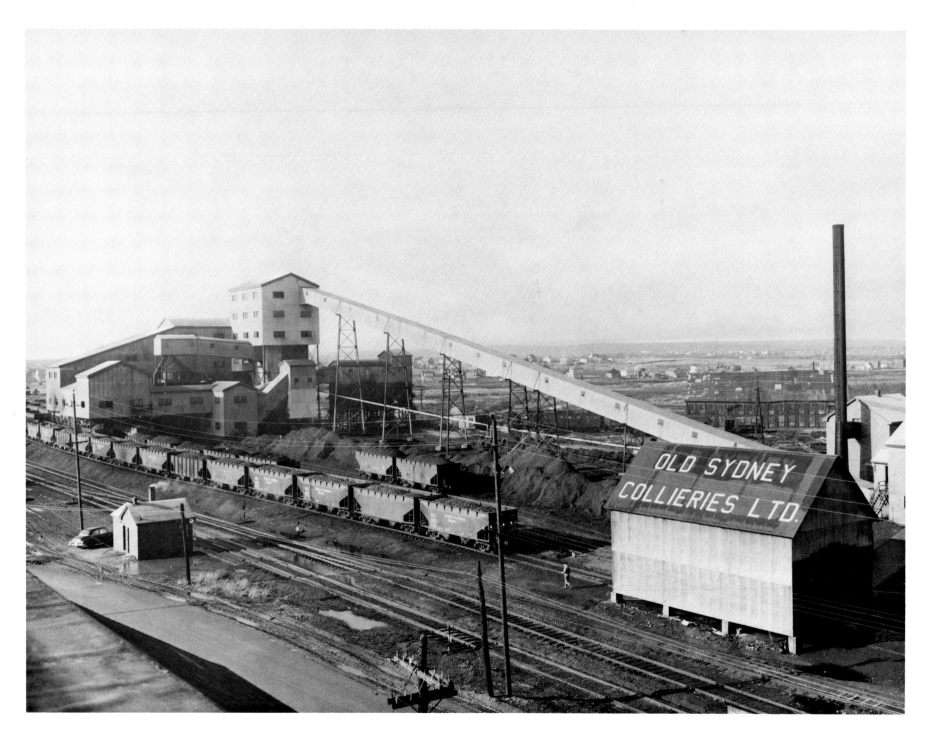

112. Princess Colliery, 1955. Sydney Mines Wash Plant. In the wash plant mud and other impurities are removed from the coal in order to meet commercial standards.

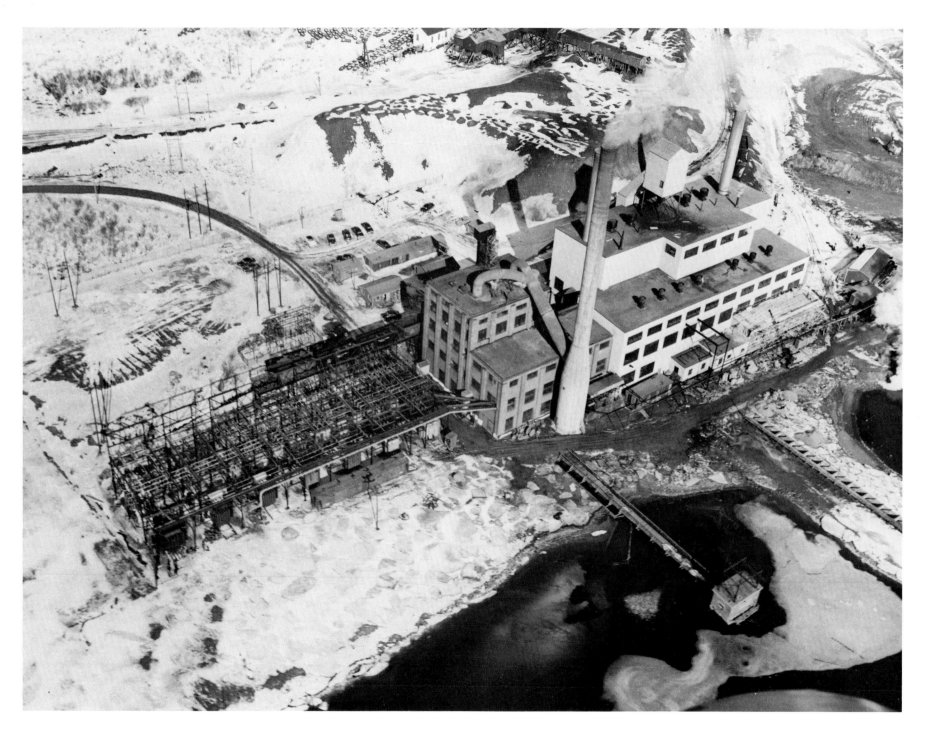

113. Seaboard Power Plant, 1952. Aerial view of the Seaboard Power Plant with the old No. 24 Colliery at the upper right side of photograph.

60

114. *(upper left)* Glace Bay, Dosco Company Laboratory, 1962. Technician in the company laboratory.

115. *(lower left)* Glace Bay, Dosco Company Laboratory, 1962. Technician in the company laboratory.

116. *(upper right)* Glace Bay, 1962. Technicians in the company laboratory. Dosco Company Laboratory.

117. *(lower right)* Glace Bay, Dosco Company Laboratory, 1962. Technician in the company laboratory.

118. Glace Bay, 1962. Dosco Company Laboratory.

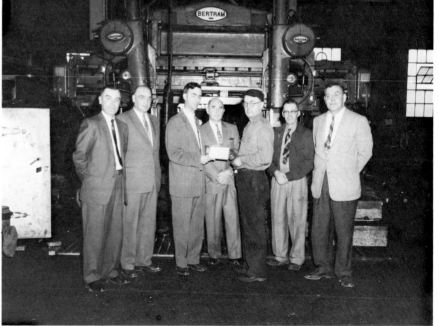

119. *(above)* Glace Bay, 1959. Photograph of shop worker illustrating the advantages of wearing shatterproof safety glasses.

120. *(top)* Glace Bay, 1957. Worker being fitted with safety glasses.

121. *(bottom)* Glace Bay, 1959. Canadian National Institute for the Blind representative making a presentation to a worker wearing safety glasses.

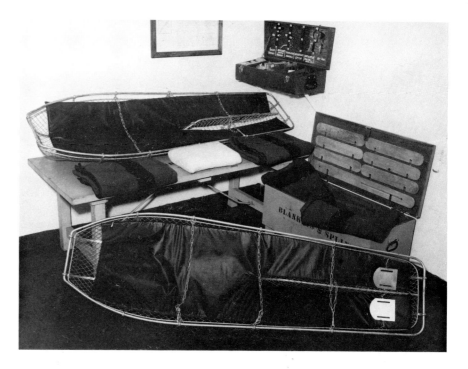

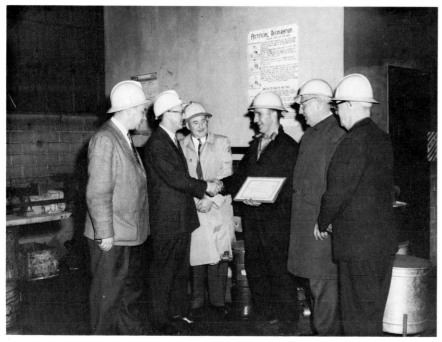

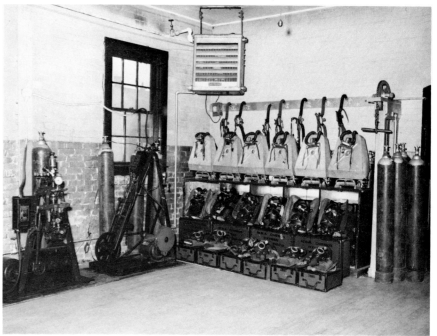

123. *(upper right)* No. 26 Colliery, 1953-57. First aid room.

124. *(lower right)* Glace Bay, 1953-57. Miners' Rescue Station, complete with Draegerman gear used in underground rescue operations.

122. *(lower left)* Glace Bay, 1954-58. Safety award ceremony.

64

125. *(top)* No. 16 Colliery, 1958. Wash-house toilets.

126. *(bottom)* No. 16 Colliery, 1958. Wash-house showers.

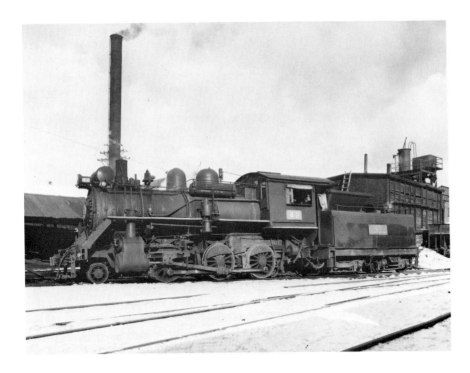

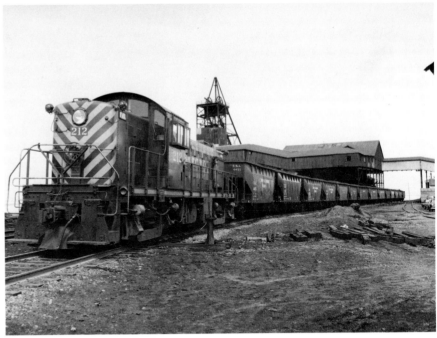

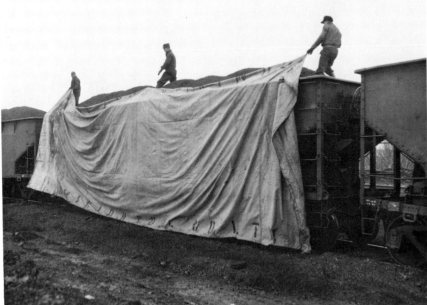

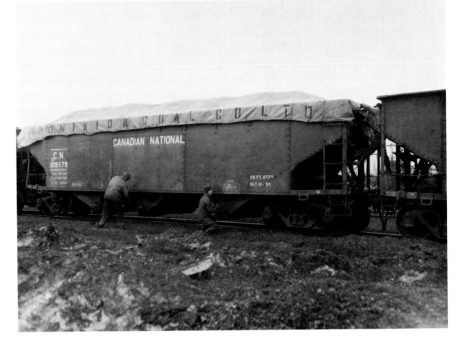

127. *(upper left)* Sydney and Louisbourg Railway, 1955. Old No. 42 steam locomotive. No. 42 eventually was brought back into service as a tourist train between Glace Bay and Louisbourg from 1975 to 1980.

128. *(lower left)* No. 18 Colliery, 1962. Workers cover cars to prevent loss of coal because of poor weather or rough stretches of track during transportation. The coal was also covered to prevent particles from falling while the coal train passed through towns and cities.

129. *(upper right)* No. 26 Colliery, 1963. Sydney and Louisbourg Railway diesel locomotive No. 212 hauling a string of coal cars from No. 26 loading depot.

130. *(lower right)* No. 18 Colliery, 1962. Workers covering coal cars.

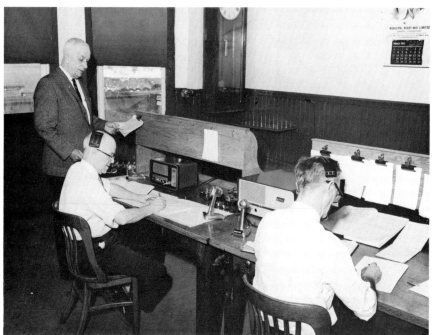

131. *(top)* Undated. Train operator.

132. *(bottom)* Glace Bay, 1963. Sydney and Louisbourg Railway Line dispatching room with chief dispatcher standing and two dispatchers seated at their radios.

133. Glace Bay, undated. Office superintendent at his desk in the General Office.

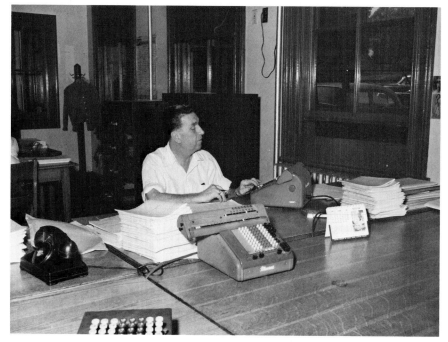

134. *(upper left)* Glace Bay, 1956. Dosco salesman on the left and customer on right. This photo marks the first sale of a Dosco Downdraft Furnace.

135. *(lower left)* Glace Bay, undated. Office clerk at his desk in the General Office.

136. *(upper right)* Glace Bay, 1952. Superintendent of the mines on the left and his successor on the right.

137. *(lower right)* Glace Bay, 1956. Superintendents' meeting.

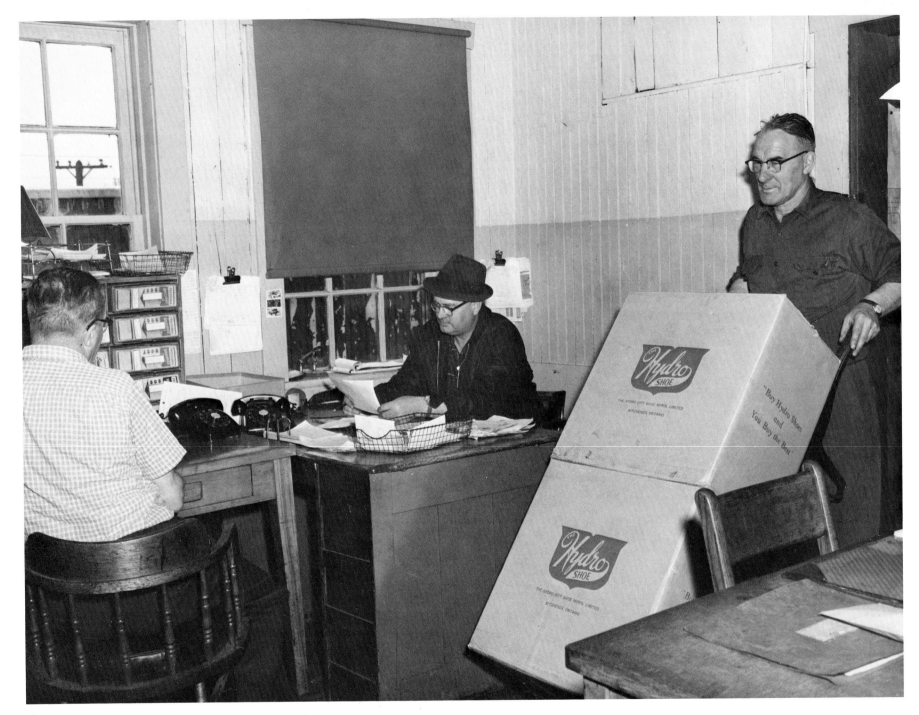

138. Glace Bay, 1965. Warehouse Office.

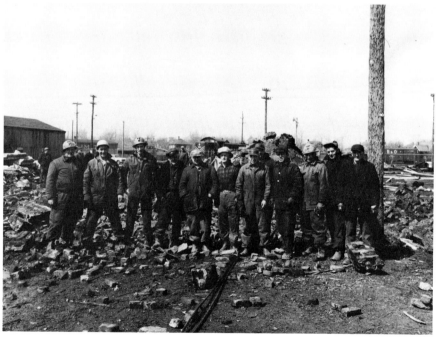

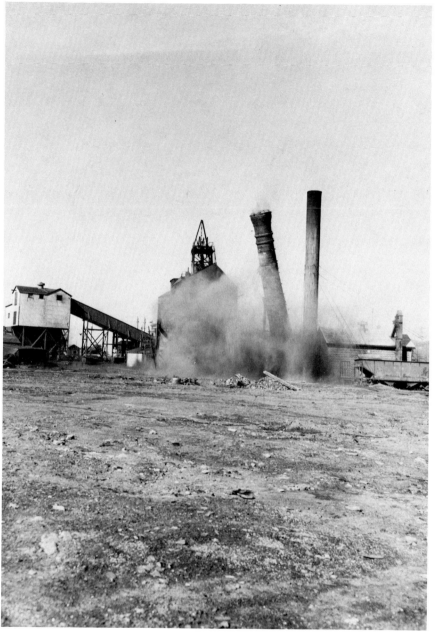

139. *(upper left)* Sterling Yard, 1963. Smoke stack just before its demolition.

140. *(lower left)* Sterling Yard, 1963. Group of men near rubble of demolished smoke stack.

141. *(above)* No. 4 Colliery, 1955. Demolition of smoke stack.

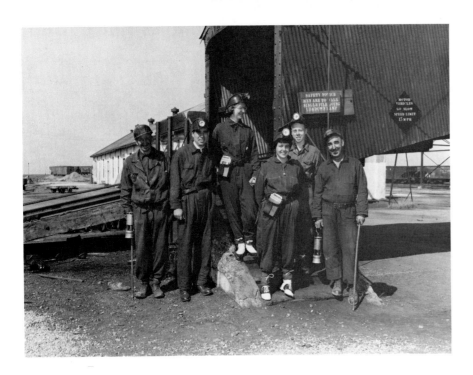

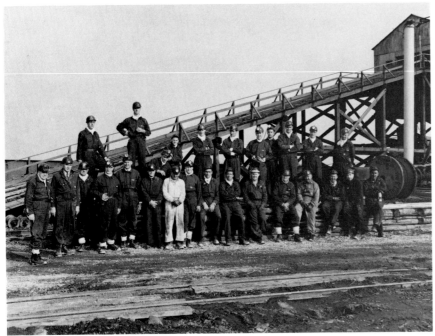

142. *(top)* No. 26 Colliery, 1956. Student tour of No. 26 Colliery.

143. *(bottom)* No. 26 Colliery, 1962. Trade delegation from the Commonwealth Conference visiting No. 26 Colliery.

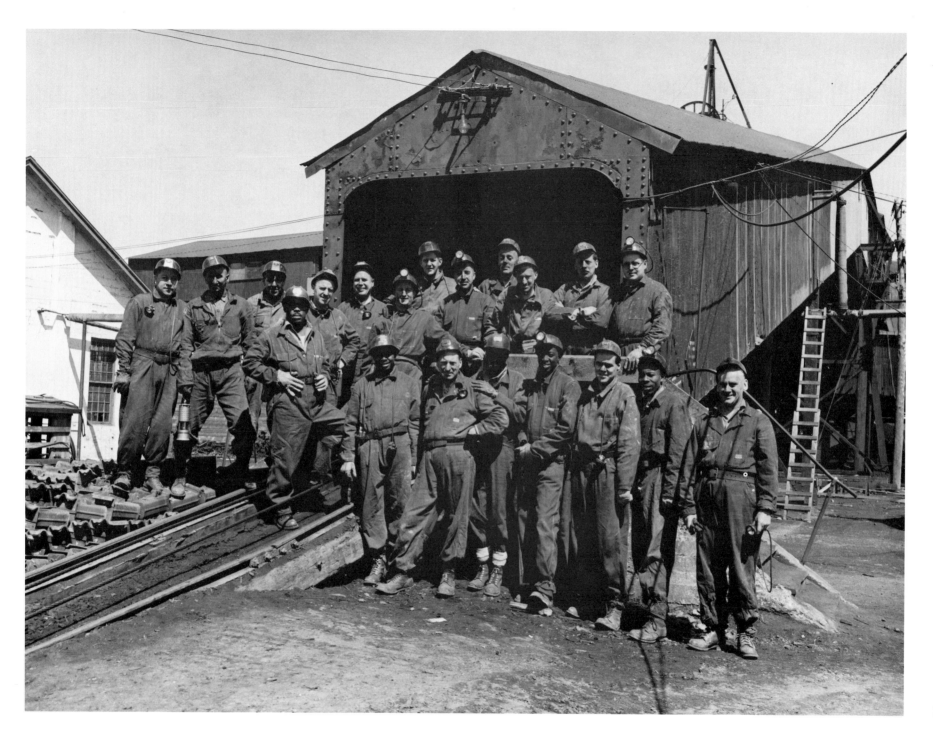

144. No. 12 Colliery, 1959. Trade delegation from the Commonwealth Conference visiting
No. 12 Colliery.

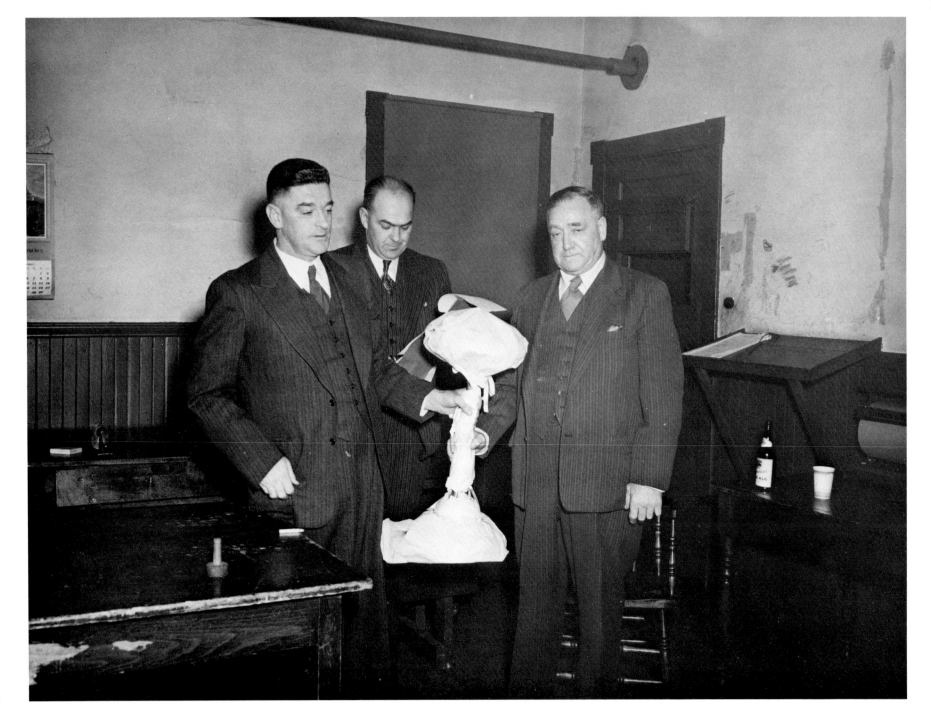

145. Glace Bay, 1954. Presentation of gift to an office worker in one of the Colliery offices.

146. *(upper left)* No. 20 Colliery, 1964. Retirement ceremony.

147. *(lower left)* Glace Bay, 1959. Dosco bowling banquet.

148. *(upper right)* 1958. Presentation of gifts to an office worker.

149. *(lower right)* Undated. Head table at Dosco banquet.

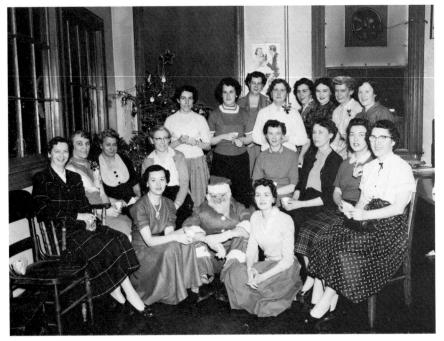

150. *(upper left)* Glace Bay, 1954. General Office Women Workers' Banquet held at a hotel in Glace Bay.

151. *(lower left)* Glace Bay, 1955. Christmas Party for General Office workers.

152. *(upper right)* Glace Bay, 1959. Dosco bowling banquet.

153. *(lower right)* Glace Bay, 1957. General Office clerical workers.

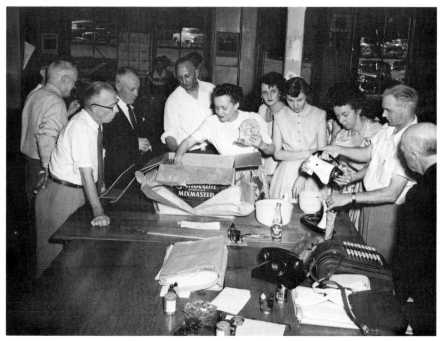

154. *(upper left)* Glace Bay, undated. Presentation of flowers to the wife of the head of the miners' rescue squad. These rescue workers were known as Draegermen.

155. *(lower left)* Glace Bay, 1958. Presentation of a gift to General Office worker.

156. *(upper right)* Glace Bay, 1959. Retirement ceremony.

157. *(lower right)* Glace Bay, 1954. Presentation of a gift to a General Office worker.

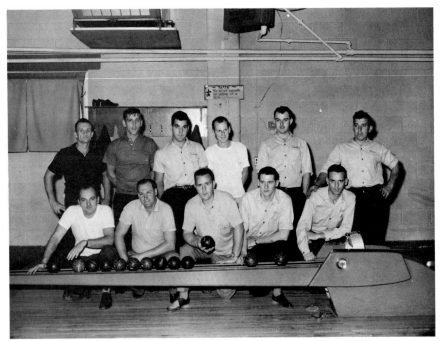

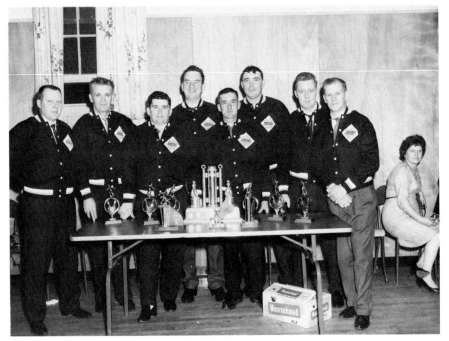

158. *(upper left)* Glace Bay, 1958. Bowlers.

159. *(lower left)* 1961. Dosco Bowling Team.

160. *(upper right)* Glace Bay, 1959. Prize winners from the Dosco Bowling League.

161. *(lower right)* Undated. Presentation of trophies to Dosco Bowling Team.

162. Glace Bay, 1963. Trophy display for Seaboard Bowling League.

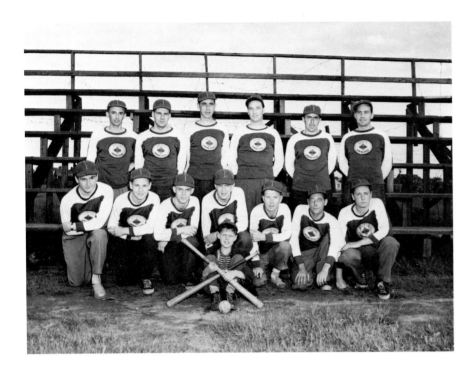

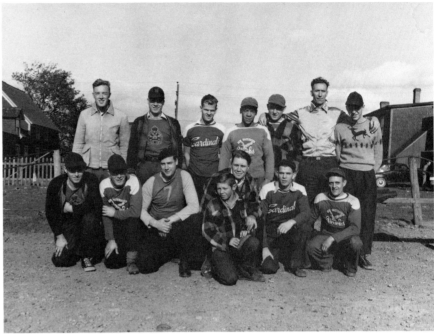

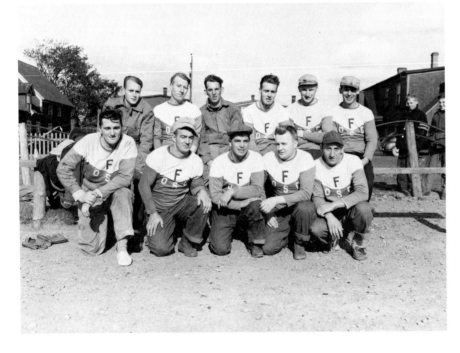

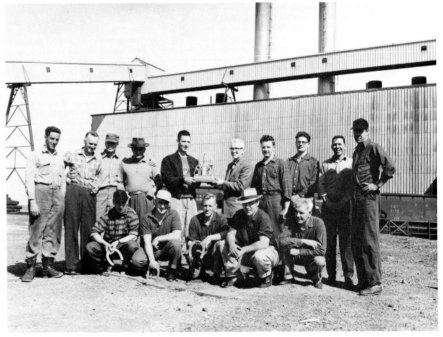

163. *(upper left)* 1954. Dosco's General Office Softball Team.

164. *(lower left)* 1955. Dosco Softball Team.

165. *(upper right)* 1955. New Waterford Softball Team.

166. *(lower right)* Glace Bay, 1958. Seaboard Horseshoe League.

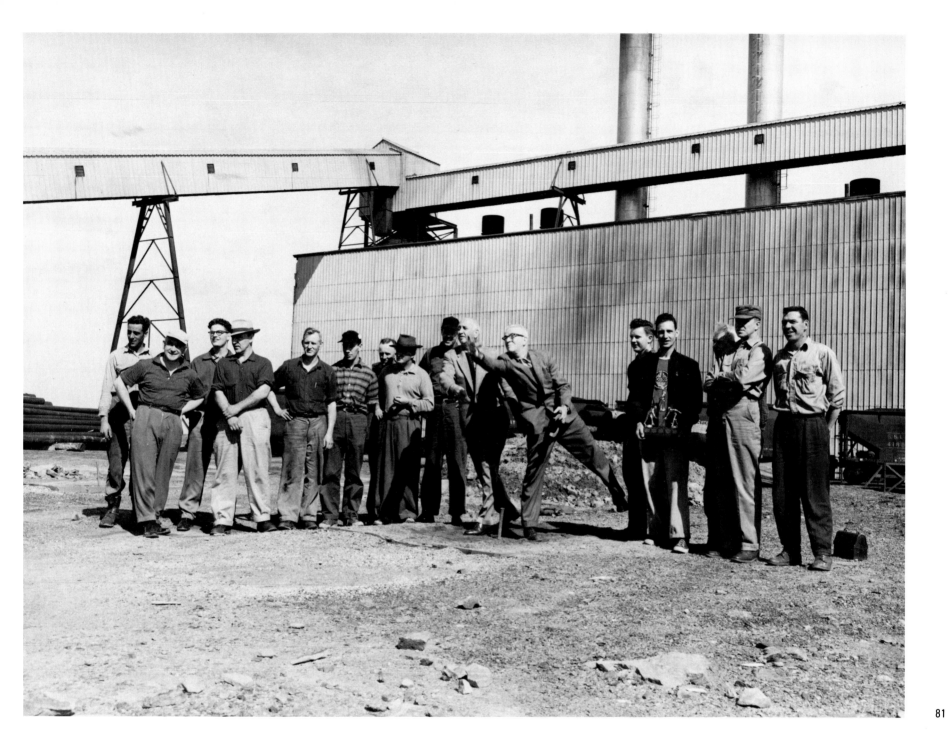

167. Glace Bay, 1958. Seaboard Horseshoe League.

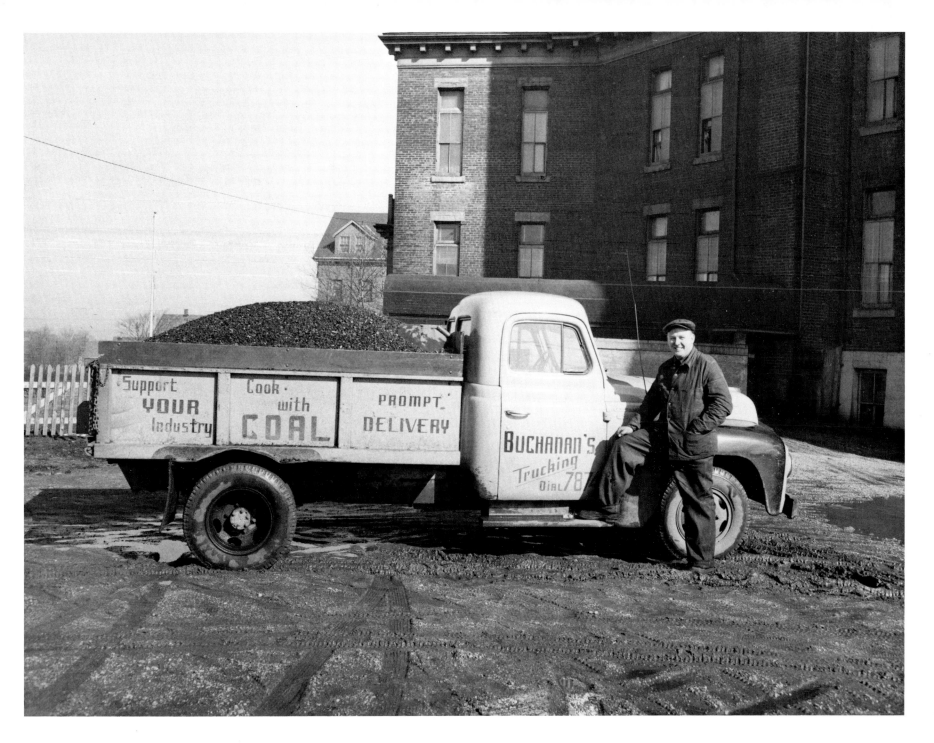

168. Glace Bay, 1956. This photograph, taken for Dosco, was part of a television advertising package to promote the various uses of coal.

169. Glace Bay, 1962. Dosco display booth at Manufacturers' Fair in the Glace Bay Miners' Forum.

170. Glace Bay, 1963.Dosco display booth at Manufacturers' Fair in the Glace Bay Miners' Forum.

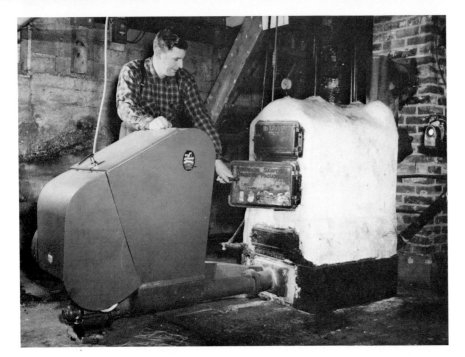

171. *(upper left)* Glace Bay, 1956. Photograph for television advertising package. Refer to #168.

172. *(lower left)* Glace Bay, 1956. Photograph for television advertising package. Refer to #168.

173. *(upper right)* Glace Bay, 1956. Photograph for television advertising package. Refer to #168.

174. *(lower right)* Glace Bay, 1956. Photograph for television advertising package. Refer to #168.

175. Glace Bay, 1956. Photograph for television advertising package. Refer to #168.

176. Undated. Vase or mug depicting the Dosco Coke Ovens and the old Princess Pit in Sydney Mines. Circa 1910.

177. 1956. Dosco Downdraft Furnace. The Dosco Downdraft Furnace was the 'Edsel' of the home heating industry. It was theoretically sound but had some practical inefficiencies.

178. Port Morien, 1963. Monument to the coal industry. The inscription reads, ''Canada's Coal Industry. Two thousand feet south easterly from this place are the remains of the first regular coal mining operations in America, established by the French in 1720. From the modest beginnings of those early days this industry has become one of national and imperial importance''.

2. Photographs from the general archives of Shedden Studios.

92

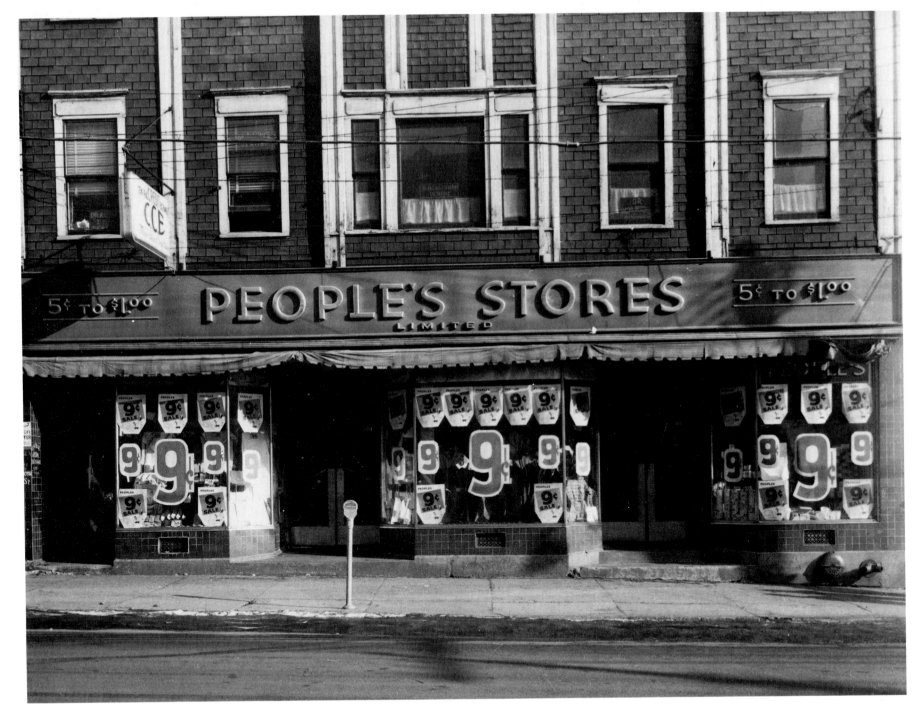

179. People's Store, Glace Bay, 1953-54.

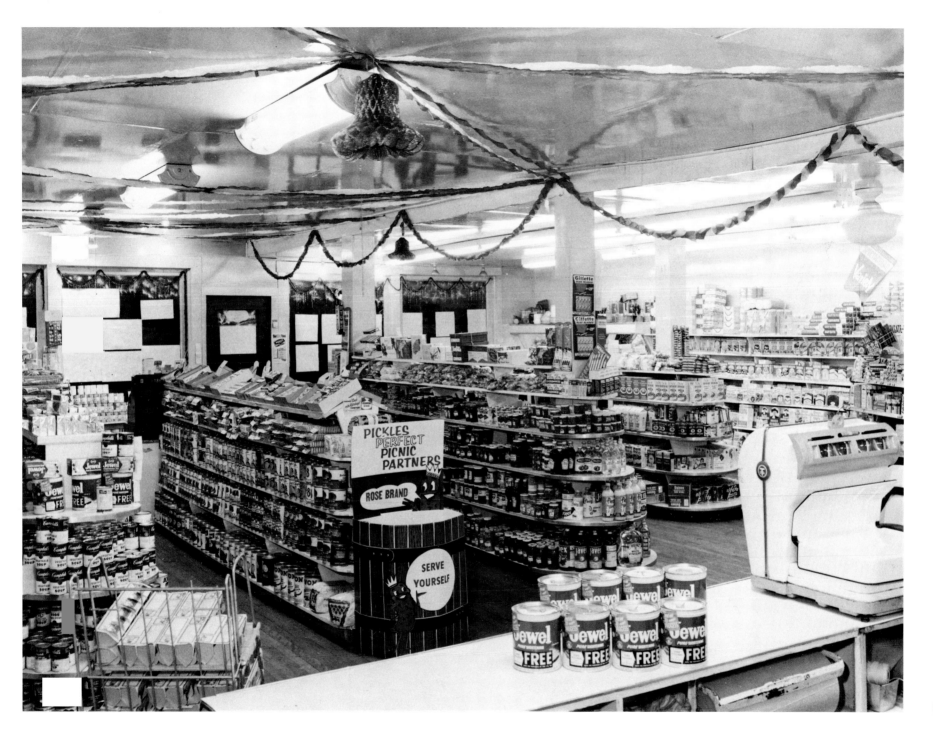

180. Myer's Marketeria, Glace Bay, late fifties. Interior during the Christmas season.

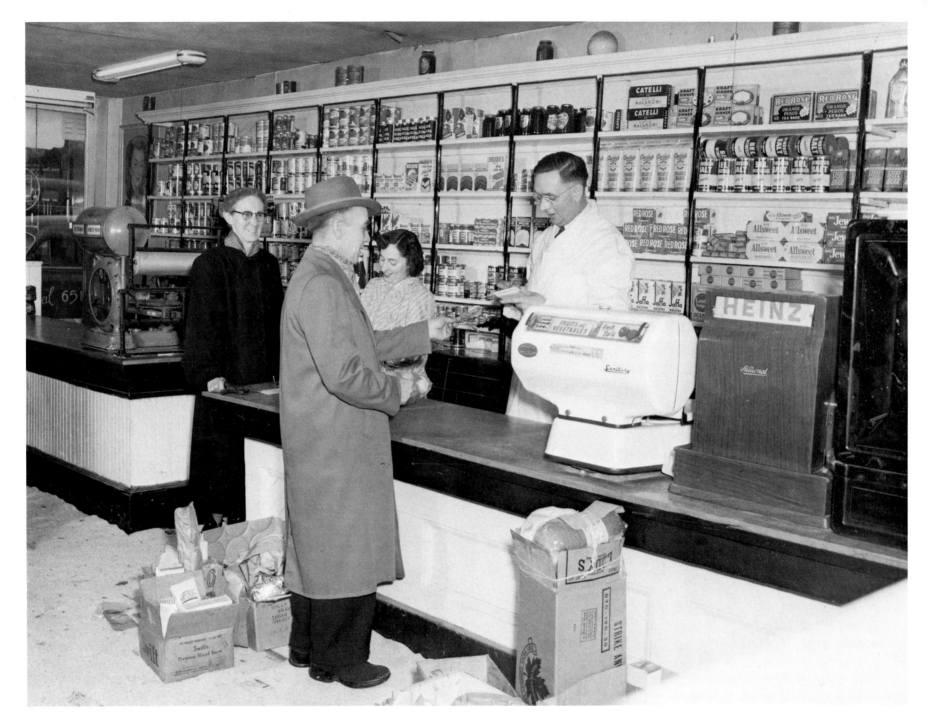

181. MacIntosh's Store, Glace Bay, 1956.

182. *(upper left)* Thompson and Sutherland Department Store, Glace Bay, 1942. Westclock window display. Photograph by David Shedden.

183. *(lower left)* Thompson and Sutherland Department Store, Glace Bay, 1950's. Westclock window display.

184. *(upper right)* Zilbert Brothers Grocery Store, Glace Bay, undated. Exterior view at night.

185. *(lower right)* MacIntyre's Men's Wear, Glace Bay, undated. These photographs of window displays were taken for advertising purposes or in some cases to prove to the manufacturer who paid for advertising, that the display had actually been installed.

96

186. *(top)* Chernin Brothers Clothing Store, Glace Bay, 1955. The proprietors in front of a showcase.

187. *(bottom)* Eaton's Department Store, Glace Bay, 1954. Women's clothing showcase/counter.

188. Chernin Brothers Clothing Store, Glace Bay, 1955. The store owners demonstrate their services to a customer.

189. Chernin Brothers Clothing Store, Glace Bay, 1955. Two women and a store owner pose for an advertising photo in the shoe department.

190. *(upper left)* Thom's Flower Shop, Glace Bay, undated. Exterior view of the local florist's shop used for advertising in local newspapers.

191. *(lower left)* Toyland Store, Glace Bay, 1957.

192. *(upper right)* Royal Bank of Canada Building (exterior), Glace Bay, 1956. Taken for the Royal Bank of Canada.

193. *(lower right)* Eaton's Department Store, Glace Bay, 1965.

194. *(upper left)* Thom's Flower Shop, Commercial Street, Glace Bay, 1952. The interiors of local businesses were often photographed for advertising purposes, usually on the occasion of a grand opening or to publicize sales.

195. *(lower left)* Toyland Store, Glace Bay, 1958.

196. *(upper right)* Eaton's Department Store, Glace Bay, undated. Mail order desk.

197. *(lower right)* Bank of Nova Scotia Building (interior), Glace Bay, 1956. Taken for the Bank of Nova Scotia.

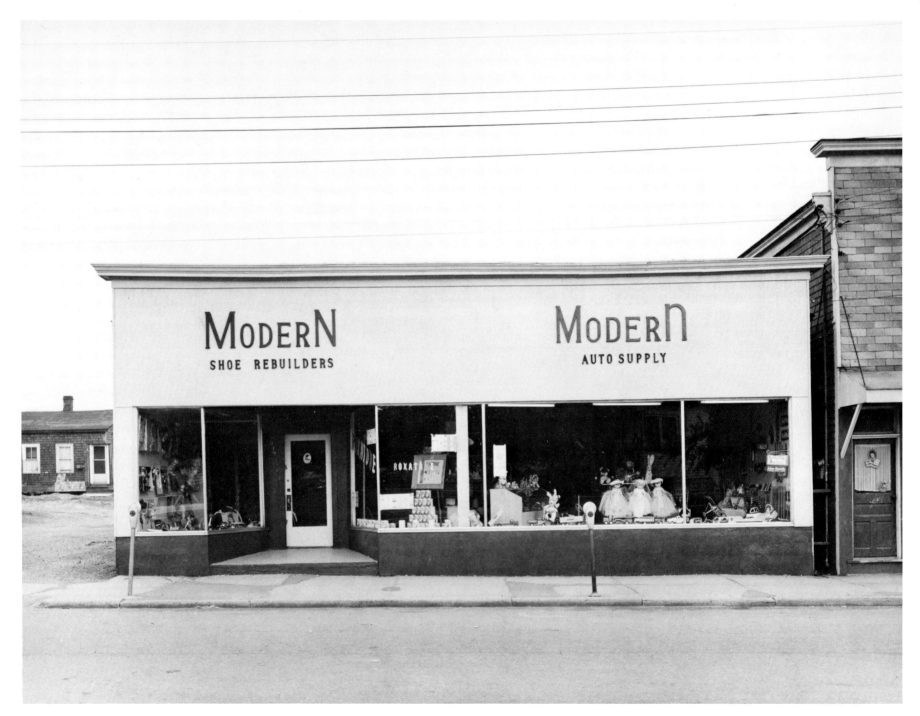

198. Modern Stores, Glace Bay, 1958.

199. *(top)* Thompson and Sutherland Department Store, Glace Bay, undated. Presentation of prize to the winner of B & H Paint sponsored contest.

200. *(bottom)* Phalen's Bakery, Glace Bay, 1956. Cook is presenting a cake to the winner of a lottery put on by the bakery.

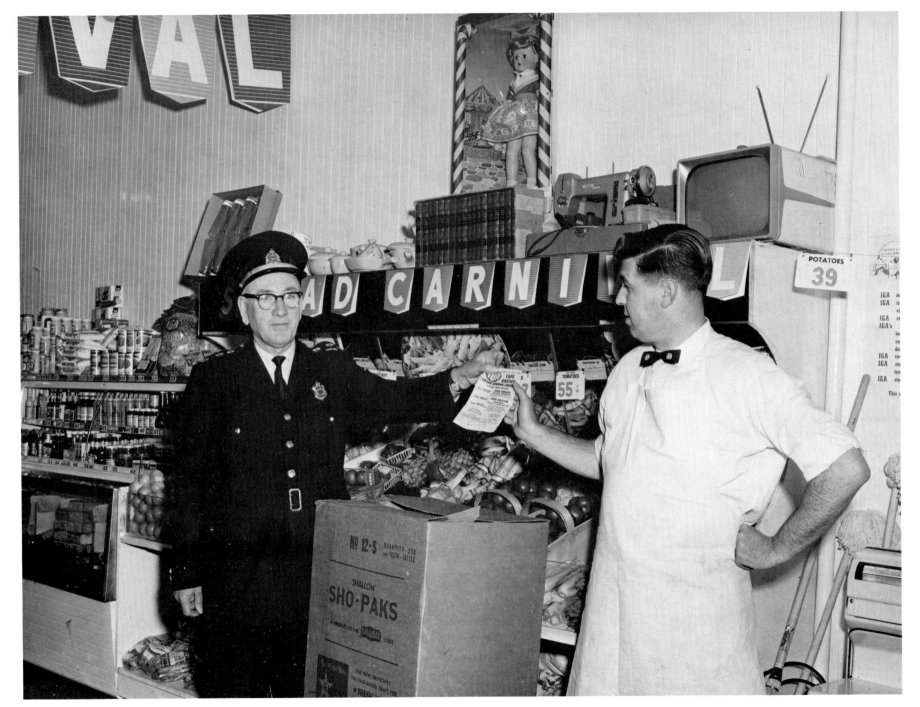

201 I.G.A. Store, Glace Bay, 1956. Grand Opening contest.

202. Glace Bay, 1956. Photograph taken for publication in the Cape Breton Post. Presentation of prize to Salada Tea contest winner.

203. *(upper left)* Manufacturers' Fair, Miners' Forum, Glace Bay, 1954. Thompson and Sutherland Limited display. Salesperson showing prospective customers radios and televisions.

204. *(lower left)* Manufacturers' Fair, Miners' Forum, Glace Bay, 1954. Home furniture and household appliances display.

205. *(upper right)* Manufacturers' Fair, Miners' Forum, Glace Bay, 1964. Lynk Electric display.

206. *(lower right)* Manufacturers' Fair, Miners' Forum, Glace Bay, 1954. Automboile display.

207. *(upper left)* I.G.A. Store, Glace Bay, 1958. Store workers and delivery men pause at the rear entrance of the store.

208. *(lower left)* MacAuley's Hennery, Glace Bay, 1961. Workers in the packing department of the Hennery.

209. *(upper right)* McKinlay and Sons Bottling Company, Glace Bay, 1961.

210. *(lower right)* Annie's Beauty Salon, Glace Bay, 1960.

211. *(upper left)* Barnhill's Transfer, Glace Bay, 1956. The management of Barnhill's Transfer, municipal officials, and the local Boy Scouts of Canada troop, celebrate the planting of a tree.

212. *(lower left)* Glace Bay, 1952. Ceremonial turf breaking for the new park.

213. *(upper right)* Burke and Chaisson Painters, Glace Bay, 1953. The management and workers of this local painting firm on the lawn in front of their most recently completed project.

214. *(lower right)* MacAuley's Hennery, Glace Bay, 1961. Four workers in front of the company's delivery van.

215. Miners' Forum, Glace Bay, undated. Contractors preparing a new base for installation of ice surface.

216. *(top)* Brodie's Printing, Glace Bay, 1956. Worker in printing plant.

217. *(bottom)* Brodie's Printing, Glace Bay, 1956. Worker in printing plant.

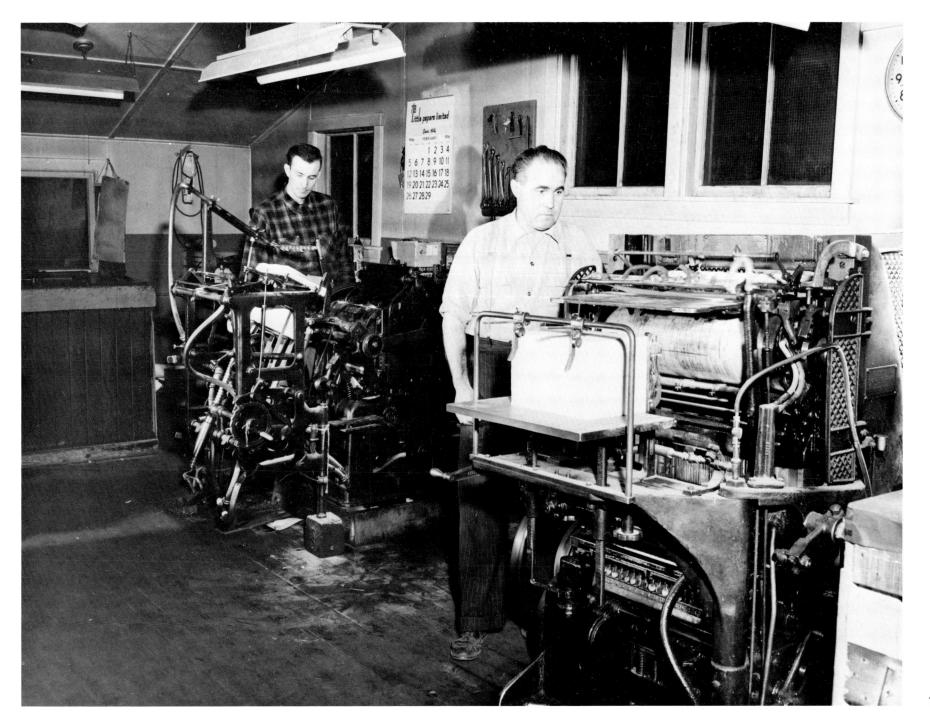

218. Brodie's Printing, Glace Bay, 1956. Worker in printing plant.

219. Glace Bay, 1954. Bridge game.

220. Glace Bay, undated. Typing class.

221. Glace Bay, undated. Police Hockey Club.

222. *(top)* The Rotary Club Sports Night, Miners' Forum, Glace Bay, 1957. The selection of a Sports Night High School Queen was one of the many events that took place during the evening. Other events included ice speed skating, hockey, broomball, and various relays.

223. *(bottom)* The Rotary Club Sports Night, Miners' Forum, Glace Bay, 1955. Crowning of the Sports Night Queen.

224. The Rotary Club Sports Night, Miners' Forum, Glace Bay, 1955.

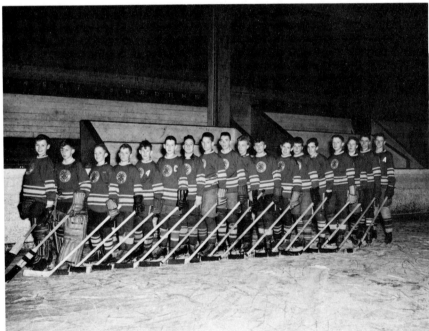

225. *(top)* Miners' Forum, Glace Bay, 1960. Morrison High School Hockey Team.

226. *(bottom)* Miners' Forum, Glace Bay, undated. High School Hockey Team.

227. The Rotary Club Sports Night, Miners' Forum, Glace Bay, undated. Hockey teams
standing for the playing of the national anthem before game.

228. Morrison High School, Glace Bay, undated. Basketball Team.

229. Glace Bay, 1965. Studio photograph of Morrison High School cheerleaders.

230. *(top)* Morrison High School, Glace Bay, 1957. Army Cadet Rifle Team.

231. *(bottom)* Morrison High School, Glace Bay, 1957. Cheerleaders.

232. *(upper left)* Morrison High School, Glace Bay, 1955. Boys Basketball ''A'' Team.

233. *(lower left)* Morrison High School, Glace Bay, 1955. Girls Basketball ''A''Team.

234. *(upper right)* Morrison High School, Glace Bay, 1955. Boys Basketball ''B'' Team.

235. *(lower right)* Morrison High School, Glace Bay, 1955. Girls Basketball ''B'' Team.

236. Morrison High School, Glace Bay, 1965. Gymnastic demonstration.

237. Morrison High School, Glace Bay, 1965. Gymnastic demonstration.

238. Morrison High School, Glace Bay, 1965. Boys Gymnastic Team.

239. *(upper left)* St. Joseph's Nursing School, Glace Bay, 1959. Group photograph taken for the yearbook.

240. *(lower left)* St. Joseph's Nursing School, Glace Bay, 1959. Group photograph taken for the yearbook.

241. *(upper right)* St. Joseph's Nursing School, Glace Bay, 1959. Group photograph taken for the yearbook.

242. *(lower right)* St. Joseph's Nursing School, Glace Bay, 1955. Group photograph of staff taken for yearbook.

243. St. Joseph's Nursing School, Glace Bay, 1955. Student nurses from out of town signing up for rooms in residence hall.

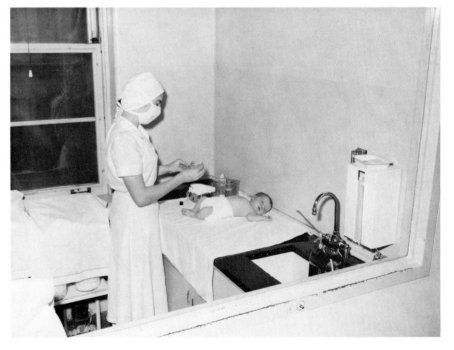

244. *(upper left)* St. Joseph's Nursing School, Glace Bay, 1959. Director of the school.

245. *(lower left)* St. Joseph's Nursing School, Glace Bay, 1959. Board of Governors.

246. *(upper right)* St. Joseph's Nursing School, Glace Bay, 1960. Pediatrics ward.

247. *(lower right)* St. Joseph's Nursing School, Glace Bay, 1960. Pediatrics ward.

249. *(upper left)* St. Joseph's Nursing School, Glace Bay, 1950. Graduation portrait.

250. *(lower left)* St. Joseph's Nursing School, Glace Bay, 1959. Graduation portrait.

251. *(upper right)* St. Joseph's Nursing School, Glace Bay, 1959. Graduation portrait.

252. *(lower right)* St. Joseph's Nursing School, Glace Bay, 1950. Graduation portrait.

248. *(above)* Glace Bay, 1959. Studio portrait of St. Joseph's Nursing School Yearbook Staff.

128

253. Knox Church, Glace Bay, 1952. Church play entitled ''Time to Retire'', with an all-male cast. The two women in the foreground were responsible for back-stage work.

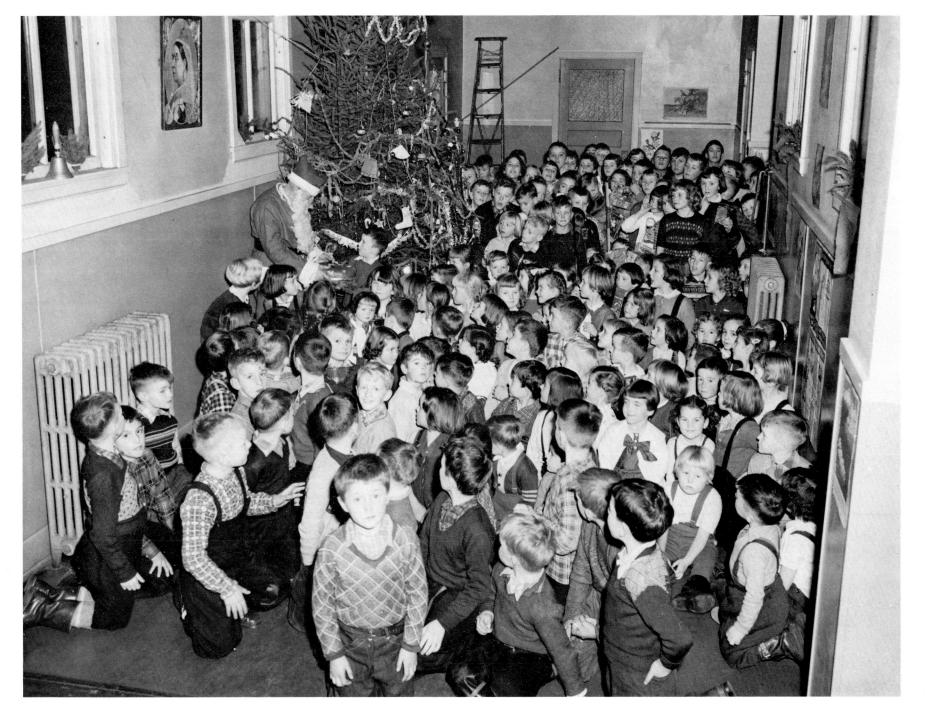

254. Elementary School Christmas Party, Glace Bay, 1957.

130

255. *(top)* Glace Bay, undated. MacDougall Girls Pipe Band.

256. *(bottom)* Baptist Church Men's Club, Glace Bay, 1955. Volunteer workers at church supper.

257. South Street Race Club, Glace Bay, 1953. Presentation of trophies to the winner of the foot race.

258. *(upper left)* Glace Bay, 1956. Canadian Cancer Society fund raising booth.

259. *(lower left)* Fall Fair, Miners' Forum, Glace Bay, 1964.

260. *(upper right)* Fall Fair, Miners' Forum, Glace Bay, 1962. Craftspeople next to their tartan display.

261. *(lower right)* Manufacturers' Fair, Miners' Forum, Glace Bay, undated. Sewing machine demonstration.

262. *(upper left)* St. Paul's Church, Glace Bay, undated. Ceremonial burning of church mortgage on the church properties, with clergy and lay officials of the church in attendance.

263. *(lower left)* Glace Bay, undated. Clergyman at his desk.

264. *(upper right)* Anniversary Parade, Glace Bay, 1962. Royal Canadian Legion float commemorating the dead of the two World Wars.

265. *(lower right)* Glace Bay, 1959. Funeral ceremony.

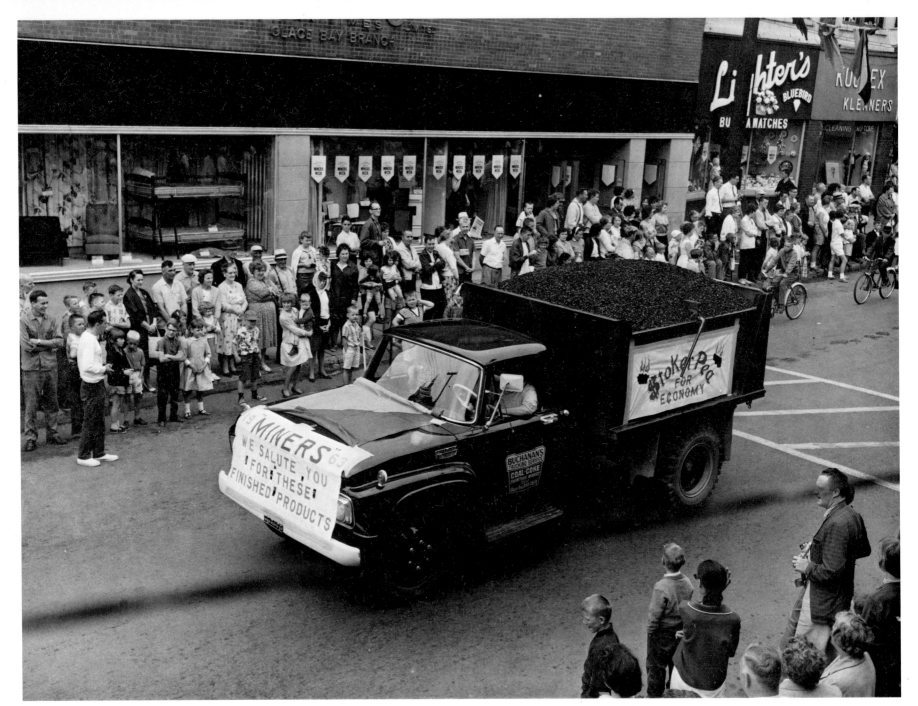

266. Anniversary Parade, Glace Bay, 1962. Buchanan's Coal and Coke Company float saluting the miners for their contribution of "finished products".

267. Glace Bay, 1963. Wedding album photograph.

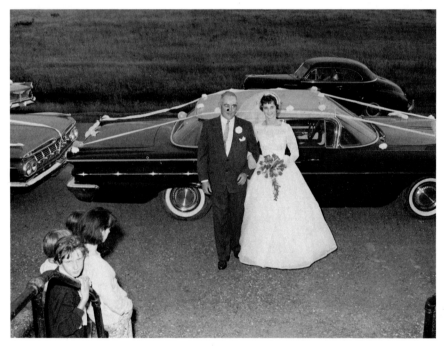

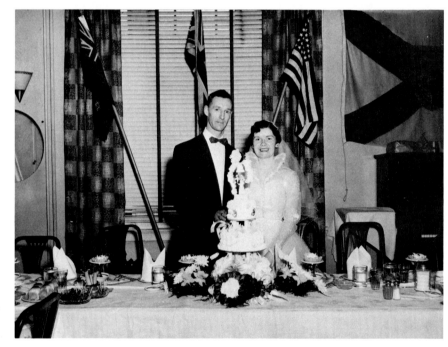

268. *(upper left)* Glace Bay, 1960. Wedding album photograph.

269. *(lower left)* Glace Bay, 1960. Wedding album photograph.

270. *(upper right)* Glace Bay, 1960. Wedding album photograph.

271. *(lower right)* Glace Bay, 1960. Wedding album photograph.

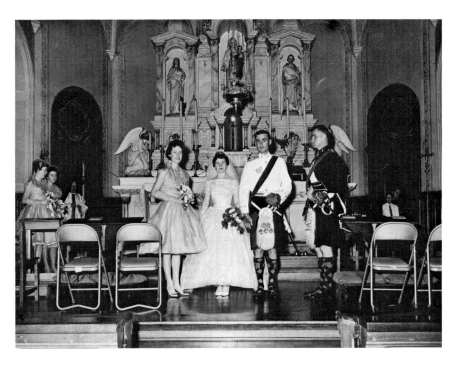

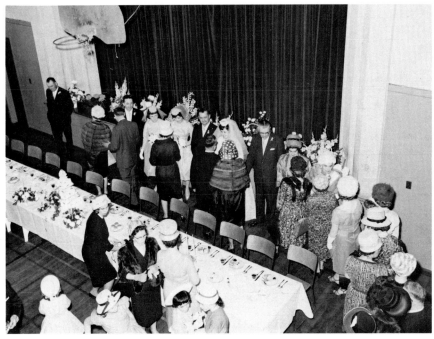

272. *(top)* Glace Bay, 1961. Wedding album photograph. The men are dressed in traditional Celtic regalia.

273. *(bottom)* Glace Bay, 1963. Wedding reception in school auditorium.

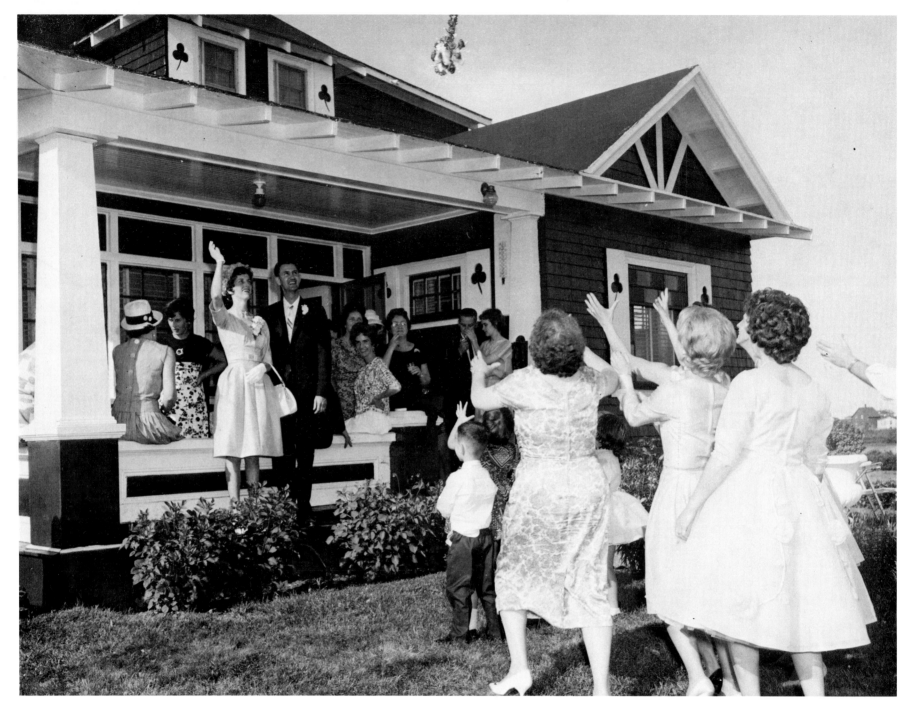

274. Glace Bay, 1963. Wedding album photograph.

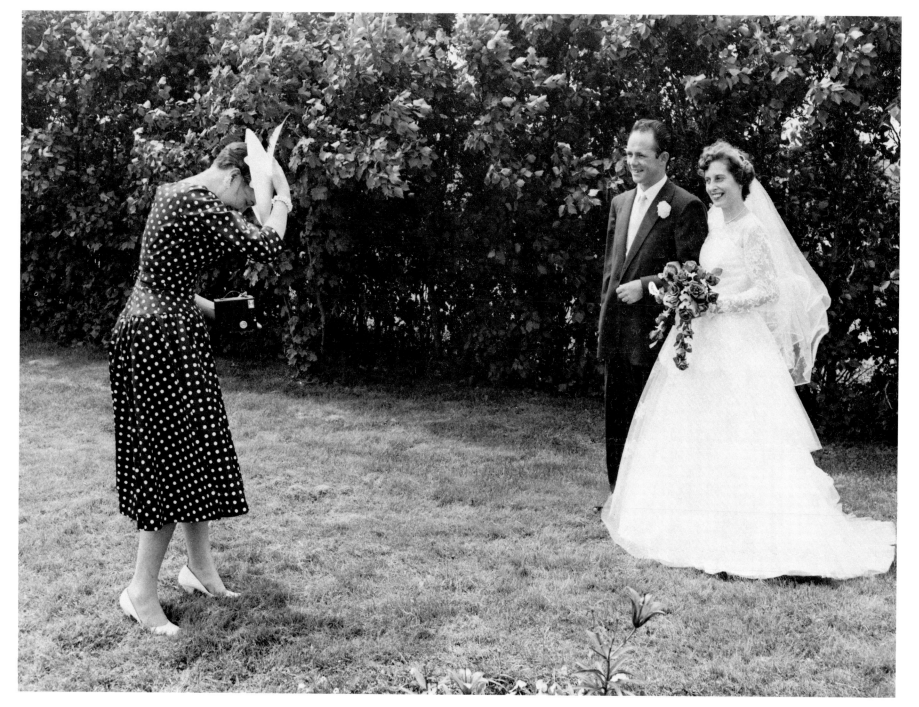

139

275. Glace Bay, 1955. Wedding album photograph.

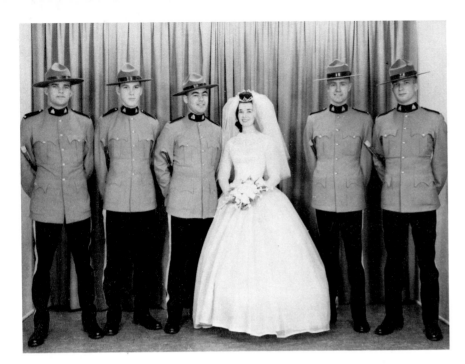

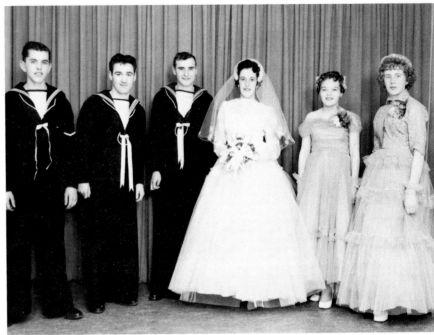

276. *(upper left)* Glace Bay, 1963. Group portrait of wedding party. Men wear ceremonial uniform of Royal Canadian Mounted Police.

277. *(lower left)* Glace Bay, 1941-42. Studio portrait of a family group. Photograph by David Shedden.

278. *(upper right)* Glace Bay, 1958. Group portrait of wedding party. The men wear naval dress uniforms.

279. *(lower right)* Glace Bay, 1940-41. Studio portrait of five brothers. Photograph by David Shedden.

141

280. *(upper left)* Glace Bay, 1955. Studio portrait of twin girls.

281. *(lower left)* Glace Bay, 1950. Studio portrait of a family group.

282. *(upper right)* Glace Bay, 1963. Studio portrait of four brothers.

283. *(lower right)* Glace Bay, 1943. Studio portrait of Salvation Army couple. Photograph by David Shedden.

284. Glace Bay, 1954. Studio portrait of a young woman in a Celtic piper's outfit.

285. Glace Bay, undated. Studio portrait of a young boy in a Roy Rogers outfit.

286. Glace Bay, undated. Studio portrait.

287. Glace Bay, 1948. Studio portrait of mother and daughters.

144

288. Glace Bay, undated. Studio portrait of a young man.

289. Glace Bay, undated. Studio portrait of a woman.

290. Glace Bay, undated. Camp advisor with a Cub Scout.

291. Glace Bay, undated. Studio portrait of two young girls in their Girl Guide uniforms.

146

292. Glace Bay, 1967. Wedding portrait.

293. Glace Bay, 1953-54. Studio portrait of a young boy dressed for First Communion.

294. Glace Bay, 1950. Studio portrait of two brothers, local merchants.

295. Glace Bay, 1949. Studio portrait.

148

296. Glace Bay, 1952. Studio portrait.

297. Glace Bay, 1940-42. Group portrait of wedding party.

149

298. Glace Bay, undated. Portrait of an elderly woman with a makeshift photographic backdrop.

299. St. Paul's Presbyterian Church. Glace Bay, 1965.

300. *(top)* St. Anne's Church Interior, Glace Bay, undated.

301. *(bottom)* Glace Bay, 1960. Wedding album photograph. View of the wedding ceremony from the back of the church.

153

302. *(upper left)* Chalmer's United Church, Glace Bay, 1959.

303. *(lower left)* St. Luke's United Church, Donkin, NS., 1964.

304. *(upper right)* St. John's Church, New Aberdeen, NS., 1960.

305. *(lower right)* St. Anne's Church, Glace Bay, 1967. Destroyed by fire in the spring of 1982.

154

306. *(top)* St. Anne's Parish School, Glace Bay, 1967.

307. *(bottom)* St. Anne's Parish School, Glace Bay, 1967.

155

308. Glace Bay, 1956. Two classrooms, opened up for assemblies.

309. *(top)* Preferred Motors Limited, Glace Bay, 1966.

310. *(bottom)* Fish Plant, Glace Bay, 1960. Commission unknown.

311. Glace Bay, 1957. Photograph taken for the Household Finance Company.

312. *(above)* Personal Finance Loans Services, Glace Bay, 1952. Commission unknown.

313. *(upper right)* Senator's Corner, Glace Bay, 1965. Commission unknown.

314. *(lower right)* Senator's Corner, Glace Bay, 1965. Commission unknown.

315. McRae Building, Senator's Corner, Glace Bay, 1965. Commission unknown.

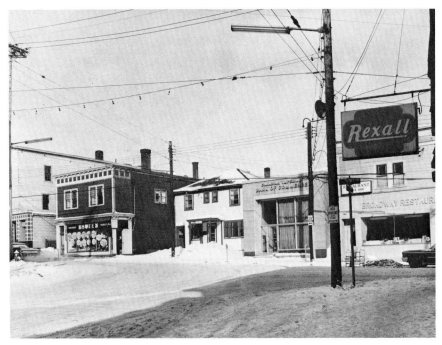

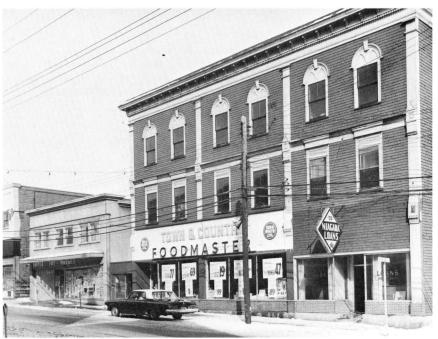

316. *(upper left)* Store fronts, Glace Bay, 1965. Commission unknown.

317. *(lower left)* Commercial Street, Glace Bay, 1965. Commission unknown.

318. *(upper right)* Store fronts, Glace Bay, 1965. Commission unknown.

319. *(lower right)* Store fronts, Glace Bay, 1965. Commission unknown.

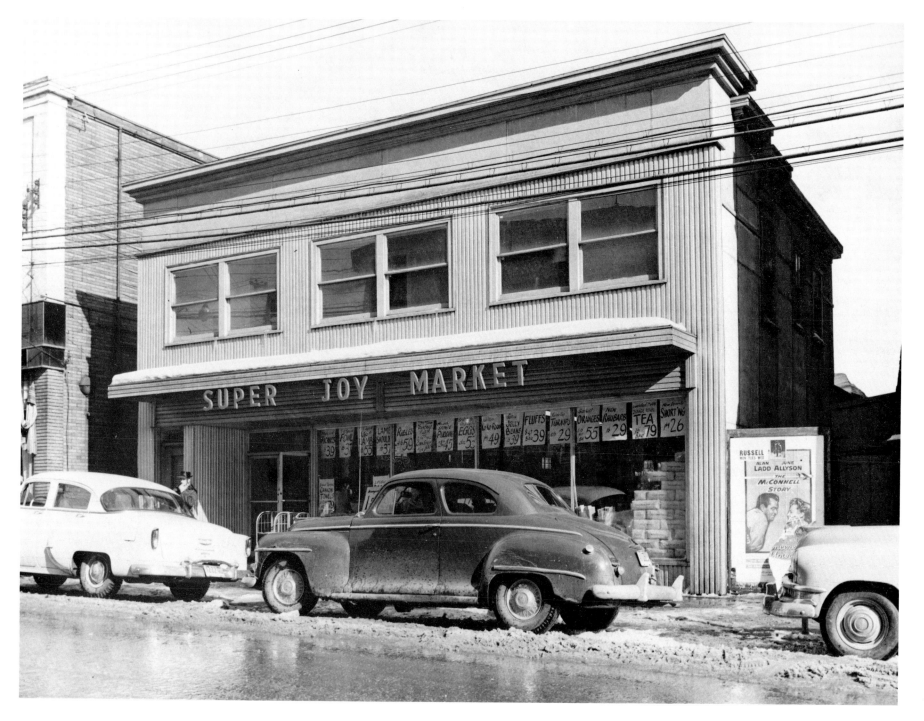

161

320. Super Joy Market, Glace Bay, 1956.

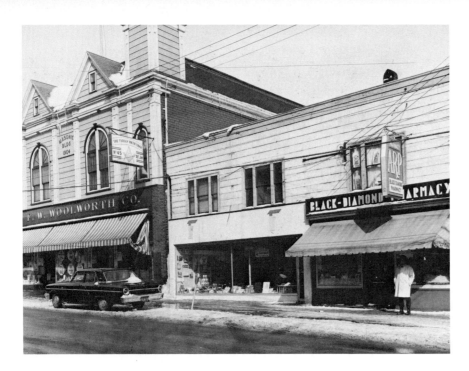

162

321. *(upper left)* Store fronts, Glace Bay, 1965. Commission unknown.

322. *(lower left)* Store fronts, Glace Bay, 1965. Commission unknown.

323. *(upper right)* Store fronts, Glace Bay, 1965. Commission unknown.

324. *(lower right)* Store fronts, Glace Bay, 1965. Commission unknown.

325. *(upper left)* Store fronts, Glace Bay, 1965. Commission unknown.

326. *(lower left)* Store fronts, Glace Bay, 1965. Commission unknown.

327. *(upper right)* Store fronts, Glace Bay, 1965. Commission unknown.

328. *(lower right)* Store fronts, Glace Bay, 1965. Commission unknown.

164

329. Mira River, NS., 1953. This landscape photograph was one of the photographs that Leslie Shedden enlarged and hand-tinted for commercial sale.

330. Water Tank, Glace Bay, 1960.

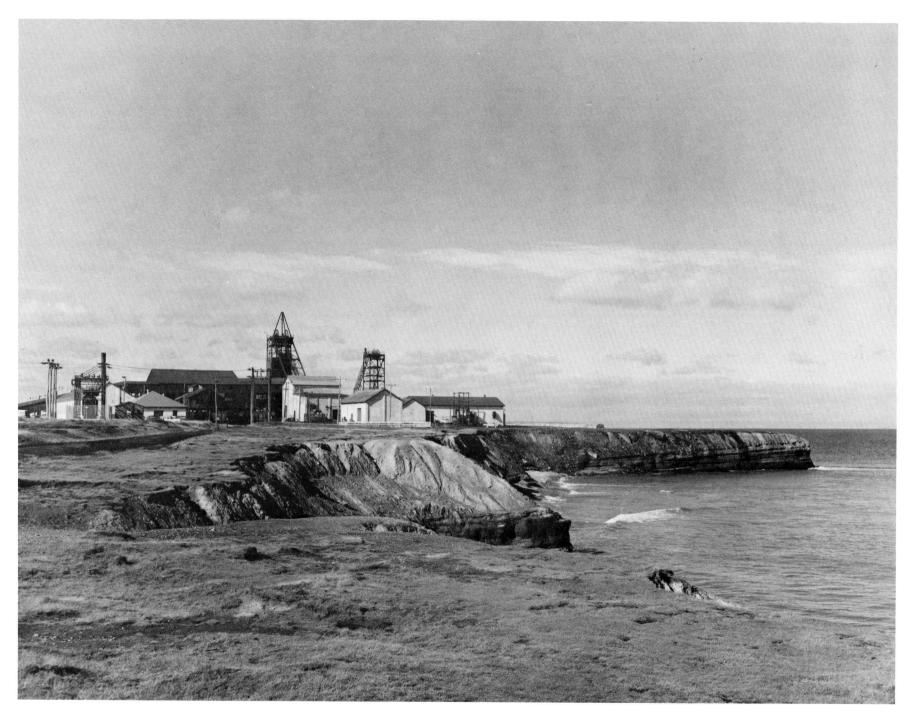

331. No. 26 Colliery, 1961. Surface view of No. 26 Colliery. The actual mining operations stretch underneath the ocean bed for several miles.

The Essays

Figure 1. Senator's Corner, Glace Bay, N.S., 1906. Citizens of Glace Bay lining the streets to watch a foot race. (Beaton Institute Archives).

Glace Bay: Images and Impressions
by Don Macgillivray

"I have been reluctantly forced to the conclusion that the true Cape Bretoner has never yet been either satisfactorily or verily portrayed in print."[1]

D.J. Rankin's observation, made in 1930, remains reasonably accurate. Cape Bretoners, in the minds of many, do have a curious, rather negative image. The characterization was flowing right along by the late nineteenth century although even earlier examples could doubtless be documented. Further, upon their transfer from a pre-industrial to an industrial setting — the transformation from rural rustic to militant working class — Cape Bretoners acquired another coat of characteristics. It was no more positive; indeed, according to some it was far more sinister. The people of the mining community of Glace Bay certainly received their share of these peculiar and not particularly perceptive assessments. Unable or unwilling to separate myth from reality, securely surrounded by their own sense of values, some writers have contributed significantly to the characterization of a people which at best is simple and misleading. Examples are neither scarce nor regulated to a particular period of time. An article in a national magazine in 1973 noted that "the typical Cape Bretoner, according to popular belief, is a well-fisted man who habitually spends the last of a night asleep under a bush with a grin on his face that betrays his drunken dreams."[2] A number of years earlier journalist Bruce Phillips suggested that the people of Glace Bay were "indolent rabble who didn't have the sense to emigrate."[3] A colleague, New Brunswick native

Charles Lynch, analyzed regional violence in the Maritimes and concluded that Nova Scotia led the pack because in Cape Breton grand battles were waged which utilized "wrenches, railroad spikes, automobiles or any other implements that lay to hand, especially on a Glace Bay Saturday night."[4] It is good copy, of course, and most Canadian journalists are not taken very seriously, but a picture begins to emerge.

Fifty years earlier Glace Bay writer Dawn Fraser was asked if it were true that people were killed every pay night at Senators' Corner and the bodies thrown over the cliff into the Atlantic Ocean at Table Head. Another writer with whom Fraser was acquainted maintained that, in Glace Bay, "the two principal streets were lined with barrooms from which tumbled drunken men to fight on the sidewalks and stain the area with blood."[5] At this point one could mention that MacRae's bar on Main Street was known as the "Slaughterhouse."[6] Whatever, the image of Glace Bay as a hard, even brutal, place is a long-standing one. And in every myth there is an element of truth. But more about that later. Stepping back further in time one stumbles across additional images. The pool of people who made up the first generation of industrial workers in Glace Bay and of the other mining communities in south Cape Breton came from the surrounding rural areas. They also were subjected to scrutiny. After a Cape Breton tour in 1889 one American visitor

171

stated: "Many of the people exhibit that easy unconcern of the flight of time which under less favourable circumstances would probably be called laziness". Presumably the criticism was tempered by the "primitive splendours" of the general area.[7] In 1893 John Gow observed that, especially in west and northwest Cape Breton, while having lost the "staid respectability" of the ancient Highlander, "some of these men are the wildest and hardest in the world". For Gow, who detected traces of a "primitive hospitality", Cape Bretoners were "nature's Ladies and Gentlemen".[8] The following year a Boston sophisticate assured his readers that: "It is worth a journey to Cape Breton merely to see the people in their native wilds". Yes, a vigorous and robust people. Some might say too much so, for "they have not developed a taste for factory or indoor work."[9] Nor, it would seem, were they visibly affected in other ways. As Lady Aberdeen noted in her journal during her tour of Cape Breton in October 1897: "It is extraordinary that the whole population should be so little spoilt by the hordes of American tourists who come to the Island every summer."[10]

Far more significant than American hordes was the arrival of large-scale industrialization and the formation of the Dominion Coal Company in 1893. Industrial capitalism demanded many changes — the standard values of industry, obedience, thrift and sobriety. It is the first generation of workers under this new regime who form the backdrop for the most widely read book on Glace Bay. For many people it is doubtless the first and only introduction to this mining community. Hugh MacLennan wrote *Each Man's Son* in 1951 although the author places it in 1913. And as one New York review noted: "He has certainly told a story which will leave Cape Breton Island permanently more than a name in the minds of readers."[11] It is important to deal with this work of fiction if only to establish the impressions the author offers about the community. One is not concerned here with literary criticism. Like the Boston sophisticate and others, MacLennan's portrayal offers far more insight into himself than into the community about which he writes, but MacLennan was in some ways closer to the source. Born in Glace Bay, he was the son of a Presbyterian doctor. MacLennan attached little significance to the date of the setting and while the speech and the colour were Cape Breton, to him those things were only secondary, as was the sub-plot, which reflected "the barbaric underside of life in Glace Bay."[12] Fair enough. And so, in the words of a recent biographer, "the pawky people of Cape Breton" were cast as comic relief as the writer grappled with "the heroism of his Calvinist protagonist."[13] Here, of course, one is concerned with the sub-plot and the backdrop. His description of the physical landscape is reminiscent of Dickens' *Hard Times*. The colliery was "black and monstrous", the pavement — precious little at the time — was "blue and naked", and the houses had a sterility of sameness about them. They were "crowded so close together they looked like a single downward-slanting building", each painted the "same fierce shade of iron-oxide red" so that "nothing distinguished it from the doors to the right or left of it." The "miners' rows looked desolate and the bankheads of the collieries loomed like monuments in a gigantic cemetery."[14] Nor were the internal surroundings much of an improvement, what with "their dusty, dark interiors, the rooms where they lived crowded together."[15]* Unintentionally, MacLennan does hint at one of the main sources of strength within the community; its homogeneity.

The actual conditions during this period were much worse than suggested and would soon be desperate. By the winter of 1925, for example, a Glace Bay health official reported that 2,000 miners were unable to get work and their families were "on the verge of starvation."[17] Four months later, prompted by the knowledge that military

*It might be appropriate to mention here the comment of a United Mine Workers organizer to a Royal Commission in 1918 about a miner's house in Glace Bay which was modern in one respect: "they had both light and water — and they both came through the roof".[16]

Figure 2. Glace Bay, N.S., circa 1920. Patrons in a local tavern. (Beaton Institute Archives).

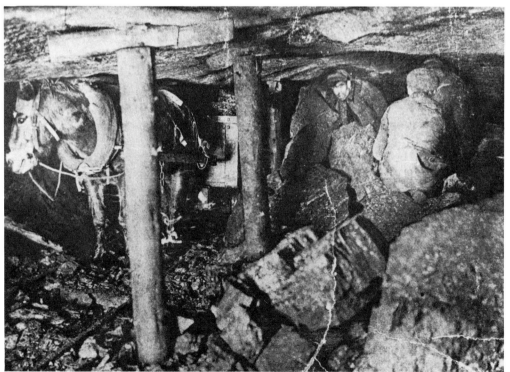

Figure 3. Glace Bay, N.S., 1905. Coal miners and pit pony at the coal face. (Beaton Institute Archives).

forces were pouring into the area — for the third time in four years — one trades council commented to Prime Minister Mackenzie King: "It is our earnest hope that they will take sufficient feed with them as they will find little or none on their arrival. It would be a national catastrophe if troops on arrival suffered any hardships through insufficient nourishment."[18] But the harsh conditions, the deprivation, the malnutrition and the threat of starvation — realities which were only partially alleviated when the industrial conflict was not blazing — do not make it into *Each Man's Son*. For MacLennan, the mines were only "a corruption."[19] The miners, however, were still in a state of innocence. They were delightful in some ways and, yes, even quaint, but they were also frustrating, especially for those with more important things to do and think about. Red Willie MacIsaac was but an "overgrown child" to the doctor's wife and the good doctor complained about "the general childishness of this whole place" with "the street swarming with aimless people."[20] The reciprocal view was rather more gentle: "The men know he likes them even when he scolds them. They know he wants them to improve."[21] Here, at any rate, MacLennan reflects an accurate attitude. When the *Cape Breton Handbook and Tourists' Guide* was written in 1891 the author explained that at Cow Bay the miners worked for the Archibald family, who had "a high sense of responsibility for those who were in a patriarchal sense their dependents.... His word was law because he loved his men and was their friend in spiritual as well as material things."[22] Or as an article, "The Colliery Manager", published in 1906 in the *Journal of the Canadian Mining Institute*, explained: "Treat them kindly, fairly and firmly, and they will be your friends forever. Don't be afraid to get angry at the right time."[23]

In MacLennan's world the only one who questioned the bowing and the scraping before the medical pedestal was an outsider — not even from the mainland, but from France: "You take off your caps and thank 'im for doing what you pay 'im for."[24] Reality was rather different. The miners of the area had complained bitterly from at least the 1880's about the medical system and were certainly not reticent about suggesting changes.[25] One unionist expressed the feelings of many in 1896: "The doctors act as if they were utterly independent of what the men think. It is time for a change — if not of doctors — of the system."[26] According to one colliery doctor who operated in the area for more than two decades: "From time immemorial the companies had enjoyed the privilege of selecting the colliery physician who was usually 'persona grata' with the General Manager or with an influential director."[27] This doctor, M.D. Morrison, was refreshingly blunt about one of his colleagues — "He is absolutely no good" — and about the facilities in Glace Bay at the time — "utterly inadequate."[28] The miners were equally explicit, pointing out that some doctors "had been riding rough-shod over the men of Cape Breton" and that management "leave any nondescript they can pick up, who gladly comes to gain a little practice experimenting upon patients."[29] One is reminded of an excerpt from a conversation between two doctors in *Each Man's Son:*

> *'Luck and guesswork — what else is medicine anyway?' Doucette's large eyes became speculative. 'All the same, it doesn't have to be that. The Viennese have the right idea. I'm told there are men in Vienna who experiment every day on those Balkan peasants who come to their clinics. We ought to do the same here.' He grinned, and watched Ainslie's face as he added. 'I couldn't do it, but you could. All these Scotchmen trust you.'[30]*

For the miners the immediate solution was to select their own doctors. It was not an unreasonable demand, considering that the latter received a portion of every miner's

pay. So, in the words of one so chosen: "A strenuous struggle ensued by virtue of the efforts of the miners to have a doctor of their own choice established in their midst."[31] They were successful. It demonstrated that doctors, like anyone else, had to earn the miners' respect. Nor did it stop there. Before too long, according to the recollections of a colliery doctor who was in the area at the time, there occurred "the development of socialistic tendencies among the more reckless of the people. The red necktie came to be much in evidence, and a spirit of class hatred was promulgated and fastened with most mischievous results. The town government assumed a Bolsheveki (sic) turn and the rabble got control. Then crass ignorance and Hunnish behaviour became passports to the filling of offices and to the exercise of authority."[32]

However one reads it, there was not much forelock-tugging. MacLennan's portrait of the mining community was accurate in the sense that he shared the perceptions and prejudices of his class. He was the son of a Protestant doctor. But the reality of a working class culture which was coming into its own at this time was, to him, as unfathomable as a pit bottom. MacLennan did acknowledge a certain admiration for "the clumsy courage they all felt in themselves" and that in the mines "physical courage had become almost the only virtue they could see clearly and see all the time."[33] Unfortunately it was almost the only virtue that he could recognize and he left little doubt but that it led to excesses. MacLennan was not alone in his myopic view but it does help one to understand B.K. Sandwell's *Saturday Night* confession in his review of the book that "when I read his novels I get interested in the wrong people."[34]

Glace Bay was incorporated as a town in 1901. Prior to that date, most of the people who made up the work force in industrial Cape Breton came from the surrounding rural areas. There were many Gaels numbered among them and there was a saying in the old country that turning a Highlander into an industrial worker was like putting a deer in the plough. Also, as one woman explained about her son, she was "not so much missing him as distressed by the disgrace he was suffering in having to take orders from another man and not being free to choose what he wished to do with his own time."[35] Charles W. Dunn, in his excellent study of the Nova Scotia Gael, explained:

> *The Highlanders were not, in fact, lazy. Their previous environment had encouraged an attitude towards life that demanded only a very meagre standard of living so long as there was ample opportunity for amusement and happiness. The Highlander was thus more of an artist than a labourer. . . .*[36]

And M.C. MacLean added: "They worked while they worked but when there was nothing particular to do, they hated to pretend to work — they went to a picnic instead."[37] One descendant of the Celtic Scots who had settled in the Washabuck area had noted that while "most civilized persons are chained to their worldly possessions as the dog is chained to his kennel" his people remained unawed by "worldly pomp and wealth."[38] Clearly such people would not be easily swayed with simple wage incentives. With the arrival of large scale industrial capitalism into Cape Breton very late in the nineteenth century the people of the area did not leap to embrace the demands of the new system. Such demands — to be thrifty, sober, obedient, diligent — clashed directly with older traditions and attitudes. Such people would not be easily trained, or broken. They were primarily a pre-industrial people with a rich and vibrant culture and the values they carried with them into industrial Cape Breton would not be easily discarded. As one miner - the recording secretary for Keystone Lodge,* Provincial Workmen's Association — ex-

*Keystone, in Glace Bay, had frequently been at odds with the PWA executive and had spearheaded with Equity Lodge of Caledonia the attack upon the company store issue in the late 1890s. In 1909 Keystone became Victory Local 648, United Mine Workers of America.

plained to his fellow unionists, they would have to find a new recording secretary "for he could not get work here without promising to do as he was told. Consequently he thought he would have to leave the place."[39] The sense of dignity and the strong streak of independence were but two of the characteristics brought into this new setting by first generation industrial workers.

These years, the last decades of the nineteenth century, were a period of expansion in the Cape Breton coal industry. The trend was significantly increased following the formation of the Dominion Coal Company in 1893. For Glace Bay and the other emerging mining communities on the south side of Sydney Harbour it resulted in an extremely homogenous population with close cultural and kinship ties. According to one local writer:

> *The industrial population is settled. Cape Breton is its home. Every man has relatives and friends and neighbours. The entire population is with him. The managing operator is the floater. He shifts every three or four years and sees only the dollar in the vision. He has no stake in the community; no love for the people.*

This homogeneity was a key ingredient in the formation of these mining communities. "It was this cohesiveness, reinforced by the common experience of the migration process and the work world of the mines that allowed for the development of a class consciousness that was unparalleled in pre-1900 Canada."[40] This assessment brings out another feature. Pitwork was difficult, dangerous and dirty. The miners had a tremendous pride in their work; for years a common greeting was 'How're you getting your coal out?' There was a strong sense of independence, based on custom and on the control the miners had within the production process. The 'gob pile orations' and the pit talk ensured that the younger miners absorbed attitudes and customs along with knowledge from those more experienced. They were also attitudes shared by the wider mining community — management and hard-working Calvinist doctors excepted. Due to a great extent to the ever-present hazards of work — injury or death — and the insecurities of employment, leisure in the mining communities was vigorous and oft times frivolous.[41] These attitudes were certainly not unique to Cape Breton mining areas. But they were here in abundance. One specific example should suffice. Throughout the 1890s complaints that the miners were "attending work very indifferently" were frequently heard.[42]

In 1900, "a disinclination among the miners for steady work" was noted and Dominion Coal put up an official notice whereby anyone not on duty after pay day would be discharged unless a satisfactory explanation was forthcoming.[43] In the summer of 1903, Dominion Coal's August production was down and, according to the *Canadian Mining Review*: "This is largely attributed to the scarcity of labour and its irregularity during the month. The miners are strong on picnics preferring a day's picnicing to a day's pay at any time, and this year the month of August was prolific in picnics." Four years later the irregular work patterns were still quite evident. "It is not unusual for 25 per cent of the employees at a colliery to be off work on certain days. Many in the Spring go fishing and farming, while in the Summer many go frolicking." Equally evident was the fact that many people were quite unable to comprehend this attitude. As a provincial commission commented in 1910: "Many miners are irregular in their work There is a proportion of absenteeism which appears to be due to the free choice of the individual miner. He simply does not report for work. He chooses to stay away for the day. This is called voluntary absenteeism."[44] It could also be viewed as a strong statement that the miners in Cape Breton were going to continue to decide their own priorities and they were not necessarily those demanded by industrial

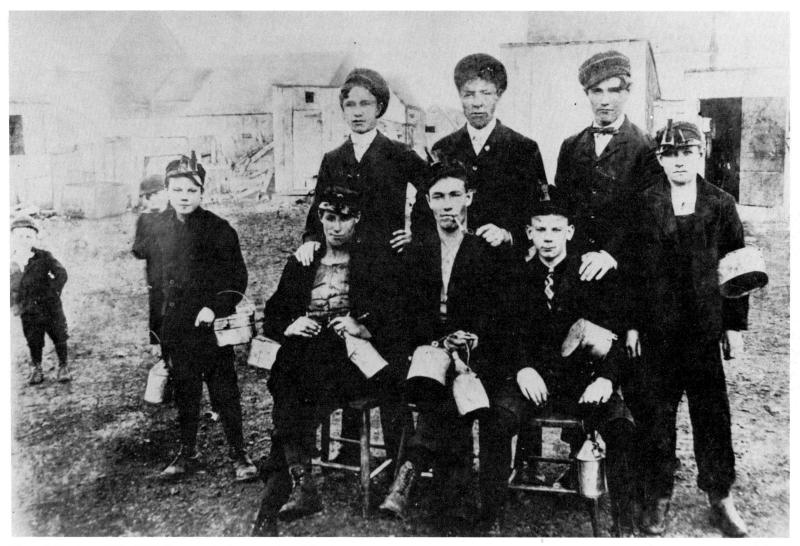

Figure 4. Caledonia, N.S., 1903. Young coal miners posed at pit-head
(Beaton Institute Archives).

capitalism. They were, however, ones which recently removed rural Cape Bretoners could easily accommodate. Similarly, they are values which would easily be absorbed by other pre-industrial people who began to move into the area and into the workforce prior to World War I.

There were, of course, those who detected a strong correlation between drink and irregular work patterns and it is not surprising to learn that Mrs. Charles Archibald — of the patriarchal Archibalds of Cow Bay — had been the president of the local temperance body. One could also note the attraction of the Highland Scots of Cape Breton to the 'water of life'.[45] It did help Red Willie MacIsaac behave like an "overgrown child" and was the lubricant for the bloody brawls at Senators' Corner. It was of concern to the Dominion Coal Company which, by 1895, stipulated a reprimand after the first drinking offence, a fine or dismissal for the second, and automatic dismissal for the third infringement.[46] It was a policy which was hotly contested by miners. By 1908 coal industry officials continued to lament that "the problem of the 'pay-day drunk' is still with us . . . The curve of output when plotted resembles the Alps, being a steady rise for thirteen days after pay day to a maximum height the day before pay day. Then comes a fall, which takes another fortnight to overcome, and this kind of thing is a continuous performance."[47] The miners did, of course, take time off and it makes sense that they would do so immediately after pay day. Saint Monday was a time-honoured tradition among the working class which was set aside to complete personal business and the like.[48] Also, mining was extremely strenuous work and it demanded days of rest with or without drink. At one point in 1894, for example, because of some managerial mix-up, pay day did not occur when scheduled but there was a significant amount of absenteeism the following day anyway.[49] It was an important point and one generally overlooked, or not understood, by management. But this is not to argue that

the miners were temperance people; merely hard working. Also, especially in the earlier part of the nineteenth century drink was thought to impart physical stamina and was closely associated with strenuous trades. As well, the harshness of the surrounding conditions would serve as an excellent reason for some. As it was the shortest road out of Manchester so it would prove a short cut out of the Bay.[50] Or possibly to the top of it:

> *I am only a common poor working chap*
> *As everyone here can see*
> *But when I get a couple of drinks on a Saturday*
> *Glace Bay belongs to me.[51]*

Even ephemeral possession was better than none. One could also mention that New Aberdeen song of praise, "The Government Store", which ends:

> *Now when you're too aged, too weak and too blind,*
> *To work for a living down in a coal mine,*
> *A pension you'll get till life's journey is o'er*
> *From the profits they make at the government store.*
> *So here's to your beer and your whiskey so fine,*
> *Your rum and your gin and your ninety cent wine,*
> *Drink as much as would fill the great lakes of Bras*
> *d'Or*
> *Sing hip hip horrah for the government store[52]*

Such attitudes were hardly in accord with the P.W.A. constitutional objectives of thrift and sobriety among the work force. This organization, which first made its appearance in Cape Breton in 1881, had a timid approach and was constantly criticized by the rank and file. A costly, determined but unsuccessful attempt to replace it with the U.M.W. resulted in the 1909-10 strike, but shortly after the end of the war, U.M.W., District 26, was firmly established. Experienced Scottish miners, and militant trade unionists, such as Jim McLachlan had added their articulate voices and

178

energies to the working class culture which had emerged. It was a sturdy and independent culture and the participants in it had developed their own specific ideas about the coal industry, politics, the economy and the community. By 1920, with a generation or two of experience with the demands and degradations of industrial capitalism behind them, they were well prepared. They had many strengths: varied aspects of their pre-industrial cultures, mining traditions, industrial experiences, and within the mining community generally their homogeneity and their sense of permanence. In the following half-decade there occurred a class struggle which in intensity, vibrancy and determination remains unequalled in Canadian history. The miners were in the vanguard and faced formidable opposition — repeatedly.

> *Yes, Roy the Wolf* had many friends*
> *To do his bidding and serve his ends—*
> *Judges, lawyers and politicians*
> *Favored him always with decisions—*
> *You see they belonged to the lazy breed*
> *Who never work but who always feed—*
> *And many of them had stock, you see,*
> *With Roy the Wolf and company.*
> *So they gathered up a lot of bums,*
> *Crooks and drifters from the slums,*
> *Dressed them pretty and soldier-like,*
> *And sent them down to break the strike....* [53]

Federal military forces made three large-scale visitations in four years and hastily-recruited provincial police forces put in a number of appearances. Company police were a regular presence. Irrational fears of revolution abounded at all levels of government. The corporation — at this point it was BESCO (British Empire Steel Corporation) — with their precarious financial structure and their intolerable demands and intransigent attitude, fueled the fires and fed the narrow minds of many of those in authority. U.M.W.

Figure 5. J.B. MacLachlan, 1935. (Beaton Institute Archives).

179

*Roy Wolvin was the President of B.E.S.C.O.

International president John L. Lewis turned the district charter "to the wall" during the pivotal strike of 1923 and deposed the militant executive of District 26.

The struggle was one of survival. As Dawn Fraser observed: "We in Glace Bay are unfortunate in being a one-industry town. Close or suspend operations at the mines and we starve. But before dying we put up a fight, and that is exactly what has happened in this mining area."[54] It was a fight waged on many fronts. Along with picket lines, union meetings, relief assistance, and demonstrations, miners would halt troop trains to check for "scabs" and they controlled the flow of liquor into the strike zones. Nor was the political arena neglected. In the provincial election of 1920 all four M.L.A.'s from Cape Breton County — with the four highest majorities in the province — were part of the newly emergent if short-lived Farmer-Labour Party, the official opposition in the Legislative Assembly. Equally significant during this period was the transformation of Glace Bay and other mining communities from company towns to labour towns. Dan Willie Morrison, who would serve as District 26 president for 14 years, became the first labour mayor of Glace Bay. As mayor he continually opposed the presence and use of military forces in the on-going industrial conflict. Nor did he consider it appropriate to pay for such forces when the federal government presented the bill. As a local writer explained, in a piece entitled "Send the Bill to BESCO:"[55]

Your bill for those toy soldiers was received, oh, Mr. King,
But does that few odd thousand cover everything
From the time of the invasion till the time they went away—
Is just three hundred thousand all we have to pay
For all their pretty uniforms, their horses and their feed?

My land, these peace-time soldiers are really cheap, indeed!
But it grieves us to inform you we're a little bit hard pressed,
And we have an empty feeling in the region of our vest.
. . . .

We would gladly do our very best to help you out, you know,
But we're sorry to inform you that our funds are kind of low,
Too bad those pretty soldiers should suffer any need,
They are really ornamental but we've other men to feed—
Yes, and little children — hungry women, too —
After we have paid that bill we will send the change to you.
. . . .

So I fear this little item will have to wait a while:
But we hasten to assure you we will place your bill on file.

Ain't it something awful how long some bills will run? I remain,
yours most sincerely,
Dan Willie Morrison.

Labour councillors were present in abundance during these years throughout the industrial area and these political developments signified not only a new political maturity, and sense of optimism, but immediate and direct effects such as improved conditions and wages for town employees, restrictions on the authority of the company police, increased assessment of the coal company, and increased relief spending during the needy twenties.[56] The miners were governing themselves; it was a far cry from *Each Man's Son*.

Economically, the 1930s were not much different than the 1920s in the mining communities of Cape Breton. Dissatisfaction with the U.M.W. resulted in the formation

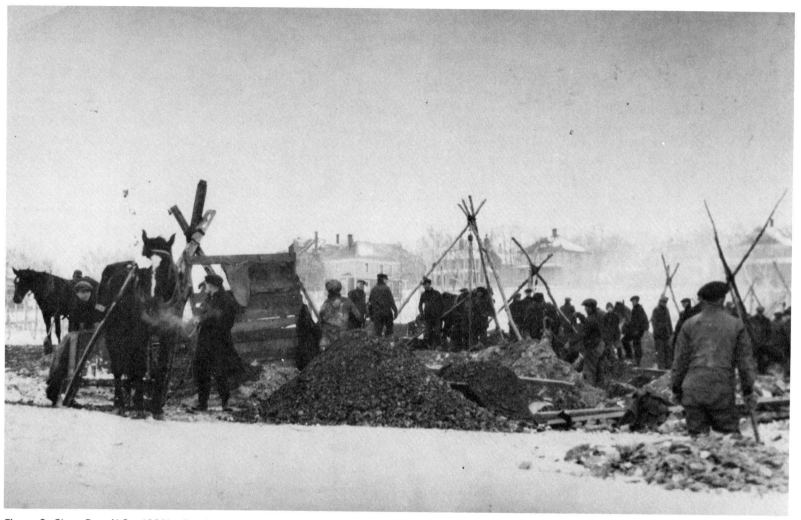

Figure 6. Glace Bay, N.S., 1930's. Bootleg coal operations.
(Beaton Institute Archives).

of a rival organization, the Amalgamated Mine Workers of Nova Scotia, in June 1932. The first locals into the new union, which emphasized the primacy of the rank and file, were all from the Glace Bay area. For a while it had considerable success and according to one U.M.W. official: "All the fighters have gone over to the A.M.W; we have all the respectable ones, too respectable to fight."[57] Due in large part to the opposition of the U.M.W., the coal company and the provincial government, and to difficulties in achieving union recognition, the check off, and a contract, the A.M.W. later disbanded.[58] It did, however, demonstrate once again the strong sense of local autonomy in the Cape Breton coal fields.

The next forty years or so were decades of decline. The solidarity of the working class and the militancy of the miners began to dissipate. The U.M.W. did not have to contend with strong opposition within the union movement and militancy and radicalism were not stepping stones to leadership in District 26. The coal industry itself had been in decline for many years. The peak production year had been 1913 with provincial production at 8,100,000 tons. Sydney coal fields had contributed 6,300,000 tons. The decline was sporadic but the trend was clear from that date.

NOVA SCOTIA COAL PRODUCTION (MILLIONS OF TONS)[59]

Year	Amount	Year	Amount
1890	2.2	1944	5.7
1895	2.2	1945	5.1
1900	3.6	1950	6.4
1905	5.8	1955	5.7
1910	6.5	1959	4.3
1913	8.1	1961	4.3
1915	7.5	1965	4.1
1920	6.4	1966	3.8
1925	3.8	1970	2.1
1930	6.2	1971	1.9
1935	5.8	1976	2.5
1940	7.8	1979	2.4

The difficulties within the industry prompted the establishment of the federal *Royal Commission on Coal* in the autumn of 1944, with W.F. Carroll as chairman. At this point 60 percent of Dominion Coal's production still came from the room-and-pillar system. Another major factor affecting production was that old bugbear of management — absenteeism. According to the Commission, what with intermittent employment and low wages in the pre-war years, "the miners became accustomed to a low standard of expenditure." Wartime brought a shortage of miners and increased wages. Now, "The miners were buying leisure." Such traditional habits had an even greater impact in areas where longwall mining was practiced because of the greater disruptions with the absence of a few key men.[60] Other traditions had continued as well. With a touch of understatement the commissioners noted that the coal company "displayed some lack of understanding in its attitude towards labour" and one, Angus J. Morrison, mentioned the "poor labour relations" and "the industrial warfare which has now been going on in the Nova Scotia coal fields for generations." Nor had general conditions improved considerably: "Present housing and community facilities in many localities reflect no credit on the industry."[61] Equally little credit can be offered to management's perceptiveness at the time. In the 15 May 1946 issue of *Teamwork*, the corporation publication, the opposite of absenteeism was praised: "To the worker, presenteeism means earnings, vacations, greater security when absence is unavoidable, and promotion. To all it means a happy industry." Four years later the company explained to its workers that: "The right approach to management — labour relations is to think of management and labour as a team, whose fundamental interests are the same." The first verse of "The Dosco Boys" (to the air of the Notre Dame March), contained in a song sheet put out by Dosco's Industrial Relations Department, went as follows:

We are the boys who get out the coal,
With a vim as if it were gold
We work in the Colliery
And always manage to keep happy.
After our work we laugh, sing and play
Because we know it shortens the day
Monday, Tuesday, Wednesday too
I'd bet you'd like to join us too.[62]

Nor did the general community fare any better. Almost thirty years earlier one high-ranking corporation official suggested that "Efforts could be made in all the mining towns to cultivate a community spirit to have the town look better and there might also be some seasonal pleasures for the people, to vary the monotony of life."[63] A few months later, in explaining Besco's approach to industrial relations in Cape Breton, another official demonstrated how the employees were "cared for." The "smiling village, with its happy, healthy workers, can only be had when conditions are good and when there are high living standards." All this meant, however, was an abundance of athletic sports being carried on at playgrounds which would be sprinkled throughout the area.[64] In the summer of 1951 Dosco president L.A. Forsyth presented a deed to the town of Glace Bay for four acres of land for a public park and hoped "it will stand as a symbol of good relations between the industry and the people of the community."[65] Predictably, there was a picture of Forsyth and newly-elected Glace Bay Mayor Dan A. MacDonald in *Teamwork*. And if this particular publication was an accurate reflection of the attitudes of management towards the workforce, what with its simple homelies and coverage of sports within the Dosco 'family', little had indeed changed.

There was cause for some community celebration in Glace Bay in the summer of 1951. The largest incorporated town (and the biggest coal town) in Canada was having its 50th Anniversary. There were still five mines operating

Figure 7. Dosco president L.A. Forsyth presenting a deed for four acres of land to the newly elected Glace Bay mayor Dan A. MacDonald. The land was to be used as a public park. (Teamwork, 1951).

183

within the town limits (1-B, 4, 20, 24, 26) and the population was reaching its upper limit. The community had reason to be proud; it had grown from 2,459 people in 1891 to 25,586 in 1951 and it had survived some very difficult decades. But the population now began to follow the general trend of the industry and by 1976 it was down to the level of the 1930s.* In this latter period (1951-76) Glace Bay's decline was greater than any other part of Cape Breton County.[66] The decline gained momentum in the 1950s. In 1946, for example, the largest coal consumers in both Eastern and Western Canada were the railways but by the end of 1960 neither Canadian National nor Canadian Pacific had a single locomotive using coal.[67] Even Dosco began to use diesel units in its surface transportation system. Longwall mining operations were producing 60 percent of the output by 1949 and by the early 1960s it was 88 percent. Throughout this period however, there was a heavy reliance on the development and utilization of the Dosco Continuous Miner. Although initial tests in March 1949 were "most satisfactory", the continual breakdown in equipment (not surprising for a piece of underground machinery with 1600 separate parts), the fact that it could only cut and load in one direction, and other difficulties, meant that "this heavy investment in equipment has failed to pay off."[68] Eventually, after tremendous expenditures, it was replaced in the mid 1960s by the Anderton Shearer. None too soon, it would appear. The capital cost of the new machine plus its maintenance for one year was equal to the annual maintenance cost of one Dosco Miner.[69] During the process of modernization and mechanization in the 1950s, which had been recommended by the Carroll Commission, one other factor was generally ignored. As a brief from Glace Bay observed in 1960: "It is humbly suggested that little effort was made to outline this program to the working force. It was started, it was simply declared that it was go-

ing to be done and this was the cure."[70] Another sin of omission from this period, from a biased source but certainly not a pro-labour one, concerned the takeover of Dosco by A.V. Roe Canada, Ltd. in 1957. According to Charlie Burns, R.A. Jodrey's investment dealer in Toronto, A.V. Roe "never did get around to giving Dosco good management and, indeed, that it had 'goddamn near ruined' Dosco."[71]

By 1960 there were only three mines operating in the Glace Bay area — 4 at Caledonia, 20 at New Aberdeen, and 26 (the latter had only opened in 1943). It was time for another royal commission. I.C. Rand was the commissioner this time and, like all of the others, he commented on the "unfortunate" legacy of past conflicts. "That strife left bitterness which, after several generations of transmission, though weakened, seems still to be lurking in too many minds. Its emotional embers are still fanned by persons outside of company and labour who are ignorant and, to some extent, influential". For Rand "there appears to be a permanent bridge only by way of grievances."[72] And until union representatives were treated "as being vitally concerned with and participating in the daily functioning of the organization", "distrust and suspicion" would continue instead of "trust and confidence." As well, "The workers, on their part, have before them the duty of rooting out of their minds the notion that the arena in which they play their parts is a civil battleground between enemies."[73] But traditions and memories, reinforced by unchanging attitudes, are not easy to abandon. The town of Glace Bay presented a pertinent brief to the Rand inquiry which acknowledged "that it perhaps lacks some of the things that one should like to see in the modern up-to-date town. But at the same time, we pride ourselves on certain things in our Community, on our loyalty, on our tradition, on the fact that we are closely connected with the Coal Mining Industry." It went on to ask if they must live at lower wage

184

*Population: Glace Bay	Year	Population	Year	Population
	1891	2,459	1951	25,586
	1901	6,945	1956	24,416
	1911	16,562	1961	24,186
	1921	17,007	1966	23,516
	1931	20,706	1971	22,440
	1941	25,147	1976	21,836

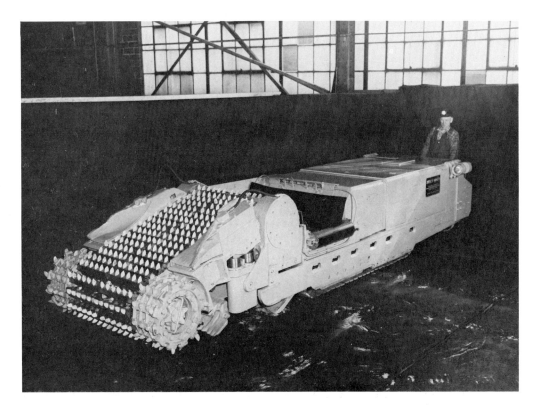

Figure 8. Dosco Miner, 1957. Side view of Dosco Miner with an operator at the controls. A canvas backdrop was used to obscure the normal shop environment. (Shedden Studios Archives).

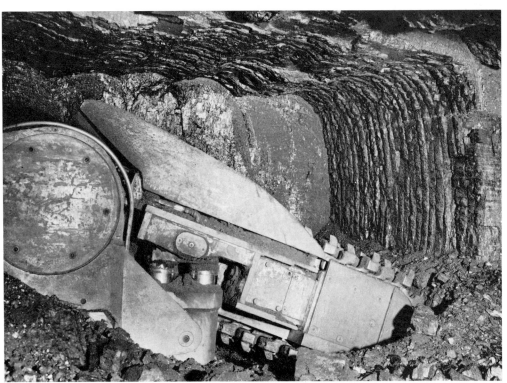

Figure 9. No. 18 Colliery, 1953. View of Dosco Miner in action, with the cutting jib gouging into the coal face on the downward cycle. (Shedden Studios Archives).

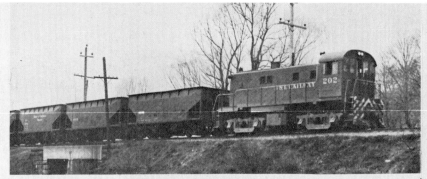

ONE OF THE FIFTEEN diesels now in service, No. 202 is shown carrying coal on the busy S & L Railway.

COUNTLESS MILLIONS tons of coal were carried by steam locomotion over a period of 60 years.

THE S. & L. IS DIESELIZED
AND A SIGH GOES UP WITH STEAM

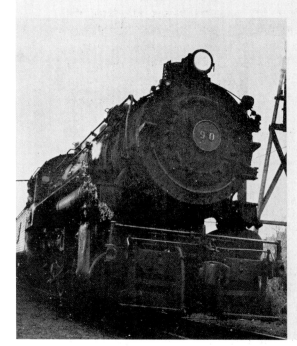

THE OLD. Old No. 90, long a familiar sight to Cape Bretoners, has made her last run on the Sydney & Louisbourg Railway.

THE NEW. This sleek, modern diesel and its counterparts have replaced the steam locomotives.

Dosco's SYDNEY & LOUISBURG RAIL-WAY in Cape Breton, only 119 miles of track but one of the busiest in Canada, has been completely converted from steam to diesel locomotion. Fifteen diesels now toot along the S. & L., replacing the 32 steam engines.

The S. & L., claiming a higher tonnage per mile of track than any other line in the country, retired the last two of its 32 giant steam locomotives — Engines No. 88 and No. 90—at Glace Bay last November in the interests of efficiency and because of the inability to obtain parts for repairs.

The Railway, now serviced with a work force of 350, transports all the coal mined by the Dominion Coal Company from five collieries at Glace Bay and New Waterford to water shipping facilities and to interchange with the Canadian National Railways, both in Sydney. The collieries produce 16,000 tons of coal daily.

The origin of the S. & L. dates back to 1872 founded with both British and American capital. In 1877 after numerous mergers of railways and coal companies a 22-mile line to Louisburg was laid. In 1881 the Sydney & Louisburg Coal and Railway Company was created as a successor of the various lines. While the program of consolidation was largely completed in 1895, it wasn't until 1910 that the present charter was obtained.

Figure 10. Two page photo essay in the company journal *DOSCO World* dealing with the change from steam to diesel of the S. & L. Railway. (DOSCO World, 1962).

levels, with lower standards of living and of health? "It strikes us as strange that each time there is talk of expansion or wage negotiations, the matter of the uncertainty of the coal industry is always brought up."[74] For his part Rand warned them that "drastic action by the Union will have the worst possible effect."[75] He need not have worried; after the 1947 strike there would not be another general strike in the Cape Breton coal fields until 1981.

Commissioner Rand was obviously a bit frustrated that some people refused to acknowledge the inevitable result of an inefficient and expensive industry. But with coal a "vital standby", subsidies should continue while gradual adjustments within the communities were made. He was not without sympathy — wholesale unemployment, and the abandonment of homes, public buildings and business premises would be "tragic to contemplate"; nor was he unaware of who these people were — "There is here not a community of footloose miners; never has their settlement been viewed as temporary generations have succeeded to the home, the traditions and the mining occupation of their fathers, and their roots in the soil of the Island are very deep."[76] For Rand, "alternative and supporting economic and cultural activities must be considered, a scheme adequate to introduce new wealth into Cape Breton and bring fresh and heightened scenes and an elevation of mind and spirit to its people." The island itself, with its "natural beauty", its "ruggedness" and the "cool, refreshing simplicities", when combined with the recommended restoration of the fortress at Louisbourg, would prove especially attractive to tourists. And "to accommodate those to whom time is . . . important", modern airports. It could be the "western heath" of the Scots and people would come seeking not only "pleasant scenes and enjoyable pursuits, but [would be] haunted by intimations of ancient northern music, there to catch fleeting recognitions of voices of ages past, sought and welcomed as a relief from the weight and humdrum of ordinary existence."[77] There we have it — right back to "nature's Ladies and Gentlemen". While the miner still wanted "to continue to live in his community to earn his living in dignity" and to enjoy "modest benefits", as was explained to Rand in 1960,[78] he was prepared to have them in a pre-industrial setting, or at least as a service industry for the post-industrial society. The miners have been better served.

"The way things stand in our fair isle today/Coal Mining is slowly fading away." So wrote Ray Holland in a song to commemorate the production of 1,000,000 tons at No. 26 in 1967.[79] That was the year of Canada's centennial; the Men of the Deeps had been recently organized, the first Miners' Museum in Glace Bay was being completed, and the death knell of the coal industry was reverberating throughout the island. Approximately $100 million in direct subventions had been provided to the coal industry since 1960. Only No. 20 and No. 26 collieries were still operating in the Glace Bay area. After a decade of uninspired ownership Hawker-Siddeley Canada, Ltd. was about to abandon the coal fields. The report this time, entitled *The Cape Breton Coal Problem*, came from J.R. Donald. In his foreword he wrote:

> *Coal Mining in Cape Breton has been a way of life for a long time. Consequently there exist traditions and emotions which tend to befog and obscure the issues and the remedies. I have endeavoured to penetrate this fog, clarify the problems and have recommended new policies.[80]*

Donald's approach was simple. Working from the assumption "that coal mining in Cape Breton, on any substantial scale, will become infeasible in about 15 years' time", one could still express sympathy and appreciation for "the traditions of Cape Breton and the independent spirit of the people" but "nevertheless, one is forced to the reluctant but overwhelming conclusion that no constructive solu-

tion to unemployment and the social needs of Cape Breton can be based on coal mining."[81] The development of a new mine at Lingan "should not be considered", and to bring young men into the industry was "ethically wrong and economically unsound." For Donald, all mines would be closed by the end of 1981.[82] That his scenario did not come to pass was primarily due, one suspects, to the determination of Cape Bretoners themselves. The federal government, modifying some of Donald's recommendations, soon established the Cape Breton Development Corporation (DEVCO) and eventually changes in the international energy picture altered the Cape Breton coal situation. But it was close. For a while in the 1970s there were more mines catering to tourists than there were engaged in production. But Lingan was opened and No. 26 continues — in 1980 it had its best production year since 1967 — while the Prince and Donkin mines proceed apace.

In 1976 Glace Bay celebrated its 75th anniversary and Mayor Dan A. Munroe brought out the old chestnut that it has been the first town in the British Empire to obtain a charter under Edward VII. That was not the only tradition he noted. "The history of our community is a long one of economic adversity so that our people have been living on false hope for as long as one can remember." And lest anyone should forget, he also reiterated that "Our people do not want to emigrate." An editorial in the anniversary issue of the *Cape Breton Post* added "And perhaps this time around, the next seventy-five years, the exploitation will be confined to coal."[83] That, however, is an ongoing struggle. In 1980 D.S. Rankin was facing the decade with "cautious optimism" and he felt that the results "will also justify the tenacity of Cape Bretoners and their faith, at times a lonely faith, in the future of the industry."[84] One suspects they are going to need all the tenacity they can muster. With government control of the industry, public funding, and the increased sense of dependency all of that entails, the miners

of Cape Breton, and their families, may yet again find themselves between a rock and a hard place. But the strike in the summer of 1981 — the first since 1947 — suggests not only that industrial relations have a far way to go but that the miners are reaffirming traditional priorities, that they will not be satisfied with simply surviving. The emergence of the United Miners' Wives Association during the recent struggle was a clear demonstration that the issue was one which involved the entire community. The more recent appearance of the Canadian Mineworkers Union, whatever the ultimate result, signifies a resurgence of rank and file activity. These recent developments have strong roots. To understand and appreciate the mining community of Glace Bay, or the other mining areas, or Cape Bretoners in general, it is necessary to penetrate the fog formulated by politicians, journalists, tourists, industrial relations experts, novelists and, yes, academics and to concentrate on the traditions and on the culture. That is why they have survived.

Notes

1. D. J. Rankin, *Our Ain Folk and Others* (Toronto, 1930), p.v.
2. Bill Howell, "The Thinkin' Man's Stompin' Tom", *MacLean's* (December 1973, p. 32.
3. *Cape Breton Post,* Sydney, 12 January 1976 (Glace Bay Supplement), p. 19.
4. Charles Lynch, "Good old horse sense, the Nova Scotia way", (Canadian Press clipping, c. 1972).
5. Dawn Fraser, *If We Saw Ourselves as others See Us: The Truth About Glace Bay and Other Mining Communities* (Glace Bay, 192?), pp. 3-5.
6. *Cape Breton Post,* 12 January 1976, p. 28.
7. 'Viator', "A tour in Cape Breton", *The Week,* 14 June 1889.
8. J.M. Gow, *Cape Breton Illustrated* (Toronto, 1893), pp. 357-367.
9. *Boston Ideas,* 6 May 1894.
10. John Saywell, ed., *The Canadian Journal of Lady Aberdeen* (Toronto, 1960), p. 421.
11. *Herald-Tribune,* New York, 8 April 1951, p. 6.
12. E. Cameron, *Hugh MacLennan, A Writer's Life* (Toronto, 1981), pp. 227-228.
13. E. Cameron, pp. 230-231.
14. Hugh MacLennan, *Each Man's Son* (Toronto, Laurentian Library, 1971 (1951)), pp. 7-8, 35, 44.
15. MacLennan, p. 87.

Figure 12. Senator's Corner, Glace Bay, N.S., 1951. Parade celebrating the fiftieth anniversary of Glace Bay's incorporation as a town. (Teamwork, 1951).

189

16. Canada. *Royal Commission on Industrial Relations,* 1919, "Minutes of Evidence", p. 3907.

17. E.H. Armstrong to W.L. Mackenzie King, 19 February 1925 (Enclosure), King Papers, Public Archives of Canada.

18. J. Dealtry to Mackenzie King, 12 June 1925, King Papers, PAC.

19. MacLennan, p. 67, See Sarah Gold, "A Social Worker Visits Cape Breton", *Social Welfare* (August-September, 1925), pp. 219-224.

20. MacLennan, pp. 158, 33-35.

21. MacLennan, p. 21.

22. C.G.D. Roberts, A. Tunnell, *Canadian Who Was Who, 1875-1937* (Toronto, 1938), pp. 16-17; Edwin Lockett, *Cape Breton handbook and tourists' guide* (North Sydney, 1891), pp. 77-87.

23. *Journal of the Canadian Mining Institute,* 1906, p. 202.

24. MacLennan, p. 21.

25. Canada. *Royal Commission on the Relations of Labour and Capital, 1889,* V. 5, pp. 409, 454, 462; Provincial Workmen's Association, Proceedings, 1893, pp. 267. 271; 1896, pp. 319-20.

26. PWA, Proceedings, 1896, p. 314.

27. M.D. Morrison Papers, vol. 705, Public Archives of Nova Scotia.

28. Morrison Papers, vols. 709, 711, PANS.

29. PWA, Proceedings, 1896, pp. 315-316.

30. MacLennan, p. 128.

31. Morrison Papers, vol. 705, PANS.

32. Morrison Papers, vol. 705, PANS.

33. MacLennan, pp. 15-16.

34. *Saturday Night* (Toronto), 24 April 1951.

35. K. MacKinnon, "A Short Study of the History and Traditions of the Highland Scot in Nova Scotia", M.A. Thesis, St. Francis Xavier University, 1964, p. 67.

36. C.W. Dunn, *Highland Settler* (Toronto, 1968 [1953]), p. 109.

37. M.C. MacLean, "Cape Breton a Half Century Ago", *Public Affairs* (1939), pp. 184-192. Reprinted in D. Macgillivray, B. Tennyson, eds., *Cape Breton Historical Essays* (Syndey, 1980).

38. Neil MacNeil, *The Highland Heart in Nova Scotia* (Toronto, 1971), pp. 34-51.

39. PWA, Keystone Lodge Letterbook, 1909, pp. 233-234, in Beaton Institute, Sydney.

40. Stuart McCawley, *Standing the Gaff: The Soreness of the Soul of Cape Breton* (Glace Bay, 1925), p. 23; Del Muise, "The Making of an Industrial Community: Cape Breton Coal Towns, 1867-1900", in *Cape Breton Historical Essays,* pp. 83-84.

41. Carter Goodrich, *The Miner's Freedom* (Francestown, N.H., 1925); Keith Dix, *Work Relations in the Coal Industry: The Hand-Loading Era, 1880-1930* (Morgantown, W.V., 1977).

42. Richard H. Brown to G.E. Franklyn, 11 July 1895, R.H. Brown Papers, PANS

43. *Canadian Mining Review* (September, 1900), p. 188; *Herald* (North Sydney), 25 July 1900.

44. Canadian Mining Review (September, 1903), p. 198; (June, 1907), p. 185; Nova Scotia, *Journals of the House of Assembly,* 1910, Appendix 26, p. 110.

45. Dunn, *Highland Settler,* pp. 105-107.

46. PWA, Proceedings, 1895, pp. 295-296.

47. *Canadian Mining Journal,* (March 1908), p. 54.

48. See E.P. Thompson, "Time, Work — Discipline, and Industrial Capitalism", *Past and Present* 38 (1967), pp. 56-96.

49. PWA, Proceedings, 1895, pp. 295-296.

50. See W.R. Lambert, "Drink and work — discipline in industrial South Wales, c. 1800-1870", *Welsh Historical Review* vii (1975).

51. Alphonse MacDonald, comp. Cape Breton Songster (Sydney, 1935), p. 22.

52. John C. O'Donnell, *The Men of the Deeps* (Waterloo, 1975), p. 46, collected by Helen Creighton.

53. Dawn Fraser, *Echoes From Labor's War: Industrial Cape Breton in the 1920's* (Toronto, 1976), pp. 56-57. See also: David Frank, "Class Conflict in the Coal Industry: Cape Breton, 1922", in G. Kealey, P. Warrian, eds., *Essays in Canadian Working Class History* (Toronto, 1976), pp. 161-184; Don Macgillivray, "Military aid to the civil power: The Cape Breton Experience in the 1920's, *Acadiensis,* 3:2 (1974), pp. 45-64.

54. Dawn Fraser, *If We Saw Ourselves as Others See Us: The Truth About Glace Bay and Other Mining Communities* (Glace Bay, 192?), p. 12.

55. Fraser, *Echoes,* pp. 80-81.

56. David Frank, "Company Town/Labour Town: Local Government in the Cape Breton Coal Towns, 1917-1926", *Social History* (May, 1981), pp. 177-196.

57. *Gazette* (Glace Bay), 22 November 1934, Cited in Paul MacEwan, *Miners and Steelworkers* (Toronto, 1976), p. 170.

58. H.A. Logan, *Trade Unions in Canada* (Toronto, 1948), pp. 204-206; MacEwan *Miners and Steelworkers,* pp. 169-184.

59. Canada. *Royal Commission on Coal* (Ottawa, 1947), (Carroll Commission), pp. 64-65; Canada. *Royal Commission on Coal* (Ottawa, 1960) (Rand Commission).

60. Carroll Commission, pp. 85, 314-315.

61. Carroll Commission, pp. 318, 590-599.

62. *Teamwork* (March, 1949); "Song Sheet", Industrial Relations Department, Dosco, n.d.

63. H. McInnes to J.S. Woodsworth, 28 April 1922. J.S. Woodworth Papers, PAC.

64. "Industrial Relations at the B.E.S.C.O.'s Plant at Cape Breton", *Industrial Canada* (October, 1922).

65. *Teamwork* (August, 1951).

66. Canada. Census, 1891, 1901; Nova Scotia. Department of Development, 1971 Census (2 August 1973): Nova Scotia. *Cape Breton County Statistical Profile.* (Halifax, 1981), p. 7.

67. Rand Commission, p. 2.

68. "Mechanization in the Collieries of the Dominion Steel and Coal Corporation", *Transactions,* Mining Society of Nova Scotia LII, 1949, pp. 178-216; John E. Terry, G. Sigut, "The Introduction and Future of the Anderton Shearer in Cape Breton Collieries", *Transactions,* Mining Society of Nova Scotia LXX, 1967, pp. 114-122; Rand Commission, p. 120.

69. Terry and Sigut, "Anderton Shearer".

70. Town of Glace Bay, brief to Rand Commission, 1960. Copy in Bras d'Or Institute, U.C.C.B., Sydney.

71. Harry Bruce, *The Story of R.A. Jodrey, Entrepeneur* (Toronto, 1979), p. 300.

72. Rand Commission, pp. 26, 124.

73. Rand Commission, pp. 27-28.

74. Glace Bay brief to Rand Commission.

75. Rand Commission, p. 40.

76. Rand Commission, pp. 22, 33.

77. Rand Commission, pp. 46-48.

78. Glace Bay brief to Rand Commission.
79. O'Donnell, *Men of the Deeps,* p. 29.
80. Canada *The Cape Breton Coal Problem* (Ottawa, 1966) (Donald Report), p. vii.
81. Donald Report, pp. 12, 24.
82. Donald Report, pp. 17, 34.
83. *Cape Breton Post* (Sydney), 12 January 1976.
84. D.S. Rankin, President, DEVCO, ''Cape Breton and DEVCO in the 1980's'',
address delivered 26 June 1980. Copy in Bras d'Or Institute, U.C.C.B.

Photography Between Labour and Capital
By Allan Sekula

I

Introduction: Reading an Archive

Every image of the past that is not recognized by the present as one of its own threatens to disappear irretrievably.

Walter Benjamin[1]

The invention of photography. For whom? against whom?

Jean-Luc Godard and Jean-Pierre Gorin[2]

Here is yet another book of photographs. All were made in the industrial and coal-mining regions of Cape Breton in the two decades between 1948 and 1968. All were made by one man, a commercial photographer named Leslie Shedden. At first glance, the economics of this work seem simple and common enough: proprietor of the biggest and only successful photographic studio in the town of Glace Bay, Shedden produced pictures on demand for a variety of clients. Thus in the range of his commissions we discover the limits of economic relations in a coal town. His largest single customer was the coal company. And prominent among the less official customers who walked in the door of Shedden Studios were the coal miners and their families. Somewhere in between the company and the workers were local shopkeepers who, like Shedden himself, depended on the miners' income for their own livelihood and who saw photography as a sensible means of local promotion.

Why stress these economic realities at the outset, as if to flaunt the ''crude thinking'' often called for by Bertolt Brecht? Surely our understandings of these photographs cannot be reduced to a knowledge of economic conditions. This latter knowledge is necessary but insufficient; we also need to grasp the way in which photography constructs an imaginary world and passes it off as reality. The aim of this essay, then, is to try to understand something of the relationship between photographic culture and economic life. How does photography serve to legitimate and normalize existing power relationships? How does it serve as the voice of authority, while simultaneously claiming to constitute a token of exchange between equal partners? What havens and temporary escapes from the realm of necessity are provided by photographic means? What resistances are encouraged and strengthened? How is historical and social memory preserved, transformed, restricted and obliterated by photographs? What futures are promised; what futures are forgotten? In the broadest sense, these questions con-

193

cern the ways in which photography constructs an *imaginary economy*. From a materialist perspective, these are reasonable questions, well worth pursuing. Certainly they would seem to be unavoidable for an archive such as this one, assembled in answer to commercial and industrial demands in a region persistently suffering from economic troubles.[3]

Nonetheless, such questions are easily eclipsed, or simply left unasked. To understand this denial of politics, this depoliticization of photographic meaning, we need to examine some of the underlying problems of photographic culture. Before we can answer the questions just posed, we need to briefly consider what a photographic archive is, and how it might be interpreted, sampled or reconstructed in a book. The model of the archive, of the quantitative ensemble of images, is a powerful one in photographic discourse. This model exerts a basic influence on the character of the truths and pleasures experienced in looking at photographs, especially today, when photographic books and exhibitions are being assembled from archives at an unprecedented rate. We might even argue that archival ambitions and procedures are intrinsic to photographic practice.

There are all sorts of photographic archives: commercial archives like Shedden's, corporate archives, government archives, museum archives, historical society archives, amateur archives, family archives, artists' archives, private collectors' archives, and so on. Archives are property, either of individuals or institutions, and their ownership may or may not coincide with authorship. One characteristic of photography is that authorship of individual images and the control and ownership of archives do not commonly reside in the same individual. Photographers are detail workers when they are not artists or leisure-time amateurs, and thus it is not unreasonable for the legal theorist Bernard Edelman to label photographers the ''proletarians of creation.''[4] Leslie Shedden, for his part, was a combination artisan and small entrepeneur. He contributed to company and family archives while retaining his own file of negatives. As is common with commercial photographers, he included these negatives in the sale of his studio to a younger photographer upon retiring in 1977.

Archives, then, constitute a *territory of images;* the unity of an archive is first and foremost that imposed by ownership. Whether or not the photographs in a particular archive are offered for sale, the general condition of archives involves the subordination of use to the logic of exchange. Thus not only are the pictures in archives often *literally* for sale, but their meanings are up for grabs. New owners are invited, new interpretations are promised. The purchase of reproduction rights under copyright law is also the purchase of a certain semantic license. This *semantic availability* of pictures in archives exhibits the same abstract logic as that which characterizes goods on the marketplace.

In an archive, the possibility of meaning is ''liberated'' from the actual contingencies of use. But this liberation is also a loss, an *abstraction* from the complexity and richness of use, a loss of context. Thus the specificity of ''original'' uses and meanings can be avoided, and even made invisible, when photographs are selected from an archive and reproduced in a book. (In reverse fashion, photographs can be removed from books and entered into archives, with a similar loss of specificity.) So new meanings come to supplant old ones, with the archive serving as a kind of ''clearing house'' of meaning.

Consider this example: some of the photographs in this book were originally reproduced in the annual reports of the Dominion Steel and Coal Company, others were carried in miners' wallets or framed on the mantlepieces of working-class homes. Imagine two different gazes. Imagine the gaze of a stockholder (who may or may not have ever visited a coal mine) thumbing his way to the table of earn-

ings and lingering for a moment on the picture of a mining machine, presumably the concrete source of the abstract wealth being accounted for in those pages. Imagine the gaze of a miner, or of a miner's spouse, child, parent, sibling, lover, or friend drifting to a portrait during breaks or odd moments during the working day. Most mine workers would agree that the investments behind these looks — financial on the one hand, emotional on the other — are not compatible. But in an archive, the difference, the *radical antagonism* between these looks is eclipsed. Instead we have two carefully made negatives, available for reproduction in a book in which all their similarities and differences could easily be reduced to "purely visual" concerns. (And even visual differences can be homogenized out of existence when negatives first printed as industrial glossies and others printed on flat paper and tinted by hand are subjected to a uniform standard of printing for reproduction in a book. Thus the difference between a mode of pictorial address which is primarily "informational" and one which is "sentimental" is obscured.) In this sense, archives establish a relation of *abstract visual equivalence* between pictures. Within this regime of the sovereign image, the underlying currents of power are hard to detect, except through the shock of montage, when pictures from antagonistic categories are juxtaposed in a polemical and disorienting way.

Conventional wisdom would have it that photographs transmit immutable truths. But although the very notion of photographic reproduction would seem to suggest that very little is lost in translation, it is clear that photographic meaning depends largely on context. Despite the powerful impression of reality (imparted by the mechanical registration of a moment of reflected light according to the rules of normal perspective), photographs, in themselves, are fragmentary and incomplete utterances. Meaning is always directed by layout, captions, text, and site and mode

Figure 1. Cover of the 1956 *Dosco Annual Report* with a Shedden photograph of the Dosco miner in action. (Dosco Annual Report, 1956)

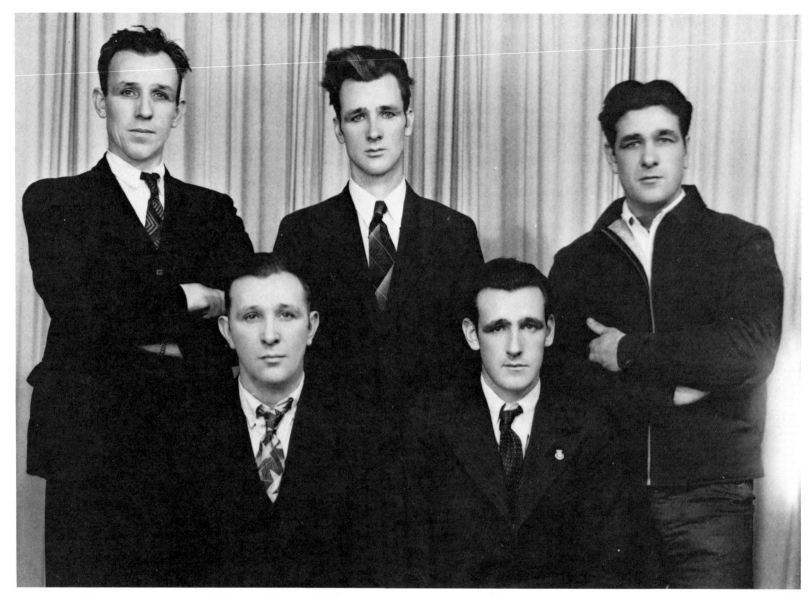

Figure 2. Glace Bay, 1940-41. Studio portrait of five brothers. Photograph by David Shedden. (Shedden Studios Archives)

of presentation, as the sample given above suggests. Thus, since photographic archives tend to suspend meaning and use; within the archive meaning exists in a state that is both residual and potential. The suggestion of past uses coexists with a plentitude of possibilities. In functional terms, an active archive is like a toolshed, a dormant archive like an abandoned toolshed. (Archives are not like coal mines; meaning is not extracted from nature, but from culture.) In terms borrowed from linguistics, the archive constitutes the paradigm or iconic system from which photographic ''statements'' are constructed. Archival potentials change over time; the keys are appropriated by different disciplines, discourse, ''specialties''. For example, the pictures in photo agency files become available to history when they are no longer useful to topical journalism. Similarly, the new art history of photography at its too prevalent worst rummages through archives of every sort in search of masterpieces to celebrate and sell.

Clearly archives are not neutral; they embody the power inherent in accumulation, collection, and hoarding as well as that power inherent in the command of the lexicon and rules of a language. Within bourgeois culture, the photographic project itself has from the very beginning been identified not only with the dream of a universal language, but also with the establishment of global archives and repostories according to models offered by libraries, encyclopedias, zoological and botanical gardens, museums, police files, and banks. (Reciprocally, photography contributed to the modernization of information flows within most of these institutions.) Any photographic archive, no matter how small, appeals indirectly to these institutions for its authority. Not only the truths, but also the pleasures of photographic archives are linked to those enjoyed in these other sites. As for the truths, their philosophical basis lies in an aggressive empiricism, bent on achieving a universal inventory of appearance. Archival projects typically manifest a complusive desire for completeness, a faith in an ultimate coherence imposed by the sheer quantity of acquisitions. In practice, knowledge of this sort can only be organized according to bureaucratic means. Thus the archival perspective is closer to that of the capitalist, the professional positivist, the bureaucrat and the engineer — not to mention the connoisseur — than it is to that of the working class. Generally speaking, working class culture is not built on such high ground.

And so archives are contradictory in character. Within their confines meaning is liberated from use, and yet at a more general level an empiricist model of truth prevails. Pictures are atomized, isolated in one way and homogenized in another. (Alphabet soup comes to mind). But any archive that is not a complete mess establishes an order of some sort among its contents. Normal orders are either taxonomic or diachronic (sequential); in most archives both methods are used, but at different, often alternating levels of organization. Taxonomic orders might be based on sponsorship, authorship, genre, technique, iconography, subject matter, and so on, depending on the range of the archive. Diachronic orders follow a chronology of production or acquisition. Anyone who has sorted or simply sifted through a box of family snapshots understands the dilemmas (and perhaps the folly) inherent in these procedures. One is torn between narration and categorization, between chronology and inventory.

What should be recognized here is that photographic books (and exhibitions), frequently cannot help but reproduce these rudimentary ordering schemes, and in so doing implicity claim a share in both the authority and illusory neutrality of the archive. Herein lies the ''primitivism'' of still photography in relation to the cinema. Unlike a film, a photographic book or exhibition can almost always be dissolved back into its component parts, back into the archive. The ensemble can seem to be both provisional and

artless. Thus, within the dominant culture of photography, we find a chain of dodges and denials: at any stage of photographic production the apparatus of selection and interpretation is liable to render itself invisible (or conversely to celebrate its own workings as a kind of moral crusade or creative magic). Photographer, archivist, editor and curator can all claim, when challenged about their interpretations, to be merely passing along a neutral reflection of an already established state of affairs. Underlying this process of professional denial is a commonsensical empiricism. The photograph reflects reality. The archive accurately catalogues the ensemble of reflections, and so on. Even if one admits — as is common enough nowadays — that the photograph interprets reality, it might still follow that the archive accurately catalogues the ensemble of interpretations, and so on again. Songs of the innocence of discovery can be snug at any point. Thus the "naturalization of the cultural," that Roland Barthes saw as an esstential characteristic of photographic discourse, is repeated and reinforced at virtually every level of the cultural apparatus — unless it is interrupted by criticism.[5]

In short, photographic archives by their very structure maintain a hidden connection between knowledge and power. Any discourse that appeals without scepticism to archival standards of truth might well be viewed with suspicion. But what narratives and inventories might be constructed, were we to interpret an archive such as this one in a normal fashion?

I can imagine two different sorts of books being made from Shedden's photographs, or for that matter from any similar archive of functional photographs. On the one hand, we might regard these pictures as "historical documents". We might, on the other hand, treat these photographs as "esthetic objects". Two more or less contradictory choices emerge. Are these photographs to be taken as a transparent means to a knowledge — intimate and detailed even if in-

complete — of industrial Cape Breton in the postwar decades? Or are we to look at these pictures "for their own sake", as opaque ends-in-themselves? This second question has a corollary. Are these pictures products of an unexpected vernacular authorship; is Leslie Shedden a "discovery" worthy of a minor seat in an expanding pantheon of photographic artists?

Consider the first option. From the first decade of the this century, popular histories and especially schoolbook histories have increasingly relied on photographic reproductions. Mass culture and mass education lean heavily on photographic realism, mixing pedagogy and entertainment in an avalanche of images. The look of the past can be retrieved, preserved and disseminated in an unprecedented fashion. But awareness of history as an *interpretation* of the past succumbs to a faith in history as representation. The viewer is confronted, not by *historical-writing,* but by the appearance of *history itself.* Photography would seem to gratify the often quoted desire of that "father of modern historical scholarship", Leopold von Ranke, to "show what actually happened."[6] Historical narration becomes a matter of appealing to the silent authority of the archive, of unobtrusively linking incontestable documents in a seamless account. (The very term "document" entails a notion of legal or official truth, as well as a notion *proximity to* and verification of an original event.) Historical narratives that rely primarily on photography almost invariably are both positivist and historicist in character. For positivism, the camera provides mechanical and thus "scientifically" objective evidence or "data". Photographs are seen as sources of factual, positive knowledge, and thus are appropriate documents for a history that claims a place among the supposedly objective sciences of human behaviour. For historicism, the archive confirms the existence of a linear progression from past to present, and offers the possibility of an easy and unproblematic retrieval of the past from the

transcendent position offered by the present. At their worst, pictorial histories offer an extraordinarily reductive view of historical causality: the First World War "begins" with a glimpse of an assassination in Sarajevo, the entry of the United States in the Second World War "begins" with a view of wrecked battleships.

Thus, most visual and pictorial histories reproduce the established patterns of historical thought in bourgeois culture. By doing so in a "popular" fashion, they extend the hegemony of that culture, while exhibiting a thinly-veiled contempt and disregard for popular literacy. The idea that photography is a "universal language" contains a persistent element of condescension as well as pedagogical zeal.

The widespread use of photographs as historical illustrations suggests that significant events are those which can be pictured, and thus history takes on the character of *spectacle*.[7] But this pictorial spectacle is a kind of rerun, since it depends on prior spectacles for its supposedly "raw" material.[8] Since the nineteen twenties, the picture press, along with the apparatuses of corporate public relations, publicity, advertising and government propaganda have contributed to a regularized flow of images: of disasters, wars, revolutions, new products, celebrities, political leaders, official ceremonies, public appearances, and so on. For a historian to use such pictures without remarking on these initial uses is naive at best, and cynical at worst. What would it mean to construct a pictorial history of postwar coal mining in Cape Breton by using pictures from a company public relations archive without calling attention to the bias inherent in that source? What present interests might be served by such an oversight? We return to this question in the third part of this essay.

The viewer of standard pictorial histories loses any ground in the present from which to make critical evaluations. In retrieving a loose succession of fragmentary glimpses of the past, the spectator is flung into a condition of imaginary temporal and geographical mobility. In this dislocated and disoriented state, the only coherence offered is that provided by the constantly shifting position of the camera, which provides the spectator with a kind of powerless omniscience. Thus the spectator comes to identify with the technical apparatus, with the authoritative institution of photography. In the face of this authority, all other forms of telling and remembering begin to fade. But the machine establishes its truth, not by logical argument, but by providing an *experience*. This experience characteristically veers between nostalgia, horror, and an overriding sense of the exoticism of the past, its irretrievable otherness for the viewer in the present. Ultimately then, when photographs are uncritically presented as historical documents, they are transformed into esthetic objects. Accordingly, the pretense to historical understanding remains, although that understanding has been replaced by esthetic experience.[9]

But what of our second option? Suppose we abandoned all pretense to historical explanation, and treated these photographs as artworks of one sort or another. This book would then be an inventory of esthetic achievement and/or an offering for disinterested esthetic perusal. The reader may well have been prepared for these likelihoods by the simple fact that this book has been published by a press with a history of exclusive concern with the contemporary vanguard art of the United States and Western Europe (and to a lesser extent, Canada). Further, as I've already suggested, in a more fundamental way the very removal of these photographs from their initial contexts invites estheticism.

I can imagine two ways of converting these photographs into "works of art", both a bit absurd, but neither without ample precedent in the current fever to assimilate photography into the discourse and market of the fine arts. The first path follows the traditional logic of romanticism, in its incessant search for esthetic origins in a coherent and

controlling authorial "voice." The second path might be labeled "post-romantic" and privileges the subjectivity of the collector, connoisseur, and viewer over that of any specific author. This latter mode of reception treats photographs as "found objects." Both strategies can be found in current photographic discourse; often they are intertwined in a single book, exhibition or magazine or journal article. The former tends to predominate, largely because of the continuing need to validate photography as a fine art, which requires an incessant appeal to the myth of authorship in order to wrest photography away from its reputation as a servile and mechanical medium. Photography needs to be won and rewon repeatedly for the ideology of romanticism to take hold.[10]

The very fact that this book reproduces photographs by a single author might seem to be an implicit concession to a romantic *auteurism*. But it would be difficult to make a credible argument for Shedden's autonomy as a maker of photographs. Like all commercial photographers, his work involved a negotiation between his own craft and the demands and expectations of his clients. Further, the presentation of his work was entirely beyond his control. One might hypothetically argue that Shedden was a hidden artist, producing an original *oeuvre* under unfavorable conditions. ("Originality" is the essential qualifying condition of genuine art under the terms dicated by romanticism. To the extent that photography was regarded as a copyist's medium by romantic art critics in the nineteenth century, it failed to achieve the status of the fine arts.) The problem with *auteurism,* as with so much else in photographic discourse, lies in its frequent misunderstanding of actual photographic practice. In the wish-fulfilling isolation of the "author", one loses sight of the social institutions — corporation, school, family — that are speaking by means of the commercial photographer's craft. One can still respect the craft work of the photographer, the skill inherent in work within a set of formal conventions and economic constraints, while refusing to indulge in romantic hyperbole.

The possible "post-romantic" reception of these photographs is perhaps even more disturbing and more likely. To the extent that photography still occupies an uncertain and problematic position within the fine arts, it becomes possible to displace subjectivity, to find refined esthetic sensibility not in the maker of images, but in the viewer. Photographs such as these then become the objects of a secondary voyeurism, which preys on, and claims superiority to, a more naive primary act of looking. The strategy here is akin to that initiated and established by Pop Art in the early nineteen sixties. The esthetically informed viewer examines the artifacts of mass or "popular" culture with a detached, ironic, and even contemptuous air. For Pop Art and its derivatives, the look of the sophisticated viewer is always constructed in relations to the inferior look which preceded it. What disturbs me about this mode of reception is its covert elitism, its implicit claim to the status of "superior" spectatorship. A patronizing, touristic, and mock-critical attitude toward "kitsch" serves to authenticate a high culture that is increasingly indistinguishable from mass culture in many of its aspects, especially in its dependence on marketing and publicity and its fascination with stardom. The possibility of this kind of intellectual and esthetic arrogance needs to be avoided, especially when a book of photographs by a small town commercial photographer is published by a press that regularly represents the culture of an international and metropolitan avant-garde.

In general, then, the hidden imperatives of photographic culture drag us in two contradictory directions: toward "science" and a myth of "objective truth" on the one hand, and toward "art" and a cult of "subjective experience" on the other. This dualism haunts photography, lending a certain goofy inconsistency to most commonplace assertions about the medium. We repeated-

ly hear the following refrain. Photography is an art. Photography is a science (or at least constitutes a "scientific" way of seeing). Photography is both an art and a science. In response to these claims, it becomes important to argue that photography is neither art nor science, but is suspended between both the *discourse* of science and that of art, staking its claims to cultural value on both the model of truth upheld by empirical science and the model of pleasure and expressiveness offered by romantic esthetics. In its own erratic way, photographic discourse has attempted to bridge the extreme philosophical and institutional separation of scientific and artistic practice that has characterized bourgeois society since the late eighteenth century. As a mechanical medium which radically transformed and displaced earlier artisanal and manual modes of visual representation, photography is implicated in a sustained crisis at the very center of bourgeois culture, a crisis rooted in the emergence of science and technology as seemingly autonomous productive forces. At the heart of this crisis lies the question of the survival and deformation of human creative energies under the impact of mechanization. The institutional promotion of photography as a fine art serves to redeem technology by suggesting that subjectivity and the machine are easily compatible. Especially today, photography contributes to the illusion of a humanized technology, open both to "democratic" self expression and to the mysterious workings of genius. In this sense, the camera seems the exemplar of the benign machine, preserving a moment of creative autonomy that is systematically denied in the rest of most people's lives. The one-sided lyricism of this view is apparent when we consider the myriad ways in which photography has served as a tool of industrial and bureaucratic power.[11]

If the position of photography within bourgeois culture is as problematic as I am suggesting here, then we might want to move away from the art historicist bias that governs most contemporary discussions of the medium. We need to understand how photography works within everyday life in advanced industrial societies: the problem is one of cultural history rather than art history. This is a matter of beginning to figure out how to read the making and reception of ordinary pictures. Leslie Shedden's photographs would seem to allow for an exemplary insight into the diverse and contradictory ways in which photography effects the lives of working people.

Let's begin again by recognizing that we are confronting a curious archive — divided and yet connected elements of an imaginary social mechanism. Pictures that depict fixed moments in an interconnected economy of flows: of coal, money, machines, consumer goods, men, women, children. Pictures that are themselves elements in a unified symbolic economy — a traffic in photographs — a traffic made up of memories, commemorations, celebrations, testimonials, evidence, facts, fantasies. Here are official pictures, matter-of-factly committed to the charting and celebration of progress. A mechanical conveyor replaces a herd of ponies. A mechanical miner replaces ten human miners. A diesel engine replaces a locomotive. Here also are private pictures, personal pictures, family pictures: weddings, graduations, family groups. One is tempted at the outset to distinguish two distinct realisms, the *instrumental realism* of the industrial photograph and the *sentimental realism* of the family photograph. And yet it would seem clear that these are not mutually exclusive categories. Industrial photographs may well be commissioned, executed, displayed, and viewed in a spirit of calculation and rationality. Such pictures seem to offer unambiguous truths, the useful truths of applied science. But a zone of virtually unacknowledged *affects* can also be reached by photographs such as these, touching on an esthetics of power, mastery, and control. The public *optimism* that suffuses these pictures is merely a respectable, *sentimentally-acceptable,* and

ideologically necessary substitute for deeper feelings — the cloak for an esthetics of exploitation. In other words, even the blandest pronouncement in words and pictures from an office of corporate public relations has a subtext marked by threats and fear. (After all, under capitalism everyone's job is on the line.) Similarly, no family photograph succeeds in creating a haven of pure sentiment. This is especially true for people who feel the persistent pressures of economic distress, and for whom even the making of a photograph has to be carefully counted as an expense. Granted, there are moments in which the photograph overcomes separation and loss, therein lies much of the emotional power of photography. Especially in a mining community, the life of the emotions is persistently tied to the instrumental workings underground. More than elsewhere, a photograph can become without warning a tragic momento.

One aim of this essay, then, is to provide certain conceptual tools for unified understanding of the social workings of photography in an industrial environment. This project might take heed of some of Walter Benjamin's last advice, from his argument for a historical materialist alternative to a historicism that inevitably empathized "with the victors":

> *There is no document of civilization which is not at the same time a document of barbarism. And just as such a document is not free of barbarism, barbarism taints also the manner in which it was transmitted from one owner to another. A historical materialist therefore dissociates himself from it as far as possible. He regards it as his task to brush history against the grain.[12]*

Benjamin's wording here is careful. Neither the contents, nor the forms, nor the many receptions and interpretations of the archive of human achievements can be assumed to be innocent. And further, even the concept of "human achievements" has to be used with critical emphasis in an age of automation. The archive has to be read from below, from a position of solidarity with those displaced, deformed, silenced, or made invisible by the machineries of profit and progress.

II

The Emerging Picture-Language of Industrial Capitalism

Those things which we see with our eyes and understand by means of our senses are more clearly to be demonstrated than if learned by means of reasoning.

Agricola[13]

We have sent designers to the workshops. We have made sketches of the machines and of the tools, omitting nothing that could present them distinctly to the viewer.

Diderot[14]

Art historians of photography have sought variously to chart continuities and discontinuities between photography and earlier modes of pictorial representation. But these efforts have given too little critical thought to what I take to be a central question: the question of the machine. For our purposes here, we might ask the following questions. What has it meant, historically, to seek the truth of technical processes by means of pictures? And what has it meant that since the middle of the last century, technical processes that were increasingly subject to mechanization were increasingly represented by mechanical means, by means of photography? In short, what role has been played by scientific picture-making in the historical development of capitalism, in the construction of capitalist dominion over nature and human labour? Clearly, this essay can provide no more than partial and very tentative answers to these questions. Fortunately for us, mining is one of the first technical endeavors to be systematically represented by pictorial means. Thus a certain narrow but exemplary lineage of technical realism can be traced: from a sixteenth century illustrated text on mining and metallurgy, Agricola's *De Re Metallica,* to the plates on mineralogy in the eight-

eenth century *Encyclopédie* of Diderot and D'Alembert, and on to the mining photography of the nineteenth and twentieth centuries. But first something should be said about mining in general.

The history of mining is an interesting case study for both economic and symbolic reasons. The economic reasons are fairly obvious. Mining is central to the emergence and development of the capitalist mode of production between the sixteenth and nineteenth centuries. It was a metallurgically superior Europe that imposed its guns and armour on Latin America. In turn, gold and silver from the mines of Mexico and Peru financed the earliest stages of industrial capitalism, as Italian, Dutch, German, and English merchants came to control the loot collected by Spain. The new industrial economy was fueled, in its turn, by coal. Thus mining has been both the primary source of primitive accumulation of wealth, and the source of power for more developed forms of exploitation.[15]

The stark contradictions of mining are those of uneven economic development. Mining remains rural, "primitive," an activity of regions that are deliberately kept "backward" and economically underdeveloped. Although mining was

essential to other forms of industry, the technology of mining initially anticipated but finally lagged behind that of the factory system. The Newcomen and Watt steam engines found their first widespread application in English coal mines during the eighteenth century. With increased demand for coal, and the exhaustion of seams closer to the surface, steam power provided a way to pump water from new, deeper mines. But this use of the steam engine was not *in itself* productive, although it certainly anticipated the "universally applicable" engine patented by Watt in 1784 which would become the main motive power for nineteenth century industry. Mining proper continued to be entirely manual work well into the nineteenth century, combining the traditional skilled labour of the coal cutter with the sheer massive toil of the women and children who hauled the coal to the surface. (It was not until the 1860s that coal-cutting machines began to be used, and coal mining did not begin to be mechanized in earnest until the 1920s in the United States and the 1930s in Great Britain.)[16]

For eyes that were willing to overlook the underground expenditures of human energies and lives, focusing instead on the marvel of those first noisy, smoking, coal-fired pumping machines, it must have seemed that coal power begat coal. Here, in the imagination of the early industrial bourgeoisie, was the embryonic ideal of a self-sustaining, autonomous productive machine. And yet the mines were not factories; they served the Industrial Revolution but were not, in themselves, the site of its principal innovations.

While actual mining practices differed materially from the developed factory system, on a symbolic level mining represented the *prototypical* form of industry. More than any other practice, mining exemplifies the direct domination of nature, the extraction of value from nature by alien means. Mining is the symbolic antithesis of agriculture, the inorganic opposite of cultivation and husbandry. Lewis Mumford well understood the cultural significance of mining; *Technics and Civilization* contains an intriguing passage on the metaphorical position of mining within Western culture. Mumford remarks that "the mine is nothing less than the concrete model of the conceptual world which was built up by the physicists of the seventeenth century."[17] To know this world, a world of pure matter, was to engage in an intellectual procedure akin to mining. Thus, for Francis Bacon, the seventeenth century philosopher whose practical empricism anticipated the Industrial Revolution, mining metaphorically corresponded to the "speculative" and inductive aspect of natural philosophy, while "operative" and constructive reason was akin to metal-smithing. For Bacon, scientific truth was found "in the bowels of Nature," only to be shaped "on an anvil" for practical purposes.[18]

Notwithstanding the long prevailing conception of mining as a paradigm for empirical and industrial science, this inorganic but rural occupation has sustained a folklore that is in part agrarian in its forms and meanings. The culture of mining communities is frequently both militantly proletarian and rich in a sense of rural continuity and resistance to industrial discipline. This culture has frequently collided with the logic of industrial rationalization. The discourse and practice of mining has come to be bracketed by two antagonistic figures: the underground toiler, "backward" and often militant, and the mining engineer. To understand this antagonism, we need to understand something of the way in which capitalism subordinates manual labour to the command and direction of intellectual labour. Mining is no exception to this rule.

The rationalization of mining begins in the sixteenth century. This process required that mining be systematically *represented* for the first time, by words and pictures. Mining, metallurgy, and medicine are among the first technical disciplines to be treated in this fashion. Georgius Agricola's *De Re Metallica,* published in 1556, is second only to *De*

Humani Corporis Fabrica of Andreas Vesalius, published in 1543, in its stature as a work of early modern empirical science based on the use of visual demonstration. Both authors sought to unite physical observation with theoretical understanding. Vesalius was vehement in his opposition to the prevailing separation of mental and manual labour in medical practice and education. The polemical frontispiece to the *Fabrica* shows Vesalius himself at the center of the medical ampitheatre. The anatomist has abandoned the professor's pulpit and displaced the barber-surgeons who previously performed the actual dissections. In this image, the power of discourse combines with physical demonstration: the anatomist is both a theorizing and practicing subject.[19] Vesalian anatomy provided a model for other empirical sciences. Agricola, a physician and burgher in the German mining region of Saxony, sought to consider "the metallic arts as a whole . . . just as if I had been considering the whole of the human body," treating "the various parts of the subject like so many members of the body."[20] Like Vesalius, Agricola stressed the importance of direct empirical observation and the corresponding value of illustrations:

> . . . *with regard to the veins, tools, vessels, sluices, machines and furnaces, I have not only described them, but have also hired illustrators to delineate their forms, lest descriptions which are conveyed by words should either not be understood, or should cause difficulty to posterity, in the same way as to us difficulty is often caused by many names which the Ancients (because such names were familiar to all of them) have handed down to us without any explanation.*
>
> *I have omitted all those things which I have not myself seen, or have not read or heard of from persons upon whom I can rely.*[21]

For both Vesalius and Agricola illustrations served to place the reader in a position akin to that of direct observation; pictures provided a kind of surrogate presence of the object. The reader became a reader-viewer. As the historian of science George Sarton noted, "it became more and more objectionable to reproduce stereotyped words in the vicinity of correct images."[22](The "correctness" of these images was, of course, always an approximate matter, as well as a matter of emerging pictorial conventions. Visual empiricism required a certain essentialism, a willingness to cluster diversity around some standard or type. The anatomical illustrations commissioned by Vesalius frequently involved the "averaging" of sketches taken from numerous, diverse specimens.) Perhaps what is most remarkable about Agricola's thinking is his clear conception of the limits placed on linguistic comprehension by history: verbal meanings change, are lost, become opaque. In his comments, we can discern an early attempt to claim a compensatory universality for pictorial communication, a certain transhistorical clarity of meaning. While the image becomes the bearer of fragments of scientific truth, it also serves as a generalized *sign* of science, an emblem of the power of science to understand and dominate nature.

The development of scientific and technical illustration directly parallels, informs, and is informed by, the development of empirical and practical science. Picture-making itself had to become worldly before it could be applied to worldly problems. Picture-making also had to become a form of intellectual labour, grounded in mathematical principles. Thus, two fifteenth century inventions, printing and perspective, provided necessary technical and conceptual groundwork for sixteenth century illustrated books on anatomy and engineering. The development of printing, and especially the arts of wood-block printing and engraving, allowed for the making of what William Ivins called "exactly repeatable pictorial statements."[23] These early forms of mechanical reproduction permitted a new degree of consistency and certainty in the discourse of empirical science.

Perspective provided both a general ideology of pictorial realism and a model of spatial analysis based on geometrical procedures. Technical illustration did not often attempt the complete construction of the planar intersection of the visual pyramid, the construction first described in writing by Alberti in his *Treatise on Painting* of 1435. But the very notion of accurate scientific pictures required the institutionalization of Alberti's more general dictum that "the painter is concerned solely with representing what can be seen."[24] Since scientific illustration sought the truth of nature in its components, the analytic procedures of the perspectival painter were more important than the final synthetic illusion. As we will see shortly, there were valid reasons for scientific illustrators to ignore or reject the possibility of constructing proportionally-correct two-dimensional "windows" or "mirrors." Painting and scientific illustration did not share the same ultimate ends. For Leonardo, following Alberti, painting was "the only imitator of all the visible works of nature."[25] Scientific illustration, and particularly engineering illustration, was a means to an end, that end being the construction of a second, artificial nature that was more than pictorial illusion. (One aspect of the unity of the representational arts and applied sciences in the Renaissance lies in the coexistence of these two projects, painting and engineering, in single individuals: Brunelleschi, Alberti, Leonardo, and Dürer.)

What about *De Re Metallica?* Agricola wrote a book that is in many ways indicative of the *transitional* character of Renaissance culture, a culture that looked backward to the authority of the Ancients and forward to the possibility of a new universal scientific empiricism. Agricola's name itself — a Latinization of Georg Bauer — suggests something of the transitional character of his project, which he claimed was modeled on Columella's work on agriculture from the first century, *De Re Rustica,* a book that was printed in numerous editions during Agricola's lifetime.

With Agricola, the discourse of industry can be seen in embryonic form. The first book of *De Re Metallica* is an elaborate justification of mining, a striking example of the often explicitly polemical — and ideological — character of emerging discourses. Mining is defended against a variety of charges: that it is mere dumb toil based on luck rather than skill; that it is an unreliable source of wealth: that its products are useless; that its products inspire avarice and theft and war; that it brings disease and death to the miner; that it poisons streams and devastates forests and fields. Agricola's defense compares the disruptive aspects of mining to those necessary to other material pursuits: agriculture, hunting, and fishing. He absolves metals of any responsibility for the human evils they inspire. Mining permits a more civilized and efficient mercantile economy:

> *When ingenious and clever men considered carefully the system of barter, which ignorant men of old employed and which even to-day is used by certain uncivilized and barbarous races, it appeared to them so troublesome and laborious that they invented money. Indeed, nothing more useful could have been devised, because a small amount of gold and silver is of as great value as things cumbrous and heavy; and so peoples far distant from one another can, by the use of money, trade very easily in these things which civilized life can scarcely do without.*[26]

This statement is followed by a litany of barbarisms and distinctly non-metallic cruelties — hanging, burning, live burial, and so on — that would occur if mining were to be abolished. (This litany, worthy of illustration by Grünewald, is perhaps a veiled reference to the atrocities of the Peasant Wars.) For all its dark toil, mining is claimed here as a force of civilization and light.

Agricola's fundamental argument is protoypically utilitarian: "I see no reason why anything that is in itself

of use should not be placed in the class of good things."[27] But there are distant precapitalist limits to his thought. For example, Agricola contrasts the honourable wealth to be gained from investment in mining with that obtained dishonourably through usury.[28] In regarding mining as a legitimate source of wealth, he recognizes that wealth derives, not only from nature, but from dignified human labour. At least in his rhetoric, Agricola does not elevate the dignity of owners above that of wage-workers, or that of skilled labourers above that of common toilers. Not only would it "not be unseemly for the owners themselves to work with their own hands on the works or ore," but also "not even the common worker in the mines is vile and abject."[29] In understanding Agricola's thinking, we would do well to consider Agnes Heller's characterization of Renaissance attitudes toward work and wealth:

> *That age was the era of the* birth *of wealth. This wealth was regarded not as a starting point but as a result . . . men attributed it to wit, to cunning, to human cleverness, and it never entered their minds that wealth or money might become a value in itself, and the creator of values independent of man. This not yet fetishized thinking found expression also in the fact that when they spoke of the products, greatness, and dignity of human work (1) they never distinguished mental labour from physical, the 'mind' from the 'hands'; (2) they did not separate living and dead labour, the work process and the tools and objects produced in the course of earlier work processes; (3) they did not distinguish reified and non-reified forms of objectification.[30]*

But despite its respect for manual labour, *De Re Metallica* marks a transition from artisanal to engineering knowledge. A profound *political* difference can be seen between a text like Albrecht Dürer's *Course in the Art of Measurement (Unterweisung der Messung)*, published in 1525, and Agricola's book. Dürer wrote in German and sought to instruct artisans and mechanics in a *practical* geometry. The Marxist philosopher Alfred Sohn-Rethel has seen Dürer's project as an important but ultimately unsuccessful attempt to resist the developing separation of intellectual and manual labour in the Renaissance.[31] Agricola, on the other hand, sought to describe a new division and hierarchy of labour in the mines. He wrote in Latin, although an inadequate German edition of *De Re Metallica* quickly appeared. His book spoke primarily to mine owners, both nobles holding sovereign rights to claims and the new class of capitalist investors (to which Agricola himself belonged). *De Re Metallica* spoke also to the upper level of mine managers, foreman, and skilled artisans. The overall viewpoint of the book was a supervisory one, involving the novel attempt to construct a comprehensive textual description of the design and management of a complex labour process.

We should note here that with increased demand for metals in the late fifteenth and early sixteenth centuries, mining in middle Europe became increasingly subject to capitalization. The system of shared concessions worked by small groups of miners gave way to absentee ownership: the silver and copper mines of Saxony were commonly divided into 128 shares or more by the early sixteenth century. Miners responded by forming pitmen's associations, striking work when necessary. German miners were active allies of the peasants in the rebellion of 1525. But just as the forces of feudalism combined to smash that rebellion, so also did the nobility continue to assert ultimate control over mining through the exercise of sovereign rights, despite the appearance of capitalist forms of ownership and elements of modern class struggle.[32]

How did Agricola use illustrations in *De Re Metallica?* With one exception, illustrations do not appear until the third of the twelve books. The isolated first illustration, presented near the end of the second book, provides a

negative example, depicting the use of a divining rod to locate veins of ore. Agricola condemns this practice as worthless, stressing that systematic visual inspection is more efficient than tactilely-inspired trial-and-error. Thus the subsequent illustrations attempt to show the miner "the natural indications of the veins which he can see for himself without the help of twigs."[33] These pictures are an early form of topographic illustration, often crude and confusing because of an attempt to graft a vertical cross-section of the earth onto a naturalistic landscape. The spatial codes are inconsistent, and often the reader must infer from definitions given in the text which veins are being shown in vertical cross-section, and which are being shown in alignment with the surface contours of the earth. Even with less ambiguous images, labeling is essential; these illustrations were not intended to be understood without reference to the accompanying text.

Indeed, Agricola's program is clearly a *physiognomic* one: the surface of the earth is to be read symptomatically for its indices of hidden wealth. The direction, type, and size of an underground vein can be assessed from surface seams. The intellectual skills employed are those of taxonomy and surveying: classification and a geometrically-based geography. Although these woodcuts fail to assume a unitary perspectival point-of-view (and in fact *must* deviate from a single viewpoint if they are to reveal simultaneously both the earth's surfaces and its depths), they nonetheless are in general accord with the fundamental axiom underlying perspectival representation. That axiom claims that nature in its essence consists of continuous and measurable space, and that all positions within this unitary space are relative.[34]

The fourth book of *De Re Metallica* treats the method of delimiting claim boundaries, the hierarchy of mining officials, the legal obligations of share holders, and the general organization of work in the mines. In this book we encounter an early form of abstract, industrial thinking, applied to both space and time. The only illustrations are nine rectangles of varying sizes and proportions, representing the various *meers,* or standard mining claims. Here mining is reduced to its economic essence. The bureaucracy of mine management is neatly described down to the level of foreman. Finally, Agricola describes a new time discipline, contrary to agricultural rhythms, a discipline which anticipates the continuous productive cycle of the factory. The "twenty-four hours of the day" are to be "divided into three shifts," although the foreman is not to impose the third, night shift "unless necessity demands it." In the one jarring passage among these pages of relentless, rational accounting, Agricola remarks that the miners on the night shift "lighten their long and arduous labours by singing, which is neither wholly untrained nor unpleasing."[35]

The fifth book treats "the principles of underground mining and the art of surveying."[36] In these passages on the basic architecture and geometry of mining, the importance of intellectual labour is stressed. Further, the point-of-view established by the illustrations is an increasingly "abstract" one, a purely conceptual, surpervisory overview which corresponds to no actual physical position. For illustrations which depict underground shafts and tunnels, a clearly decipherable system of cut-away views is established. The inner workings are pictured against a vertical mountainside scene. This vertical scenery could be read as the outcome of confused or conflated representational ambitions. On the one hand, these pictures employ spatial hyperbole to emphasize the characteristic mountainous geography of the German mining regions. (In German, a miner was traditionally a *bergmann,* a mountain man.) On the other hand, this "verticalization" is also an attempt to construct a diagrammatic space, a flat non-illusionistic space upon which the cross-section of the mine could be plotted. As with the earlier woodcuts that demonstrated the variety and

direction of ore deposits, here the viewer is expected to read the image as a composite of surface and interior views.

With these cut-away views, Agricola's illustrations begin to manifest an ontological similarity to mining itself. The eye digs away from the side, a metaphorical miner cutting at right angles to the actual diggings being pictured. The line of sight intersects the plane of physical toil. A hierarchy of labour and knowledge is charted here, at this intersection of "digging" and "looking;" the mole-like work of the diggers is subordinated to command from above and beyond the mine. As Agricola argued at an earlier point in his text, "the master's watchfulness in all things is of utmost importance."[36] Quite literally, the line of sight assumes the privileged status of *supervision.*

In accord with this emphasis on rational visual inspection, Agricola stresses the fundamental and preliminary importance of the intellectual skills of the surveyor, stating that "miners measure the solid mass of the mountain in order that the owners may lay out their plans, and that their workers may not encroach on other people's possessions."[37] If any one figure embodies intellectual labour in Agricola's schema, it is the surveyor, who stands between property and toil, between conception and execution, the master of what came to be called two centuries later in the *Encyclopedia,* "subterranean geometry." As evidence of this priority, Agricola describes and illustrates the instruments of the surveyor — compass, measuring rods, hemicycle, and plummet level — before treating any of the tools and machines necessary to mining itself. Agricola provides a long treatise on the practical geometry of surveying, moving from the principles and method of measurement by triangulation to a description of survey-plotting. We should note here that surveys were plotted on the above-ground "surveyor's field" of the same overall size as the underground mine. No reduced-scale maps or charts of underground mines were produced until after the sixteenth century. Thus one

condition of fully-developed technical illustration — the ability to make charts and diagrams from which accurate measurements could be taken — had not been met in Agricola's time. The diagrammatic elements of the woodcuts in *De Re Metallica* remain merely approximate, a matter of pedagogical demonstration rather than actual measurement. These are *models,* not *plans;* one more indication of the transitional character of this work.

Agricola's sixth book is devoted to the tools and machines used in mining. In the opening passages we find a clear separation of the representational roles assigned to word and image: the visual medium is reserved for static display and the text provides a narrative description of the work process. Thus, a visual inventory of the tools parallels a textual description of their uses. The overall order of the illustrations is taxonomic. Each object is more or less isolated, although similar or functionally related implements are included in the same illustration. Sometimes the order is one of *functional equivalence:* an array of hammers of different sizes, for example. In other illustrations an element of *functional contiguity* appears, suggesting the potential linkage of one tool to another: an array of buckets is shown in conjunction with iron hooks, for example. The pictorial rhetoric that emerges here underlies all realisms which treat the manufactured world as an ensemble of useful *objects.* To modern eyes, here is an early form of the illustrated catalogue void of all narrative or poetic elaboration: the object reduced to a condition of pure potentiality, waiting to be *used.*

These tools are displayed in a space which remains ambiguous, like that of the earlier woodcuts. Occasionally, two views or a disassembled view of a single implement are given, especially when a single view would have omitted important features. Tools are always shown in perspective; no attempt was made to isolate frontal, side, or overhead views. Again, these are not plans. In some pictures, the im-

A, B—VEINS. C—TRANSVERSE STRINGER. D—OBLIQUE STRINGER.
E—ASSOCIATED STRINGER. F—*Fibra dilatata*

Figure 3. From Book III

THREE INCLINED SHAFTS, OF WHICH A DOES NOT YET REACH THE TUNNEL; B REACHES THE TUNNEL; TO THE THIRD, C, THE TUNNEL HAS NOT YET BEEN DRIVEN. D—TUNNEL.

Figure 4. From Book V

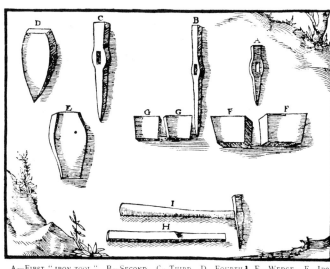

A—FIRST "IRON TOOL." B—SECOND. C—THIRD. D—FOURTH. E—WEDGE. F—IRON BLOCK. G—IRON PLATE. H—WOODEN HANDLE. I—HANDLE INSERTED IN FIRST TOOL.

Figure 5. From Book VI

Figures 3-7. From Georgius Agricola, *De Re Metallica* (Froben, Basel) 1556, English translation by Herbert Clark Hoover and Lou Henry Hoover (*The Mining Magazine*, London) 1912.

210

A—UPRIGHT AXLE. B—TOOTHED WHEEL. C—TEETH. D—HORIZONTAL AXLE.
E—DRUM WHICH IS MADE OF BUNDLES. F—SECOND DRUM. G—DRAWING-CHAIN.
H—THE BALLS.

Figure 6. From Book VI

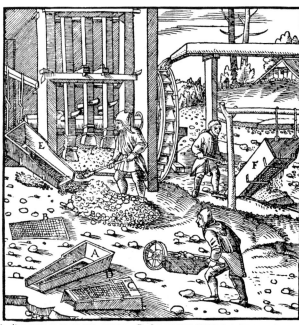

A—BOX LAID FLAT ON THE GROUND. B—ITS BOTTOM WHICH IS MADE OF IRON WIRE.
C—BOX INVERTED. D—IRON RODS. E—BOX SUSPENDED FROM A BEAM, THE INSIDE BEING VISIBLE. F—BOX SUSPENDED FROM A BEAM, THE OUTSIDE BEING VISIBLE.

Figure 7. From Book VIII

plements are shown arranged upon the ground, as if displayed by a workman to a viewer who looks down from an oblique angle. In others, the tools are shown suspended against yet another vertical mountainside scene. Thus, an abstract space, a space of display, is opened up within the naturalistic frame provided by marginal hints of shrubbery and rock. Even when tools are no longer shown upon the ground, the earth against which these tools will be used is indicated. Visual inspection and display remains in *touch* with the manual handling of tools. The abstract diagrammatic rhetoric of the engineer has not yet fully displaced the physically demonstrative rhetoric of the artisan.

More elaborate functional ensembles follow as the text of the sixth book moves from hand tools to machines. Cutaway views reappear: mechanical linkages are traced from the surface to the subterranean depths and back. The emphasis here is on the transmission of power for lifting, pumping, and ventilating. Agricola describes machines of increasing strength: hand-cranked windlasses are followed by horse and cattle-driven lifting engines. Waterwheels are shown connected to pumps; windmills are connected to ventilating fans and pipes. Power derives from no single source. Wind and water provide assistance, but the essential work is still the human toil of building mines and cutting away at the earth with pick and shovel. Here Agricola explicitly addresses the carpenter-engineer who constructs the mostly wooden machines. Thus, despite the complexity of these engines, the human figure continues to dominate the scene, physically, conceptually, and metaphorically. Technics and nature are anthropomorphized; remember that Agricola's epistemological model is anatomy. It is also worth noting that the wind is given a human face in these illustrations, following a cartographer's convention in vogue from the tenth to the eighteenth century. This anthropomorphism surfaces elsewhere in Agricola's belief in subterranean demons, or gnomes, who "mimic men" and are "clothed like miners" and cause trouble.[39] (The remnants of this medieval mythology are visible in German kitsch statuary even today. The complementary view of the *miner* as a gnome-like, extra-human or even subhuman creature did not develop in Germany, but in England in the seventeenth century.)[40]

The pictures in the sixth book underscore the division of labour outlined throughout Agricola's text. Human figures attend to different tasks, shoveling here, cranking there. And yet this labour remains sociable. Pairs of men are frequently shown engaged in conversation, as if to portray the discursive aspects of craft, and Agricola's own gleaning of verbally-transmitted craft wisdom.

The attention to mechanical linkages and sequentially-related tasks lends a certain narrativity to these pictures of work and machines, in contrast with those of tools. A single woodcut might show a machine under construction and in use. This representational strategy provides both an analysis of the machine — a delineation of its parts — and a description of the process of work. With these illustrations, the tasks of words and pictures are no longer so severely divided between visual display and verbal narrative. Now both words and pictures chart the temporal logic of cause and effect. A pictorial rhetoric of *production* emerges. In this sixth book, then, the mine is represented as a kind of *workshop,* in which manual tasks are assisted by machinery.

The subsequent books of *De Re Metallica* extend this treatment to the latter stages of ore processing: sorting, crushing, sifting, washing, smelting, refining and, finally, casting. Of these latter books, only the seventh, on assaying, describes an environment that differs from the workshop by being a site of measurement and evaluation rather than production. (In this assignment of a limited role to the laboratory, Agricola made a fundamental break with alchemcy.)

I have devoted this much attention to *De Re Metallica*

because no other book of the Renaissance was as ambitious in attempting to describe the totality of an industry in words and pictures. Agricola's book was the repository and model of a new centralized knowledge, the knowledge of the engineer. This discourse assimilated, transcribed, rationalized, and transformed older artisanal knowledges that were transmitted both orally and by practical demonstration. Thus in the sixteenth century, the illustrated book (the technical treatise, the *manual,* the *handbook)* became the locus of a new discursive power — the power of supervision, of design, of scientifically-guided investment.

Herbert Hoover, a mining engineer and Republican president of the United States from 1929 until 1933, translated *De Re Metallica* into English between 1907 and 1912. His wife, Lou Henry Hoover, the better Latinist of the two, was the co-translator. Herbert Hoover offered the following assessment of Agricola's importance:

> De Re Metallica . . . *was the first important attempt to assemble systematically in print the world-knowledge on mining, metallurgy, and industrial chemistry. It was the great textbook of these industries for two centuries and had dominated thought and practice all that time. In many mining regions and camps, including the Spanish South American, it was chained to the church altar and translated by the priest to the miners between religious services.*[41]

If we were to read Hoover's remarks with a degree of irony, we might think of *De Re Metallica* as a Bible of primitive accumulation; its truth presiding over what Marx termed the "extirpation, enslavement and entombment in mines of the indigenous population" of Latin America.[42] Although labour conditions in German mines were markedly different from the horrors of Potosí, Agricola's text was of great technical value to the engineers of the massive New World mines. But Hoover perhaps overstates his case. *De Re Metallica* was certainly the major text on mining until the eighteenth century, when steam power began to alter fundamentally the scale and character of mining operations in England. But between the sixteenth and eighteenth centuries, advanced German mining methods were also exported to the rest of continental Europe and to England by German miners themselves.[43] We might also recall that the quality of Agricola's observations had more than a little to do with the skill of his informants. If modern scientific empiricism begins in the fifteenth and sixteenth centuries with a respect for manual labour, it matures by forgetting and even inverting that initial respect. But that reversal is not complete until the very end of the nineteenth century, the beginning of the era of scientific management, when the labour-process becomes the object of rigorous scientific inspection and redefinition. As a principal American ideologue of professional engineering and champion of scientific management, Hoover stresses textual authority and underemphasizes the historical importance of artisanal forms of knowledge. In accord with Hoover's often-expressed belief in "rugged individualism," scientific truth is traced to a solitary author, rather than to any social nexus of technical knowledge. Thus, Hoover's translation was an attempt to construct a respectable intellectual genealogy for business-oriented engineering. He sought a classical "tradition" for an aggressive and youthful profession, a profession that was establishing its hegemony in American intellectual life during the early years of this century. Again, we need to read this genealogy against the grain.[44]

And so Agricola was resurrected as a father of mining engineering at the beginning of this century, in what was yet another example of confident bourgeois historicism. But I want to pay more attention to the earlier stages of the rift between intellectual and manual labour, which means considering Agricola's influence on seventeenth and eighteenth century scientific thought. The line I want to trace runs from

Agricola to Diderot, from *De Re Metallica* to the *Encyclopedia.* The intermediary figure is Francis Bacon.

The Italian historian of science, Paolo Rossi, sees Agricola as one of a number of precursors to Baconian empiricism.[45] Along with Dürer, Vesalius, Rabelais, and other less well-remembered sixteenth century writer-artisans like Bernard Palissy and Robert Norman, Agricola stresses the dignity of manual work and the importance of learning from material practice. But it was Francis Bacon who first constructed a coherent philosophical program around this principle. Bacon's taxonomy of knowledge, outlined in *The Dignity and Advancement of Learning* of 1623, assigned a "most radical and fundamental" role to the study of the mechanical arts. As Bacon argued, the systematic study of "History Mechanical" prevented natural philosophy from vanishing "in the fumes of subtle or sublime speculation." In this Bacon echoed his predecessors. But Bacon also imagined a unified technical discourse, a discourse within which it might be possible to transfer the "observations of one art to the use of others."[46] For Bacon, cooperative technical knowledge was the source of truth, utility, and progress; its aim was the establishment of human dominion over nature. His utopian technological ambition was perhaps most clearly stated in his unfinished fable, *New Atlantis:*

> *The End of our Foundation is the knowledge of Causes and secret motions of things, and the enlarging of the bonds of Human Empire, to the effecting of all things possible.*[47]

Bacon's followers produced other, less fanciful models of technical education. William Petty proposed a *gymnasium mechanicum,* or "college of artisans," in 1648. The school was to make use of a book on the history of the mechanical arts:

> *In this work bare words are not sufficient: all the tools and instruments should be painted and colored inasmuch as description, without colors, would turn out to be insufficient Young men, instead of reading difficult Hebrew words in the Bible, . . . or repeating like parrots nouns or irregular verbs, will be able to read and learn the history of human faculties From this work must needs derive a great progress of useful and honorable inventions since a man, at a glance, will be able to embrace all the work carried out by our predecessors and consequently be in a position to remedy all the deficiencies of an individual trade with the perfection of another.*[48]

The text that sought to realize this ambition was the *Encyclopedia.*

The Encyclopedia; or Analytic Dictionary of Science, Arts, and Trades was published in twenty-seven volumes between 1751 and 1765. Eleven supplementary volumes of plates were published between 1762 and 1772.[49] This monumental compendium of universal knowledge was in many ways the emblematic textual product of the French Enlightenment. It was, in a sense, Leibniz' "republic of the mind" realized as a library. The editors, Diderot and D'Alembert, explicitly modeled their work on Bacon's inductive empiricism, his emphasis on the mechanical arts, his notion of collaborative science, and his organization of human knowledge.

Diderot, himself a cutler's son, sought an alliance of intellectual and manual labour, "a society of men of letters and of skilled workmen . . . men bound together by zeal for the best interests of the human race and by a feeling of mutual good will."[50] Although egalitarian on the surface, the relationship between thinker and artisan proposed by Diderot rested on a hidden hierarchy. In his "Prospectus" for the *Encyclopedia,* Diderot outlines, a virtual *circuit* of knowledge. Technical knowledge would flow from

213

artisans to intellectuals, from whom it would be returned to artisans in an altered and improved condition. In this schema, the intellectual was the *active* agent, the agent of change, while the worker was a more *passive* figure, a resource.

I'd like to consider this circuit, this *Enlightenment machine,* in a bit more detail. The characteristic eighteenth century man of letters was ignorant of the mechanical arts; thus, for Diderot, "everything impelled us to go directly to the workers."[51] The skill of the worker was necessary for scientific progress, but in itself it was inert and incapable of development. For Diderot, workmen were by and large inarticulate and unreflective people:

> *Most of those who engage in the mechanical arts have embraced them only by necessity and work only by instinct. Hardly a dozen among a thousand can be found who are in a position to express themselves with some clarity upon the instrument they use and the things they manufacture. We have seen some workers who have worked for forty years without knowing anything about their machines. With them, it was necessary to exercise the function in which Socrates gloried, the painful and delicate function of being midwife of the mind,* obstetrix animorum.[52]

Doubtless there was some measure of truth in Diderot's assessment of his informants. But doubtless also there was another history, an unwritten and lost history of *artisanal resistance,* of stubborn and deliberate *dumbness* in the face of Diderot's probings. In contrast to Diderot, Marx, while commenting on the "petrification" of craft knowledge through the eighteenth century, at least conceded that the craft secrets, or "mysteries," were actively defended by protocols of silence.[53]

The Encyclopedists considered traditional work as if it were nature, as if it were a submerged activity, beneath reason. Work was specific, contingent, habitual, unchanging. For Diderot, the first part of the solution was the *active seizure* of work by empirical reason. Intellectuals who desired to become technical pedagogues not only had to observe the trades but also practice them in a limited fashion, to "become apprentices."[54]

The second part of Diderot's program required that the new intellectual understanding of work be *represented.* His "Prospectus" treated traditional artisanal practices as if they were silent, lacking in all but the most primitive forms of language. (To be fair to Diderot, we should note that he also criticized the semantic poverty of intellectual discourse.) Workers learned "more by the repetition of contingent actions than by the use of terms." For Diderot, work-knowledge was bound to the specificity of its referent, and to the endless need to repeat the same actions. Accordingly, there was no such thing as an autonomous artisanal speech, no general language of work. Diderot stated this quite bluntly: "In the workshop it is the moment that speaks, and not the artisan."[55]

A language had to be invented. Otherwise, work could not be liberated from the endless repetition of the "moment." Scientific language was to be the motor of progress, the means by which work could begin to "advance toward perfection."[56] It was preciasely the *image* that could offer up the "moment" of work for scientific inspection. So, like Vesalius and Agricola, Diderot sought to construct a visual and verbal discourse for the communication of scientific truths. But unlike his sixteenth century predecessors, Diderot, following Bacon, explicitly sought to *universalize* the discourse of instrumental science. This goal of an all-embracing system of practical reason is the distinguishing feature of Enlightenment thought. Diderot's "Prospectus" is a metacommentary, a deliberate treatise on the *means* of representation; its object is not work as such, but work mediated by language.

Diderot proposed a uniform method of representation, applicable to all the mechanical arts. This method combined narration with analysis. The narrative of industry began with nature, with raw materials, and traced a sequence of linked productive steps. This path was intersected by a number of inventories; of raw materials, of tools, of finished products. The characteristic form of illustration used in the *Encyclopedia* involved the placement of a workshop tableau (or vignette) above an abstract inventory of tools or products. For Roland Barthes, the plates are a model of the Encyclopedic mind; and a preliminary diagram of the "thinking machine:"

> *Here we find prophetically formulated the very principle of cybernetic ensembles: the plate, the image of the machine, is indeed in its way a brain; we introduce substance into it and set up the "program:" the vignette (the syntagm) serves as a conclusion. This logical character of the image has another model, that of dialectics: the image analyzes, first enumerating the scattered elements of the object or of the operation and flinging them on the table before the reader's eyes, then recomposing them, even adding to them the density of the scene, i.e., of life.* [57]

I owe a lot to Barthes' essay on these plates; certainly he provides the essentials of a semiology of instrumental realism. But Barthes is more or less silent on one crucial issue: the division of labour. He argues that, "the Encyclopedic image is human not only because man is represented in it but also because it constitutes a structure of *information*." [58] Barthes fails to perceive the division of humanity into two camps, those who *work* and those who *know*. For ultimately, in the system of practical knowledge constructed by the Encyclopedists, the worker is the *object* but never the *subject* of knowledge. Barthes recognizes a certain violence in these images, but it is violence directed at nature, not at those who work. He detects a logic of classification, appropriation, and domestication, but this power is embodied in an abstract human subject. His reading does not touch on the discursive power that places the spectator, the surveyor, in a superior position to the manual worker.

Consider this: many of the plates show "only the hand of the artisan in action" (Diderot). [59] For Barthes, these artisanal hands are "inevitably the inductive sign of the human essence." But in the century following the publication of the *Encyclopedia,* the hand was eclipsed by the machine; artisanal craft succumbed to machine industry. Nevertheless, the image of the hand lingers. Barthes notes that "our advertising constantly returns to this mysterious motif." (The imaginary replenishment of a lost essence?) He continues, "It is not easy to be done with a civilization of the hand." [60] But it is precisely the "cybernetic ensemble," intellectual labour, that facilitates the replacement of the hand by the machine, the replacement of living labour by dead labour.

Diderot proposed an instrumental mode of looking: an economy of the look. Like Vesalius, Agricola, and William Petty, he sought to replace vague terminologies with accurate pictures. But pictures were not only regarded as accurate and comprehensive records. Implicitly, pictures were *fast*, they offered an *accelerated* way of knowing. Like Petty, Diderot sought to know *at a glance*. As he put it: "A glance at the object or at its picture tells us more about it than a page of text." [62] This is obviously an early formulation of what has become a modern cliché of the *worth* of pictures. Diderot claimed to have commissioned his illustrations with an eye toward efficiency:

> *As for the figures, we have restricted them to the important movements of the worker and to only those phases of the operation which it is very easy to portray and very difficult to explain. We have held*

ourselves to essential circumstances, to those whose picture, if it is well executed, necessarily results in the knowledge of the other circumstances which one does not see.[62]

The strategy of pictorial selection that emerges here would become fundamental to the production of photographic archives in the next two centuries.

However, as I've already suggested in the first part of this essay, the instrumental pictorial archive can easily be severed from its moorings. For our purposes, one of Roland Barthes' most important insights is his understanding of the relationship between autonomous looking and estheticism, his understanding of the way in which *spectacle* emerges:

> . . . *technological purpose no doubt compelled the description of objects, but by separating image from text, the* Encyclopedia *committed itself to an autnomous iconography of the object whose power we enjoy today, since we no longer look at these illustrations with mere information in mind.[63]*

The figure of this "disinterested" spectator, this tourist, is already present in some of the mineralogical plates of the *Encyclopedia*. This figure does not survey instrumentally but merely looks at what becomes, by virtue of that act of looking, a *landscape*. For Barthes, the look invited by the *Encyclopedia* is ultimately fantastic and surreal; analytic reason never achieves its goal. What Barthes detects in these plates, although he doesn't name it as such, is the muted resonance of the *sublime,* an unnameable and awesome plenitude of nature.

The mineralogical plates of the *Encyclopedia* are the meeting ground of nature and culture. Nature is at first awesome; in the initial plates, Vesuvius erupts. Next, geological formations are shown being inspected by well-dressed spectators. Mining follows; nature is tamed. Then

216

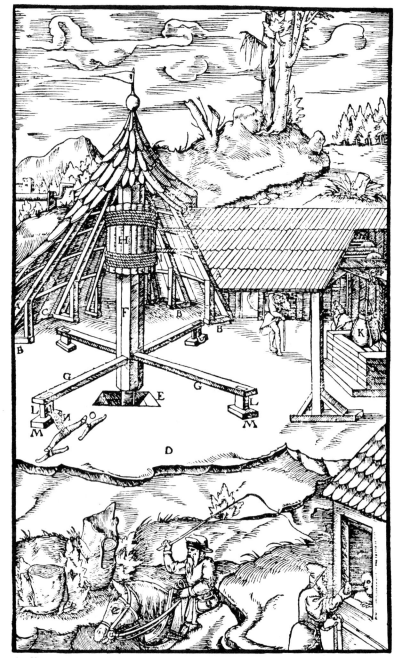

A—Upright beams. B—Sills laid flat upon the ground. C—Posts. D—Area. E—Sill set at the bottom of the hole. F—Axle. G—Double cross-beams. H—Drum. I—Winding-ropes. K—Bucket. L—Small pieces of wood hanging from double cross-beams. M—Short wooden block. N—Chain. O—Pole bar. P—Grappling hook. (Some members mentioned in the text are not shown).

Figure 8. From Georgius Agricola, *De Re Metallica*, Book VI (Froben, Basel) 1556, English translation by Herbert Clark Hoover and Lou Henry Hoover (*The Mining Magazine*, London) 1912.

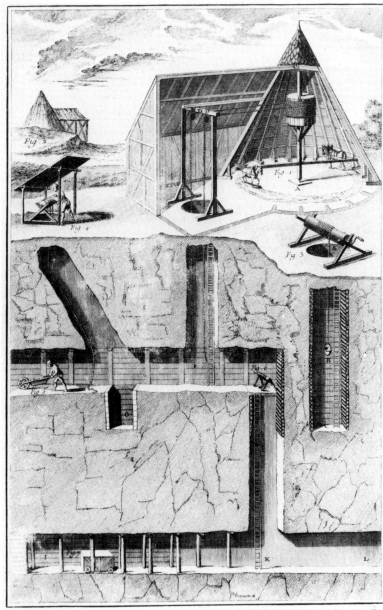

the *Encylopedia* follows the same sequence as *De Re Metallica*. The use of the divining rod is illustrated only to be condemned and replaced by surveying. The mines themselves are shown as if they were underground workshops: clean, geometrically-ordered spaces. The technology of mining remains more or less the same as that depicted in *De Re Metallica*. The steam engine, although used in English mines since 1712, does not appear. What is novel in the *Encyclopedia* is that mining has fallen into place within a universal taxonomy of industries. It becomes possible to imagine new linkages and substitutions, a new mobility of labour power, for example. A cyclopean eye — the eye of science and capital — inspects the whole of human industry. The *Encyclopedia* illustrates a world of production that can be engineered, made better, made to "advance toward perfection." Thus the *Encyclopedia* is the conceptual guidebook to a mode of industrial production that was only just beginning to be forged in the eighteenth century.

* * *

Photography inherited and transformed the role assigned to illustration in the *Encyclopedia*. There was an explicit and enthusiastic element of encyclopedism in early photographic discourse; photography was frequently lauded as a "universal language" and as the new epitome of scientific representation. As I suggested in the first part of this essay, photography promised a global inventory or archive of appearances, appearances taken "directly from nature." Accordingly, the triumph of photography involved changes in both the quantity and quality of visual "truth." What sort of truth-claims were made for photography? Generally speaking, the enthusiasm for photographic truth was Baconian in character: photographs were seen as initial empirical moves in an inductive process. Unlike the hand-drawn illustrations in the

217

Figure 9. From Jean Le Rond d'Alembert and Denis Diderot, editors, *L'Encyclopédie, ou Dictionnaire Raisonné des Sciences, des Arts et des Métiers* (Paris) 1751-1772.

Encyclopedia, which were for the most part generalized or idealized *models* based on more direct empirical observation, photographs *invariably* traced the specificity of individual objects and events. Presumably, only a process of empirical sampling or a theatrical staging could allow a photograph to stand for a *typical* instance. As the American philospher C.S. Peirce pointed out, photographs are physical traces of their objects; that is, they belong to the category of *indexical signs,* signs that are linked by a relation of physical causality or connection to their objects.[64]. Because of this indexical property, photographs are fundamentally grounded in contingency, even if subsequent contextualizations and interpretations might obscure or even deny the contingency of the photograph's origins.

For a culture committed to an inductive model of scientific reasoning, the photographic plate could be seen as the meeting ground of nature and science; here was a preliminary, and physically direct, reception of nature. As a bearer of truth, the photograph exhibited a paradoxical double authority, an authority attributed to both "nature" and "science." The camera appropriated nature for science, and did so by scientific means; but unlike other machines it was passive, receptive. Thus photography, as a cultural practice, could signify both the domination and preservation of nature. The camera could preserve remnants of a pre-industrial world, while embodying the very essence of technological progress. Photography could offer its mid-nineteenth century audience both the past and the future. Nature (and the past) could be restored to an imaginary completeness by means of the mechanical perspectival synthesis effected by lens and light-sensitive surface. Or nature could be submitted to the logic of analysis; fragmented, dissected, measured. The tension between these two possibilities — between romanticism and scientism — pervades photographic discourse.

Daguerre's characterization of his inventions is instructive: "the DAGUERREOTYPE is not merely an instrument which serves to draw Nature; on the contrary it is a chemical and physical process which gives her the power to reproduce herself."[65] What grew in this *medium* was a *culture,* a decipherable nature, a nature reconstituted, re-presented as *language.* For many early observers, photography was a language that surpassed all other means of representation, precisely because of its transparency, its "identity of aspect" with its object. In an early description of the daguerreotype, written in 1840, Edgar Allan Poe argued in this vein:

> *All language must fall short of conveying any just idea of the truth, and this will not appear so wonderful when we reflect that the source of vision itself has been, in this instance, the designer. Perhaps, if we imagine the distinctness with which an object is reflected in a positively perfect mirror, we come as near the reality as by any other means. For, in truth, the Daguerreotyped plate is infinitely (we use the term advisedly) is infinitely more accurate in its representation than any painting by human hands. If we examine a work of ordinary art, by means of a powerful microscope, all traces of resemblance to nature will disappear — but the closest scrutiny of the photogenic drawing discloses only a more absolute truth, a more perfect identity of aspect with the thing represented. The variations of shade, and the gradations of both linear and aerial perspective are those of truth itself in the supremeness of its perfection.*[66]

Once captured in its infinitude, this nature could then be subjected to analysis. Poe continued in the next and final paragraph of his article to suggest that "among the obvious advantages" of the new medium was the possibility of measurement: "the height of inaccessible elevations may in many cases be immediately ascertained, since it will afford an absolute perspective of objects in such situations."[67]

Poe seems to have borrowed this claim from François Arago who stressed the possibility of what would later be

called photogrammetry, or survey-plotting based on photographs, in his 1839 report to the French Chamber of Deputies on the virtues of Daguerre's invention. Arago's assessment of the objectivity and utility of photography was in many ways exemplary and was frequently echoed by other early promoters of photgraphy. He welcomed photography as an *acceleration* and refinement of the encyclopedic project:

> To copy the millions of hieroglyphics which cover even the exterior of the great monuments of Thebes, Memphis, Karnak, and others would require decades of time and legions of draughtsmen. By daguerreotype one person would suffice to accomplish this immense work successfully Since the invention follows the laws of geometry, it will be possible to re-establish with the aid of a small number of given factors the exact size of the highest points of the most inaccessible structures.[68]

After an interlude in which he deferred to the authority of the painter Paul Delaroche for an opinion on photograph's usefulness to the arts, Arago turned to an even more abstract form of measurement: *photometry*. For Arago, who was a physicist and astronomer, here was the first practical method for comparing light intensities with some degree of rigour and consistency:

> We do not hesitate to say that the reagents discovered by M. Daguerre will accelerate the progress of one of the sciences, which most honors the human spirit. With its aid the physicist will be able henceforth to proceed to the determination of absolute intensities; he will compare the various lights by their relative effects.[69]

With this proposal, which might seem rather lacklustre to those of us who have come to regard photography as a medium which produces images, Arago's enthusiasm became boundless. His address went on to argue that future scientific applications of photography were virtually impossible to predict, but likely to be numerous beyond belief.

As a physicist, Arago welcomed photography as yet another instrument for the mathematicization of nature. His comments on photometry suggest that he was able to isolate conceptually and even privilege the indexical properties of the photograph, envisioning a role for the new medium that was completely independent of any iconic, or picture-making, function. And photometrics aside, here was a pictorial medium from which exact mathematical data could be extracted, or as Arago put it, a medium "in which objects preserve mathematically their forms."[70] Photography doubly fulfilled the Enlightment dream of a universal language: the universal *mimetic* language of pictures yielded up a higher truth, a truth that could be expressed in the universal *abstract* language of mathematics. For all its messy contingency, photography could be accomodated to a Galilean vision of the world as a "book . . . written in the language of mathematics."[71]

In another early commentary on photography, the notion of a photographically mathematicized nature took on an explicit *economic* character. The American physician, poet, and essayist Oliver Wendell Holmes proposed a grand encyclopedic archive, a global library of *exchangable* images. For Holmes, the meaning and value of the photograph ultimately resided in its *exchangable character*, its inclusion within this global archive which translated all sights, all visions, into relations of formal (and mathematical) equivalence. Holmes regarded photography as the stripping of form from matter, and foresaw "a universal currency of these banknotes . . . which the sun has engraved for the great Bank of Nature."[72] Metaphorically, he made the connection between photographic representation, quantification, and commodity exchange. Photography submitted the world to a uniform logic of representation, just as the global market economy established a uniform logic of exchange. Holmes

was writing in 1859. Eight years later, Marx published his analysis of the theretofore obscure logic of capitalist exchange relations. With Marx's aid, we can understand that Holmes was proposing a system of communication that mirrored the logic of commodity fetishism. Just as exchange value came to eclipse the use value of commodities, so the very form of the photographic sign came to eclipse the contingency of its referent. Like the commodity (and, indeed, *as* a commodity) the photograph appeared to have a "life of its own." As Holmes put it with the characteristic optimism of his epoch and his class: "We have got the fruit of creation now, and need not trouble ourselves with the core."[73]

The arguments of Arago and Holmes indicate that photography was quickly absorbed into what the German sociologist Georg Simmel termed in 1900 the "calculating character of modern times."[74] But photography was not promoted only as a positivist instrument for the further mathematicization of the world. Nor was it seen only as an encyclopedic machine for establishing a global archive of knowledge and a universal system of communication. Understandably, photography was also embraced in *utilitarian* terms: that is, in terms of a social calculus of pleasure and discipline. Especially in England, early promoters of photography struck up a Benthamite chorus. Here was a machine for supplying happiness on a mass scale, for providing in Jeremy Bentham's famous phrase, "the greatest happiness of the greatest number."[75] Photography, and particularly the photographic portrait, was welcomed as a socially ameliorative instrument. Jane Welsh Carlyle voiced characteristic hopes in 1859, when she described inexpensive portrait photography as a social palliative:

> *Blessed be the inventor of photography. I set him even above the inventor of chloroform! It has given more positive pleasure to poor suffering humanity than anything that has been "cast up" in my time . . . — this art, by which even the poor can possess themselves of tolerable likenesses of their absent dear ones.*[76]

In the United States, similar but more ambitious utilitarian claims were made. A prominent American portrait photographer, Marcus Aurelius Root, published a book-length treatise on photography entitled *The Camera and the Pencil* in 1864. Root's rambling manual is interesting for a number of reasons. Writing in a country without a monumental cultural archive, he was able to make an unabashed claim for photography's status as a fine art. For Root, photography did not simply disseminate a remote high culture by means of reproduction, but also stood as an art in its own right. Furthermore, Root proposed a formal canon for commercial portrait practice, juggling instruction in the phsyiognomic interpretation of character with practical lessons in flattery. But what is most interesting for our purposes here is Root's persistent attention to the *moral effects* of photography. Like Carlyle, he stressed the salutory effects of photography on working-class family life. Photography provided the vicarious experience of travel and thus the means of cultural enlightenment for the working classes, so that, for example, "all forms and diversities of natural sublimity and beauty" might be "inspected in their minutest particulars by the day-laborer, surrounded by his family at his own fireside." Family photographs sustained sentimental ties in a nation of migrants. This "primal household affection" served a socially cohesive function. Root argued in a characteristically American vein: "a nation is virtuous and united according as the households composing it are well ordered and bound together by mutual regard." Furthermore, widely distributed portraits of the great filled daily life with a regular parade of moral exemplars.[77]

After cataloguing these familial functions, Root moved on to list actual and potential scientific and industrial applications of photography, ranging from the illustration of

scientific specimens to the production of photographic advertisements for "machinery, mortuary monuments, and a multitude of articles besides." He then turned to industrial supervision and military reconnaissance:

> *Civil engineering, mining works, and all military operations may profit largely from photography*
> *In the construction of the Grand Trunk Railway of Canada, it is said that the chief engineers of Great Britain were able to supervise the work, virtually* in person, *without leaving their homes.*
> *In war the camera is variously useful in taking views of fortifications, or other places, to be attacked, and in exhibiting the effects of cannonfire upon breaches; in giving correct representations of the difficulties of any route to be traversed by troops; or in getting from a balloon a view of the enemy's forces. . . .*[78]

Indeed, the first sophisticated applications of photography to engineering problems seem to have been made in military contexts. French military engineers developed practical photogrammetric methods during the 1850s. At least one of the several published works on "military topography" and "topographic reconnaissance" from that period explicitly acknowledged Arago's 1839 prediction of the value of the new medium for mathematically accurate rendering.[79] Photographs also seem to have played a role in the transfer of military technologies from the continent to the United States. Photographs made in 1855 in Crimea by James Robertson were reproduced as lithographs in an elaborate American volume entitled *The Art of War in Europe.*[80] These lithographic plates of intact and demolished fortifications were indexed to structural diagrams and maps. The author of this text was a military attaché and major in the Corps of Engineers. Appropriately enough this compendium of lessons from technologically superior European armies was published in 1861.

Having commended photography to the pursuit of politics by other means, our American portraitist Root returned to his chosen genre:

> *Public order seems likely to be . . . secured by the custom lately adopted, of taking photographic likenesses of all criminals sentenced Such persons . . . will find it not easy to renew their criminal careers, while their faces and general aspects are familiar to so many, especially to the keen-sighted detective police.*[81]

And here Root's utilitarianism comes full circle. Beginning with cheaply-affordable esthetic pleasures and moral lessons, he ends with the photographic equivalent of that exemplary utilitarian social-machine, the Panopticon. The Panopticon, or Inspection House, was Jeremy Bentham's proposal, written in 1787, for an architectural system of social discipline, applicable to prison, factory, workhouse, asylum, and school. The operative principle of the Panopticon was total and perpetual surveillance; unable to see into the central observation tower, inmates were forced to assume that they were watched continually. (As Thomas Hobbes remarked over a century earlier, "the reputation of Power is Power.")[82] The salutory effects of this program were trumpeted by Bentham in the famous opening remarks of his proposal:

> *Morals reformed—health preserved—industry invigorated—instruction diffused—public burdens lightened—Economy seated, as it were, upon a rock—all by a sinple idea of architecture.*[83]

With Bentham, the principle of supervision, which we saw in embryonic form in the writings of Agricola, takes on an explicit industrial-capitalist character. Even Bentham's prisons were to function as profit-making establishments, based on the private contracting-out of convict labour. Within the Panopticon, every space, every operation, and every

221

human action was to be tailored to the logic of efficiency.[84]

And so photography did not simply inherit and "democratize" the honorific functions of bourgeois portraiture. Photography served to introduce the Panopticon principle into daily life. Every portrait implicitly took its place within social and moral hierarchy. The *private* moment of sentimental individuation, the reception of the gaze-of-the-loved-one, was shadowed by two other, *public* looks: a look up, at one's "betters;" and a look down, at one's "inferiors." Nevertheless, photography could promote an imaginary mobility within this hierarchy; serving to honor the unhonored by granting them the momentary dignity of a conscious, isolated pose.

If I have dealt with Marcus Aurelius Root at length here, it is because the utilitarian program he described is essentially that which characterizes the institution of photography as it came to be practiced within mass culture. In a sense, he described a paradigm for everyday photographic realism, a realism that links sentimentalism and instrumentality, binding together familial happiness, social discipline, and a faith in science. This unity is fragile and fraught with contradictions.

Again, I want to stress the industrial character of this system of realism, its fundamental ground in large-scale mechanized production, not only of photographic materials, but of photographs themselves. Early observers of the American photographic portrait industry spoke of daguerreotype "factories" in New York City, establishments in which the process of portrait-making was subjected to an assembly-line style division of labour.[85] The triumph of photographic representation can be regarded as a particular instance of the more general economic transformations of the nineteenth century. Just as the artisanal mode of production gave way to what Marx called "machinofacture" in that century, so photography came to supplant hand-drawing, painting, and engraving as the dominant form of

visual culture. Photography mechanized both the primary act of representation and, ultimately, the means of pictorial reproductions as well. This displacement of pictorial handwork was not complete until after the development of high speed photomechanical reproduction in the eighteen nineties.

The advent of photography met resistance on many fronts. Charles Baudelaire articulated sentiments that were elitist, quasi-aristocratic and bohemian as well when he argued, "when industry erupts into the sphere of art, it becomes the latter's mortal enemy."[86] Photography also generated a distinct *artisanal resistance.* Honoré Daumier and Gérard Fontallard produced cartoons welcoming photography as an art of layabouts and dolts. Both regarded photography as an exercise in passive clock-watching. Fontallard depicted a daguerreotypist sleeping through a long exposure, watch in hand; the caption read, "Talent through sleep."[87] Daumier produced a lithograph of a photographer and customer waiting out an exposure. His caption read, "Patience is the virtue of asses."[88] The response of photography's defenders was to glory in the mechanical character of the medium when truth was at issue, and to repress that character when esthetic claims were being made. In a sense, the dominant culture of photography generated its own denial and its own alibi.

The bourgeois portrait gallery and studio in nineteenth century America was a deliberately anti-industrial space, a combination museum, parlour, and secular church: ornate, almost roccoco in its decorative embellishment. The "better" galleries stressed craftsmanship and leisurely comfort in their advertising, decor and finished products, thereby distinguishing their services from the overtly industrial operations of galleries patronized by the lower classes. The space of the gallery allowed for an imaginary flowering of the self, an expressive *completion* of the social ego. The time encapsulated in the formal portrait was distinct from industrial

and commercial time. In 1851, a French writer described the opulence of American studios and went on to suggest something of the relation between the portrait photograph and everyday life.

> *Everything is here united to distract the mind of the visitor from his cares and give to his countenance an expression of calm contentment. The merchant, the physician, the lawyer, the manufacturer, even the restless politican, here forget their labors. Surrounded thus, how is it possible to hesitate at the cost of a portrait.*[89]

The portrait was the suspended moment of what Thorstein Veblen was to term "conspicuous leisure," a leisure that harked back to pre-industrial civilization for its values.[90]

Until the advent of photographic modernism in the second decade of the twentieth century, most culturally ambitious photographers studiously avoided the iconography of industrialism, preferring instead the pastoral, the baroque, the sentimental, and the romantic individualism of the portrait. (Alfred Stieglitz's photographs of steamships, dirigibles, and aeroplanes mark a watershed for self-conscious art photography.)[91] Since photography mechanized both the manual and a good portion of the intellectual work of visual representation (that is, the intellectual work of perspectival construction), the figure of artistic genius had to be reconstructed. On the one hand, an attempt was made to reintroduce craft to photography through the appropriation of painterly methods and painterly styles of presentation. On the other hand, and this was the modernist tendency, artistic work came to be regarded as a primarily *intellectual* undertaking, more or less independent of the exercise of manual skill. Vision was disembodied, and was given priority over manual and mechanical skill. But here we are getting ahead of our story.

So much, for the moment, for the work of photographic representation. What can be said about the photographic representation of work, and particularly, of work conducted underground? Perhaps the earliest underground photographs were those made by Nadar in the sewers and catacombs of Paris in 1861. Nadar combined serious esthetic ambition with technological bravado and a flair for publicity. In a famous and rather ironic lithograph, Daumier depicted Nadar "elevating photography to artistic heights" while photographing Paris from a balloon, floating above a city cluttered with lesser photographers' studios.[92] Nadar seems to have persistently sought the technological limits of photographic representation by linking the camera with new sources of transport and illumination: before he gained his reputation as an aeronaut, he descended underground with electric lights, photographing first the city sewers, which were then being rebuilt as part of Haussmann's reconstruction of Paris.[93] Next Nadar photographed the city's catacombs. His projects underground seemed to have been planned with publicity in mind; the catacombs were already being opened up for tourists several times a year, and the new sewers were to become important tourist attractions by the time of the Paris Exposition of 1867. The sewer photographs can easily be read as pictorial expressions of technological optimism: the galvanic arc illuminated the underground architecture of a new urban hygiene. Electricity itself could be welcomed as a hygenic force. The catacomb pictures are a bit more complicated. Perhaps no more obvious metaphor than this necropolis could have been found for the old Paris that was being razed to make way for the "Paris of the sightseer."[94] Clearly, the catacombs were a spectacle, but they were a spectacle in the sublime mode, filled with darkness and death. Nadar's galvanic arc brought enlightenment into space, banishing, or at least domesticating the sublime, pushing it back into the shadows. His pictures, like the plates of the *Encyclopedia,* depict what Barthes called "a world without fear."[95] In this light we might recall

Préparatifs d'un Bourrage.

Figure 10. Nadar. Preparation for a "jamming" of bones into the walls of the Paris catacombs. 1861.

Diderot's resolutely materialist commentary on the sublime:

> *Everything that astonishes the soul, everything that impresses it with a sensation of terror, leads to the sublime... Darkness adds to terror... Priests, raise your altars, erect your temples in the hearts of forests... Let your arcane, theurgic, bloody scenes be lit only by the fateful glare of torches. Light is useful when you wish to persuade; it is worthless for emotional effect.[96]*

Nadar, for his part, recalled his subterranean project as a kind of encyclopedic quest; this was an entirely rational endeavor, a triumph of science over the mysteries of death:

> *The world underground offered an infinite field of activity no less interesting than that of the top surface. We were going into it, to reveal the secrets of its deepest, most secret, caverns.[97]*

Again, it was electricity that illuminated this hidden place. Nadar seemed to have viewed exaggerated claims for electricity with skepticism, but at the same time, he shared the attitudes of his epoch in regarding electric power as a marvelous and *autonomous* force. In a passage in his memoirs (written in 1900) in which he described his skeptical but interested reception of a confidence-man with a scheme for taking "electric photographs" at a distance, Nadar celebrated electricity in terms that can only be described as characteristic of commodity fetishism:

> *We had seen it invisibly discharge all duties and perform all functions, realizing all the dreams of the human imagination. Obedient and ready to execute our commands, this all-powerful yet discreet servant is unrivaled in all its forms A first-class worker, a Jack-of-All-Trades — one at a time or all at once as you like...[98]*

Now suppose we return to Nadar's photographs of the catacombs with this passage in mind. For some extraordinary reason, perhaps out of respect for the encyclopedic paradigm, Nadar felt compelled to introduce the figure of *human labour* into these scenes. Thus his photographs demonstrated a sequence of instrumental actions: the hauling, sorting, and "packing" of bones in the underground vaults. In this cold, bright, materialist light, such as process could only be seen as a kind of negative industry, as the reversal of mining. There was a tension in Nadar's project between the absolute novelty of revelation, and a recognition that the world underground was already the site of human labour. On the one hand: the seeing of that-which-has-not-been-seen-before, the muted appeal to morbid appetites, the momentary taming of the sublime by electric light. On the other hand: a routine. Nadar extracted a republican moral from this quasi-industrial dismantling of skeletons. Here, in the mixing, sorting, and packing of ordered ensembles of bones of "great men, saints, and criminals" he discovered an "egalitarian confusion of death."[99] The bourgeois observer of these pictures is invited to sit in two seats; the seat of the spectator, confronting a republican *memento-mori,* and the seat of the boss, dependent upon, but in command of, other people's labour and the scientifically-harnessed forces of nature.

There is a further irony in these pictures from the catacombs. Nadar was forced to expose his collodion-on-glass negatives for as long as eighteen minutes. Since no living worker could be expected to stand still for so long, the figures we see in these photographs are *mannequins,* clothed in workers garb. Nadar's dummies stood-in for their living counterparts, and in so doing indicated the future refinement of photographic technique, when living movement would be photographically recorded as apparent stasis. (That is, these pictures wistfully anticipate the motion studies of Muybridge and Marey.) Thus we can read this substitution

in a number of ways: as a compensation for technical inadequacy, as technological prophecy, and finally, as a comment on the artificiality, the perversity, of photographic representation. Nadar's overtly theatrical construction could be taken as a self-conscious demonstration of the already inherently static, arresting, and consequently anti-natural property of the photographic medium. Despite the flow of electricity, this underground produced nothing more than a still life, a *nature morte.* But perhaps this line of interpretation attributes to Nadar a proto-modernist sensibility that is otherwise contradicted by his faith in the progress of photographic realism. Nevertheless, this much can be said. Photographs such as these suggested that the naturalism of the static image was of a limited order. It was as if photography, with its manifest ability to arrest a fragment of temporal duration, challenged for the first time the apparent naturalism of the established pictorial arts. (More accurately, perhaps, this challenge had begun with the changing scenes of the diorama, if not with optical toys that produced the illusion of movement.) Thus photography undermined even its own authority by bringing to the foreground the issue of the representation of time. This lack, this absence of movement, could only be overcome by the invention of cinema.

There is more to be said about these curious photographs from the catacombs of Paris. The perversity of these pictures has another aspect, an economic and psychological dimension. Here was the visible, figurative complement to Nadar's anthropomorphized, workmanlike electricity. Just as the source of illumination was personified, so the figure of human labour was reduced to dumb static objectivity. In these pictures, living labour was figuratively consigned to the city of the dead. Inasmuch as Nadar's mannequins were iconic *substitutes* for living workers, they were also the signs of the *replacement* of living labour by "dead labour," by machinery. When we recall that Nadar obviously sought to illustrate a *sequence* of ac-

225

tions, it is possible to understand that the narrative linkage of these static mannequin positions was as much the model of a functioning automation as it was the description by fictional means of a process performed by living workers. Conversely, we might argue that Nadar sought to symbolically revivify an underground world of machines and death. These artificial "workers" compensated for the dead, and for the absent and problematic figure of the photographic artist. Thus, in the face of mortality and mechanization, the *image* of life is preserved.

With this ensemble of static, artificial *tableaux,* Nadar can be said to have revealed — more or less unwittingly — not only the *modus operandi* of photography, but that of capitalism as well. These photographs provide an exaggerated paradigm for the photographic realism of the industrial engineer (as well as that of the ninethenth-century maker of death portraits). The realism of the engineer frequently accords the worker the status of a prop — humanly "interesting" and useful for establishing the relative scale of inanimate objects, but ultimately replaceable by a machine. But the overt artifice and the morbidity of Nadar's pictures also suggests an undercurrent of another less optimistic paradigm — that of romantic anti-capitalism. I'm thinking here of that genre of horror fiction in which the proletarian appears as a marauding zombie or automaton, the genre which can be said to begin with Mary Shelley's *Frankenstein* and end with George Romero's *Dawn of the Dead*, a film in which the zombies emerge initially from the ranks of the permanently unemployed.

I am arguing here that Nadar's underground project generated photographic meaning along both the metonymic and metaphoric axes of linguistic expression. This rhetorical dualism was intentional. Nadar's metonymic ambition, his essential *realism*, led him to technologically extend the limits of photographic representation, to discover new vantage points, new illuminating powers. On the other hand,

Nadar sought to metaphorize his underground excursions; that much is clear from his autobiographical account. The world underground and especially the catacombs were conducive to allegorical suggestion, even without the overt theatricality of his staging, which further impells our reading in that direction.

In short, it is because of Nadar's presence as an *author* that we assign to these first underground photographs a rather unique allegorical status. The allegory involved a contradictory ideological movement: toward a materialist *demystification* of religion and aristocratic class privilege, and toward the *mystification* of material science. In this, the essentially bourgeois character of Nadar's republicanism and materialism is evident.

Moving from tombs to mines, I want to begin by examining the reception — both contemporary and historical — of one of the earliest examples of underground photography in a mine. To the extent that this reception has sought to invest these first mining pictures with cultural and artistic value, the industrial character of the enterprise has been suppressed, denied, or oddly distorted. Nadar sought, in part, to "materialize" death by portraying the processing of the dead as a variety of subterranean industry. Now we will examine the opposite tendency, the attempt to idealize subterranean industry (and photography itself) by interpreting underground photographs as a variety of religious icon or formal abstraction.

The photographs I have in mind were made by Timothy O'Sullivan in the silver mines of the Comstock Lode in Nevada in 1867. These were not the first pictures of underground mining operations; burning magnesium was used to expose stereo views of an English coal mine as early as 1864. O'Sullivan's pictures, which also employed magnesium light, were made in conjunction with the United States Geological Survey of the Fortieth Parallel. The survey was sponsored by the War Department, and directed *in*

absentia by the Chief of Army Engineers. However, unlike earlier surveys, this one was conceived, planned, and directed by a civilian geologist, and staffed by civilian scientists. Clarence King, the geologist-in-charge, was a young, aggressive, theoretically sophisticated and politically well-connected graduate of Yale's Sheffield Scientific School. King proposed a thorough mapping of the region bordered by the Sierras on the west and the front range of the Rockies on the east, encompassing the then virtually uncharted terrain of the Great Basin and the central Cordilleras.

The bulk of O'Sullivan's pictures were extraordinary views of geological formations and topographic features of the American West. On first consideration, the mining pictures would seem to be the novel products of a side excursion. Indeed, this is how they were presented to the public in the one contemporary journalistic account of the photographic aspects of the expedition, and this is also how they are now being re-presented by photographic historians.

Overall, O'Sullivan's photographs have been accorded a special status by historians of photography, and he himself has been assigned a prominent position in the pantheon of early photographic artists. Interpretations of these pictures tend to emphasize either their artistic or their scientific importance, although the former tendency predominates. This tension between estheticism and scientism is characteristic of the historiography of photography, and is especially evident in the reception of O'Sullivan.

On the one hand, various attempts have been made to assess O'Sullivan's "landscapes" in relation to the esthetics of the sublime, and in particular to establish continuity or discontinuity between his work and that of nineteenth century American landscape painters like Frederic Church and Albert Bierstadt. Ultimately, such readings assign a metaphorical meaning to the photographs. The most sophisticated and exhaustive version of this tendency is found in the recent monograph on O'Sullivan by Joel

Snyder, who finds in the photographer's work a rehabilitation of the quest for the sublime, a quest that — in Snyder's view — had been debased by painters dallying with the picturesque.[100]

On the other hand, Rosalind Krauss has recently examined O'Sullivan's pictures in relation to what she terms, quite aptly, "the discourse of the survey." Krauss criticizes the art historical appropriation — and decontextualization — of photographs which are more correctly to be understood as metonymic fragments, as empirical elements in a vast scientific "mapping" project. Overall, Krauss is seeking to describe the two discursive formations — one metaphoric and the other metonymic — within which photographic meaning is generated.[101]

Krauss and — in less critical way — Snyder are both aware of the antinomy between artistic and scientific thought in nineteenth and twentieth century culture. (Snyder tries to diminish the tension by suggesting that O'Sullivan's pictures were "both documentary and expressive," a typical claim, and one that leads in this and most cases to a privileging of the expressive function.)[102] Nevertheless, their work perpetuates this antinomy by failing to seriously consider the social and economic conditions of scientific and artistic work. They fail to address the *fundamentally instrumental* character of the Western surveys. Thus the spectres of "pure" art and "pure" science emerge from their meditations on O'Sullivan. Snyder seeks to describe a creative innovation, and thus to isolate a moment of autonomous artistic subjectivity. For Krauss, the photographer is an actor within an objectively-given discursive formation. Her approach assumes that the discourse of photographic realism, "the discourse of the survey," can be understood without addressing issues of ideology, interest, and power. The idealism inherent in these two critical approaches pivots, ultimately, on another famous "antinomy of bourgeois thought": that between subjec-

227

tivism and objectivism. As Marx argued, that antinomy can only be overcome in a *practical* way.[103]

We can look at this problem in another way. The almost exclusive emphasis on O'Sullivan's "landscapes" or "topographical views" tends to strengthen the impression that the encounter between white men and "nature" was of a strictly comtemplative order, and that this contemplative encounter took two forms for its human subject, that of esthetic awe and that of disciplined scientific curiosity. The mining photographs, however, present a nature that had *already* been radically altered by organized human energies. They introduce another spectre, that of industry. That spectre, because it raises the issue of practice, proves to be embarrasing for idealist historiography.

How *have* art historians regarded the mining photographs of Timothy O'Sullivan? Snyder, for his part, stresses the "technical achievement" of working underground with wet plates in mines where temperatures climbed to 130 Fahrenheit. He claims that "men could work for about one-half hour at most before returning to the surface." A labour historian, Richard Lingenfelter, agrees about the temperatures but disagrees about the length of miner's shifts in the Comstock Lode: "The miner usually worked a shift of from eight to ten hours."[104] Snyder, like many art historians, seems to have given little thought to the actual conditions experienced by those who live and work in the world depicted by artists. Whatever the source of his error, he manages to condense the time normally spent underground into a period roughly suitable for the making of a wet-plate photograph. For Snyder the artist's work overshadows all other work. And so he concludes that "the strong pictorial quality of the results make the accomplishment even more remarkable."[105]

Perhaps the most curious assessment of the Comstock Lode photographs is found in the first extensive art-historical study of Western "landscape" photographs, an exhibition and book entitled *Era of Exploration: The Rise of Landscape Photography in the American West, 1860-1885*.[106] This project, while rich in information, manifests its art-historicist bias in its reference to United States government-sponsored geographical and geological surveys as instances of "government patronage," as if we were talking about some nineteenth century version of the National Endowment for the Arts. Here is how James N. Wood, curator of the Albright-Knox Art Gallery which co-sponsored the exhibit along with the Metropolitan Museum of Art, describes O'Sullivan's underground pictorial work:

> *At Virginia City O'Sullivan descended into the shafts of the Comstock Lode to photograph with an improvised magnesium flash apparatus. Taken hundreds of feet below sunlight, these were the earliest known photographs of mine interiors. O'Sullivan intuitively seized upon the structure of this subterranean world with its imprisioned population working within the shafts. Few photographers since have conveyed so intensely the claustrophobic experience underground. His image of miners waiting to descend the Curtis Shaft of the Savage Mine contains a sense of finality reminiscent of a Last Judgement while his image of a mine cave-in is simultaneously a factual record of the disaster and a strikingly abstract composition.[107]*

Evidently, these photographs are all things to all viewers. By Wood's account, they fall into at least five generic categories: technological firsts ("earliest known photographs"), humanistic social documentary ("imprisoned population"), reportage ("factual record"), religious allegory ("Last Judgement"), and, last but not least, abstraction. Thus the move is made from religious idealism to the secular esthetic idealism of modernism.

Both Wood and Snyder fail to explain adequately what the King survey party was doing in the Comstock Lode.

UNITED STATES GEOLOGICAL EXPLORATION OF THE FORTIETH PARALLEL.
CLARENCE KING, GEOLOGIST-IN-CHARGE.

MINING INDUSTRY

BY

JAMES D. HAGUE

WITH GEOLOGICAL CONTRIBUTIONS

BY

CLARENCE KING.

SUBMITTED TO THE CHIEF OF ENGINEERS AND PUBLISHED BY ORDER OF THE SECRETARY OF WAR UNDER AUTHORITY OF CONGRESS.

ILLUSTRATED BY XXXVII PLATES AND ACCOMPANYING ATLAS.

WASHINGTON.
GOVERNMENT PRINTING OFFICE.
1870.

Figure 11. Frontispiece and title page from *Mining Industry* by James D. Hague and Clarence King. Professional papers of the Engineer Department, U.S. Army, No. 18 (Washington, 1870). Lithograph by Julius Bien from photograph by Timothy O'Sullivan. Caption: "Shaft-landing of Savage Mine."

UNITED STATES GEOLOGICAL EXPLORATION OF THE FORTIETH PARALLEL.
CLARENCE KING, GEOLOGIST-IN-CHARGE.

DESCRIPTIVE GEOLOGY.

BY

ARNOLD HAGUE AND S. F. EMMONS.

SUBMITTED TO THE CHIEF OF ENGINEERS AND PUBLISHED BY ORDER OF THE SECRETARY OF WAR UNDER AUTHORITY OF CONGRESS.

ILLUSTRATED BY XXVI PLATES.

WASHINGTON:
GOVERNMENT PRINTING OFFICE.
1877.

Figure 12. Frontispiece and title page from *Descriptive Geology* by Arnold Hague and S.F. Emmons. Professional Papers of the Engineer Department, U.S. Army, No. 18 (Washington, 1877). Lithograph by Julius Bien from photograph by Timothy O'Sullivan. Caption: "Eocene Bad-Lands—Washakie Basin—Wyoming."

What importance was attached to the study of mining by the survey? Furthermore, what role did O'Sullivan's mining pictures play in the official government documentation of the expedition? If we discount a very limited number of sets of albumen prints, O'Sullivan's pictures received their widest distribution in the form of lithographic copies in three of the seven volumes of the final survey reports. Here we can begin by noting that the photograph described by Wood as "reminiscent of a Last Judgement" was published an extraordinary *seven years* before any of the now better-known pictures of geological formations. This picture provided the frontispiece to *Mining Industry* (1870), the first of the volumes to be published. Thus, this comprehensive scientific report on the West began with an image full of industrial promise. O'Sullivan's "landscapes" and "topographic views" appeared in *Descriptive Geology* (1877) and in the theoretical *magnum opus* of the survey, King's *Systematic Geology* (1878).

Thus, topical priority was given to immediate problems of mining engineering and to the geological evaluation of mineral resources. King, however, reasserted the privileged position of geological science by assigning *Systematic Geology* a numerical position as the first volume of the series. The more empirical and less theoretical *Descriptive Geology* followed as volume two, and the practical *Mining Industry* followed in turn as volume three.[108]

Clarence King outlined the goals of the project in terms that clearly revealed the conjunction of pure and applied science. The one hundred mile wide belt of land mapped by the survey team encompassed both the route of the Union Pacific Railroad and the Cordilleran mountain system: this choice of terrain was made "alike for the purposes of illustrating the leading natural resources of the country contiguous to the railroad and for purely scientific research."[109] The study of Comstock Lode mining methods had immediate practical results; King and his mining-engineer colleagues Arnold Hague and James Hague proposed major improvements in ore smelting methods and correctly predicted that deeper mining would strike richer veins of silver.

Historian William Goetzmann has argued that King, more than any other individual, "incorporated the West into the realm of academic science."[110] *Systematic Geology*, with its rigorous induction of the geological history of the Cordilleran system, was a masterpiece of nineteenth century American scientific thought. But despite the fact that King replaced the "solider-engineer"of earlier surveys with the scientific specialist, the Fortieth Parallel Survey was implicated from the beginning in larger strategies of conquest, colonization, and industrialization. We need to understand the relationship between King's voice and that of the state. Goetzmann, a cultural historian stresses a point art historians seem eager to forget:

> He [Clarence King] intended to survey the land forms of the region, map them with a new degree of accuracy . . . and he planned to examine closely all the possibilities for economic development along the line of the railroad, particularly those having to do with mining. In addition, there was the added military increment not stated but clearly in the minds of those who were concerned with subduing the Indians and settling the West. General Sherman's overall military policy . . . depended upon pushing the railroad through Indian country and with it a wedge of settlers . . . eventually overwhelming the redmen with civilization and sheer population. King's survey contributed mightily to that long range strategy. Even his scientific findings were directly relevant to military considerations.[111]

Goetzmann provides ample evidence that King was ideologically suited for this mission. As first director of the United States Geological Survey between 1880 and 1882,

King emphasized mining industry over all else; he resigned to pursue (unsuccessfully) his own mining interests. King "believed that mining and technology, rather than agriculture, were the keys to Western development." Furthermore, "he was a Whig who conceived of government as a means of helping business."[112]

One final point needs to be made about the reception of O'Sullivan's photographs. Art historians like Joel Snyder have sought to affiliate the formal severity of these pictures with King's catastrophic geological theory, which held that geological change was a matter of intermittant cataclysmic upheavals. For King, the "earth's surface-film" bore the evidence of ancient violence, and this record could·be "read" as a historical narrative.[113] Catastrophism rejected the uniformitarianism of Charles Lyell, who saw geological development as a gradual process. King gave his science a theological cast, and argued further that "moments of great catastrophe, thus translated into the language of life, became moments of creation, when out of plastic organisms something new and nobler is called into being."[114] Snyder argues in turn that O'Sullivan was ideally suited to the task of recording the static, frozen evidence of geological upheaval: he had photographed corpses in the aftermath of Civil War battles. For Snyder, "the human counterpart of explosive, natural action is war."[115] This analogy between organized political violence and geological upheaval is a commonplace yet remarkable mystification, a mystification in keeping with King's own metaphysics. How is it possible to construct a cultural history of the conquest of the American West without recognizing the instrumentality, the *social* violence, and the commercial interest inherent in that project? Snyder's interpretation is an example of the profoundly *conservative* character of photographic historiography in the United States.

Catastrophism provides Snyder with a theoretical ground upon which to effect the merger of science and the artistic quest for the sublime. O'Sullivan is presented as an artist in the Burkean mold, confronting a nature that is terrifying and awe-inspiring. The search for sublimity is extended to the mining photographs, with their evidence of underground danger and disaster. Snyder emphasizes the hellish temperatures of the mines, and the claustrophobic experience underground. Similarly, James Wood's earlier essay on O'Sullivan stresses underground imprisonment, claustrophobia, and disaster. It is worth noting that the editors of *Mining Industry* did not include any of O'Sullivan's *underground* pictures in that volume, but selected instead a neatly symmetrical view that presented a disciplined work crew about to descend into the depths. The remaining illustrations were engineering drawings of the mining machineries and the timbering system used in the deep mines of the Comstock Lode. *Mining Industry* followed in the tradition of the *Encyclopedia* by presenting ordered arrangements of mechanical components. But, with the exception of the frontispiece, the tableau or "vignette" is absent, no image of human labour or of the sheer mass of the earth is anywhere to be found. These are technical drawings; elements are presented in a virtually abstract space. (To late-modernist eyes, the diagrams of timbering systems look remarkably like illustrations of sculptures by Sol Lewitt.) The reality was somewhat different: the major disaster in the Comstock Lode during the late 1860s was a fire which raged out of control in the extensive timbering underground. In fact, it was the intensive capitalization and industrialization of mining operations in the West that brought into being a new degree of risk and danger for miners. In this case, the "sublime" resided, not in nature, but in the character of the organized human intervention into nature. I would argue that King's catastrophism was ideologically in keeping with his vision of an industrially-harnessed Western landscape.

In order to understand the transformation of the

231

sublime, we ought to turn to the work of the English art historian Francis Klingender, whose *Art and the Industrial Revolution* is an intriguing study of the ways in which the rhetoric of the sublime was applied to industry in late eighteenth and early nineteenth century England. Klingender describes a new and complex fear experienced by observers of the new industrial environment. This fear, this experience of the ''industrial''sublime, had a *social* dimension. One remark seems especially pertinent:

> *The sense of awe and terror which the middle-class visitor was likely to experience at a mine was not, however, entirely due to the strangeness of the scene, the wild appearance of the men or the danger of their work. The effect produced was heightened by a growing consciousness that the miners, and indeed the industrial workers generally, were beginning to form a distinct, ever more numerous and hostile nation.*[116]

A similar fear did not develop in the United States until the 1870s. Militant miners, particularly the ''Molly Maguires'' of the Pennsylvania anthracite fields, were to become objects of hatred in the middle-class press. The Comstock Lode was another early site of militant industrial unionism, beginning in the years just before the visit by the King survey.[117] As in Agricola's Saxony in the sixteenth century, here the making of pictures, capitalization, and the intensification of class struggle seem to have curiously coincided.

The invention of photographic dry plates in the 1880s permitted photographers to work underground with greater ease. The Smithsonian Institution commissioned a Pennsylvania commercial photographer, George Bretz, to make pictures inside anthracite mines. Bretz, like Nadar, used electric light. These photographs, and others commissioned later by the coal operators, were displayed at a number of international industrial expositions between 1884 and 1893. In the late 1870s Bretz seems to have covered both sides of the class war in the Eastern Pennsylvania coal fields. He photographed Franklin B. Gowen, president of the Philadelphia Reading Coal and Iron Company and state prosecutor in the trial of a number of the Molly Maguires. Bretz also made formal portraits of the ten convicted unionists on the day before their execution by hanging; these pictures he sold as *cartes de visite*. In the 1890s Bretz gave lantern-slide lectures on mining, with catchy titles like ''Black Diamonds.'' His career seems to be the earliest example of the kind of diversified work done in the 1950s by Leslie Shedden, combining a small-town commercial practice with documentation of the coal industry.[118]

* * *

Thus far I have discussed isolated and early examples of underground and mining photography, the sorts of examples that are easily enveloped in a mythology of origins. We need to explore the *institutionalization* of industrial photography.

Despite the fact that industrial photographs were made as early as 1850, and despite the fact that a lineage of technical realism can be traced back to the sixteenth century, the technological, economic, and ideological conditions for modern industrial documentation did not fully emerge until the very end of the nineteenth century. For our purposes here, I am defining as ''modern'' any system of documentation in which pictures are made available for circulation in mechanically-reproduced form. Before the 1890s photographic prints depicting machines and industrial operations were displayed chiefly on ceremonial occasions. At the international exhibitions, beginning with the London Crystal Palace Exhibition of 1851, the photographic print was a technological novelty in itself, and eventually a means of incorporating remote and untransportable industrial artifacts and sites (such as coal mines) into the spectacle of goods and inventions. Despite their modernity, their novel status as the

232

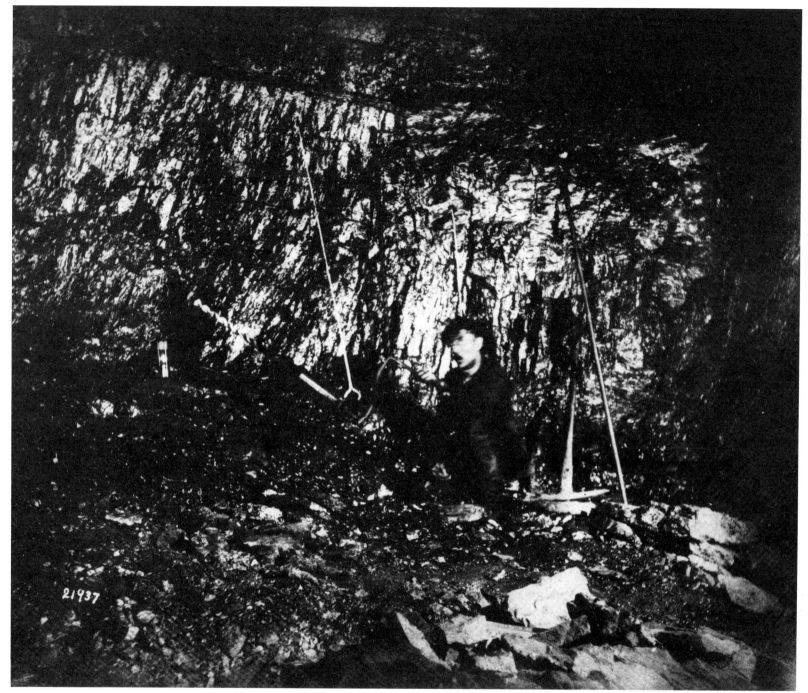

233

Figure 13. George Bretz, Face of breast, miner at work using Patent Drill or coal auger, Kobinoor Colliery; one of the first U.S. coal mine interior views by electric light, 1884.

ephemeral museums of the present, the mid-century Exhibitions adhered to an eighteenth century model of the museum. Walter Benjamin hints at the overlap of archaism and modernity in these displays: "World exhibitions were places of pilgrimage to the fetish Commodity."[119] The more modern system of display would allow the commodity to embark on a pilgrimage of its own. One form of that pilgrimage began in the 1880s and 1890s with the development of the stereograph industry. Companies like Underwood and Underwood introduced Oliver Wendell Holmes' "universal currency" into the schoolrooms and middle-class parlours of the United States. Otherwise, industrial photographs usually were translated by hand into engravings in technical publications and journals of "popular" science like *La Nature* in France and *Scientific American* in the United States. Finally, with the invention and refinement of the half-tone process in the late 1880s and 1890s, the camera and the high-speed offset printing press were made compatible. By 1900, the photograph can be said to have become the dominant form of visual culture, a form that was capable of subsuming all previous modes of static visual representation. The traffic in photographs shifted into high gear.

Archives became "active" repositories of images. Photographs were commissioned with the expectation that they would be widely reproduced. In turn, the possibilities of reproduction began to determine the character of commissions. Clearly, other technical developments of the 1880s and 1890s were crucial to the progress of industrial documentation. Hand cameras, flash powder, as well as rapid dry plates permitted photographers to work in dim factory interiors, and to record clear images of moving workers and machinery.

However, it would be a mistake to assume that the work performed by Leslie Shedden and countless other photographers before him was grounded in technological innovation alone. What larger economic and social conditions created specific and often conflicting needs for photographic documentation of industrial processes and environments?

Industrial documentation is fundamentally an outcome of the second industrial revolution, that is, of the emergence and triumph of the monopoly form of capitalism in the years between 1880 and 1920. I'm speaking here of the United States, although developments in the rest of the industrialized world more or less conformed to this pattern. The distinctive features of this transformation were these: the concentration of industrial ownership, the movement toward mechanized and largescale production, the harnessing of scientific research, the development of bureaucratic and "scientific" methods of management, and, historically last but not least, the intensified and "scientific" use of advertising to both legitimate and motivate mass consumption.

These factors all contributed to a pressing *internal* demand for images of industry. Large firms began to accumulate archives, and to employ photographers on a regular basis. Within the industrial firm, photographs were used to document capital improvements, to illustrate catalogues of industrial equipment, and ultimately to intervene directly in the labour process. These "operational" documents were seen by engineers and managers. Applied photography also became an important adjunct to instruction in engineering. (I teach at a university where instruction in photography had its origins in 1891, within a college of engineering.) In these contexts—the industrial firm, the engineering college, the professional engineering journal—the role assigned to photography was primarily functional. The image served as a convenient empirical substitute for the object, as evidence, as demonstration, as model. But this functional realism had an ideological and political-economic dimension as well. We'll return to this last issue in a moment.

The simultaneous development of a highly competitive picture press based on advertising and directed at a broad

234

public created an *external* demand for photographs of industry, although it can be argued that the essential modernist iconography of the machine was not fully integrated into mass culture until the 1920s. It should also be noted that advertising, in keeping with the logic of commodity fetishism, tended (and still tends) to obliterate the industrial origins of goods. When the factory was visible, it was visible as ''news,'' as esthetic spectacle, or as popular instruction in the wonders and workings of modernity. In these contexts, the meaning of the industrial photograph was more ideological than functional. Only in journals of popular mechanics do we find any pretense of useful instruction, a pretense made pathetic by the increasing scale and complexity of industrial production. Such journals reconstituted autonomous craftwork as a domestic hobby, but did so with a fascinated eye on the larger world of production.[120]

By 1915, the external machinery of the media was being fed images and stories by the new internal machinery of corporate public relations. Concerted efforts were made to demonstrate the progressivism, public-spiritedness, and ''humanity'' of large-scale bureaucratic enterprise. The rise of public relations was in large measure a response to vehement criticism of industrialists by trade unionists, socialists, liberal journalists, and Progressive social reformers. (One of the earliest programs in public relations was orchestrated by a publicist named Ivy Lee, who began working in 1913 for John D. Rockfeller Sr. Lee's dime giveaway scheme is a well-known attempt to combine the lessons of corporate benevolence and petit-bourgeois thrift in a single avuncular gesture. Lee also fought mightily to restore the sullied reputation of John D. Rockefeller Jr. in the wake of the 1914 Ludlow Massacre of striking Colorado coal miners and their families. It is further worth noting, especially in this context, that Lee's external efforts at ''image enhancement'' had their internal complement in an early program of industrial relations. Rockefeller hired MacKenzie King, former Canadian Secretary of Labour, to patch things up with the defeated miners. King led Rockefeller on a personal tour of the Ludlow area. In one mining town Rockefeller danced with the miners' wives and promised the residents a bandstand and dance pavillion. Ultimately King and Rockefeller were able to sell a majority of the miners on what amounted to a company union. King went on to become Prime Minister of Canada for all but five of the years between 1921 and 1948.)[121]

In social reform work especially, we find another sort of photographic investigation of the industrial environment, one that sought evidence of the social crisis engendered by the rise of monopoly capital. Historians of photography have tended to privilege this latter mode of documentation, in part because of the remarkable work of Lewis Hine, but also out of a persistent need to demonstrate the moral efficacy and essential humanism of a mechanical and instrumental medium. (This need to establish the ethical power of the photograph is almost as strong as the need to establish the esthetic credentials of the medium.) Consequently, the complex relationship between the realism of the social reformer and the realisms of the engineer and the public relations officer has been generally neglected. Especially overlooked has been the tendency of corporate officials to appropriate elements of the rhetoric and substance of social reform.

If we discount the less frequent and largely second-hand use of photographs by turn-of-the-century socialists and trade unionists (a subject which needs further study), the most obvious tension to be found in early twentieth century representations of industry existed between the discourse of the engineer and the discourse of the social reformer. Engineers worked directly for industry. Even though they were increasingly critical of antiquated methods of capitalist administration, and increasingly assertive of their own professional autonomy and expertise, engineers accepted private ownership of the means of production and viewed their own

235

profession in entrepreneurial terms. Social reformers were a more diverse group, largely a coalition of middle-class professionals—social workers, lawyers, and sociologists. Social reform groups also counted among their members some trade unionists, socialists, middle-class feminists, and even some women of the working class who had been rebuffed by the male-dominated trade union movement. The support for social reform work came indirectly from capital, through philanthropic organizations like the Russell Sage Foundation. The majority of social reformers implicity accepted the logic of private ownership, but sought to extend civil protection to the working class.

Though engineers were distinguished from reformers by their relentless obsession with Efficiency, by the middle of the second decade of the century, these two discourses began to merge, or rather, the new science of management began to absorb lessons learned from the social reformer. What emerged finally was a new paradigm of social-engineering. This paradigm accepted the need for government regulation of industry, recognized the importance of public relations and acknowledged the value of sociological and psychological considerations in the management of labour. The social reformer, on the other hand, increasingly accepted the logic of efficiency promoted by the engineering professional.

Clearly what I'm presenting here is a very schematic overview of complex historical changes. This much should be recognized: Leslie Shedden's work for Dosco, like most other industrial photography done after 1940, is an amalgam of visual rhetorics which were once distinct, and even politically antagonistic. Shedden made pictures that can best be described as "technicist:" pictures that operated within the tradition of technical realism. But he also made pictures that could be described as "humanly-interesting," and—if the word wasn't automatically assumed to be an honorific—"humanist." These latter pictures were indebted to a tradition of social realism, that is, to the realism of the social reformer. By the 1920s, that social realism had begun to diffuse, its rhetoric no longer necessarily served a reformist purpose.

What can be said of this "realism" of the engineer? During the period in question—the years between 1880 and 1920—the engineering profession constituted itself as a new and powerful agent of capital. Gradually but forcefully, engineers seized technical and intellectual control of the labour process and effectively abolished an older system of production based on the knowledge and skills of the artisanal worker. The avatar and principal architect of this movement, which came to be called "scientific management," was a mechanical engineer from Philadelphia named Frederick Winslow Taylor.

More than any other individual, Taylor realized the project that was incipient in Diderot's writings on the mechanical arts over a century earlier. Diderot proposed an alliance of artisans and men of letters, but I have argued that this alliance favoured the potential power of the intellectual observer. It was the intellectual who was to become the master of empirical language and universal learning. Taylor established the power and authority of the practical and specialized intellectual in matters of production. He grounded that power in experiment, in the exercise of authority over work, and in professional pedagogy and polemic. In so doing, he declared open war on the very category of the artisan. Less openly, he—like others of his profession—waged war on the category of the universal intellectual. His unquestioning embrace of instrumental reason, his positivist attempt to discover the scientific laws of work were both the logical outcome and the final nosedive of enlightenment thought. Taylor proposed a world in which "thought" occupied a glassed-in booth, commanding the activities of those who had been robbed of thought. In this, as Daniel Bell has suggested, Taylor actually applied the Panopticon principle to

236

the modern factory.[122]

Taylor's positivist revision of the encyclopedic project is evident in his description of the first principle of scientific management:

The first of the four groups of duties taken over by the management is the deliberate gathering in on the part of those on the management's side of all the great mass of traditional knowledge, which in the past has been in the heads of the workman, and in the physical skill and knack of the workman, which he has acquired through years of experience. The duty of gathering in all of this great mass of traditional knowledge and then recording it, tabulating it, and, in many cases finally reducing it to laws, rules, and even to mathematical formulas, is voluntarily assumed by the scientific managers.[123]

For Taylor, the artisan's "rule of thumb" was overly empirical, mired in tradition, and both unwittingly and deliberately inefficient. Workers were both ignorant of the scientific bases of their work, and guilty of "systematic soldiering," or loafing under the piece-rate method of production.

Taylor's search for a science of work extended from the skilled trades to sheer toil. His most thorough experiments, which were conducted over a period of twenty-six years between 1880 and 1906, were devoted to the perfecting of machine tool work, one of the most highly-skilled of late-nineteenth century crafts. At the other extreme Taylor wanted to determine the brute quantity, in foot-pounds, of a "maximum day's work for a first-class workman" involved in unskilled labour. This "law" eluded Taylor's grasp, although his time-study and incentive "experiments" with pig-iron handlers were central to his reputation as a scientific accelerator of work.[124]

Taylor's methods were essentially analytic: he divided work into elemental components, and used a stopwatch to determine optimum times for each procedure. Once sufficient data was accumulated, Taylor sought to redefine the labour process in a more efficient and accelerated configuration. Increased production most frequently required a subdivision of tasks. He sought further to win the allegiance of workers to these new methods of work, over which they had no control, by a system of incentive payments. In the process, Taylor greatly widened the abyss between intellectual and manual labour; planning and execution were irrevocably separated. Work itself was deskilled, fragmented, rationalized, and subjected to regular inspection. The factory became the site of bureaucratically-administered routines. Taylor repeatedly emphasized the need to "enforce" his standards. Furthermore, he referred to his system of control as a "human managing machine."[125]

I want to refer briefly here to Taylor's most exhaustive work, *On the Art of Cutting Metals,* published in 1906. This is only one of his texts which makes use of photographs. Although Taylor did not share the faith held by some of his followers in the analytic power of photography, he does seem to have recognized the demonstrative potential of the medium.

On the Art of Cutting Metals was the intellectual product of Taylor's quarter century of experimentation at Midvale Steel, Bethlehem Steel, and a number of other companies. A strict accountant, he recalled cutting up 800,000 pounds of steel in the process. The work began when Taylor, a newly appointed assistant foreman, encountered organized resistance to his efforts to increase production in the Midvale Steel machine shop. In order to win his struggle with recalcitrant machinists, Taylor developed a long-term strategy. He sought to know more than they knew, to understand the complex relationship between the factors that affected the metal-cutting process on the lathe, drill press, planer, and milling machine. He was able to isolate twelve variables, and developed an intellectual-machine for solv-

Figure 14. Folder 1. Process of Forging a Standard Tool, from Frederick Winslow Taylor *On the Art of Cutting Metals* (American Society of Mechanical Engineers, New York, 1906).

Modern Mining Practice

"Radialax" is supplied with the usual rotating device by which the bitt is continuously turned, presenting a new edge to the face at every stroke. This feature permits the machine to be used as a drill for putting in holes preparatory to blasting the coal. The change from a coal cutter to a rock drill, or *vice-versa*, can be made in a moment. Used as a rock drill, the machine has a distinct value for brushing purposes. It can also be used to great advantage as a drill in sinking shafts and driving tunnels in rock,

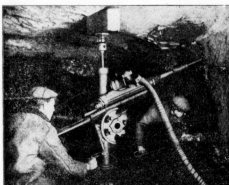

Fig. 601

in drilling through clay seams, horsebacks, spars, etc. The machine operates with compressed air and gives its best performance under a pressure of from 60 to 80 pounds.

The "Radialax" Coal Cutter is in essentials a long-stroke rock drill provided with a method of mounting specially adapted for coal mining work. The primary support is a standard single-screw tunnel column which can be furnished in various lengths from 2 to 7 feet. It has a rosette in one end and a heavy jack-screw in the other, terminating in a rosette foot-piece. With the column is supplied a very short column arm, upon which the

174

Modern Mining Practice

"Radialax" is mounted when used as a shearing machine. When the arm is used, a safety clamp or collar is mounted on the column below it, which, being bolted in place, permits the arm to be swung to any position without sliding down on the column. With position properly adjusted, the arm is secured in place by means of a heavy clamp bolt. The worm wheel sector is rigidly fastened on column or arm by means of its clamp bolts. The saddle is then mounted on the sector sleeve. It carries two cone cups, front and rear, in one of which the cone of the guide shell rests. Extending backward from the saddle is a bracket supporting a steel worm meshing with the sector teeth, on the spindle of which is mounted a hand wheel giving the swing to the "Radialax." The guide shell is very similar to the shell of the ordinary rock drill, carrying a feed screw, standards, and a hand wheel on the screw. It has also a cone fitting into the cone cup on the saddle and is secured in place by a bolt and nut which passes through the cone cup and is screwed tight on a split washer below (fig. 602).

Fig. 602

In operation the column is set up vertically about 3½ or 4 feet from the coal face and at a distance of 6 or 6½ feet from the rib, when undercutting, or about 10 inches in shearing. A substantial block of wood about 4 inches thick is placed under the footpiece of the column and a tough block of oak or other hard wood 1 inch or 1½ inch thick is placed on top of the column

175

Figure 15. From G.M. Bailes and the Professional Staff of the Bennett College, *Modern Mining Practice: A Pratical Work of Reference on Mining Engineering,* Vol. 4, (The Bennett College, Sheffield, 1909).

238

ing metal-cutting problems. This device, a slide rule, was the "embodiment" of his science. It is worth quoting his description of this invention:

The development of an instrument (a slide rule) which embodies on the one hand, the laws of cutting metals, and on the other, the possibilities and limitations of the particular lathe or planer, etc., to which it applies and which can be used by a machinist without mathematical training to quickly indicate in each case the speed and feed which will do the work quickest and best.[126]

Despite the last part of this remark, Taylor went on to suggest that this instrument was something quite different from an intellectual aid to the workman. Rather, what he was proposing was a new division of labour and a new hierarchy of control:

The slide rules cannot be left at the lathe to be banged about by the machinist. They must be used by a man with reasonably clean hands, and at a table or desk, and this man must write his instructions as to speed, depth of cut, etc., and send them to the machinist well in advance of the time the work is to be done.[127]

For Taylor, this privileged "embodiment" of the laws governing skilled work was essentially mathematical and abstract. The machine-shop was redesigned in terms of a new flow of representations: slide rule computations, instruction cards, work diagrams and so on. In his 1903 treatise on *Shop Management,* Taylor proposed a central archive or "information bureau" within the factory:

The information bureau should include catalogues of drawings. . . as well as all records and reports for the whole establishment. The art of properly indexing information is by no means a simple one, and as far as possible should be centred in one man.[128]

The visual image was for Taylor a specialized form of representation, intended for the manager and engineer. In the machine shop, it was the instruction card that conveyed the predetermined job plan to workers, who had previously been able to design their own approach to problems of production. The machinist no longer worked from a drawing of the desired part, but from an analytic and quantified list of sequential moves.

It is worth noting that the photographic plates in *On the Art of Cutting Metals* are curiously peripheral to the actual process of machine tool work. Taylor, or his editors, chose to illustrate the preliminary work of the blacksmith. Six photographs, in each of which the background has been obliterated to show only the significant details of work, depict the "best method" of forging a standard cutting tool. The plates indicate that Taylor's twenty-six years of metallurgical research so thoroughly altered machine-shop practice that the basic tools had to be redesigned and forged in a new way. Although the transformations of machinist practice would have been difficult to represent photographically, blacksmithing provided a *visible* example of a newly rationalized craft. The other photographs in the book suggest something of the extent of Taylor's empiricism: these include detailed, sequential close-ups of cutting tools in the process of forging and in the process of wear from use and microphotographs of specimens of tool steel treated at various temperatures. (Taylor concluded that microphotography provided no evidence of a correlation between the microscopic structure and the high-speed cutting ability of steel. In this, he clearly recognized a limit to photographic empiricism.)

Taylor's illustrations in *On the Art of Cutting Metals* differ from earlier technical representation in one very important sense: the revised work models presented here are based on rigorous experiment. The "truth" of these images is the truth of the *laboratory,* of an active and interventionist,

rather than a contemplative, empiricism. But Taylor's metallurgical and mechanical experiments should not be viewed in isolation from the managerial imperative that drove his work. Taylor's "truth," despite its claim to universal scientific status, was grounded in a fundamentally capitalist logic. His search for "efficiency" bent mechanistic physics to the demands of bourgeois political economy. As Harry Braverman has argued, Taylor did not invent a "science of work." Rather, he invented a *"science of the management of other's work* under capitalist conditions."[129]

Taylor's influence has been so pervasive that his project deserved some consideration in this essay. The general principles of Taylorism have been institutionalized within every modern industry. Nonetheless, since coal cutting and metal cutting are rather different occupations, I want to examine for a moment an early twentieth century work on mining engineering.

In 1909, while Herbert Hoover was busy as a consulting engineer and leisure-time translator of *De Re Metallica,* a standard reference work entitled *Modern Mining Practice* was published in England. Its five volumes attempt to consolidate all of the technical aspects of mining, from exploratory boring, to shaft-sinking, to timbering, ventilation and the machine-cutting of coal, and so on. Many of the photographs and diagrams in these volumes were taken from catalogues prepared by the manufacturers of mining equipment; in this connection the mining engineer functions as a purchasing agent of sorts, choosing among available technologies in accordance with specific mining conditions. *Modern Mining Practice* is symptomatic of the unique status of mining among industries. The text attempts to treat the coal mine as if it were a factory, subject to the same visibility and control. Nonetheless, there is no attempt to propose a "science" of coal-cutting as such, and clearly much of the knowledge of mine work presented is an appropriation of traditional miner's wisdom. Mining offered no "law," no mathematically interrelated set of twelve variables. The mining engineer remained in essence an empiricist, balancing economic and technical considerations with a reading of the quantity and quality of coal to be gotten in any one situation. It is also evident that the orderly factory-like appearance of the mine is frequently shattered by disaster. Thus, disaster itself is rationalized and prepared for; casualties are regretted but expected:

> *Dead bodies can be put on one side and covered up until it is convenient to remove and take them out. If recognized, the name should be attached to each corpse, to save time and confusion after; and when brought out all identified bodies may be put together, and those not identified, kept apart.[130]*

In a sense, the mine is treated as a machine that is prone to breakdown; the mining engineer is an energetic master mechanic, committed to the prevention of avoidable failures and to the restoration of a smooth running condition after accidents happen.

The most "modern" feature of *Modern Mining Practice* is its promotion of mechanical methods of coal-cutting. Here the logic of efficiency is most pronounced:

> *A new era in the history of coal mining is rapidly developing and the hand pick is, under favourable conditions, being replaced, whenever possible, by more effective methods. The principal reasons for the installation of mining machinery are to reduce the cost of production, to increase the output, and to ensure a market by the production of a superior sample of round coal at a consequently higher selling price.[131]*

Despite reassurances by these writers that mechanization involved "no desire to reduce the number of men," between 1920 and 1930 machine-based overproduction had led to a serious displacement of miners in the United States. (Britain and Canada lagged behind in introducing mechanization on

240

a large scale.) With the introduction of continuous coal-loading equipment during that decade, mining increasingly took on the character and rhythm of rationalized factory work. (We should note that the modernization of mining was less a matter of scientific management *per se*, than an effort to use machinery to institute a continuous flow of production. In this, mining took on the character of the assembly-line.) Miners who had worked with pick and shovel understood that a craft had disappeared. Homer Morris, an American economist who studied unemployment in the bituminous fields in the early 1930s, argued that ''mechanization is thus reducing the miner to a mere coal loader, whose chief qualification is a strong back. This changes the position of the miner from that of a craftsman to an unskilled workman.''[132] He went on to quote an older miner:

> *It takes five years for a man to learn to be a real coal miner, and some men never learn it. I would rather use the pick and shovel then to load machine coal. Anyone with a weak head and a strong back can load machine coal. But a man has to think and study every day like you was studying a book if he is going to get the best of the coal when he uses only a pick.*[133]

Morris' book *The Plight of the Bituminous Coal Miner,* was published in 1934. Following a tradition established by social reformers over a quarter of a century earlier, he used photographs to illustrate his thesis. The frontispiece is a portrait of a miner, pick and lunch bucket in hand, standing near what is presumably his home. Morris's caption reads: ''The miner wants to earn his living.'' Three years earlier a similarly dignified but artificially-lit close-up portrait of a miner appeared in an early issue of *Fortune* magazine, accompanying an article on the troubled anthracite business. The photograph was taken by Margaret Bourke-White. Here in this new modernist glamour magazine of industry, a more optimistic and harmonious note was struck:

A YOUNG MINER
He sees modernity coming to the mines. Besides the traditional art of his trade, he learns a new technique. Brawn he has and, more, machinery to help him.[134]

The editors of *Fortune* were able to celebrate technological progress and animate the ghost of artisanal work in the same article, the same layout, occasionally—as here—in the same picture and caption. *Fortune* harmonized the rhetoric of modernism and the rhetoric of humanist documentary, combining an estheticized version of engineering realism with an estheticized version of the realism of the social reformer. In order to understand the corporate ''humanization'' of the worker, we need to return to the discourse of social reform, and to the role assigned to the portrait within that discourse.

What can be said, then, of the ''realism'' of the social reformer? I want to look briefly at the *Pittsburgh Survey,* which was published in six volumes between 1909 and 1914. One early model of this sort of urban investigation was Henry Mayhew's *London Labour and London Poor,* which was published in four volumes between 1851 and 1862. Both works relied heavily on pictures: Mayhew used engravings based on daguerreotypes; the *Pittsburgh Survey* used half-tone reproductions of photographs and drawings. In all, the latter work contained over four hundred illustrations; the vast majority were photographs.

The *Pittsburgh Survey* was one of the first projects to be funded by a newly-formed philanthropy, the Russell Sage Foundation. It's sponsors clearly saw the work as an exemplary study of the social conditions engendered by modern industrialism; the ''facts'' uncovered in Pittsburgh were assumed to be relatively typical of large American cities. The director of the Pittsburgh project was Paul Kellogg, who was editor and founder of the social work journal, *The Survey.* Kellogg's introduction to the first volume of the *Pittsburgh Survey* is revealing of the ambiguous tension between

progressive social reformers and engineers in the first decade of this century. Kellogg argued that the survey supplied "a record of labour adjustments and technique in factory work such as neither mechanical nor business training offered the individual manager." He went on to tell the story of a factory tour led by a "young, enthusiastic" manager "with engineering training," who grossly overestimated the wages paid to women machine operatives. Kellogg preferred to see this misinformation as the product of ignorance rather than duplicity, and drew his moral accordingly:

> *My point is not so much the meagreness of actual wages, as the disparity between the technical equipment of this official and his ignorance of the human factors in production. He had at his fingertips the threads, the measurements, the temper, the revolutions per second—all the factors that were going into the new turbine. Yet here was human machinery, more delicate, more sensitive, of finer metal than his propeller shaft. And of this he was ignorant.[135]*

Of course, the most progressive engineers of the period, the scientific managers, claimed to have taken this "human machine" into account. But Kellogg was establishing the authority of a new professional, the *social* expert.

On the basis of its findings—which Kellogg called a "blue print" of the city—The *Pittsburgh Survey* called for a living wage, for workmen's compensation and industrial safety standards, for vocational training for young men and women, for better housing and recreation, and for an equitable policy of civic taxation.[136]

The survey sought to bridge the gap between industrial production and family life. Women were prominent among the authors of the survey, and the conditions experienced by working women and working-class families were of central importance to the study. The three volumes that were the work of single authors were all written by women:

Elizabeth Butler's *Women and the Trades*, Margaret Byington's *Homestead: The Households of a Mill Town*, and Crystal Eastman's *Work Accidents and the Law*. Butler and Byington were social workers, Eastman was a lawyer, and became a socialist as well as a feminist. Feminist concerns unite these three volumes: the economic exploitation of young women workers, the problems of household budgeting under conditions of scarcity, the pauperization of families that have lost their economic support due to the death or injury of a male worker.

If the characteristic visual images used by the engineer were diagrams, detail shorts, and excised fragments of bodies and machinery, the characteristic visual images of the social reformer were the environmental study and the portrait. We might also argue that the "social photographer" tended toward a sociologized version of family photography.

Byington's *Homestead* was introduced by Kellogg as "a portrayal of these two older social institutions, the family and the town, as they are brought into contact with this new insurgent third," the factory.[137] Accordingly, *Homestead* opens with a fold-out panoramic photograph, and establishing shot, taken from the hillside above the Carnegie Steel Works, showing clearly the worker's housing in the foreground between camera and factory. The caption reads: "To these mills and furnaces, the households of the community look for their livelihood." The spectator is placed in a position metaphorically analogous to that occupied by the working class of Homestead. It's worth comparing this view with a similar one provided in James Howard Bridge's *The Inside Story of the Carnegie Steel Company: A Romance of Millions,* an early unofficial celebration of corporate growth, published in 1903.[138] There, nestled between two other panoramas of Carnegie mills, is another view of the Homestead works. These earlier photographs were taken from positions on the opposite side of the Monongahela River from the mills. The mill towns on the hills behind are

obscured by smoke and haze. The spectator views the steel mill as it meets the river front: these pictures suggest the unceasing flow of steel and dividends.

Many of the photographs in the *Pittsburgh Survey* were taken from industrial archives. Some of these pictures simply illustrated industrial processes; others had originally been intended to exhibit measures already taken for the safety and welfare of wage earners. But many photographs had to be commissioned especially for the survey: photographers were dispatched to record family life, housing conditions, ethnic and occupational types, accident victims, conditions within the smaller workshops and conditions within the larger factories that were ignored by company photographers. The most prominent photographer who worked for the survey, the only one whose work was consistently credited, was Lewis Wickes Hine.

Hine was a sociologist by training. As a teacher at the Ethical Culture School in New York City, he began to use photography pedagogically in 1903 or 1904; he went on to photograph for reform agencies such as the National Child Labor Committee and later the Red Cross, and for the lineage of social work journals edited by Paul Kellogg: *Charities and Commons, Survey*, and *Survey Graphic*.[139]

Hine believed in both the evidentiary and honorific powers of photography. His photographs provide testimony of industrial abuses and violence, but they also dignify and "humanize" the immigrant worker. Many of Hine's photographs for the *Pittsburgh Survey* fall into the latter category; in this they are similar in function to portrait sketches by Joseph Stella which were also commissioned by Kellogg.

If we consider only the photographic representation of coal mining within the six volumes of the *Pittsburgh Survey*, we discover a broad range of images. A few photographs from coal company archives depict the latest in coal-cutting machinery. Another uncredited photograph shows families waiting at a pithead for news of a disaster. In yet another image, a miner is shown trudging wearily homeward through a mine tunnel. Thus the image of technological progress and efficiency is balanced by attention to family life, fatigue, and disaster. Hine's contribution here is especially striking. One of his portraits appears in a chapter on soft-coal mining in Crystal Eastman's *Work Accidents and the Law*. This portrait is captioned: "An English-speaking miner." (Elsewhere in the survey, the same photograph is captioned: "A Pittsburgh miner.") If we compare the reproduction with the original print, we realize that this miner has been given a bath by a retoucher, (In reality, no matter how hard a coal miner scrubs, a tattoo of coal dust remains in the creases of the skin.) Futhermore, Hine's original notes probably included mention of this miner's fluency in English, but this print has been reproduced in yet another instance with no other caption beyond an identification of the miner's Slavic background. This is perhaps a rather extreme example of one of the survey's main strategies. In a sense, the survey sought to *assimilate* this miner, to overcome his otherness for middle-class observers. Thus Hine's picture is the political and esthetic inverse of portraits of criminals and immigrants used by eugenicists and "scientific" racists during the same period, which were sometimes retouched to exaggerate physiognomic evidence of what was purported to be moral and intellectual inferiority and degeneracy.

Throughout his career, Hine remained committed to the dignity of manual work, and to the defense of artisanal values. In a stubborn and even conservative way, he resisted commodity fetishism. Late in his career, in 1932, he published his only book, a children's book called *Men at Work*. In his introduction, he argued that: "Cities do not build themselves, machines cannot make machines, unless back of them all are the brains and toil of men."[140] Hine's social realism provided a model for an American tradition of liberal and left social documentary. He also provided a model for

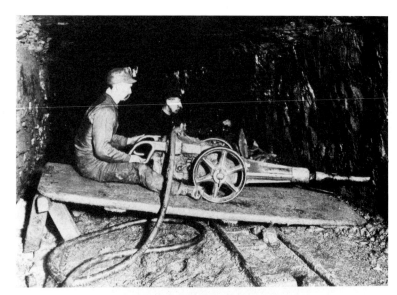

UNDERGROUND MACHINE MEN
Electric drills and chain saws have revolutionized coal digging in the bituminous field since the days of the pit miner

Figure 16. Uncredited photograph from Paul U. Kellogg, editor, *Wage Earning Pittsburgh*, 1914.

AT THE DAY'S END

Figure 17. Uncredited photograph from Crystal Eastman, *Work Accidents and the Law*, 1910.

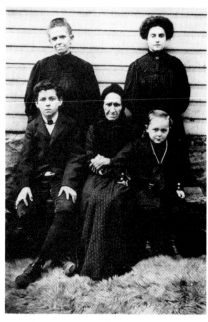

A BREADWINNER OF THREE GENERATIONS TAKEN

Figure 18. Uncredited photograph from Crystal Eastman, *Work Accidents and the Law*, 1910.

244

Figures 16-19. From Paul U. Kellogg, edition, *The Pittsburgh Survey: Findings in Six Volumes* (The Russell Sage Foundation, New York, 1909-1914).

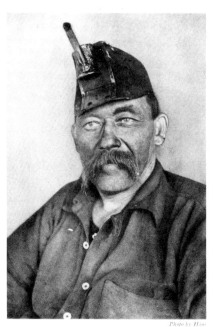

Photo by Hine

AN ENGLISH-SPEAKING MINER

Figure 19. Lewis Hine, an English-Speaking Miner, from Crystal Eastman, *Work Accidents and the Law,* 1910.

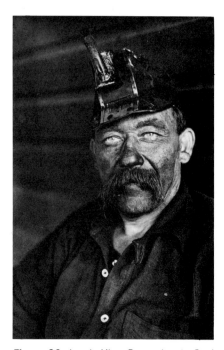

Figure 20. Lewis Hine, Pennsylvania Coal Miner, 1910.

picture editors who were less sympathetic to these values, but who tacitly understood the ideological power of honorific images in a society that objectively degraded craft. Early in his career, in 1909, Hine invoked the energy of corporate advertising in an attempt to inspire the reformers' interest in the potential value of publicity. He argued that, unlike businessmen, social workers were "only beginning to realize the innumerable methods of reaching this great public." He went on to make a statement that in retrospect seems full of unintended irony:

I wonder sometimes, what an enterprising manufacturer would do if his wares, instead of being inanimate things, were the problems and activities of life itself, with all their possibilities of human appeal. Would we not grasp eagerly at such opportunities to play upon the sympathies of his customers as are afforded by the camera?[141]

By 1915, corporate officials had begun to speak to their employees and to the public in a voice reminiscent of Hine and his Progressive colleagues.

With this we return to scientific management, and to the genesis of industrial psychology. Frank and Lilian Gilbreth were a husband-and-wife team of Taylor disciples. Frank Gilbreth had begun his career as a bricklayer, and had became a successful building contractor in the 1890s. His earliest efficiency studies had covered contracting, bricklaying, and concrete work. The Gilbreths improved upon Taylor's methods in two ways. Frank Gilbreth replaced the stopwatch with the camera, and thus replaced the rather crude time-study with a more precise mode of analysis, the motion-study. Secondly, Lillian Gilbreth supplemented the study of the physiology of work with a systematic concern for the psychology of the worker. Taken together, the Gilbreths' work involves a double movement, toward a more thorough treatment of the worker as a machine and toward a com-

pensatory "humanization" of the worker. That is, the Gilbreths attempted to convince workers that self-alienation was the key to happiness, although they wouldn't have described their project in those terms. Lillian Gilbreth saw the goals of management in this light:

The ultimate result of all this physical improvement, mental development and moral development is increased capacity, increased capacity not only for work, but for health, and for life in general.[142]

In their writings, scientific management takes on the character of a *total system,* a system that extends beyond the factory and throughout the entirety of daily life. (According to two of their twelve children, who later wrote a genial family memoir, *Cheaper by the Dozen,* the Gilbreths sought to embody the principles of efficiency in nearly every aspect of their family life.)[143]

Frank Gilbreth claimed in 1916 to "have found the photographs [to be] the most valuable of records, and to have used it continuously since 1892."[144] The context for this remark was their joint work on *Fatigue Study: The Elimination of Humanity's Greatest Unnecessary Waste.* The Gilbreths described a process remarkably similar in its general features to the work of the social reformer. "Fatigue study" began with a "fatigue survey;" this survey was the "*systematic* study of existing conditions" in the factory.[145] The Gilbreths acknowledged that "some managers are not willing to allow their work places to be photographed when they realize that such phtographs will live as "before and after" records."[146] Like Lewis Hine, the Gilbreths recognized the need for written explanations to accompany the photograph. Furthermore, they understood the importance of archival ordering of survey findings. Again, like Lewis Hine and like Diderot, they regarded the visual image as a way of knowing efficiently, rapidly, "at a glance."[147] The prin-

245

ciple difference between the Gilbreths and the social reformers lay in their differing notions of "waste." The reformers had an expansive and profoundly social image of waste. Lewis Hine, for example, produced a montage-poster on child labour entitled "Making Human Junk." (We should note here that historically the abolition of child labour was a necessary and "efficient" step in the development of monopoly capitalism, even though the child labour debate was conducted largely on moral grounds. Even so, there is more than a hint of economism mixed in with the irony of Hine's metaphor.) The Gilbreths, on the other hand, viewed waste in reductive terms. Although they regarded fatigue as a problem involving physical, physiological, psychological, and environmental factors, the ultimate terms were economic, terms dictated by the capitalist need to increase relative surplus value. For the Gilbreths, of course, this imperative led to utopia. Increased productivity was the "one best way" to an era of permanent prosperity.

Between 1911 and 1912, Frank Gilbreth developed his method of photographic motion study. Essentially, his techniques refined and applied to industry the methods developed by Anglo-American photographer Eadweard Muybridge in the late 1870s and the French physiologist Etienne Jules Marey in the 1880s. Gilbreth used a geometrical grid, as did Muybridge, in his later work, to allow for precise measurements of motion paths. Implicity, Gilbreth sought an analytic geometry of work: unlike the use of gridded "veils" by Alberti, Leonardo, and Durer as an aid to perspectival construction, the aim here was analysis rather than synthesis.[148] On the basis of this analysis, work would be reconstructed.[149]

Gilbreth's *chronocyclegraph* was a modification of Marey's *geometrical chronophotography*. Both methods involved the recording of an abstract, geometrical trace of movement on a fixed plate. Marey had attached luminous tape to the black hooded costumes of his models, who went through their paces in front of a black backdrop. Thus, a sequence of instantaneous, linear configurations was registered in white on a black field. For Marey, the geometrical chronophotograph provided the clearest evidence of the essentially *mechanical* character of human and animal movement. Along with less abstract, figurative chronophotographs, these images were seen by Marey as pedadogical as well as research tools:

> In order to render chronophotographs of movement more instructive, these images should be taken from very strong and competent atheletes.... These champions will thus betray the secret of their success, perhaps unconsciously acquired, and which they would doubtless be incapable of defining themselves.
> The same method could equally well be applied to the teaching of movements necessary for the execution of various skilled industries. It would show how the stroke of a skilful blacksmith differed from that of a novice.[150]

The echoes of Diderot are explicit here.

Marey's proposal was realized fifteen years later by Frank Gilbreth, with profound consequences for the "skilled industries." Instead of luminous tape, Gilbreth attached small lights to the hands of his experimental subjects. Gilbreth was able to digitalize this analogue trace by pulsing the electric current to the light: in effect, a sequence of directional "arrow heads" was registered. In the interest of temporal precision, and in order to combine time-study with motion study, he included a clock within the frame. He also used stereo cameras, so that movement could be perceived in three dimensions, and so that wire models of "paths of least waste" could be made for workers' edification. And, because some workers didn't like being watched, he invented a worker-activated automicromotion device, a mode of self-surveillance. With a quasi-Germanic love for the splicing of words, Gilbreth named the most complicated of these

FIG. 16

FIG. 17

Figure 21. Plate from Frank B. Gilbreth and L.M. Gilbreth. *Applied Motion Study* (Macmillan, New York) 1919.

Figure 16: *"First photograph of wire models showing one man's progress in learning paths of least waste. These wire models represent the paths of the left hand of a manager on a drill press — a machine which he had not touched in twenty-five years."*

Figure 17: *"Chronocyclegraph showing two cycles of a foreman's left hand on the same machine — showing habits of 'positioning' before 'transporting load'."*

machines the *autostereochronocyclegraph apparatus.*[151]

Micromotion study provided the Gilbreths with the basic elements of work. By 1916, they were able to identify seventeen basic movements which were taken to be constitutive of all human productive activity. They christened these elements, *therbligs.* Once work was analyzed in this fashion, the "one best way" of working could be determined. As Lillian Gilbreth put it, this process "functionalized" the worker:

> *Under Scientific Management, the worker as well as the foreman is a specialist. This he becomes by being relieved of everything that he is not best fitted to do, and allowed to concentrate on doing according to exact and scientifically derived methods, that work at which he is an expert.*[152]

But despite this celebration of expertise, she recognized one fundamental psychological difference between managers and workers:

> *It is not every man who is filled by nature to observe closely, hence to plan. To observe is a condition precedent to visualizing. Practice in visualizing makes for increasing the faculty of constructive imagination. He with the best constructive imagination is the master planner.*[153]

Photographs, films, and wire motion-models served a pedagogical role similar to that proposed by Marey. These images presented the worker's own capabilities as a "thing apart," and as an *abstraction.* Marx understood this process well in advance of its systematization by the Gilbreths:

> *What is lost by the specialized workers is concentrated in the capital which confronts them. It is as a result of the division of labour in manufacture that the worker is brought face to face with the intellectual potentialities of the material process of production as*

247

the property of another and as a power which rules over him. This process of separation . . . is completed in large-scale industry, which makes science a potentiality for production which is distinct from labour and presses it into the service of capital.[154]

Furthermore, the Gilbreths regarded workers as people who had to be *shown* possibilities that they themselves were incapable of thinking. (There is a distinct element of biological determinism in Lillian Gilbreth's hierarchy of "visualizers" and "non-visualizers.") It was the manager who controlled the abstract theory of work; the worker was left with a merely mimetic, imitative, visual empiricism. (Or, as Lillian Gilbreth put it: "Imitation is Expected of All.")[155] In Charles Saunders Peirce's terms, the worker was stuck in the realm of icons and indices, while the manager roamed the high ground of the symbolic. And, as in Peirce's hierarchy of signs, the worker could "assert nothing."[156]

The Gilbreths' eagerness to fragment work was matched by a desire to treat the worker as an "individual." They argued that managerial selection of the proper worker for the job had to take into account as many as fifty or sixty variables, including "anatomy, brawn, contentment, and creed."[157] Lillian Gilbreth argued that the very process of industrial surveillance had a laudatory effect upon the worker. In one of the more fantastic passages in their writings, she claimed that the keeping of separate records on each worker fostered "the spirit of individuality." as part of this argument, she drew an analogy with the performing arts:

. . . the world's best actors and singers are now grasping the opportunity to make their best efforts permanent through the instrumentality of the motion picture films and the talking machine records. This same feeling, minus the glow of enthusiasm that at least attends the actor during the work, is present in more or less degree in the mind of the worker.[158]

Lillian Gilbreth seems to have seen records as a way of lending continuity, coherence, and a sense of self-worth to episodic and interrupted work histories:

With the feeling that the work is recorded comes the feeling that work is really worth while, for even if the work itself does not last, the records of it are such as can go on.[159]

She was shrewd in portraying a mode of documentation that was in management's interest as a benefit to the worker. In a sense, the work record was a "positive" version of the criminal record perfected by Alphonse Bertillon in the 1880s. The worker had to assume that he or she was followed by this schematic biographical text. The work record had obvious utility when jobs were scarce and the employment office could pick and choose on the basis of documented work histories. But Gilbreth was writing her treatise on management in a decade when the reverse was true: jobs were plentiful and labour turnover was the bane of every manager committed to efficiency.

Quitting was one form of work resistance, an ultimate expression of dissatisfaction. David Montgomery has noted that quitting and the "celebration of national holidays in defiance of foreman's threats, 'blue Mondays' and binges . . . were not the only ways immigrants coped with the new industrial setting." Workers also resisted on the job in informal groups: "Older hands taught newcomers the techniques of survival and the covert forms of collective resistance — 'lift it like this, lotsa time, slow down, there's the boss, here's where we hide, what the hell!' "[160] Just as the criminal record was an archive, a "bringing to light" of aliases and past offenses, the work record was a potential register of incidents of soldiering and resistance. Like the Panopticon, the work record enforced its discipline simply by being known to the worker.

Lillian Gilbreth understood that stern disciplinary

measures would be met with resistance, and thus, she introduced an element of charm, an appeal to narcissism, into her program. (Frank Gilbreth also is remembered for his jovial relations with workers.)[161] Significantly, photography was seen as a reward, a token of managerial approval, as well as a pedagogical instrument. The *operational* value of the photograph was supplemented by an *ideological* function. The motion study became an honorific portrait:

> The photographs of the "high priced men," copies of which may be given to the workers themselves, allow the worker to carry home a record and thus impress his family with what he has done. Too often the family is unable by themselves to understand the value of the worker's work, or to appreciate the effect of his home life, food, and rest conditions upon his life work, and this entire strong element of interest of the worker's family in his work is often lost.[162]

The photograph became a reward, a trophy, the visual equivalent of a gold watch.

Furthermore, Lillian Gilbreth saw the industrial photographs as a means of reintegrating factory-life and family-life, thus fusing together by industrial and imaginary means the two spheres of existance that had been separated by industrialism. Her utilitarianism could not resist the attempt to combine pleasure and pedagogy. And, her pedagogy extended to the family, and particularly to housewives. The photograph functioned as an advertisement of sorts, urging the housewife to consume in a rational and informed fashion. In this, her proposal intersects with attempts to apply the principles of efficiency to domestic economy.[163] Overall, the logic of social reform would seem to be operating in reverse. Industry is not being challenged to address the needs of working-class families, but rather working-class families are being asked to accommodate their habits to the demands of industry. In fact, this is not so much a reversal, as it is a *fantasy* of a new synthesis, a synthesis grounded in increased production, an end to scarcity, and "the elimination of that most wasteful of all warfare — Industrial Warfare."[164]

The double system of images employed by the Gilbreths, the engineer's abstraction and the psychologist's familial realism, can be seen as the modernist version of Marcus Aurelius Root's photographic program for nineteenth century America. Certainly their use of photographs combines surveillance and sentiment, reification and moral instruction, reification and pleasure. In this sense, the Gilbreths can be said to have completed the invention of the picture-language of industrial capitalism. In its "advanced" form, that language speaks with three overlapping voices: the voice of surveillance, the voice of advertising, and the voice of family photography.

III

Pictures from the Deeps

Still pictures remain the surest way to attract the deserved share of public notice for an industry. Once obtained, the photographs are always available for use. To identify the subject and win understanding, each picture must be attractive and clean in details.

Many people were involved in attaining the photography standards of these catalogues. First to become involved are the employees whose common sense and interest and pride causes them to keep facilities and equipment attractive enough to photograph. There was planning for the picture, the photographer making the exposure and finally the printing. All deserve credit!

Full value and better exploitation of the industry's great picture-potential is only possible through maintenance of the service and through improvement. Your thoughts will therefore be welcomed.
Introduction to catalogue of Dosco photographs[165]

If you go down there being the big "I am," the miners will tell you to go to hell: "Take your godamn pictures."
Leslie Shedden[166]

Nova Scotia — Canada's Ocean Playground
License plate slogan

This essay is a triptych of sorts: two small panels flanking an historical panoroma. A dangerous metaphor, one that I have tried to undermine: Can historical writing be so easily equated with the making of pictures? Another metaphor comes to mind, borrowed from the German novelist Alfred Döblin, who wrote in 1929 an introduction to a famous book of photographic portraits by August Sander, *Antlitz der Zeit* (Face of the Times). After a long discussion of the relationship between typology and individuation in portraiture, Döblin turned to some final specific comments on Sander's work. As he made this transition from the general to the specific, Döblin commented: "This essay is like a huge balloon which is carrying a small gondola." Another dangerous metaphor, or one with hint or self-mockery. In English, of course, we think immediately of hot air.[167]

But I had something other than a balloon in mind when I began this essay. I did not want this text to allow you to drift over these pictures, guided by an invisible force. (That's not what Döblin wanted either.) Rather, what, *we* had in mind—and it's important to stress the collaborative character of this project—was a picture book which allowed pictures to exercise their considerable power, to offer their density of meaning, *and* a picture book which developed the critique of picture books. We wanted the reader to be able to think differently about the history of work, industry and everyday life, and to be able to think differently about the ways in which history is normally represented. In Michel Foucault's sense, this book is a "tool kit" for the reader.

Class conflict is not simply economic and political in character. It is also a conflict of representations. (This is true of all dynamics of exploitation and resistance, especially those that are configured around gender, ethnicity, and race.) We might make a rough inventory. Every ruling class invents images of itself for its own entertainment and edification. Every ruling class invents images of itself for the entertainment and edification of the subordinate classes. Every ruling class invents two basic types of images of the subordinate classes: images for the ruling class' own entertainment and edification, and images for the entertainment and edification of the subordinate classes themselves. Finally, every subordinate class constructs an image of itself, and of the ruling class, which does not entirely conform to this invention from above. Something else, something resistant and resiliant and hopeful, is retrieved from the slag heap of dominant culture, from tradition, from "popular memory," from political struggles and from everyday experience. These representations are, for the most part, invisible to the domi-

250

nant culture, although particles of gesture and mannerism are appropriated from time to time by an omnivorous culture industry, enjoyed upstairs, vitiated and fed-back to the people downstairs. (Yes, I know there's a utopian aspect to *Saturday Night Fever*, but when the anarchist Emma Goldman said quite sensibly that she didn't want to have anything to do with a revolution that didn't allow for dancing, she wasn't suggesting that the former be abandoned for the latter.)

This is a rather crude inventory of representations and it leaves out a vast middle ground, and a process of mediation. One of the marvels of advanced capitalism is the development of a huge "professional and managerial" sector. This sector, or "class," is made up of "experts" and "specialists:" teachers, engineers, social workers, health care professionals, media professionals, and so on. Some members of this group are high level corporate managers, and share in company profits. Others are small entrepreneurs, often organized in economically and politically powerful professional organizations. Still others, the vast majority, experience more or less proletarianized conditions of wage work. Two points have to be made here. First, the work of representation is grounded in this sector. Here are the administrators, entrepreneurs, and detail workers of sounds, images, texts. Here are writers, directors, graphic artists, photographers, and so on. Second, this sector takes on a central *imaginary* importance within the culture of advanced capitalism: advertising addresses everyone as if they were members of this vast "middle class." To the extent that if work is mentioned at all, it is always "expert" or "professional" work, with the possible exception of certain fantasies of male-bonding and brawny outdoors adventure. The photographer also has come to embody a certain professionalism. So in some senses, the photographer is obviously positioned between capital and labour, as a professional or small entrepreneur. Furthermore, the photographer mediates *between* capital and labour, acting as kind of middle-man in the unequal traffic in

representations. Finally, it is the work of the industrial photographer and the advertising photographer that helps construct the phantasmagoric middle ground, the ground upon which "we're-all-in-this-thing-together-and-our-interests-are-identical." We've seen the development of this program in the writings of the Gilbreths.[168]

With the notion of a conflict of representations in mind, suppose we return to the archive. We need to know more about the photographic culture of Cape Breton. I have in mind a group of floating captions, short meditations on these pictures and their making, and on the reception of photographs in Cape Breton.

The Working-Class Sublime

The coal mines of Cape Breton are known as The Deeps. The bituminous fields around Glace Bay extend out beneath the ocean floor for several miles. So the distance between the miner and the sky is measured in salt water, as well as rock and earth. A story floats around industrial Cape Breton about a novice miner, making his first trip to the coal face. One of his companions, an experienced miner, smuggles a fresh fish along for the ride. I like to think that this fish is a flounder. When they reach the spot where the day's shift will be spent, the fish is surreptitiously deposited in a crack in the coal seam, somewhere up near the roof. Suddenly the trickster shines his lamp in that direction and remarks that the mine must be springing a leak.[169]

Tricks like this are common to workplace culture, and serve as apprenticeship rituals of sorts. But there are other dimensions to this story. Mining may be the antithesis of farming, but coal mining in particular often occurs in farming regions. Historically, miners have often come from farming backgrounds, or have harboured the desire to farm. This has certainly been true in Cape Breton, but there another maritime mode of living and working has traditionally

beckoned. The flounder in the mines is a momentary recognition of that other mode of work, the work of the fisherman and coastal sailor: dangerous, often poorly rewarded, but open to the sky. But this is rather remote from the underlying purpose of this fish performance. That purpose is a kind of ritual exorcism of the terror inherent in underground work. The sublime is named, mocked, and invoked repeatedly in stories, gestures, and jokes. Again, this way of dealing with the ever-present dangers of industrial work is common to workplace culture. Stories of accidents and disasters may be told and retold in grim detail, and become part of an oral tradition. I'm not entirely sure how to think about this. There are strong elements of mourning, of rage, and even a certain fatalism in these stories. Clearly the essentially aristocratic and bourgeois concept of the sublime that we've inherited from the eighteenth century is inadquate to explain the experience of people whose lives are expended in the material domination of nature. The category of the awed spectator does not apply to those who live with the violence of machines and recalcitrant matter.[170]

The Protocols of Disaster

Despite the facts that the verbal culture of mining communities may dwell on the grim aspects of industrial calamities, miners also respect certain protocols in times of crisis. In this, we can detect a certain resistance to the machineries of public spectacle. Miners actively resisted the making of what Roland Barthes called "shock photographs" or "traumatic photographs." I have one example in mind. In order to make this example worthwhile, I need to introduce another photographer, and describe the flow of local news photographs for one week in 1952.

During the 1950s, the major newspaper in Cape Breton was the *Post-Record* (now the *Cape Breton Post*) published in the steel-mill city of Sydney, a few miles from Glace Bay.

(A rival newspaper, the *Glace Bay Gazette,* was published by the United Mine Workers. This paper made only minimal use of local photographs.) Between 1942 and 1975 the chief photographer of the *Post-Record* was John Abbass, who operated a successful commercial studio in Sydney. He worked for the newspaper on retainer. In the newspaper, Abbass emerges as something of a local celebrity, his pictures were frequently captioned with more than a by-line. In effect, the *Post-Record* treated its news photographer not as an objective and invisible reporter, but as a prominent and energetic artist of the news. Example: On July 7, 1952, the paper's front page story treated a major freight derailment. The featured photograph depicted a flast-lit jumble of freight cars. The caption read:

> *Johnny Abbass, official photographer for the* Post-Record, *assisted by his brother Frank, shot this impressive picture at 11 o'clock last night. It was a time exposure multi-flash photographic job.*[171]

Two days later, the major news was a communist victory in Korea. At home, the big story was a summer heat-wave. Abbass' cover photo depicted kids escaping the heat in a wading pool; one girl was caught "as the photographer snapped her stretching her bubble gum"[172]

The next day, things got worse. There was an explosion in the Number 20 mine; six men were killed, another was injured and died shortly after. Abbass' front page photographs were a portrait of a miner who had risked his life in an attempt to reach the victims, and a group picture of the draegermen, or mine rescue team. The paper complained about the treatment of reporters:

> *Dosco and union officials kept last night's mine fatality a secret for nearly three hours, and when the grim news finally got to the press, reporters and photograhers were given a rough reception...*

Figure 22. Front page of the Sydney *Post-Record,* Wednesday, July 9, 1952. (Beaton Institute Archives).

Figure 23. Front page of the Sydney *Post-Record,* Thursday, July 10, 1952. (Beaton Institute Archives).

Company police blocked off the privately-owned mine area and a reporter trying to gain the pit head said he was slightly manhandled.

A company watchman relieved a Sydney Post-Record *photographer of his camera and the only picture of the rescue activity. The camera-man was escorted behind the restricted area.*[173]

The paper presented a picture of official obstruction, of a bureaucratic attempt to interfere with the public's right to know. Tactfully, the blame was distributed evenly between company and union. In a recent conversation a long-term resident of Glace Bay recalled the disaster, and recalled stories of that night's events at the pit-head. Five of the men who were killed were Black. As the bodies were brought up from the pit, pushy photographers met with anger from some of the assembled miners. A camera was confiscated, and someone threatened to "throw the son-of-a-bitch down the shaft."

On the occasion of even bigger mine disasters, such as the Springhill Mine explosion of 1956, in which thirty-eight miners died, the *Post-Record* printed its headlines in red ink, and Abbass' photographs were printed on a pink ground.[174]

So, in certain moments of frustration, anger, and grief, relations between the picture press and working people in industrial Cape Breton seem to have been strained. But things quickly returned to normal. The day after the 1956 disaster the *Post* ran what seems to have been a regular advertisement:

POST-RECORD PHOTOGRAPHS
May be purchased from either Abbass Studios . . . or by ordering from the Post-Record *Advertising Department.*

Appointments for picture-taking of weddings, parties, and other events may be made by contacting Abbass Studios, official photographers for the Post-Record.[175]

The combination of press work and commercial work by a simple photographer seems to have been a common practice in Nova Scotia during the 1950s. Also, John Abbass seems to have had a particular knack for combining news work with business promotion.

Craft, Commercial Optimism, and Hard Times

The demand for portraits is high in times of war, and in regions from which migration is common. Shedden Studio opened in 1916, and by 1942, when competing studios opened in the area, David Shedden was able to claim the virtues of experience in his advertisements. Like his father, Leslie Shedden considered himself primarily a portrait photographer; the technique and commerce of portraiture had provided the substance of his apprenticeship and training. In effect, Shedden came to regard portraiture as his *art*, in the older artisanal sense of that term. It was to portraits (and to landscapes) that the work of the hand applied. These were the pictures that, in their most refined and honorific form, were painstakingly hand-coloured. Within the hierarchy of offerings of a commercial portrait studio, these were the most labour-intensive, and hence the most expensive, items. As Thorstein Veblen has suggested, the honorific properties of such objects depend upon the display of gratuitous handwork in an age of mechanization. Such pictures are a popular grasp at the pedestal occupied by traditional portrait painting. It's interesting to note that Shedden resisted the use of colour photographic materials even when they became widely available. In many ways, Shedden remained committed to a model of commercial photographic practice that developed during the nineteenth century. In this he was not at all unique. His industrial and advertising photographs accept the demands of realism, and sought the truth of well-lit and sharply-focused details. His portraits seek the enobling effect of light and applied colour.

Shedden had a distinct sense of the division in his work, the boundary between *job* and *craft*:

> *Of course I was interested in every picture I took. I was interested in quality. After all, the people in the Dominion Coal Company hired me to take these pictures, and if after 2 or 3 trips in the mine I came up with mediocre results or even poor results, I was sure they wouldn't call me back. Artistic expression wasn't there at all. I was basically a portrait man, myself, and the artistic end of it came into that. I was definitely interested there. But not with the commercial work I did with the Dominion Coal Company.*[176]

Shedden moves here from the slight uneasiness of the *employee* to the confidence of the self-employed artisan. He remained the model of a photographic craftsman and small entrepreneur. In some ways his attitudes were characteristic of older ways, ways that have been eroded by franchise capitalism and the modern fragmentation and specialization of photographic work. The diversity of his work is rare nowadays; most commercial photographers specialize. But in a region of small towns and industry, Shedden and other photographers like John Abbass were provided with a wide range of commercial opportunities, thus combining genres that are separated in more urban areas.

There is another aspect to Shedden's traditionalism. As in many rural industrial regions, regions controlled economically by absentee corporations, small-business people in Glace Bay were traditionally sympathetic to the working class. The labour wars of the 1920s involved a remarkable unity of the local population against corporate power and military force. A similar unity was exhibited in the struggle to nationalize the steel and coal industry with the demise of Dosco in 1967. Leslie Shedden expressed a genuine respect for working people, and remembers his childhood glimpses of the troubles of the 1920s with a strong sympathy for the

miners. Shedden's vision of business was a restrained one. His status in Glace Bay was perhaps somewhere between that of a physician and a pharmacist. He understood his role as an archivist of family life, as someone to whom customers would return on commemorative occasions. Thus his attitudes toward business stressed continuity and professional good-will. He started with one studio, and ended with one studio, which continued with his family name under a new owner.

By way of contrast, Shedden's counterpart in Sydney, John Abbass, was the model of the expansionist small entrepreneur. Abbass recognized the drift in photographic markets toward home photography and commercial photofinishing. By 1981, Abbass owned his one studio, three processing plants handling orders from five-hundred dealers throughout the Maritimes, and eighteen retail camera stores.[177] Studio photography itself is increasingly rationalized. The younger commercial photographers in Cape Breton advertise their "professional training." Nowadays, apprenticeships and summer school experiences like Shedden's have more or less disappeared in favour of costly and concentrated study of technique and business methods at commercial art academies. In general, this tendency leads to a further homogenization of photographic styles, and to a certain regularization of fashionable innovation in portrait work. Regional and individual mannerisms tend to fade, although young commercial photographers may seek out other avenues from those that beckon from their studio windows.

Leslie Shedden contributed to the promotion efforts of other local entrepreneurs. His photographs of store fronts, of shop displays, of posed merchandising gestures, of local trade fairs (the regional outgrowth of the nineteenth century world exhibitions) helped sustain a spirit of commercial optimism in a region with high unemployment and labour migration. Beginning in 1945, industrial Cape Breton was increasingly infused with Americanized consumer

culture, although the local version was more modest than that which took place in central and western Canada or in most of the United States itself. Shedden chronicled the arrival of television in Cape Breton, and even made stills for local television commercials. He also charted the appearance of chain-store and franchise economy, and he recorded the local versions of national brand-name promotion schemes.

It seems arguable that a once vocal and militant working-class culture was more or less submerged during the Cold War. Earlier, in 1942, when the United Mine Workers began publishing the *Glace Bay Gazette,* a notice ran:

> BROTHER: *This is your newspaper. You have a vital stake in it. It is vital to your community. Don't let any misinformed person tell you differently. Ask your union officer anywhere. Your Paper—The People's Paper.*[178]

By the late 1940s, this voice, while still present, was muted. The 1950s Sydney *Post-Record* was full of anti-communism and optimistic reports on the latest American weapons. The only movies showing at the new drive-in theatre and four older movie houses in Sydney in 1952 were Hollywood productions. A vision of modest affluence descended upon a region in which times were still tough, and jobs often could only be found by moving to the factories and offices of southern Ontario. A vision of a nuclear family, of a natural harmony between the waged work of men and the unpaid work of women descended upon a region in which women *had* worked at industrial jobs during the war and *still worked* in other areas of the local economy. This vision of the nuclear family also descended upon a region in which extended ethnic kinship ties remained strong, despite the pressures of migration.

It goes without saying that Leslie Shedden's advertising pictures address the workers of industrial Cape Breton as consumers. But this mode of address is also present in some of his employee-relations pictures for Dosco. In these instances, he documents the giving of commodites—radios, ashtrays, luggage, lamps, cutlery sets and so on—as tokens of managerial approval. Office workers, and particularly women, seem to have been the main recipients of these gestures of good will. Often the occasion was the retirement of a woman who was about to be married, thus passing from the paid to the unpaid work force.

When working people came to Leslie Shedden for a portrait, it was always a special and honorific occasion. The studio provided an abstract but privileged ground for the presentation of the self. These photographs do not provide us with the same sense of everyday life and leisure that we might find in a collection of casual family snapshots. When these formal portraits are grouped anonymously in a book, their emotional effects are muted, or shifted to another *social* level of identification and projection. For those who know and remember these anonymous sitters, the original effects are, I would think, present once again, but in a fashion that is also transformed by this new, more widely social context. In this wider context, the *economic character* of ceremonial occasions becomes evident. Graduations, weddings, and the like are layered in sentiment, but underneath lies a bedrock of economic constraint. Young people enter the economy to find work, not to find work, to migrate, to marry. Weddings still ritualize what the anthropologist Claude Levi-Strauss called the "exchange of women." The family, still the unit of social reproduction, is itself reproduced.

A number of ironies—the ironies of economic underdevelopment—emerge. Leslie Shedden made yearbook pictures for all six of Cape Breton's nursing schools, documenting the arrival of new students and making portraits of administrators, faculty, and graduates. Cape Breton exports nurses to the rest of Canada. Health care in the region itself remains inadequate. Serious cases have to be rushed to Halifax, over four hundred kilometres to the southwest

of industrial Cape Breton. Furthermore, the only major facilities for the treatment of industrial diseases are found in Halifax hospitals. Another irony is found in a 1956 decision by the Sydney school board, reported in the *Post-Record:*

> *A school board meeting decided last night to allow only group photographs to be taken in Sydney schools. In making the motion, alderman Carl Neville said the taking of individual photos was becoming too big a burden on parents. He also said the value of group photographs in later life was far greater.*[179]

And so here was another kind of community resistance to photography, directed this time at the pressures of the commercial photographer.

Those in Darkness, Those in Light[180]

The actual experience of a coal mine is quite unlike anything that can be depicted in a still photograph. (But then the equation of the photograpic images with "experience" is always problematic.) The darkness in mines is penetrated only intermittently and meagerly by miners' lights. The dangers of the mine are either invisible, or are compounded by the darkness. Literary descriptions and miners' stories are frequently more revealing of claustrophobia, darkness, and phenomenal duration than any photograph could be. I'm thinking here especially of George Orwell's *The Road to Wigan Pier,* with its rigorous attention to the heat, dust, noise, darkness, and, above all, the experience of time and exertion underground.[181]

Leslie Shedden's photographs of coal mines conform to the Encyclopedic paradigm. Here are clean, well-lit tableaux. There are two kinds of stasis, both uncharacteristic of normal events in the mine. First, there is the overt stasis of the "pose," of a group of managers or miners standing self-

consciously in front of the camera. For the miners it was a momentary break. For the managers it was a momentary performance as miners. Second, there is a duplicitous sort of stasis, a stasis which poses as movement. A machine is shown "in action," cutting into the coal face. But if this were true the camera would have registered a black fog of coal dust.

Shedden used light to introduce the codes of classical perspective into the mine. His tunnel and longwall-face photographs are quite remarkable in this regard. These were frequently multiple exposures, involving the incremental movement of lights away from the camera and toward a vanishing point. In one picture of a rectangular longwall-face, what we see is a receding series of luminous frames, diminishing in size as the vanishing point is approached. In another photograph, Shedden's method is revealed: we see the ghostly figure of his underground assistant repeated three times.

Why were so many photographs taken of machinery, and so few of miners? Shedden is very direct on this point: "We didn't go down in the mines to take pictures of workmen, we went down to take pictures of machinery, of equipment."[182] It was only at the end of a picture session, which required the assistance of the miners in positioning cables and equipment and in occasionally posing behind the controls of a mchine, that the mine manager would suggest that Shedden take a group portrait as a reward. Certainly, in most of these photographs, miners are either absent, or are seem as mere "appendages to the machine." Dosco, of course, was not just a colliery company, but was also a manufacturer of mining machines. Don Macgillivray's essay in this book describes well the problems of the Dosco Miner, the Edsel of continuous longwall mining machines. Nonetheless, during the 1950s and early 1960s, this machine was doubly important to the directors of the Dominion Steel and Coal Company. Here, they

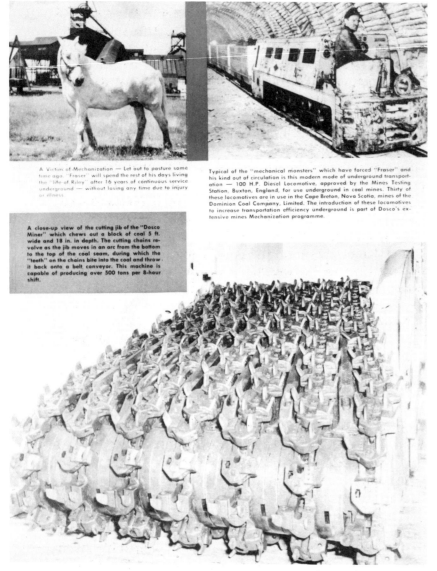

A Victim of Mechanization — Let out to pasture some time ago. "Fraser" will spend the rest of his days living the "life of Riley" after 16 years of continuous service underground — without losing any time due to injury or illness

Typical of the "mechanical monsters" which have forced "Fraser" and his kind out of circulation is this modern mode of underground transportation — 100 H.P. Diesel Locomotive, approved by the Mines Testing Station, Buxton, England, for use underground in coal mines. Thirty of these locomotives are in use in the Cape Breton, Nova Scotia, mines of the Dominion Coal Company, Limited. The introduction of these locomotives to increase transportation efficiency underground is part of Dosco's extensive mines Mechanization programme.

A close-up view of the cutting jib of the "Dosco Miner" which chews out a block of coal 5 ft. wide and 18 in. depth. The cutting chains revolve as the jib moves in an arc from the bottom to the top of the coal seam, during which the "teeth" on the chains bite into the coal and throw it back onto a belt conveyor. This machine is capable of producing over 500 tons per 8-hour shift.

Figure 24. A page from the *Dominion Coal Annual Report*, 1956. (Devco Company Archives).

thought, was the key to increased production in the Cape Breton mines and a product to be aggressively marketed to other colliery operators. Generally speaking, coal companies *per se* are not so enthusiastic about commissioning underground photographs.

How were these underground photographs used? They appeared in technical reports, in engineering journals, and in mining industry magazines. Within the company, they were reproduced in the *Dominion Coal Annual Report* and in the two employee-relations magazines, the Montreal-produced *Dosco World* and the local *Teamwork*. (The latter's graphic motif was a cartoon of a worker and a manager pulling together for "quality, safety, efficiency, quantity.") Mining pictures also appeared in the local newspapers from time to time. And, as Shedden's installation photographs reveal, the company used his pictures at local trade fairs in Cape Breton.

In general, the *Annual Report* favoured machinery, while *Dosco World* and *Teamwork* favoured "human interest" pictures, showing miners at work. Robert Wilkie has discussed the paternalistic character of Dosco employee-relations in his introductory essay. Here's an example of the discourse of the stockholder.

The 1956 *Annual Report* touted the Dosco continuous miner. The cover includes a view of the machine "in action" with a more reserved shop photograph. Inside the report, a layout focuses on Dosco's "extensive mines mechanization programme." Another shop photograph of the continuous miner, its cutting jib ready to chew coal, accompanies a "before-and-after" narrative in two frames. The last of the pit horses is juxtaposed with a new underground locomotive. Interestingly enough, no equivalent antecedent is mentioned for the continuous miner. It is as if we were staring at a ratio with a missing term:

Locomotive replaces horse.

Continuous miner replaces X.

But this repressed entity returns in the form of an anthropomorphized horse. The caption beneath the horse picture reads as follows:

A Victim of Mechanization—Let out to pasture some time ago, "Fraser" will spend the rest of his days living the "life of Riley" after 16 years of continuous service underground— without losing any time due to injury or illness.[183]

"Fraser" is named. The driver of the locomotive, like other miners who appear from time to time in the corporate report, is not named. The caption exhibits the same glibness that we find in *Fortune* magazine captions beginning in the 1930s, although here the tone is more folksy. Furthermore, the caption appropriates and trivializes any critique of mechanization. This "victim," this exemplary worker, is moving on to greener pastures. "Fraser" is a pet, the imaginary displacement of the displaced miner.

Shedden's photograph of Fraser-the-horse was popular in industrial Cape Breton as well. But here the meaning was rather different. This image of an aged horse, posed nobly against a pit head, suggested a pastoral ideal. Here then, was an expression of agrarian longing. Other photographs were popular as well. One in particular comes to mind. Among all of Shedden's mine photographs, only one portrays the exercise of brute physical strength. This picture shows a pair of miners securing roof supports behind a Dosco continuous miner. One of the men is almost invisible, but he assists a man who is kneeling and swinging a sledge with his bare arms. This latter action is reminiscent of the obsolete work of the coal shoveler, or pick handler, who had to exert the strength of the upper body while kneeling under a low roof. It was this photograph that was reproduced in the *Post-Record* on Labour Day. It was this photograph that embodied the dignity of manual labour for the residents of an industrial community.

Thus there were, in effect, two separate representations of mining emanating from the archives of Dosco. One, for stockholders, stressed efficiency and mechanization. The other, for workers, stressed the dignity of work, the need for cooperation and efficiency, and the benevolence of the company. However, sometimes these discourses got confused. In September, 1955, *Teamwork* ran an article entitled "Industry Can Be Beautiful." In this instance, the rhetoric of corporate modernism was brought within earshot of the workplace itself. An esthetic sensibility that had been previously reserved for managers and stockholders was now offered to the workers. In effect, the article seems to have been an attempt to explain and justify the presence of photographers within mine and steel mill. The article suggested that increased sales depended upon industry's ability to estheticize itself to the public. Furthermore, the industrial photographer was not an instrusive pest, but a genius *and* a worker:

It is far easier to picture cows in a field, or the cascading waters of a Niagara. Industrial photography requires a generous amount of artistic genius, in addition to a willingness to labor long and hard.[184]

Implicitly this article is stressing the need for workers "to keep facilities and equipment attractive enough to photograph."[185] Even the industrial "landscape" contains an injunction.

Tourism and Industrial Decline

A tourist economy is eminently compatible with economic underdevelopment, as the Cuban critic Edmundo Desnoes has argued. Tourism seeks sites in which nature and the past still live, although it also seeks the cosmopolitanism and modernism of the city. Industrial

259

An aerial photograph of Dosco's Blast Furnace Department in Sydney, operated by Dominion Iron & Steel Limited.

INDUSTRY CAN BE BEAUTIFUL

In 55 B. C. Julius Caesar said, "Nothing is great until it stands revealed." Several thousands of years before Caesar's day, a far-seeing Chinese, possibly with the instincts of a commercial photographer, observed: "One picture is worth 10,000 words." Combining the two axioms, modern industry has come up with this merger: "The best way to reveal something great is — with pictures."

The surprising thing is that it took industry, which is traditionally strong on initiative, so long to get around to this bit of wisdom. Years before, the trail for industrial photography had been blazed by such pioneers as John A. Mather, who in 1860 followed the oil rush to Titusville, Pennsylvania, and for forty years thereafter devoted himself to creating a priceless photographic record of industrial progress.

Only a few photographers, however, chose to follow the Mather example. Most of them were content to establish their studios and go into local portraiture. Those who did "hit the road", were mainly intent on picturing mountains, gardens, rivers, historical landmarks, and other scenes of popular interest. They saw no romance in grimy industry.

Today the story is different. Some of the nation's foremost photographers are specializing in pictures which reveal to the public the massiveness of industry, the wonders of its production facilities, the intensiveness of its research efforts. In molten fire, in mighty hammers, in delicate instruments, in a thousand ways which the ingenuity of the photographer can choose from the endless panorama of industrial enterprise, the story is being revealed to the people.

All this is good advertising, and mighty good public relations, and as such it justifies the liberal allotments being made to this phase of industrial activity today, along with budget items for sales, production, research, administration.

How big the job is to be, depends on the size and scope of an industry's operations, and the ultimate practical value which the photographic undertaking can have to the picture enterprise. A steel mill may have little direct contact with the consuming public, but other purposes are served in keeping the company and the scope and quality of its products before millions of readers. Industry, which must sell its products through thousands of retail outlets, has further reason for emphasizing in the public mind that it can be relied on, because of its facilities, experience, and its record of achievement, to give its customers complete satisfaction.

Figure 25. "Industry Can Be Beautiful," a one page photo essay from the Dosco employee-relations magazine, *Teamwork*. (Beaton Institute Archives).

260

regions are frequently bypassed, driven through hastily, or mentioned with disdain.[186] And yet, on occasion, the factory, the coal mine, the industrial waterfront are converted into spectacle. With the decline of industry, or with the replacement of older forms of production, industrial zones can become the site of a new nostalgic and essentially touristic look at the past. This is especially true of the harbour cities, which have long sustained a romance of primitive accumulation, of piracy, and pre-industrial commerce and adventure. Recently, however, the replacement of older forms of longshoring by centralized and mechanized containerization depots has opened up old waterfront warehouses to boutiques and restaurants in which antique nautical motifs predominate. But what the tourist sees through the fishing net draped over the picture window, is a modern automated harbour, a harbour from which the small fisherman and the stevedore are increasingly absent. This is especially true in Los Angeles, in San Francisco, and in Halifax. In San Francisco, for example, the harbour itself does not function, but merely looks like it does. The real work goes on in Oakland, miles away.

Industrial Cape Breton has long been the logistical center of a tourist region. But the scenic beauties of the island are generally considered to reside elsewhere; in the highlands, in the rural countryside, and along the rugged coast. Nonetheless, the mines and the mills can be accomodated to a certain romance, a romance of the Industrial Revolution, a North American version of the industrial sublime. I believe this is happening in a more extreme fashion in a city like Pittsburgh, where massive unemployment in the steel industry parallels the "redevelopment" of the downtown area into the world's third largest concentration of corporate headquarters. The old, industrial Pittsburgh becomes a silent, hulking spectacle for a new breed of multinational managers. United States Steel runs its mills well below capacity, but buys out Marathon Oil.

Cape Breton has been photographed a lot, by tourists and by professionals who sell their work to tourists. Virtually any bookstore in Nova Scotia will carry a number of coffee-table books, illustrated with colour photographs. Most of these books prefer the pictorial possibilities of rural and coastal Cape Breton. In this, they offer an updated version of Leslie Shedden's own sense of landscape. Within these books, landscape is offered as the antihesis of an industry that is not pictured. We should note, however, that the actual "landscape" of Cape Breton is not exempt from the pressures of industrial development. A Swedish multinational company is attempting to defoliate the hardwood forests of the island, in order to plant faster-growing evergreens for pulpwood. The chemcial of choice is virtually the same as that used by the Americans in Vietnam. This form of organized ecological violence is being met with organized resistance by the people of Cape Breton, with native Canadians taking a leading role. And so perhaps, today, the very idea of a "landscape" has to be defended, but in a politically-organized and ecologically-sensitive fashion.

One recent book of colour pictures from Cape Breton is markedly different from the rest. I'm thinking here of Owen Fitzgerald's *Cape Breton*.[187] His pictures tend to be more casual, more snapshot like, and more interested in industrial Cape Breton than the careful pictorialist efforts of his colleagues. One photograph in particular is interesting, for what it reveals about one Cape Bretoner's ambivalence towards industry. Fitzgerald photographed the Sydney steel mill from behind a bed of yellow daisies, so that the blast furnaces emerge from an ocean of flowers. Here, as in Shedden's portrait of Fraser-the-horse, is an attempt to construct the industrial pastoral, to harmonize nature and industry. But we can also read this photograph as a lament for a troubled industry, an industry plagued by antique equipment and barely surviving despite nationalization. Fitzgerald's photograph is both lyrical and pessimistic, suggesting a funeral bouquet.

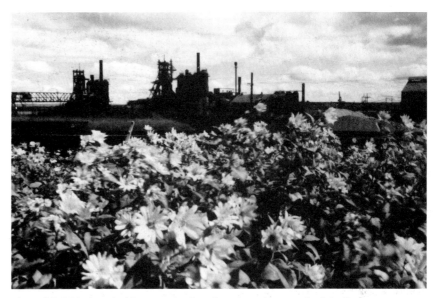

Figure 26. A black and white reproduction of a colour photograph of the Sydney steel plant from Owen Fitzgerald's book entitled *Cape Breton*. (Collection: Owen Fitzgerald).

The difficulty with this edge of pessimism is that it lends itself too easily to the economic development policies of those who would like to see tourism and pulpwood production replace steel and coal as the major industries of Cape Breton. The factory is remembered with nostalgia but abandoned. A similar commemoration could have enveloped Leslie Shedden's coal mining archive.

The Group Photograph

Recently, *Vanity Fair* magazine was resurrected from the dustbin of publishing history. This relic of leisure-class self promotion from the 1920s and 1930s was the complement to *Fortune*. *Fortune* celebrated corporate dynamism and the new captains of industry. Its characteristic visual image was the modernist industrial abstraction, of the sort produced by Margaret Bourke-White. *Vanity Fair* celebrated life at the top. Its characteristic visual image was the celebrity portrait, of the sort produced by Edward Steichen. Why am I telling you this? Because in the New *Vanity Fair* we discover the *post-modernist inversion* of the icon of the heroic worker, an icon that appeared—as I have already noted— in the pages of *Fortune* in the 1930s alongside the modernist industrial abstraction.

We are treated to a portfolio of Richard Avedon photographs: group portraits, taken against Avedon's trademark white backdrop, of coal miners and oil riggers from Wyoming, Colorado and Oklahoma.[188] Apparently these pictures are part of an exhibition project scheduled for 1985 at the Amon Carter Museum in Fort Worth, Texas. It's hard to know exactly what Avedon's up to with this larger work. The project's title is: "In the American West." Maybe we'll have portraits of the real-life counterparts of J.W. Ewing of *Dallas* fame installed next to these grimy workers, whose names are provided in Avedon's captions. Nonetheless, within the pages of the new *Vanity Fair* these

photographs seem appropriate to a cynical esthetics of Reaganism. Imagine a smooth managerial voice offering advice to unemployed workers of the Northeast: "That's where the jobs are, out West." In one foldout portrait in particular Avedon performs a bit of hackneyed cubist surgery, perhaps a deliberate attempt to offend what remains of humanist sensibilities in photographic circles. One miner is bisected by a black frame line, and given an extra nose. But Avedon, like many post-modernists, revels in an ambivalent relation to genre. Thus, on the other hand, these miners display an easy camaraderie, arms around shoulders, touching one another.

I want to end this essay by thinking of Leslie Shedden's group photographs of working people. The businessmen who commissioned these pictures sought to exhibit the virtues of "teamwork" in industry and of skilled and attentive service in small enterprise. They also sought, on occasion, to validate and reward their employees by means of portraiture. Leslie Shedden also photographed family groups, school groups and occasional clubs and civic organizations. We should not assume that herein lies a complete picture of social life in Glace Bay. The union, in particular, is markedly absent from this archive. Furthermore, more informal social groupings, which may or may not be pictured in amateur and snapshot photographs, are also absent. (Think also of how absent home life is from this archive, despite the various domestic advertisements. Do we learn or remember anything about miners' housing or unofficial leisure from these pictures?) Thus a restricted range of sociality is charted here.

Nonetheless, this archive acknowledges the *social* character of work, despite the fact that Dosco wanted Shedden to celebrate its search for an automated coal mine. To modify Roland Barthes' remark that: "It is hard to be done with a civilization of the hand," we might argue that it is hard to be done with a civilization of working people. The people of industrial Cape Breton have demonstrated this with

Figure 27. Long wall face.

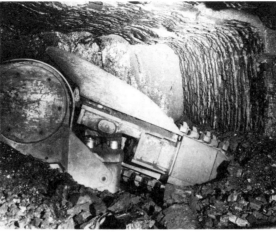

Figure 28. Dosco continuous miner in action.

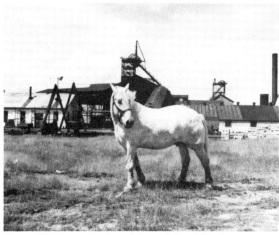

Figure 29. Fraser-the-horse; last of the 1-B pit ponies.

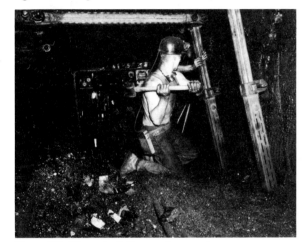

Figure 30. Miners installing roof supports.

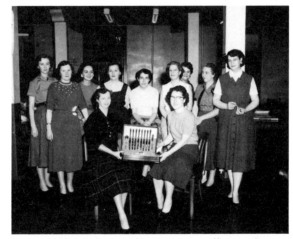

Figure 31. Presentation of cutlery to an office worker.

Figure 32. Glace Bay, Manufacturers' Fair.

Figures 27-34. From the negative archives of Shedden Studio. All photographs taken by Leslie Shedden. (See plate sections for more detailed captions.)

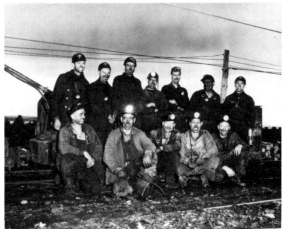

Figure 33. Group of miners after finishing shift.

Figure 34. Annie's Beauty Salon staff.

263

their solidarity, their resiliance, their strong sense of cultural continuity, and their willingness to struggle.

The group photograph, then, harbours another meaning, a meaning that contradicts the logic of managment. Here, posed confidently around the instruments and materials of production, are people who could quite reasonably control those instruments and materials. Therein lies a promise and a hope for the future.

A final note: This essay is dedicated to my parents. It was helped along by a number of people. I'm grateful to David Paskin, a labour historian, for initial encouragement. Don Macgillivray and Robert Wilkie introduced me to Cape Breton and steered me in the right directions. Bob kept me going with encouragement and support. My biggest thanks is to Sally Stein, for everything.

Notes

1. Walter Benjamin, ''Theses on the Philosophy of History'' (1940) in *Illuminations,* edited by Hannah Arendt and translated by Harry Zohn, (New York, 1969), p. 255.

2. Jean-Luc Godard and Jean-Pierre Gorin, *Vent d'Est* (Rome, Paris, Berlin) filmscript published in Jean-Luc Godard, *Weekend/Wind from the East,* (New York, 1972), p. 121.

3. ''What is represented in ideology is therefore not the system of the real relations which govern the existence of individuals, but the imaginary relation of those individuals to the real relations in which they live.'' Louis Althusser, ''Ideology and Ideological State Apparatuses'', (1969) in *Lenin and Philosophy and Other Essays,* translated by Ben Brewster, (New York, 1971), p. 165. Althusser's model of ideology is based in part on Marx and in part on the work of the psychoanalyst Jacques Lacan. Without belabouring this lineage, or explaining it further, I would like to refer the Canadian reader especially to a work by Lacan's first English translator and critical interpreter, Anthony Wilden: *The Imaginary Canadian: An Examination for Discovery,* (Vancouver, 1980).

4. Bernard Edelman, *Ledroit saisi par la photographie* (Paris, 1973) translated by Elizabeth Kingdom, *Ownership of the Image: Elements for a Marxist Theory of Law,* (London, 1979), p. 45.

5. Roland Barthes, ''Rhetorique de l'image,'' *Communications 4,* 1964, in *Image, Music, Text,* translated by Stephen Heath, (New York, 1977), p. 51.

6. Leopold von Ranke, preface to *Histories of the Latin and Germanic Nations from 1494-1514,* in *The Varieties of History,* edited by Fritz Stern, (New York, 1972), p. 57.

7. See Guy DeBord, *La societé du spectacle,* (Editions Buchet-Chastel, Paris) 1967 unauthorized translation, *Society of the Spectacle,* (Detroit, 1970, revised edition, 1977).

8. We might think here of the reliance, by the executive branch of the United States government, on ''photo opportunities.'' For a discussion of an unrelated example see Susan Sontag's dissection of Leni Reifenstahl's alibi that *Triumph of the Will* was merely an innocent documentary of the orchestrated-for-cinema 1934 Nuremberg Rally of the National Socialists. Sontag quotes Riefenstahl: ''Everything is genuine . . . It is *history—pure history.''* Susan Sontag, ''Fascinating Fascism,'' *New York Review of Books,* Vol. XXII, No. 1, February, 1975, reprinted in *Under the Sign of Saturn,* (New York, 1980), p. 82.

9. Two recent books counter this prevailing tendency in ''visual history'' by directing attention to the power relationships behind the making of pictures: C. Heron, S. Hoffmitz, W. Roberts, R. Storey. *All That Our Hands Have Done: A Pictorial History of the Hamilton Workers* (Oakville, Ontario, 1981) and Sarah Graham-Brown *Palestinians and Their Society 1880-1946,* (London, 1980).

10. In the first category are books which discover unsung commercial photographers: e.g. Mike Disfarmer, *Disfarmer: The Heber Springs Portraits,* text by Julia Scully, (Danbury, New Hampshire, 1976). In the second category are books which testify to the esthetic sense of the collector: e.g. Sam Wagstaff, *A Book of Photographs from the Collection of Sam Wagstaff,* (New York, 1978).

11. This passage restates an argument made in my essay, ''The Traffic in Photographs,'' *The Art Journal,* Vol. 41, No. 1, Spring 1981, pp. 15-16.

12. Walter Benjamin, ''Theses on the Philosophy of History.'' pp. 256-257.

13. Georgius Agricola, *De Ortu et Causis Subterraneorum,* Book III (1546) quoted in Herbert Clark Hoover and Lou Henry Hoover, Introduction to *De ReMetallica,* (Original edition: Basel, 1556), translated by Herbert Clark Hoover and Lou Henry Hoover, (London, 1912), reprint edition, (New York, 1950), p. XIII.

14. Denis Diderot, ''Prospectus'' (1750) published as Part III of Jean le Rond d'Alembert and Denis Diderot, ''Discours préliminaire de editeurs,'' in Volume I (1751) of *Encyclopédie, ou Dictionnaire raisonné des sciences, des arts et des metiers, par une societé de gens de lettres,* (Paris, 1751) English translation by Richard N. Schwab in d'Alembert, *Preliminary Discourse to the Encyclopedia of Diderot,* (Indianapolis, 1963), p. 124.

15. See Andre Gunder Frank, *World Accumulation 1492-1789* (New York, 1978) and Eduardo Galeano, *Open Veins of Latin America: Five Centuries of the Pillage of a Continent,* (New York, 1973), pp. 21-70.

16. On the ''universal applicability'' of steam power, see Karl Marx *Capital,* Vol. I translated by Ben Fowkes, (New York, 1977), p. 499. For a very general history of mining since antiquity, see John Temple, *Mining: An International History,* (New York, 1972).

17. Lewis Mumford, *Technics and Civilization,* first edition 1934, (New York, 1963), p. 70.

18. Francis Bacon, *Of the Dignity and Advancement of Learning,* (De Dignitate et Augmentis Scientiarum, 1623), in *The Works of Francis Bacon,* (London, 1870), Vol. IV, p. 343.

19. Andreas Vesalius, *De Humani Corporis Fabrica,* (Basel, 1543). In his preface Vesalius argued: ''After the barbarian invasions all the sciences . . . went to rack and ruin. At that time . . . fashionable doctors began to despise the work of the hand, in imitation of the ancient Romans. They assigned the manual treatment . . . to slaves and limited themselves to supervising . . . Thus it happened that this deplorable division of the medical arts has introduced into our schools the odious system, now in vogue, through which one individual performs the dissection of the human body and the other describes the parts . . . Thus everything is poorly taught, days are wasted in absurd questions . . . (quoted in Paolo Rossi, *Philosophy, Technology and the Arts in the Early Modern Era,* translated by Salvator Atlanasio, New York, 1970, p. 8).

20. Agricola, *De Re Metallica,* p. xxv.

21. *Ibid.,* p. xxx.

22. George Sarton, *The Appreciation of Ancient and Medieval Science During The Renaissance,* (Philadelphia, 1955), p. 93.

23. William Ivins, *Prints and Visual Communication,* (Cambridge, Massachusetts, 1953), p. 3. See also Elizabeth L. Eisenstein, *The Printing Press as an Agent of Change,* (Cambridge, England, 1979) pp. 265-272, pp. 467-488.

24. Leon Battista Alberti, *Della pittura* (1435), translated by John R. Spencer, *On Painting,* (New Haven, 1966), p. 43.

25. Leonardo da Vinci, *The Notebooks of Leonardo da Vinci,* edited by Pamela Taylor, (New York, 1960), p. 73.

26. Agricola, *De Re Metallica,* p. 17.

27. *Ibid.,* p. 18.

28. It is worth noting here that Agricola remained an ardent Roman Catholic in the midst of the Reformation, in a region politically dominated by Protestants. The principal intellectual opponent of the Reformation, Erasmus, was friendly with Agricola and contributed an introduction to his first book on mining and metallurgy, *Bermannus,* published in 1530. In that text Erasmus remarked that Agricola's description of veins of gold and silver ''almost aroused a feeling of avarice in his own bosom.'' (Frank Adams, *The Birth and Development of the Geological Sciences,* New York, 1938, p. 190). But as Max Weber points out, Luther also resisted the logic of emerging capitalism, and explicitly attacked usury, (*The Protestant Ethic and the Spirit of Capitalism,* first published 1904-1905, translated by Talcott Parsons, New York, 1958, p. 82).

29. *De Re Metallica,* p. 23-24.

30. Agnes Heller, *Renaissance Man,* translated from Hungarian by Richard E. Allen, (London, 1978), p. 396.

31. Alfred Sohn-Rethel, *Intellectual and Manual Labour: A Critique of Epistemology,* (London, 1978), pp. 113-116. See also Erwin Panofsky, *The Life and Art of Albrecht Dürer,* (Princeton, 1954), p. 254.

32. John U. Nef, ''Introductory: Mining and Metallurgy in Medieval Society,'' in *The Conquest of the Material World,* (Cleveland, 1967), p. 49. See also Friedrich Engels, ''The Peasant War in Germany'' (1850) in *The German Revolutions,* edited by Leonard Krieger, (Chicago, 1967), pp. 3-119.

33. *De Re Metallica,* p. 41.

34. William Ivins, *Art and Geometry,* (New York, 1946), pp. 64-86.

35. *De Re Metallica,* p. 99. On early industrial time-discipline see E.P. Thompson, ''Time, Work-Discipline, and Industrial Capitalism,'' in *Past and Present,* No. 38, December 1967, pp. 56-97.

36. *De Re Metallica,* p. 101.

36. *Ibid.,* p. 26.

37. *Ibid.,* p. 129.

39. *Ibid.,* p. 217. On cartography see Lloyd A. Brown, *The Story of Maps,* (New York, 1949), p. 99-100.

40. Nef, *The Conquest of the Material World,* pp. 50-51.

41. Herbert Hoover, *The Memoirs of Herbert Hoover: Years of Adventure: 1874-1920,* (New York, 1951), p. 117.

42. Karl Marx, *Capital,* Vol. I, p. 915.

43. Mumford, *Technics and Civilization,* p. 74.

44. Edwin T. Layton, Jr., *The Revolt of the Engineers,* (Cleveland, 1971), p. 189. Layton argues that: ''Mining engineers were more closely involved in management than any others . . . Of all the technical fields, it was the least influenced by science. There was no parallel to the virtual merger with physics that had occurred in electrical enginnering.'' In this light, Hoover's attempt to reproduce the vellum binding, paper and typeface of Agricola's original text can be seen as both an historicist gesture and as an attempt to indicate the esthetic refinement of the engineer-businessman: ''A limited edition is in effect a guarantee—somewhat crude, it is true—that this book is scarce and that it therefore is costly and lends pecuniary distinction to its consumer.'' (Thorstein Veblen, *The Theory of the Leisure Class,* first edition 1899, New York, 1934, pp. 163-164). On the rise of the engineering profession, see also David Noble, *American by Design: Science, Technology, and the Rise of Corporate Capitalism,* (New York, 1977).

45. Paolo Rossi, *Philosophy, Technology, and the Arts in the Early Modern Era,* pp. 2-15.

46. *Francis Bacon, A Selection of His Works,* edited by Sidney Warhaft, (Toronto, 1965), p. 400.

47. *Ibid.,* p. 447.

48. *The advice of William Petty to Mr. Samuel Hartlib for the Advancement of some particular Parts of Learning,* quoted in Rossi, p. 124.

49. See note 14.

50. Denis Diderot, ''The Encyclopedia'' (1775) in *Rameau's Newphew and Other Works,* translated by Jacques Barzun and Ralph H. Bowen, (New York, 1956), p. 298.

51. Diderot, in d'Alembert, *Preliminary Discourse,* p. 122.

52. *Ibid.,* p. 123.

53. Marx, *Capital,* Vol. I, p. 616. To be fair to Diderot, we should note another of his remarks on the secretive character of Parisian artisans: '' . . . fear of the tax collector keeps them in a state of perpetual mistrust . . . they regard every man who questions them at all closely either as a spy for the farmers general (tax collectors) or as a rival craftsman who wants to set up shop.'' (''The Encyclopedia,'' p. 319).

54. *Preliminary Discourse,* p. 124.

55. *Ibid.*

56. *Ibid.,* p. 126.

57. Roland Barthes, ''The Plates of the Encyclopedia,'' (1964) in *New Critical Essays,* translated by Richard Howard, (New York, 1980), p. 33.

58. *Ibid.,* p. 29.

59. *Preliminary Discourse,* p. 124.

60. Barthes, p. 29.

62. *Preliminary Discourse,* p. 124.

62. *Ibid.,* p. 125. It's worth nothing that Diderot both borrowed from and improved upon earlier technological plates. On the controversy surrounding accusations of plagiarism see John Lough, *The Encyclopédie,* (London, 1971), pp. 85-91.

63. Barthes, p. 23.

64. Charles Saunders Peirce, *Philosophical Writings of Peirce,* edited by Justus Buchler, (New York, 1955), pp. 99-119. Peirce developed three trichotomies of signs. The second of these classified signs as Icons, Indices, or Symbols. Icons exhibit the qualities of an object. A drawing would be an icon. Indices exhibit the qualities of an object and are physically affected by, or connected to, that object. A photograph would be an index (and, in most cases, an icon as well). A symbol signifies by virtue of a law or convention. Verbal language would be considered symbolic in Peirce's system. Peirce argued that ''icons and indices assert nothing. If an icon could be interpreted by a sentence, that sentence must be a 'potential mood', that is, it would merely say, 'suppose a figure has three

sides', etc. Were an index so interpreted, the mood must be imperative, or exclamatory, as 'See there!' or 'Look out!' '' For Peirce, only symbols could register meaning in the "declarative" mood. (p. 111) Peirce's semiotics have had an important effect on recent photographic criticism in the United States, primarily through the work of Rosalind Krauss. See her "Notes on the Index: American Art in the 70s" *October* Nos. 3 and 4, Spring and Fall 1977.

65. Louis Jacques Mandé Daguerre, "Daguerreotype," (1839) in Helmut and Alison Gernsheim, *L.J.M. Daguerre: The History of the Diorama and the Daguerreotype,* (New York, 1968), p. 81.

66. Edgar Allan Poe, "The Daguerreotype" *Alexander's Weekly Messenger,* (January 15, 1840), p. 2, reprinted in Alan Trachtenberg, editor, *Classic Essays on Photography,* (New Haven, 1980), p. 38.

67. *Ibid.,* p. 38.

68. Francois Arago, "Report," in Josef Maria Eder, *History of Photography,* translated by Edward Epstean, (New York, 1945), pp. 234-235.

69. *Ibid.,* p. 238.

70. Arago, letter to Duchâtel, (June, 1839) in Gernsheim, *L.J.M. Daguerre,* p. 91.

71. Quoted in A. Rupert Hall, *From Galileo to Newton,* (New York, 1963), p. 84.

72. Oliver Wendell Holmes, "The Stereoscope and the Stereograph," *Atlantic Monthly* III, No. 20, June 1859, p. 748.

73. *Ibid.* See also Karl Marx, *Capital,* Vol. I, pp. 163-177. For a more developed reading of Holmes' equation of photography and money, see my "Traffic in Photographs," pp. 21-23.

74. Georg Simmel, *The Philosophy of Money,* translated by Tom Bottomore and David Firisby, (London, 1978), pp. 443-446.

75. Jeremy Bentham, "A Fragment on Government," (1776) in Mary Peter Mack, editor, *A Bentham Reader,* (New York, 1969), p. 45.

76. Quoted in Helmut and Alison Gernsheim, *The History of Photography,* (New York, 1969), p. 239.

77. Marcus A. Root, *The Camera and the Pencil,* (Philadelphia, 1864), pp. 413-414.

78. *Ibid.,* pp. 419-420.

79. See Eder, *History of Photography,* Chapter LV, "Photogrammetry," pp. 398-402. Also, see Jean Pierre Edouard Paté, *Application de la photographie à la topographie militaire,* (Paris, 1862).

80. U.S. Military Commission to Europe, *Report on the Art of War in Europe* by Colonel R. Delafield, U.S.A.,(Washington, 1861).

81. *The Camera and the Pencil,* pp. 420-421.

82. Thomas Hobbes, *Leviathan* (1651), edited by C.B. Macpherson, (London, 1968), p. 150.

83. Jeremy Bentham, *Panopticon; or The Inspection House* (1787) in *The Works of Jeremy Bentham,* Vol. IV, edited by John Bowring, 1843, p. 39.

84. See Gertrude Himmelfarb, "The Haunted House of Jeremy Bentham," in *Victorian Minds,* (New York, 1968), pp. 32-81. See also Michel Foucault, "Panopticism," in *Discipline and Punish: The Birth of the Prison,* translated by Alan Sheridan, (New York, 1977), pp. 195-228.

85. See John Werge, "Rambles Among the Studios of America" (1865) in *The Evolution of Photography,* (London, 1890), pp. 200-201. For a history of the nineteenth century photographic industry in the United States, see Reese Jenkins, *Images and Enterprise: Technology and the American Photographic Industry,1839 to 1925.* (Baltimore, 1975).

86. Charles Baudelaire, "The Modern Public and Photography" in *Classic Essays on Photography,* p. 88. This was part of Baudelaire's review of the Salon of 1859, and was published in *Le Boulevard,* September 14, 1862.

87. Published in *Aujourd'hui,* March 15, 1840.

88. Published in *Le Charivari,* July 2, 1840.

89. La Lumiere, v. 1, p. 138 (1851) quoted in Robert Taft, *Photography and the American Scene,* (New York, 1938), p. 76.

90. Thorstein Veblen, *The Theory of the Leisure Class,* pp. 35-67.

91. These photographs appeared together in *Camera Work,* 36:5, October 1911. See my essay "On the Invention of Photographic Meaning," *Artforum* Vol. XIII, No. 5, January 1975, pp. 36-45.

92. Published in *Le Boulevard,* May 25, 1862.

93. See David H. Pinkney, *Napoleon III and the Rebuilding of Paris,* (Princeton, 1958), pp. 127-150. See also Nadar, "Paris, souterrain" in *Quand j'etais photographe,* (Paris, 1899), pp. 99-129.

94. The phrase is Marx's, from a passage on Haussmann's "Vandalism". Karl Marx and Friedrich Engels, *Writings on the Paris Commune,* edited by Hal Draper, (New York, 1971),p. 94.

95. Barthes, "The Plates of the Encyclopedia", p. 28.

96. Diderot, "Salon of 1767", in *Diderot's Selected Writings,* edited by Lester Crocker, translated by Derek Coltman, (New York, 1966), p. 174.

97. Nadar, *Quand j'etais photographe,* p. 116. Translation in Gail Buckland, *First Photographs,* (New York, 1980), p. 79.

98. Nadar, pp. 23-24. Translation by Thomas Repensek, "My Life as a Photographer," *October,* No. 5, 1978, p. 18.

99. Nadar, p. 104.

100. Joel Snyder, *American Frontiers: The Photographs of Timothy O'Sullivan 1867-1874,* (Millerton, New York), pp. 37-51.

101. Rosalind Krauss, "Photography's Discursive Spaces: Landscape/View," *Art Journal,* Winter 1982. As I write, her article has not yet appeared in print. My remarks are based on a version read in October 1982 at the National Gallery of Canada, at a symposium entitled *August Sander, His Work and His Time.* Krauss' paper, which dealt at length with O'Sullivan, was called "August Sander and the Discourse of the Survey."

The notion of metaphoric and metonymic poles of meaning is taken from Roman Jakobson, "Two Aspects of Language and Two Types of Aphasic Disturbances" in Jakobson and Halle, *Fundamentals of Language,* (The Hague, 1956), pp. 90-96. Metonomy involves the production of meaning on a contextual basis. Metonymic signification samples, selects, builds linkages and casual connections. For Jakobson, realism, and particularly the discourse of the novel, is essentially metonymic. Metaphor, on the other hand, involves the production of meaning on the basis of substitution. Metaphor involves a kind of linguistic play based on analogy and likeness. For Jakobson, poetry is essentially metaphoric. Certainly this would hold for symbolist poetry, which made a cult of metaphor. My essay "On the Invention of Photographic Meaning" applies this model to photographic practice, treating the work of Lewis Hine as emblematic of a realist, documentary, metonymic mode and the work of Alfred Stieglitz as emblematic of a symbolist, "artistic", metaphoric mode. I think we need to consider the way in which the realist image and the "scientific" image becomes metaphoric in certain contexts; we also need to think about the latent "realism" of the most abstract and expressionist images.

102. Snyder, p. 41.

103. Georg Lukacs, *History and Class Consciousness,* translated by Rodney Liv-

ingstone, (Cambridge, Massachusetts, 1971), pp. 110-148. Karl Marx, *Economic and Philosophic Manuscripts of 1844,* (Moscow, 1959), p. 102.

104. Snyder, p. 24. Richard Lingenfelter, *The Hardrock Miners: A History of the Mining Labor Movement in the American West, 1863-1893,* (Berkeley, 1974), p. 17.

105. Snyder, p. 24.

106. Weston Naef and James Wood, *Era of Exploration: The Rise of Landscape Photography in the American West,* 1860-1885, (Boston, 1975).

107. *Ibid.,* p. 127.

108. Clarence King, editor, Professional Papers of the Engineer Department U.S. Army, No. 18, (Washington, 1870-1880). In all, seven volumes and an atlas were published. The volumes in question, the only ones to contain lithographic reproductions of O'Sullivan's photographs, were:

 I: Clarence King, *Systematic Geology* (1878).

 II: A. Hague and S.F. Emmons, *Descriptive Geology* (1877).

 III: J. Hague and Clarence King, *Mining Industry* (1870).

The remaining volumes treated paleontology, ornithology, botany, microscopial petrography, and odontornithes—extinct toothed birds.

109. Clarence King, *Systematic Geology,* p. 2

110. William Goetzmann, *Exploration and Empire: The Explorer and the Scientist in the Winning of the American West,* (New York, 1966), p. 466. This is by far the best source on the social and intellectual context of the surveys.

111. *Ibid.,* pp. 437-438.

112. *Ibid.,* pp. 593-594.

113. *Systematic Geology,* p. xi.

114. Clarence King, "Catastrophism and Evolution," *The American Naturalist,* Vol. XI, No. 8, August 1877, p. 470.

115. Snyder, p. 19.

116. Francis Klingender, *Art and the Industrial Revolution,* edited and revised by Arthur Elton, (New York, 1970), pp. 128-129.

117. Anthony Bimba, *The Molly Maguires,* (New York, 1932). Lingenfelter, *The Hardrock Miners,* pp. 31-65.

118. Tom Beck, *George M. Bretz: Photographer in the Mines,* (Baltimore, 1977).

119. Walter Benjamin, *Charles Baudelaire: A Lyric Poet in the Era of High Capitalism,* translated by Harry Zohn, (London, 1973), p. 165.

120. William Ivins, writing in 1953:

"Today the news counters in our smallest towns are piled with cheap illustrated magazines at which the self-consciously educated turn up their noses, but in those piles are prominently displayed long series of magazines devoted to mechanical problems and ways of doing things, and it would be well for the cultured if they but thought a little about the meaning of that.

I think it can be truthfully said that in 1800 no man anywhere, no matter how rich or highly placed, lived in such physical comfort or so healthly, or enjoyed such freedom of mind and body, as do the mechanics of today in my little Connecticut town."

If any one thing can be credited with this, it is the persavion of the cheap usefully informative illustrated book."

(*Prints and Visual Communication,* p. 53).

121. Peter Collier and David Horowitz, *The Rockefellers: An American Dynasty,* (New York, 1976), pp. 66-129. Mackenzie King's major work on industrial relations is *Industry and Humanity,* (Boston, 1918).

122. Daniel Bell, "Work and its Discontents," in *The End of Ideology,* (New York, 1961), pp. 227-274. The best work on the social effects of Taylorism is Harry Braverman, *Labor and Monopoly Capital: The Degradation of Work in the Twentieth Century,* (New York, 1974). A detailed history of Taylor's career and be found in Daniel Nelson, *Taylor and Scientific Management,* (Madison, 1980). For a general overview of the period in question, I have relied upon Daniel Nelson, *Managers and Workers: Origins of the New Factory System in the United States 1880-1920,* (Madison, 1975); David Brody, "The American Worker in the Progressive Era," in *Workers in Industrial America ,* (New York, 1980). The best history of workers' resistance to scientific management is found in David Montgomery, *Workers' Control in America,* (Cambridge, 1979). I have already cited Noble's book on the rise of corporate science, *America by Design.*

123. F.W. Taylor, "Testimony Before the Special House Committee," January 25, 1912, in *Scientific Management,* (New York, 1939), p. 40.

124. F.W. Taylor, "The Principles of Scientific Management" (1911) in *Scientific Management,* p. 55.

125. *On the Art of Cutting Metals,* (New York, 1906), p. 28. "Principles", p. 83.

126. *Art of Cutting Metals,* p. 5.

127. *Ibid.,* p. 25.

128. "Shop Management", in *Scientific Management,* p. 116.

129. Braverman, *Labor and Monopoly Capital,* p. 90.

130. G.M. Bailes and the professional staff of the Bennett College, *Modern Mining Practice: A Practical Work of Reference on Mining Engineering,* (Sheffield, 1909), Vol. 1, p. 83.

131. *Ibid.,* Vol. 4, p. 148.

132. Homer Morris, *The Plight of the Bituminous Coal Miner,* (Philadelphia, 1934), p. 83.

133. *Ibid.*

134. "Hard Coal", *Fortune,* Vol. III, No. 2, February 1931, p. 77.

135. Paul Kellogg, "Editor's Foreward," Elizabeth Butler, *Women and the Trades: Pittsburgh 1907-1908,* Pittsburgh Survey, Vol. I, (New York, 1909), pp. 4-5.

136. The blue-print metaphor is found in Paul Kellogg, "The Pittsburgh Survey", *Charities and Commons,* January 2, 1909, p. 517. One of the volumes of the survey was comprised of three issues of *Charities and Commons:* January 2, February 6, and March 6, 1909. Essentially, these issues offered a selection of materials that would appear later in the other five volumes.

137. Paul Kellogg, "Editor's Foreward," Margaret Byington, *Homestead: The Households of a Mill Town,* Pittsburgh Survey, Vol. IV, (New York, 1910), p. v.

138. James Howard Bridge, *The Inside Story of the Carnegie Steel Company: A Romance of Millions,* (New York, 1903), Plate X.

139. See Alan Tranchtenberg "Ever—the Human Document," in *America and Lewis Hine: Photographs 1904-1940,* (Millerton, New York, 1977) for a critical biography of Hine.

140. Lewis Hine, *Men at Work,* (New York, 1932), Introduction. Trachtenberg's essay is particularly good on Hine's relation to craft values.

141. Lewis Hine, "Social Photography, How the Camera May Help in the Social Uplift," *Proceedings, National Conference of Charities and Corrections* (June, 1909) reprinted in Trachtenberg, ed., *Classic Essays on Photography,* p. 110.

142. Lillian Gilbreth, *Psychology of Management,* (New York, 1914), p. 329. This work originally was published in installments in *Industrial Engineering* between May 1912 and May 1913.

143. Frank B. Gilbreth, Jr. and Ernestine Gilbreth Carey, *Cheaper by the Dozen,* (New York, 1916), p. 31.

144. Frank B. Gilbreth and Lillian M. Gilbreth, *Fatigue Study,* (New York, 1916), p. 31.

145. *Ibid.,* p. 19.

146. *Ibid.,* p. 31.

147. *Ibid.*, p. 34. Trachtenberg points out Hine's repeatedly expressed interest in the pedagogical efficiency of photography. (*America and Lewis Hine, p. 121).*

148. Alberti, *On Painting,* p. 69, 121.

149. See Bruce Kaiper, ''The Cyclegraph and Work Motion Model,'' in *Still Photography: The Problematic Model,* edited by Lew Thomas and Peter D'Agostno (San Francisco, 1981), pp. 57-63. I'm grateful to Bruce Kaiper for allowing me to read a longer, unpublished version of this essay, entitled ''The Gilbreths: Work Films and Management Ideology'' (1977). In 1975, Kaiper introduced me to the critique of scientific management, and to the work of Harry Braverman. A former machinist and union organizer, Kaiper is what Antonio Gramsci called ''an organic intellectual'' of the working class. I'm grateful to my colleague Thom Andersen for the recent opportunity to read his unpublished manuscript-in-progress ''Cinema and its Discontents,'' which treats Marey, Taylor, and the Gilbreths in some detail. That essay—which builds on insights in Andersen's 1975 film, *Eadweard Muybridge: Zoopraxographer*—is an exceptional work, a materialist history of film and film theory.

150. Etienne Jules Marey, *Le mouvement,* (Paris, 1894), translated by Eric Pritchard, *Movement,* (New York, 1895), p. 139.

151. *Applied Motion Study,* pp. 58-72.

152. *Psychology of Management,* p. 76.

153. *Ibid.,* p. 77.

154. *Capital, Vol. I, p. 482.* See also Alfred Sohn-Rethel, *Intellectual and Manual Labour.*

155. *Psychology of Management,* p. 258.

156. See note 64.

157. *Psychology of Management,* p. 28, Frank B. Gilbreth, *Motion Study,* (New York, 1911), p. 7.

158. *Psychology of Management,* pp. 38-39.

159. *Ibid.,* p. 159.

160. David Montgomery, ''Immigrant Workers and Managerial Reform,'' in *Worker's Control in America,* pp. 40-44.

161. Edna Yost, *Frank and Lillian Gilbreth: Partners for Life,* (New Brunswick, New Jersey, 1949), p. 224.

162. *Psychology of Management,* p. 42.

163. See Sally Stein, ''The Composite Photographic Image and the Composition of Consumer Ideology,'' *Art Journal,* Vol. 41, No. 1, Spring 1981, pp. 39-45. Also see Stuart Ewen, *Captains of Consciousness: Advertising and the Social Roots of Consumer Culture,* (New York, 1976).

164. *Psychology of Management,* p. 332.

165. *Catalogue of Photographs and Artist's Drawings Showing the Coal Mining Operations and Facilities of the Dominion Coal Company Limited and Dosco Industries Limited in Nova Scotia* in Devco company archives, Glace Bay, Nova Scotia.

166. Conversation with Leslie Shedden, July 14, 1981.

167. Alfred Döblin, ''Von geschichten bildern and ihrer wahrheit,'' in August Sander, *Antlitz der Zeit* (Berlin, 1929), p. 13; translation, ''About Faces, Portraits and Their Reality,'' in David Mellor, editor, *Germany: The New Photography,* 1927-1933 (London, 1978) p. 58.

168. For the debate on the class position of professionals, see Pat Walker, editor, *Between Labour and Capital: The Professional and Managerial Class* (Boston, 1979)

169. Lest I pretend falsely to be a folklorist or an oral historian or even to be very familiar with Cape Breton, I'll admit that I first heard this story on a record called the *Rise and Follies of Cape Breton,* made by a group of local singers, actors, and musicians. This was my first trip, and I was having occasional difficulty understanding the accent common to the island. The novice miner was referred to as the ''new guy.'' Not quite catching the context, I asked who the ''new guy'' was and was told by someone in the room that the ''new guy'' was me.

170. See, for example, Roger David Brown, *Blood on the Coal: The Story of the Springhill Mining Disasters* (Hantsport, Nova Scotia, 1976).

171. Sydney *Post-Record,* Monday, July 7, 1952.

172. *Post-Record,* Wednesday, July 9, 1952.

173. *Post-Record,* Thursday, July 10, 1952.

174. *Post-Record,* Saturday, November 3, 1956.

175. *Post-Record,* Friday, July 4, 1952.

176. Leslie Shedden, interview with Ronald Caplan, *Cape Breton's Magazine* No. 32, Autumn, 1982. This interview was occasioned by plans for an exhibition of Shedden's photographs, curated by Robert Wilkie.

177. Conversation with John Abbass, July 14, 1981.

178. *Glace Bay Gazette,* September 23, 1942.

179. *Post-Record,* Tuesday, November 6, 1956.

180. This title is taken from Bertolt Brecht and Kurt Weill's opera *Die dreigroschenoper (The Threepenny Opera)* (Berlin, 1928). The lyric in question runs as follows:

> There are those who live in darkness/while the others live in
> light/we see those who live in daylight/those in darkness, out
> of sight.

This translation appears, very appropriately, at the beginning of Harry Braverman's *Labor and Monopoly Capital.*

181. George Orwell, *The Road to Wigan Pier,* first published 1937 (New York 1958) pp. 21-35.

182. Conversation with Leslie Shedden July 14, 1981.

183. *Dominion Coal Company Annual Report,* 1956, n.p.

184. *Teamwork,* September 1955, n.p.

185. See note 165.

186. Robert Wilkie tells me that a travel writer in the *Toronto Star Weekly* in the mid 1960s advised his readers not to linger in the ''grimy and disheartened town of North Sydney.'' This comment caused a local uproar and the columnist was forced to publicly apologize.

187. Owen Fitzgerald *Cape Breton, (Toronto, 1978).*

188. Richard Avedon, ''In the American West'', *Vanity Fair,* Vol. 46, No. 1, March 1983 pp. 88-94.

Appendix I

Glossary of Mining Terms*

Air shaft — A vertical opening into a mine for the passage of air.

Airway — Any passage in a mine along which an air current moves. Some passages are driven solely for air; some passages, such as main level, are all purpose, to move air, men, coal, and materials.

Anderton shearer — A patented, long wall mechanical miner with blades or shearers for cutting into the coal.

Arch booming — Booming that supports a mine roof shaped like an arch.

Automatic air-course door — Underground doors which open and close automatically to allow the passage of underground trains at the same time controlling the air supply. These doors replaced the trapper boy from earlier mining days.

Balance — An inclined passage running up at right angles from a main level, into the coal seam, normally tracked, with boxes drawn up and lowered by balance-gravity; the term generally refers to a pair of passages connected at the top, one of which is upcast and the other downcast for ventilation.

Bankhead — The building at the entrance to a mine, into which the coal cars are drawn and dumped into the mine screens, and from there to railway cars; the term is loosely used to describe all surface buildings of a mine.

Booming — Wooden or steel rafter used to support the mine roof. They were either set horizontally, like a building rafter, or in the form of an arch.

Bord — a chamber excavated in coal, off a balance; in some coal fields a bord is called a "room."

Box — A mine car or wagon into which coal is loaded at the face or at some determined spot in close proximity to the face, and from there transported to the surface.

Brushing — Keeping the roof, sides and pavement of a passage in repair and clear of any loose ore.

Cage — An apparatus in a shaft in which coal, men, and materials are transported.

Chain conveyor — A chain driven conveyor used in the mines to transport coal from one section of the mine to another. A chain conveyor is sometimes one in a series of conveyors set up to carry the coal from the face to the awaiting boxes.

Coal field — The coal deposit, or bed, in total, in a given geographic locality.

Colliery — A coal mine inclusive of surface plant and underground workings.

Continuous Miner — A machine which fractures coal from the face of the seam and loads it onto a conveyor in a single step. Used in both long wall and room and pillar mining operations. Modern continuous miners are built in several sizes to operate in seams that range from two to ten feet thick. The most widely adopted machines have a rotating drum studded with cutting bits that dig into the coal face. The drum is driven into the top of the seam and travels downward. Gathering arms push the coal onto a central conveyor that discharges the coal onto a haulage system coupled to the rear of the continuous miner.

Creeper feed — The loaded boxes or cars are slowly fed, individually, into the tipple mechanism and then tipped upside down by the rotating drum of the tipple, emptying the

269

*Most of the definitions for this glossary were taken from a very useful book by James M. Cameron entitled *The Pictounian Collier,* (Halifax: 1974) pp. 340-44.

coal onto conveyors or screens.

Crush — A settling down of the strata overlying a portion of an excavated coal seam.

Cut — A groove excavated in the coal face preparatory to using an explosive.

Cutting jib, head or drum — The mechanism on a continuous miner or shearer that cuts into or fractures the coal from the coal seam.

Dosco — Dominion Steel and Coal Corporation. At one point in its history Dosco was made up of thirty-three subsidary companies.

Dosco continuous miner — A version — in fact several versions — of the continuous miner patented by Dosco

Dosco Downdraft Furnace — A home-heating unit invented at Dosco that was supposedly revolutionary due to its safe, clean, and efficient features.

Downcast — The passage through which air is drawn into a mine.

Draegerman — A mine workman, or official, engaged in mine rescue while wearing a self-contained breathing apparatus.

Drivage — To excavate a passage.

Examiner or inspector — An official who patrols a mine section to examine the workings for accumulation of gas and other hazards

Face — The end wall at the working extremity of any excavation in a mine: the place where a miner works in extracting coal and rock.

Face conveyor — A conveyor belt that is connected to a continuous miner or other long wall mining machines such as the Anderton shearer. This conveyor is the first in a series of conveyors to carry the fallen coal from the face or mining site to the waiting underground rail system.

Friction steel support jacks — Adjustable, slip-free, safety jacks used to support the mine roof in various long wall mining operations. After the long wall mining machine makes a pass along the long wall face, the jacks are collapsed and moved into the next position allowing the roof to cave in creating a void space called the "gob." Once in the next position the mining machine makes its next pass.

Gob — The void resulting from the excavation of coal; also called "crush" or "waste" and also meaning the area where the coal has been extracted and the roof is permitted to fall in.

Hard rock miners — Miners that specialize in the excavation and extraction of ores which are composed of a substance more solid than coal and from which metals such as iron, copper, silver and nickel are extracted through a smelting process. Hard rock miners are usually hired by coal mining companies to make the initial tunnel drivage through the harder surface rock to gain access to the coal.

Haulage or hoist engine — An engine with a winding drum and rope (cable) which hauls or hoists a trip or cage.

Haulage system — A series of various conveyors which catches the fallen coal and carries it from the face to the awaiting boxes or underground rail cars.

Joy continuous miners — A continuous mining machine patented by the Joy Manufacturing Company of Pittsburgh, Penn. Joy was the first company to manufacture a continuous miner in 1948.

Joy loader — A loading machine patented by the Joy Manufacturing company. The loading machines are used to scoop up the fallen ore after it has been blasted away from the main ore seam by explosives set in pattern.

Level — An excavation or passageway driven in the coal, establishing a base from which other workings begin, e.g. from a level balances are driven off at right angles and from balances bords are driven off at right angles into the coal. The coal is moved from the bord via the balance to the level, then from the level to the pit bottom, then to the surface. Notwithstanding the name, a colliery "level" does not mean a passage excavated on a horizontal plane. A level is generally driven in one or more slight (inclines).

Lift — All workings driven upwards from one level in a steep-pitching seam.

Long wall — A mining operation at a long coal face (wall), between parallel passages (levels), the face being from fifty to more than one hundred feet in length, from which the coal is extracted by either blasting and loading or by con-

tinuous mining machines.

Pillar — A column or body of coal left unmined to support the roof.

Pillar and bord or room and pillar — The name used to describe a mining method i.e., coal is extracted from the bords or rooms and pillars are left for support. The extraction of the pillars is the final mining process in this method. This type of mining has existed for over one hundred years the difference being, of course, that machines have replaced the pick and shovel and many of the men.

Pit — A mine.

Prop — A wooden or steel upright post used to support the roof.

Pivotal conveyor — A conveyor that can be shifted around to accomodate the sometimes awkward spatial conditions in the mining area. Again this conveyor could be one of many various conveyors in a series, used to carry the coal from the face to the awaiting boxes.

Rake — A number of boxes drawn by any motive power as in a trip.

Rib — The side of an excavation.

Roof — Strata immediately over a coal seam; rock or coal overhead in any excavation.

Roof bolt — Steel bolts which are commonly four to six feet in length, and are generally inserted at intervals of every four feet in a gridlike pattern. The bolts are held in place either by a mechanical expansion shell or, more recently, by polyester resin. The bolts, which were introduced into coal mining in 1947 and into other mineral mining as early as 1927, bond the various rock strata overlying the coal seam to support the mine roof.

Screening plant — An enclosed area of the surface works where coal is separated into various sizes. The coal is dumped onto a series of shaking screens; the screens are actually perforated plates. The coal passes down through the screens which are arranged one over the other. The screen with the largest holes is on the top and the screen with the smallest is at the bottom, allowing the coal to separate out as it drops through openings of decreasing size,

from screen to screen, until only the smallest size coal remains at the bottom.

Seam — A strata of coal also called a vein.

Shaft — A vertical excavation connecting surface and mine workings.

Slope — An entrance to a mine driven down through an inclined coal seam; an inside slope is a passage in a mine driven from one system of workings down through a seam, to bring up coal from a lower system of workings.

Tipple — A mechanism with a rotating drum-like housing. Loaded cars or boxes are fed, individually, into the tipple; once inside the mechanism is rotated and the coal from the loaded car is dumped into a conveyor or screen for further conveyance or for screening. Just before entering the tipple each car passes over a scale where the exact tonnage of each load is recorded.

Trapper — Trapper boy, a boy; stationed at an underground door, to open and close it when boxes pass, and thus control the air current. Trapper boys were replaced by automatic, electrically operated doors.

Trip — A number of boxes or cars drawn by any motive power, as in a rake. In many coal mines the means of transporting the miners to and from the surface were by the rake or trip.

Tunnel — A connecting, horizontal passage between two mines or systems of workings.

Undercutter — A machine equipped with a movable cutter bar that resembles a chain saw. Undercutting is done to insure the effectiveness of a blast. A narrow slot or undercut six to eight inchs in height and about ten feet deep is cut in the base of the seam. The undercut provides an additional free face into which the coal can expand when it is blasted. Before the undercutting machine was introduced a miner would hack out a smaller slot with a pick.

Upcast — The passages from, and in a mine from which air leaves the mine.

Wash plant — An enclosed area of the surface works where many types of machines clean, wash, and break the coal as it comes from the mines.

Appendix II

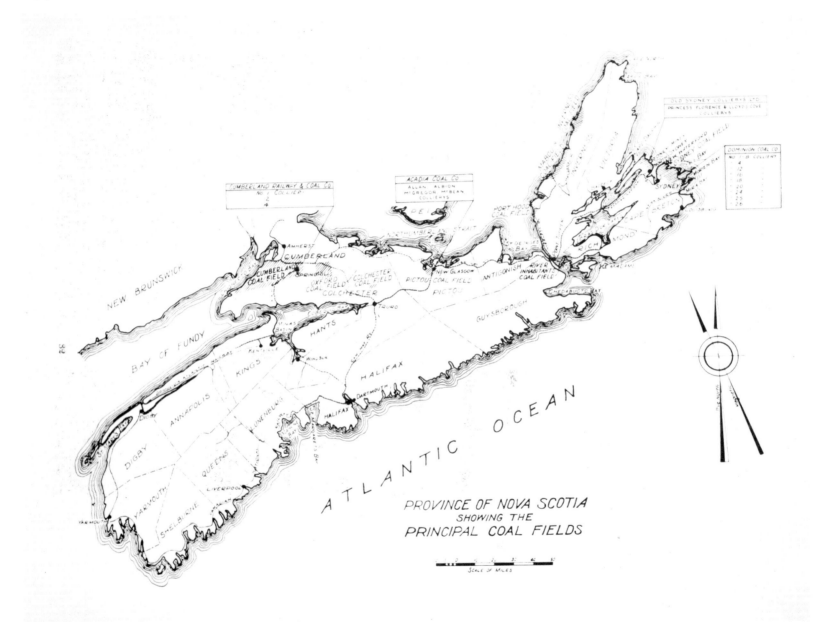

Figure 1. Map of Nova Scotia indicating the Dominion Coal Company colliery holdings (Devco Company Archives).

Figure 1. "Havenside, Louisbourg", a hand-tinted colour photograph by Leslie Shedden, from the early 1950's of the lighthouse at Louisbourg, Cape Breton. (Collection: Robert Shedden).

274

Figure 2. Hand-tinted colour photograph, by Leslie Shedden, from the early 1950's of the Cabot Trail. The Cabot Trail is supposedly the path followed by the early sixteenth century English explorer, John Cabot, during one of his expeditions which took him to Cape Breton Island. The "Trail" is now a popular tourist attraction for both visitors to Cape Breton Island and the local population (Collection: Robert Shedden.).

Figure 3. Presque Isle, Cape Breton, a hand-tinted, colour photograph by Leslie Shedden, from the early 1950's of portion of the Cabot Trail near Margaree on the western side of Cape Breton Island. (Collection: Robert Shedden).

Photo Credits

American Society of Mechanical Engineers, N.Y.C., N.Y., p. 238, fig. 14.

Beaton Institute Archives, U.C.C.B., Sydney, N.S., pp. XII, 170, 173, 177, 179, 180.

Canadian Defense Quarterly, Toronto, Ont., p. XI.

Cape Breton Development Corp. Archives, Glace Bay, N.S., pp. 195, 258.

Cape Breton Post, Sydney, N.S., p. 253.

Dosco World, Montreal, P.Q., pp. XXII, XXIII, XXIV, 186.

Edward L. Bafford Photography Collection, University of Maryland, Baltimore County Library, p. 233.

Dover Publications, Inc., N.Y.C., N.Y. pp. 210, 216.

Martin Secker & Warburg Ltd., London, Eng., p. 224.

Owen Fitzgerald, Sydney, N.S.,p. 261.

International Museum of Photography at George Eastman House, Rochester, N.Y. p. 244, fig. 20.

Russel Sage Foundation, N.Y.C., N.Y., p. 244, figs. 16-19.

Leslie Shedden, Glace Bay, N.S., p. VIII, p. XIII, p. XV, fig. 7, p. XVI.

Robert Shedden, Dartmouth, N.S., pp. 273-275.

Shedden Studio, Glace Bay, N.S. pp. 3-16, 185, 196, 263.

Teamwork, Sydney, N.S.,pp. XIX, 183, 189, 259.

World Wide Photo, N.Y.C., N.Y., p. 15, fig. 8.

Production Note

The photographs used for reproduction in the plate sections of this book were selected from the negative (4'' x 5'') archive of Shedden Studio, Glace Bay, N.S., and printed by Ron Dickie, Gary Kibbins, and Robert Wilkie, in the Photography Department of the Nova Scotia College of Art and Design. The halftones and colour separations (150 line screen) for the plate sections and a portion of the essay illustrations were produced by Owen Innes Lithographic Plate Service, Halifax, N.S. The remainder of the halftones for the essay illustrations and the line negatives were produced by Allan Scarth in the Printshop/Design Division of the Nova Scotia College of Art and Design. Much of the typing of the manuscripts and captions was done by Barbara Taylor and Moya Murphy. The typesetting (Garamond, Univers) was produced by Artistat, Halifax, N.S. Guy Harrison printed the plate section and the essay sections on the Press of the Nova Scotia College of Art and Design. He was assisted by Brad Harley on the varnish run of the photo plate section. Murray Lively prepared the printed forms for shipment. McCurdy Printing, Halifax, N.S. printed the cover jacket and did the binding.

The Press of the Nova Scotia College of Art and Design gratefully acknowledges the support of the Canada Council.

Errata

p. X, col. 1, line 31, *portraitive* should read portraiture
p. XII, col. 2, line 23, *well-crafted, crafted* should read *well-crafted*
p. XVI, col. 1, line 27, *Glace Bay,* should read *Glace Bay.*
p. I, **Dominion of Canada Steel and Coal Corporation* should read **Dominion Steel and Coal Corporation*
p. 176, col. 1, line 14, *homogenous* should read *homogeneous*
p. 178, col. 2, line 8, *top* should read *'top'*
p. 183, col. 1, line 32, *homelies* should read *homilies*
p. 197, col. 1, line 1, *sample* should read *example*
p. 197, col. 1, line 13, *discourse* should read *discourses*
p. 198, col. 1, line 17, *snug* should read *sung*
p. 198, col. 1, line 18, *esstential* should read *essential*
p. 200, col. 2, line 17, *relations* should read *relation*
p. 202, col. 1, line 16, *momento* should read *memento*
p. 202, col. 1, line 18, *for unified* should read *for a unified*
p. 203, col. 2, line 1, *D'Alembert* should read *d'Alembert*
p. 211, col. 2, line 35, *alchemcy* should read *alchemy*
p. 213, col. 2, line 17, *of Science* should read *of Sciences*
p. 214, col. 2, line 25, *preciasely* should read *precisely*
p. 218, col. 1, line 36, *inventions* should read *invention.*
p. 219, col. 1, line 20, *photograph's* should read *photography*
p. 220, col. 2, line 16, *phsyiognomic* should read *physiognomic*
p. 222, col. 1, line 6, *within social* should read *within a social*
p. 222, col. 2, line 29, *roccoco* should read *rococo*
p. 223, col. 2, line 33, *into space* should read *into this space*
p. 227, col. 2, line 22, *perpetautes* should read *perpetuates*
p. 230, col. 2, line 11, *"solider engineer"* should read *soldier engineer*
p. 223, caption, *Kobinoor* should read *Kohinoor*
p. 241, col. 1, line 18, *then* should read *than*
p. 241, col. 1, line 28, *Morris's* should read *Morris'*
p. 244, Figures 16-19, line 1, *edition* should read *editor*
p. 245, col. 1, line 22, *Lilian* should read *Lillian*
p. 245, col. 2, line 18, *photographs* should read *photograph*
p. 246, col. 2, line 8, *pedadogical* should read *pedagogical*
p. 248, col. 1, line 27, *as part* should read *As part*
p. 251, col. 1, line 28, *that if work* should read *that work*
p. 254, col. 2, line 2, *simple* should read *single*
p. 261, col. 1, line 14, *chemcial* should read *chemical*
p. 262, col. 1, lines 31-32, *J. W. Ewing* should read *J. R. Ewing*
p. 264, note 19, line 11, *Atlanasio* should read *Attanasio*
p. 267, note 143, line 2, *(New York, 1916),* p. 31. should read *(New York, 1948)*
p. 269, F.N., line 2, *Pictounian* should read *Pictonian*
p. 275, caption, line 2, *Margarie,* should read *Cheticamp*

Nova Scotia Pamphlets

Martha Rosler	*3 Works*
Gerhard Richter	*128 Details from a Picture* (Halifax 1978)
Jenny Holzer	*Truisms & Essays*

Forthcoming Publications

Serge Guilbaut (ed.)	*Modernism and Modernity*
Michael Asher	*Work 1967-1978*
Allan Sekula	*Photography Against the Grain*
Dara Birnbaum	*Rough Edits: Popular Image Video*